On Art and the Mind

Richard Wollheim

ON ART AND
THE MIND

Harvard University Press
Cambridge, Massachusetts
1974

Z49491

For
Marcus Dick
1920–71

Preface

The essays and lectures that I have collected in this volume treat of two general themes. Both represent for me old interests: I would find it impossible to say when I first experienced their fascination or their authority. I remember early phantasies about how the mind works and how thoughts are transmitted: I remember, from slightly later on, childish incursions into illustrated books and encyclopedias: and I can recall being driven home, one chill afternoon, in high excitement after first setting eyes on the sumptuously austere canvases of Poussin, still my ideal of art. The kind of thinking that has gone into these essays, or that I have tried to put there, is remote from the infantile. And yet I doubt whether I would have found the effort worthwhile if it had not been for a sense of continuity with the past, and also for the presence of certain historic images never far away when I think of art or of the mind. Brought out into the day, these images seem banal or inadequate: the box of thoughts, the curtains of the mind, the poet's inner voyage, the holy calling of art: but, by the candlelight by which they are usually seen, they are powerful enough to inspire dedication. When at certain periods of my life, as I can clearly remember, philosophy appeared to me to be dragging me away bodily from these original interests, I felt it to be cruel and harsh. I know now that these conflicts, these dramas, were of my own making. Nevertheless they have left me with some sympathy for those who find philosophy in its uncorrupt forms a forbidding master. The lesson, to be learnt only very slowly, is that philosophy has virtually nothing to offer those who would rifle it. Like paint, it requires that we find ourselves in it before it gives us anything.

Culturally we are, I suppose, heirs to our adolescence. Mine, like most, was passed in a variety of enthusiasms whose unity, immediate at the time, has often proved hard to recapture or retain. In my case these enthusiasms were socialism, poetry in all its manifestations,

something we thought of as psychology, the past, and from time to time the more extreme forms of religion. My heroes were Baudelaire, Kropotkin, Villon, Cézanne, Donne, Dostoevsky. I subscribed to the virtuous belief that all art and thought should treat of society: but inwardly I must have always known that there were more interesting possibilities.

I mention these names because they define a kind of aestheticism: an aestheticism which is probably produced no longer, at any rate in just that form, and which I still respect. In one way I can clearly recognize its continuing influence: in an impatience I have after a little while with any form of culture that turns its back on history, or complexity, or melancholy. These essays may be seen as written in defence of this aestheticism: though making use of weapons some of which it would not recognize.

To philosophize about art seems to me appropriate for a variety of reasons. Art and philosophy meet when both are either at their worst or at their best. At their worst, when they encourage the hideous sense of omnipotence: at their best, when they restrain it.

These essays have all been written since 1963. Their writing therefore coincides with a period of more practical involvement on my part with both the two themes of this volume. It coincides with an analysis lasting over eight years, and the writing of a novel. I cannot say much about the influence these events must have had upon the essays; except that sometimes they gave them, or the arguments developed within them, a painful urgency. But then they did this to so much else at the time.

I have rewritten freely, profiting from the fact that some of these essays have never been printed before. Here are their histories:

1. On Drawing an Object. An Inaugural Lecture delivered at University College London, 1 December 1964. Published as *On Drawing an Object* (London, 1965).
2. The Mind and the Mind's Image of Itself. Ernest Jones Lecture given before the British Psycho-Analytical Society, 13 March 1968. Published in *International Journal of Psycho-Analysis*, 50 (1969), pp. 209–20.
3. Imagination and Identification. Banquet Address at the Oberlin

Colloquium in Philosophy, 11 April 1970. Not previously published.

4. Expression. Delivered at the Royal Institute of Philosophy, winter 1966–7. Published in *Royal Institute of Philosophy Lectures 1966–67. Vol. 1: The Human Agent*, ed. G. N. A. Vesey (London, 1968).

5. Minimal Art. Published in *Arts Magazine* (January 1965), pp. 26–32.

6. The Work of Art as Object. Delivered at Gardner Centre for the Arts, University of Sussex, 4 November 1970. Published in *Studio International*, vol. 180, no. 928 (December 1970), pp. 231–5. Revised.

7. The Art Lesson. Maurice de Sausmarez Memorial Lecture 1971, delivered at the Byam Shaw School of Painting and Drawing, London, 18 March 1971. Published in *Studio International*, vol. 181, no. 934 (June 1971), pp. 278–83.

8. Walter Pater as a Critic of the Arts. Given for the Department of the History of Art, University of Cambridge. Not previously published.

9. Giovanni Morelli and the Origins of Scientific Connoisseurship. Given for the Department of the History of Art, University of Cambridge. Not previously published.

10. Freud and the Understanding of Art. Published in the *British Journal of Aesthetics*, vol. 10, no. 3 (July 1970), pp. 211–24. Revised.

11. Eliot and F. H. Bradley. Published in *Eliot in Perspective*, ed. G. Martin (London, 1970). Revised and enlarged.

12. On an Alleged Inconsistency in Collingwood's Aesthetic. Published in *Critical Essays on the Philosophy of R. G. Collingwood*, ed. M. Krausz (London, 1972). Revised and enlarged.

13. Reflections on *Art and Illusion*. Published in *Arts Yearbook*, no. 4 (1961), pp. 169–76; reprinted in an extended form in the *British Journal of Aesthetics*, no. 3 (January 1963), pp. 15–37. Considerably revised.

14. Nelson Goodman's *Languages of Art*. Delivered at the 66th Annual Meeting of the American Philosophical Association, Eastern Division, 29 December 1969. Published in *Journal of Philosophy*, vol. LXXII, no. 16 (20 August 1970), pp. 531–9. Considerably revised and enlarged.

15. Adrian Stokes. Introduction to *The Image in Form: Selected Writings of Adrian Stokes* (London, 1972).

I am grateful to many friends, colleagues and students for their advice and assistance. I have benefited greatly from visits to universities both in England and in America where I have read some of these essays. I should like to thank Katherine Backhouse for her extensive work on the manuscript. I have dedicated this volume to my first teacher in philosophy.

Contents

Illustrations

12. Michelangelo, *Moses*, begun before 1515 – finished after 1542, [7' 8½″ × 3' 3¾″ × 3' 1½″, marble]. S. Pietro in Vincoli, Rome. (Photograph: Mansell Collection, London)
13. G. D. Tiepolo, *The Family passing Near a Statue*, 1753, [7½″ × 9½″, etching]. National Gallery of Art, Washington, D.C.: Rosenwald Collection
14. *after* Hendrick Goltzius *Whale washed Ashore in Holland*, 1598, [1$\frac{1}{10}$″ × 1½″, engraving]. Rijksmuseum, Amsterdam: F. Muller Collection.

PART I

1 On Drawing an Object

'What is the criterion of the visual experience?', Wittgenstein writes in the *Philosophical Investigations*. 'Well, what would you expect the criterion to be? The representation of "what is seen".'[1]

The remark is taken from the second half of the *Investigations* where whatever structure the book possesses elsewhere is more or less abandoned, and it occurs there rather as a hint, as a suggestion, than as an articulated contribution to the philosophy of mind. In this lecture, however, I want to take up this stray thought and, without in any way systematizing it, simply see where it leads us. For I suspect that, if we follow its light, we may find that areas of thought we had believed disparate or apart prove contiguous.

2. It is at this stage worth pointing out that the question to which Wittgenstein's remark suggests an answer is one of which we have heard surprisingly little in the philosophy of recent years: given, that is, the extreme interest that philosophers have taken in the visual experience, or in the problem of what we really see. For they have, on the whole, confined themselves to the more epistemological questions: such as whether we can ever really know for certain what we see, or whether this can be a matter only for hypothesis and belief, or whether, if this is something on which we can be certain, this is the same as saying that we couldn't be wrong or that our perceptual judgements are incorrigible. Or again, they have asked what is the relation between these judgements, between the deliverances of visual experience, that is, and all the other kinds of judgement that we claim to know, and whether it is true that, as the philosophy within which we are all supposed to fall has traditionally claimed,

1. '*Was ist das Kriterium des Seherlebnisses? – Was soll das Kriterium sein? Die Darstellung dessen, "was gesehen wird",*' Ludwig Wittgenstein, *Philosophical Investigations* (Oxford, 1959), II, xi. I have adjusted the translation.

the latter are based exclusively on the former. Or, in so far as contemporary philosophers have taken an interest in the judgement of perception itself and its correlative, the visual experience, they have wanted to know what sort of object, in the most general of senses, the judgement was about or the experience of: sense-datum, material object, appearance. But as to the question of any particular judgement or experience, and what makes that judgement true or how we decide what that experience is of, the matter has been left rather like this: that, if an observer claims to see something or to see something in a certain way, then, if this could be so, that is, if his judgement falls within the general specifications of what is possible, we may assume that it is so. Of course, according to some philosophers (though not to others) what the observer says may be false: but that we cannot go behind what he says is common ground to nearly all.

3. Wittgenstein's criterion is, then, an attempt to get behind the observer's words. Not (though the fragmentary character of the quotation may obscure this) in all cases: but in some. In some cases, that is, the answer to the question, What did such-and-such a man see? is directly given by how he represents what he saw or by what he would draw in response to this question. To try to go behind the representation is, in those cases, vain.

Such a criterion, I feel, fits a great deal of our experience. Consider, for instance, the way in which we often conceive of naturalistic art as a kind of exploration: a research into the world of appearances: by which is meant, of course, how things look to us. Implicit in such a conception is the view that draughtsmanship, or the techniques of representation taken more generally, afford us in certain cases a direct revelation of what we see, a revelation not mediated by any perceptual judgement.

Or, again, take a visual phenomenon already known in the Middle Ages, which modern psychology has illuminated. An object, seen obliquely or at a distance or in a poor light, can seem to us in shape, colour, size, much more as it seems to us in standard conditions than the stimulus pattern would lead us to anticipate. Various interpretations of this have been suggested, but there seems fairly general agreement on the existence of the phenomenon. When, however, we ask what is the criterion employed in determining that things do look

to us in this deviant way, it turns out to be one very close to how we would represent them. Take, for instance, the experiment which is supposed to establish shape constancy.[2] A circle is exposed to the subject, tilted so that it is no longer at right angles to the line of vision, and the subject is then asked to select from a graded series of ovals that which corresponds most closely to what he sees: and the fact that he selects an oval divergent from the perspectival profile in the direction of the circle is taken as conclusive evidence that this is how he sees the circle. But why should we regard the experiment in this way? Why should we not rather see it as establishing a characteristic error to which human beings are susceptible when they try to select shapes to match their perceptions? And I suspect that a large part of the reason why we think that the experiment relates to vision is because of the substantial overlap between matching and representation. The subject may, indeed, be thought of as selecting out of a pre-existent assortment a representation of what he saw, and it is obviously but a short step from the selection to the construction of a representation.[3]

4. However, it might be objected against this criterion that it allows of the absurd eventuality that we could come to know what our visual experience was by observing our representation of it: that when we had finished our drawing, we could look at the sheet and, by scrutinizing the configuration lying upon it, learn what we have seen – where 'what we have seen' means, of course, not what thing we have seen but how we saw whatever it was or what it looked like to us. And absurd as such a supposition may seem when the visual experience and the representation are very close together in time, to the point virtually of simultaneity, the absurdity is felt to be compounded when one occurs considerably after the other. The artist, say, goes back to his studio, and works up the sketch he made on the spot, as we know Constable did: are we to say that *then* he comes to know, or that it is *only then* that he really knows, what he saw? Put like this, the conclusion certainly sounds absurd.

2. R. H. Thouless, 'Phenomenal Regression to the "Real" Object', I-II, *British Journal of Psychology*, 21 (1930–1), pp. 339–59; 22 (1931–2), pp. 1–30.

3. It is interesting to observe that Thouless originally employed as his criterion what he calls 'the drawing method' and only later substituted, for reasons presumably of convenience, 'the matching method'.

Now without deciding at this stage whether this is so absurd or not, I want to consider two arguments both of which bear on this issue. One assumes that the conclusion does follow from accepting the criterion, and uses this against the criterion, and the other maintains that the conclusion does not follow, and thinks this goes some way towards vindicating the criterion.

5. And now at this juncture, when we have already effected an entry, the merest entry it is true, into the subject, and can see stretching ahead of us some of the territories we must pass through – perception, action, knowledge, representation, verisimilitude – I should like to pause and carry out a task which those well versed in the conventional structure of an inaugural lecture might have thought I was about to omit, but which those at all acquainted with the history of my Chair must have known it was inconceivable I could. And that is to pay a tribute to my predecessors. Predecessors, I say: for I could not, on such an occasion as this, unyoke the names of the two philosophers under whom I worked over a period of fourteen years, both of whom I can regard as close friends, and from whom conjointly I derived a consciousness of how philosophy should be pursued, and why.

If I have waited till now to bring them into this lecture, it is not only because (though that *is* a reason) I preferred to introduce the names of Ayer and Hampshire in close proximity to topics with which the history of twentieth-century philosophy, when it comes to be written, will always associate them. But it is also because it seemed wanton to insert them where they so obviously do not belong, in a cold or formal paragraph, when, with just a little patience, I could place them, more fittingly, in the context of an argument.

Some of what I shall say this evening would not, will not, be found acceptable by my predecessors: but then I did not learn – or may I, just for a moment, speak here for my colleagues too, and say *we* did not learn? – either from Professor Ayer or from Professor Hampshire the desire to agree. This was not what we learnt, because this was not what they had to teach us. What they had to teach us was a virtue which might well be called systematic irreverence. By which I mean the desire, the insistence to test for lucidity, for relevance, above all for truth, any idea that solicits our allegiance,

whatever its standing, whether it originates from the tradition, or from some eminent contemporary, or from what is only too often the most seductive and irresistible of sources, ourselves: and if it is found wanting, to reject it without more ado. Philosophy can never become a mere idle or indulgent occupation as long as it incorporates this virtue. University College London is a very fitting place for its cultivation.

6. The first argument runs like this: so far from its being a possibility that we might come to know how we saw things by observing how we represent them, on the contrary we must already know how we saw them before we can represent them. Suppose our medium of representation is drawing – and I shall stick to this supposition for most of the lecture, and use the terms 'represent' and 'draw' by and large interchangeably: then, we must be able to answer the question, How do we decide whether the drawing that we do is correct or not? Unless any drawing that we choose to do counts equally as an adequate representation, then there must be something by appeal to which we assess the adequacy of what we have done. We need, in other words, a criterion, and where is this to be found but in the knowledge that we already possess of what we have seen? Put in stronger terms, the argument asserts that the idea of the representation of what we see as the criterion of what we see is a self-contradictory idea. For it in the first place assumes (by talking of representation) that there is an independent means of identifying what we see, independent that is of how we represent it, and then goes on to deny that this is so.

7. Now it is certainly true that not *any* drawing we might choose to produce of what we have seen will do.

Indeed, when we consider just the very cases that make our criterion acceptable – cases, that is, like the perceptual constancies, where there is a divergence between what we would expect to see and what we actually see – it seems likely that the drawing that is a faithful representation of our visual experience is one that will come about only as the product of trial and error. We can imagine the observer making a few strokes, scrutinizing them, accepting them, or finding them unsatisfactory and then correcting them, and so

working his way forward to the finished product through erasures and *pentimenti*. In other words, in so far as it is plausible to talk of the representation of what is seen as the criterion of the visual experience, this representation is going to be the result of a process within which judgements of adequacy or inadequacy, of verisimilitude or distortion, will have an essential place.

But does this involve, as the argument before us would suggest, that we need have any prior knowledge of what we have seen by reference to which we make these judgements: let alone a criterion that we apply in making them?

I think that we can see that the supposition that a criterion is necessary is wrong by considering what at first might seem a rather special sort of case: one, that is, where we do employ a criterion in drawing what we have seen, but unfortunately the criterion gives us a faulty representation. The problem is then to correct what we have drawn so as to bring it into line with the visual experience. Imagine, as the traditional writers on perspective so often ask us to,[4] a man placed in front of a landscape: between him and the scene before him is interposed a large sheet of paper, transparent but also firm enough for him to draw on without difficulty, set at right angles to the line of vision. With a pencil he starts to trace on the paper the outlines of the various objects in the landscape as they manifest themselves through the sheet of paper: when he has done this, he then proceeds, on the same principle, to block in the various silhouettes so that, within the restrictions of the medium, the sheet will bear upon it the imprint of the various lines and areas of colour as, seen through it, they showed up on it. But if we take into account the perceptual constancies and the various phenomena that arise out of, or are magnified by, the change of scale, such as colour-juxtaposition, it is evident that the drawing that is produced in this way, upon 'the diaphanous plain',[5] will not be a fair representation. As soon, indeed, as the man abandons the purely mechanical part of his task and stands back and looks at what he has done, he will straightway see

4. e.g. L. B. Alberti, *Della Pittura* (1435–6), Lib. II; Leonardo da Vinci, *Libro di Pittura*, Parte secunda, 118; *La Perspective Pratique*, by Un Religieux de la Compagnie de Jésus (Paris, 1640), Tr. II, Pract. XCIII. There are four woodcuts by Dürer (Panofsky, 361–4) showing a similar mechanism in operation.

5. The phrase is Berkeley's: *Theory of Vision Vindicated* (1733), Sec. 55.

that it is out of drawing. Now this is the point; he will simply *see* it: and to talk of any criterion in terms of which he judges the representation to be at fault or by reference to which he corrects it, seems here totally gratuitous. The man corrects the drawing by seeing that it is wrong.

But surely the process of correcting the drawing is not essentially different from the process of constructing it; and so, if the former can be conducted without the aid of a criterion, it must be that the latter could have been too. We may need to imagine that the drawing was done with the aid of a criterion in order to see how it could then be corrected without one. But once we see how it could be corrected without one, we also see how it could be done without one.

8. Of course, if a man draws what he has seen, there is something that is prior to his doing the drawing and which is also that on the basis of which he does the drawing. And that is the visual experience itself. If the visual experience had not been as it was, the man would not have drawn as he did, nor would he have corrected what he did draw as he did.

That is indubitable. But the fact that the visual experience can be in this way operative after it has passed, should not lead us into the view that it somehow persists in the form of a lingering image, which we then try to reproduce when we set ourselves to represent what we have seen. For there is no reason either in logic or in experience[6] to believe in the existence of such an image. We do not need it in order to explain the facts of the case, nor do we have any independent evidence for its existence in our actual consciousness. It seems a pure invention conjured into being to bridge the gap between one event – our seeing as we do – and another event, when what we have seen asserts its efficacy.

9. And yet this last phrase – 'asserts its efficacy' – seems to bring us back to the view that something must have happened at the time of

6. cf. '*Il n'est pas besoin d'avoir une profonde expérience du dessin pour avoir remarqué que l'on saisit quelquefois mieux la ressemblance quand on travaille de souvenir. Mais je ne croirai pas plus celui qui dit voir à volonté son modèle absent comme s'il était présente, que je ne crois l'enfant qui s'enfuit en disant qu'il a vu le diable et ses cornes.*' Alain, *Système des Beaux-Arts* (Paris, 1963), p. 289.

the visual experience which allows us, or influences us, to draw as we do. And if it is crude to identify this enabling power with the creation of an image which endures, then a more sophisticated view of the matter might be to think of this as the establishment in the mind of a disposition. And the natural name for such a disposition would be 'knowledge'. When we have the visual experience, we *eo ipso* know what we have seen, and this is why we are able, at a later point in time, to represent it. And this in turn is why it is absurd to think that by looking at what we have drawn, we could come to know what we have seen. For it is this knowledge that guides the drawing.

Now there is little to be said against talking of a disposition in this context: precisely because in talking of it, we are really saying so little. It is hard to feel that we are in fact doing more than simply to redescribe the facts we start off with. Nor is there even perhaps so much to be said against thinking of this disposition as knowledge: if, that is, we recognize one important point. And that is that we can be conscious to widely differing degrees of what knowledge we possess. So that, for instance, when some dispositional form of knowledge about what we have done or felt or experienced becomes actualized, the shock or surprise can be so great for us that it seems perfectly appropriate for us to describe the situation as one in which we *come to know* such-and-such a fact about ourselves: that we wished someone dead, that we desired a certain person, that we helped only in order to dominate. If, however, we wantonly refuse to admit this, if we insist that we have equally ready access to anything that we truly know, then we must also abandon thinking of the disposition that we have anyhow so gratuitously postulated, as a form or mode of knowledge.

10. However, it might now be maintained – and this is the second argument that I want to consider – that, even if we accept the contention that the representation (or let us say, more specifically, the drawing) of what is seen is the criterion of the visual experience, and do not insist (as the last argument would) that we must have prior knowledge of what we have seen before we can draw it, we still do not have to embrace the conclusion, which seems to some so objectionable, that we could ever come to know what we have seen by looking at our drawing of it. For we would have to accept this

only if it were true that we could come to know what we have drawn by looking at our drawing. But this (the argument runs) is impossible. In the case of someone else's drawing, I can, indeed must, obtain my knowledge in this way. But in my own case, when it is I who draw, it is not open to me to come to know by observation what I have done. No more indeed than (which is much the same thing) I could predict what I will draw, and then check my prediction by looking at the drawing I actually produce.

Or rather there *might be* cases where something like this happened – cases of automatic drawing, or working under drugs or in hallucinated states. But they would not be central cases, and moreover they almost certainly would not be amongst those cases which did anything to suggest that representation is a good criterion of the visual experience. For, if we drew in this way, our depiction of what we saw would not be, in the full sense of the word, an action of ours: it would be something that just happened, rather than something we did. And that in which it issued, the drawing, would have to be relegated more to the status of a 'symptom'[7] of the visual experience: just as, in the case of Perdita, blushing was a symptom of what she saw.

11. This argument is, of course, grounded in a certain view of human action, properly so called, of which we have come to hear so much recently that we might call it an orthodoxy of the day. The general form of this view is that action, or what is sometimes more narrowly identified as voluntary or intentional action, can be marked off, or is differentiated, by some epistemic property that it possesses. An action, on one variant of this view, is something whose nature is known by the agent, or more neutrally by the 'doer', without observation: it being, of course, a necessary but not a sufficient condition of action that it should be known of in this way, for the same thing is also true (it is said) of the disposition of one's limbs.[8]

7. For the distinction between criterion and symptom, see Ludwig Wittgenstein, *Blue and Brown Books* (Oxford, 1958), pp. 24–5.

8. e.g. G. E. M. Anscombe, *Intention* (Oxford, 1957), para. 8; P. F. Strawson, *Individuals* (London, 1959), ch. III; A. I. Melden, *Free Action* (London, 1961), ch. IV; Brian O'Shaughnessy, 'Observation and the Will', *Journal of Philosophy*, LX (1963), pp. 367–92, reprinted in *Philosophy of Mind*, ed. Stuart Hampshire (New York, 1966), pp. 169–201.

On another variant of this view, an action is not something that the agent can predict: where to predict means to come to know in advance by inductive or observational means. The agent can possess knowledge of his future actions, but this knowledge will be of a non-inductive kind and is most succinctly expressed in an assertion of the form 'I intend to do such-and-such a thing'.[9]

12. However, it would be as well explicitly from the start to distinguish the question whether we could come to know what we have drawn by observation, from two other issues with which, largely for verbal reasons, it might get confused. The first is whether we could come to know by observation what we have done a drawing of, in the sense of what precise thing we have drawn – to which I am sure that the answer is that (except in very irregular circumstances) we certainly could not. However, I shall not spend any time on this question, for it would lead us on to rather deeper issues, of which it is indeed the mere epistemological shadow, such as, What is it for a drawing to have an object?, or, What is the link that ties a representation to that which it represents? These issues have come to interest philosophers in recent years, since they provide such excellent examples of intentionality. But here I mention them only *en passant*: and then only because of the unfortunate ambiguity of the phrase 'what we have drawn': for besides meaning 'what sort of drawing we have done', as it has with us so far, this phrase can also mean 'what we have done a drawing of', so that 'coming to know what we have drawn' can, from this latter meaning, derive a secondary usage equivalent to 'coming to know what we have done a drawing of'. But I hope it is apparent that none of my argument either refers to, or derives its authority from, anything that is true in or of this usage.

13. The second issue with which we ought not to confuse the question before us is whether we need to use our eyes in order to draw. For it is certainly true that to many an activity the use of the eyes is

9. e.g. H. L. A. Hart and S. Hampshire, 'Decision, Intention and Certainty', *Mind*, LXVII (1958), pp. 1–12; Stuart Hampshire, *Thought and Action* (London, 1959), ch. II–III; D. M. MacKay, 'On the Logical Indeterminacy of a Free Choice', *Mind*, LXIX (1969), pp. 31–40.

essential or intrinsic. We need them in order to perform it. Consider, for instance, driving a car: or reading: or aiming a gun: or threading a needle. But it would obviously be wrong to say that we find out by observation that we are driving, or reading, or aiming a gun, or threading a needle. For in such cases the use of the eyes is not primarily cognitive: either as to the mere performance of the activity (i.e. that we are doing it), or, for that matter, as to any subsidiary or ancillary piece of information. In reading, for instance, we do not use our eyes in order to find what words are before us, which we then proceed to read: we read, rather, with our eyes.

What we need to distinguish, then, is the necessity of the eyes for the performance of some activity and the necessity of them for knowledge of that activity. For instance, I have seen it argued that a man could not come to know by observation what he was writing, since, though he might, while writing, keep his eyes open, as an aid, 'the essential thing he does, namely to write such-and-such, is done without the eyes'.[10] But while I am convinced that the conclusion here is true, that we could not use our eyes to find out that, or what, we had written, this does not follow from the equally true premiss that we do not need our eyes in order to write. For there could, after all, be activities for the doing of which the eyes were inessential: but where we could not know that we had done whatever it was, save by observation. Conjuring-tricks might be an example. Equally, there could be cases where the eyes were essential for the perfor-mance, yet it would not follow that we had, or even could, come to know what we had done by observation. We could not, for instance, after we had read a paragraph, look back over it to find out what we had read: and if there are moments of great torpor, in which we are tempted to say that this is what we are doing, we use the phrase to call in doubt that we have been reading at all. To return then to the main argument, my point is that, if someone were to claim, as one well might, that we could not draw without the use of the eyes, or that we must use the eyes in order to draw, this would not establish that we could use the eyes in order to come to know what we had drawn.

14. However, though it would be wrong to argue in this way, I am

10. G. E. M. Anscombe, op. cit., para. 29.

nevertheless convinced that the conclusion is true and that we could use our eyes in order to come to know what we have drawn.

There are, of course, cases where we draw, and the drawing we might say flows out of us, and what appears on the sheet is exactly what all the while we had expected to appear there. It is, indeed, in cases such as these that we are tempted to conceive, quite erroneously as we have seen, of the act of representation, given that the actual object is not there, as the reproduction of some inner image: for, however implausible such a conception may turn out to be under analysis, it does at least go some way to accounting for the feel of inevitability and familiarity that accompanies the drawing.

But there are other cases where the process is stickier: where there is no such smooth interlocking of anticipation and performance: and where, after the drawing has been done, the draughtsman has to make a separate act of accepting it as his own, as corresponding to his wishes or designs. In such cases there may eventually arise feelings of familiarity which attach themselves to the drawing, but, in contrast to the earlier kind of case, here it will be familiarity breaking through some initial cloud of surprise or suspicion.

Now, I want to maintain two things. First of all, it is more likely to be the second than the first kind of case that will provide us with instances in which it is plausible to think of a representation of what we have seen as a criterion of the visual experience. What I said initially, on the occasion of introducing my criterion will, I hope, have sufficed to make this point fairly evident. Secondly, though just now I talked of the latter kind of case as primarily one where after we have completed the drawing, and only then, do we come to see that it is right, I think that on many occasions, when the drawing is complete, what we also do is to come to know what we have drawn. Indeed, I suspect that with many activities the distinction between these two kinds of discovery or revelation is far from sharp; perhaps, in particular with activities the performance of which is not readily verbalized. Take, for instance, the case of someone trying to reproduce a noise that he had heard in the night. Who will claim that he can distinguish, as the noise comes out of his mouth, between, on the one hand, recognizing that the noise is right and, on the other hand, finding out what noise he has made? But even suppose the distinction to be sharp, and moreover sharp in the case of drawing:

then I still want to maintain that in many cases where someone experiences uncertainty while drawing, or surprise afterwards, the uncertainty and the surprise will relate as much to what he is drawing or has drawn, as to its rightness as a representation. In other words, it would be erroneous to think of all cases of the second kind on the analogy of a man doing a crossword puzzle and trying out a certain word, to see if it will fit: in many cases, the perception of the fit is simultaneous with the perception of what is being tried out, and the analogy (to be appropriate) should require that the word forms itself or comes into being for us only as it falls into place in the puzzle.

15. Must we then conclude that in many cases the act of drawing what we have seen is not a true action of ours at all? And that, so far from being entitled to infer from the intentionality of representation to the fact that we cannot come to know what we have drawn by observation, we ought rather to argue contrapositively: that is to say, from the evident fact that we *can* come to know what we have drawn by observation to the non-intentionality of representation?

But perhaps we need not go so far. For even the adherents of the view that every intentional action that we do is known by us without observation, have conceded that there will always also be certain descriptions of our actions that we do not know to be true of them or that we know to be true of them only by observation.[11] Similarly the adherents of the view that we have a non-inductive knowledge of our future actions allow that there will always also be certain descriptions of these actions under which we can in an ordinary inductive fashion predict that they will come about.[12] So for instance, a man might be building a wall intentionally and know that he was building a wall, but not know that he was depriving his neighbour of a cherished view. A man might intend to track his enemy all afternoon and know that he was going to do this non-inductively, but might also be in a position to predict, on the basis of a knowledge of his enemy's habits, that around three o'clock he would find himself walking in front of the church of St Stephen.

Mightn't we then have here a possible let-out: in that we could say that the act of representing what we have seen is intentional since

11. e.g. G. E. M. Anscombe, op. cit., para. 6.
12. Stuart Hampshire, loc. cit.

even if we don't know directly what we are doing under one description, there is another description under which we do know what we are doing? Even if we don't know that we are drawing two figures the same size, or don't know this until after we've finished, we do at any rate know that we are drawing two figures. Isn't that good enough? And the answer, of course, is that it isn't. For those who allow that, though for any intentional action there must be one description under which we know immediately what we are doing, there could also be others under which we don't, insist in the same breath that the action is intentional only under the former description and that it is unintentional under the latter. In other words, their view is that the intentionality or otherwise of an action is relative to the description under which we subsume it. Applied to our example, this gives the conclusion that the drawing of two figures would be intentional but the drawing of two figures the same size would not be.

16. I hope I have already indicated how undesirable I should find such a conclusion, and why. The point is that it is only in so far as an action is intentional that it can be regarded as the criterion of an experience. Otherwise it can at best be a symptom of that experience. Now the distinction here, criterion or symptom, might be thought to be a purely verbal matter, since, either way round, the representation could still be (to use a neutral term) the index of what I have seen. That is true. But if the representation of what we see were to make good its claim to be a symptom, then there would have to be shown to be something like a series of causal connections holding between, on the one hand, specific visual experiences and, on the other hand, specific configurations. To believe in such connections would be a pretty strenuous exercise of the mind. Accordingly, the only plausible way in which representation and visual experience can be linked is one according to which the former is the criterion of the latter, which in turn means that the former must be fully intentional, which is just what looks threatened at the moment.

I want to maintain, however, that this threat can be grossly exaggerated. For we do wrong to adopt as a universal principle the idea that, if a man does a certain action and there is a description under which he knows directly that he is doing it and another under which he doesn't, then, though the second description is also true of

it, it is only under the first description that the action is intentional. It may well be true that in the case where a man builds a wall which obscures his neighbour's view and he knows directly that he is building a wall but only, say, afterwards that he has obscured the view, then the building of the wall was intentional but the obscuring of the view not. But the argument could easily be extrapolated invalidly. For, I want to maintain, there are cases where the description under which the action is known directly and the description under which it isn't are so related that intentionality transmits itself from the action described in the one way to the action described in the other. For instance – and I suggest this without prejudicing that there might be other ways in which the two descriptions are related with the same result – when one description refers to the following of a rule and the other to the carrying out of a particular instance of that rule.

17. Suppose that I decide to count aloud, starting with the number 2 and proceeding in accordance with a simple progression: say, one expressed by the instruction, 'Add 7'. Now it is not hard to imagine that, though I was able to do this with great fluency, I could not say beforehand, short of sitting down with paper and pencil and calculating, what number I would come out with at, for example, the eighth place. It was, indeed, only when I heard the number actually issue from my mouth, which it did (we are to assume) quite correctly, that I even knew what number I was saying. But surely there is nothing in all this that could conceivably give us reason to say that, whereas counting in accordance with the progression was something I *did* intentionally, coming out with the number 51 was something that merely happened. On the contrary, what seems right to say here, and anything else absurd, is that if the counting in general was intentional, then so also *must* have been the coming out with this particular number.

An older way of characterizing intentional actions, which is at any rate plausible, is to say that they are actions that can be commanded.[13] Now we might regard our embarking on the process of counting in this particular way as the acceptance of a command that we give to ourselves. But if this is so, would it not be odd to say that all the

13. e.g. Erasmus, *De Libero Arbitrio Diatribe* (1524), II a 1, II a 5–8, II a 13–b 8.

absurd. If, however, we say that the intentions of the two men are the same, this looks more plausible, but it also has its difficulties. For amongst other things, it makes the failure of the incompetent man quite peculiarly hard to understand. For if his failure is specifically a failure to realize his intention, then it looks as though either he is particularly unfortunate, in that the world is very persistent in its refusal to co-operate with him, or else he is unbelievably incompetent, in that he cannot even draw two figures the same size. Now, of course, we need to exclude the man who cannot, say, draw, from the application of our criterion: for it cannot be right to take his representation as the criterion of his visual experience. But the approach we are considering seems unable to account adequately for this exclusion: since the reasons it suggests for it are either far too weak or far too strong, making the man into a victim, on the one hand, or an imbecile, on the other.

19. But now it might be asked, How can I talk of a drawing that I do as the criterion of what I see, when a drawing is so very unlike a visual experience? When, for instance, a drawing is bound to be full of contours, whereas – except in the limiting case where what I am looking at happens itself to be a drawing – what I see lacks contours?

Now before I embark on this problem, which is, I think, both interesting and difficult, I should like parenthetically to mention one way out of it, which is inviting, but which it would, I feel, be wrong to take. For (it might be said) the difficulties I refer to are not really intrinsic to representation as such. They arise specifically out of the particular medium I have invoked, that of drawing, and they do not raise any general issues about how we can represent what we see. Since the issue here is a philosophical or conceptual one, I am entitled to assume an ideal method of representation, and, if I am to make any progress, I must begin by saying: Let us suppose that we take a sheet of paper and that we breathe on it, and that as we breathe on it there is left behind a perfect imprint of everything that we see as we see it, i.e. a complete representation of our visual experience.

The appeal to such magical procedures is not uncommon in contemporary philosophy. 'Imagine', it might be said, 'that we were watching our own funeral', or 'Imagine that we just directly knew what other people were feeling'. Now, doubtless such invitations

have considerable pedagogic value, in persuading us to ignore some contingent features of a situation in favour of the essential phenomenon. But they also have their dangers, in that this magical way of thinking is not always confined to the procedures envisaged, but can so easily leak out and infect the results that these procedures are supposed to bring about, and turn them into something of a mystery. Is it so clear what it would be for our funeral to pass our eyes, or for us to be directly cognizant of our neighbour's jealousy?

20. But once we reject the notion of an ideal mode of representation, and content ourselves with the existent and admittedly imperfect modes, how can we avoid the objection that arose a moment ago, that we cannot hope to find amongst these modes adequate criteria of our visual experiences, since any drawing is bound to contain contours, whereas there are no contours to be found in the visual field?

Now, if someone at this stage were to retort that my example was badly chosen, in that the visual field does or sometimes does contain contours and that the extent to which we experience contour in perceiving real objects is an experimental, not an *a priori*, issue, I should regard this retort as at once misguided and yet also illuminating, if indirectly, on the point I am trying to make. For what this retort assumes is that contours in the sense in which they occur in drawings and contours in the sense in which they have been postulated of our perception of objects are one and the same thing. Yet they evidently aren't. For what we are alleged or asserted to see objects as having might alternatively be expressed by talking of 'edges': edges perhaps marked, or articulated for us, by some kind of separation or boundary-mechanism, such as a sharp gradation of colour, or a brightness difference, or a halo or corona around the object, but nevertheless edges. But no one could maintain that drawings contain edges: within, that is, the edges of the sheet. And now perhaps we can see – and this is what I meant by saying that the retort was illuminating – just why my example of contours as something that differentiates drawings from visual experiences was well chosen. For I wanted something that differentiates them essentially. And that is what contours do. For contours in the sense in which they belong to drawings can belong only to two-dimensional surfaces: which is why they belong to drawings, and possibly

to other forms of representation, and why they do not belong to visual experiences.

21. Yet it cannot be right to think of it as a mere coincidence that we should use the same word to refer both to the lines in a drawing and to the edges of perceived objects. 'Contour' is not in this context a homonym. There is a reason for this double usage, and the reason surely is this: that, though the contours in a drawing aren't themselves edges, when we look at a drawing as a representation we see the contours as edges.

But implicit in this explanation is, I feel, a way of meeting the more general objection that is holding us up: namely, that a drawing couldn't be the criterion of a visual experience, because drawings and visual experiences are so very unalike. For in making this judgement of dissimilarity, the objector is presumably contrasting visual experiences with two-dimensional configurations of lines and strokes. Now to do so might seem in order, since this is certainly what drawings *are*. But though this is what they are, this is not the only way in which they can be seen. They can also be seen as representations. Now my suggestion is that in so far as we see a drawing as a representation, instead of as a configuration of lines and strokes, the incongruity between what we draw and what we see disappears. Or, to put the matter the other way round, it is only when we think of our drawing as a flat configuration that we can talk of the unalikeness or dissimilarity of the thing we draw and the thing we see. This is not, of course, to say that we do not distinguish between good and bad representations, where good and bad mean more or less like. But it is significant that in such cases we never make any appeal to the general or pervasive dissimilarity that, according to the argument we have been considering, is supposed to hold between what we represent and how we represent it. Indeed it has even been argued[16] that a good representation, or a representation that is 'revealing', requires an alien or resistant medium through which it is then 'filtered'.

22. But now I must pause and consider this new phrase, which has apparently been so useful, and ask, What is it to see something as a

16. Stuart Hampshire, *Feeling and Expression* (London, 1961), pp. 14–15.

representation? A question that I rather dread, because I have so little constructive to say in answer to it. I shall begin with a view that has of recent years been canvassed with great brilliance but which I am convinced is fundamentally wrong, and that is that to see something as a representation of a lion or a bowl of fruit is to be disposed to some degree or other, though probably never totally, to take it for a lion or a bowl of fruit: the degree to which we are so disposed being an index of its verisimilitude or goodness as a representation.[17] That representation is a kind of partial or inhibited illusion, working only for one sense or from one point of view, and that to see something as a representation is to enter into this illusion so far as is practicable, is a view that has obvious attractions: even if only because it offers to explain a very puzzling phenomenon in terms of one that is easy and accessible.

Yet it is, I am convinced, misguided. For, in the first place, it does not fit our experience. We have only to think of the undoubted cases of illusion and *trompe l'œil* that do exist, and compare what we experience in front of them with what we experience in front of an ordinary work of representation, to be immediately and over-whelmingly struck by the difference between the two situations. Just one instance of this: to enter into an illusion (as opposed to seeing through it) depends by and large on a subversion of our ordinary beliefs; whereas to look at something as a representation seems not to necessitate either denial or erroneous belief *vis-à-vis* reality.

And this connects with the second objection I have to the equation of representation with illusion. And that is that it tends to falsify – or perhaps it springs from a false conception of – the relation between seeing something as a representation and seeing it as a configuration. For though there certainly are these two different ways of seeing the same thing – sheet, canvas, mural – there is no reason to think of them as incompatible ways. Indeed, does not a great deal of the pleasure, of the depth that is attributed to the visual arts, come from

17. E. H. Gombrich, *Art and Illusion*, (second ed., London, 1962), chs. VII-IX, e.g. pp. 172–6, 233–6, 256. Of course Gombrich combines his thesis with a very complex account of what constitutes illusion, in which great emphasis is placed on the role of projection: but as the discussion of Shadow Antiqua, op. cit. pp. 175–6, clearly brings out, for him illusion certainly involves false belief. On Gombrich's views see Richard Wollheim, 'Reflections on *Art and Illusion*', collected in this volume pp. 261–89.

our ability at once to attend to the texture, the line, the composition of a work and to see it as depicting for us a lion, a bowl of fruit, a prince and his cortège? Yet on the view we are considering it should be as difficult to look at a work in these two ways simultaneously as it is at once to experience a *trompe l'œil* and to admire the brush-strokes that go to its making.

It is surely no coincidence that the author of *Art and Illusion* – if I may refer in this impersonal way to my former colleague, to whose thinking on these subjects I am so deeply, so transparently indebted – it is no coincidence, I say, that the author of *Art and Illusion* should assimilate what he calls the 'canvas or nature' dichotomy, which corresponds to what I have talked of as the difference between seeing something as a configuration and seeing it as a representation, to the kind of ambiguities of vision typified in the diagrams that decorate textbooks of perception: the reversible staircase, the Necker cube, or, Gombrich's own example, the duck–rabbit figure.[18] For with such figures, we can see them sometimes one way, sometimes the other, but never both ways simultaneously. We can see the duck–rabbit figure sometimes as a rabbit, sometimes as a duck, but never as both.

23. The rejection of the idea that representation is a kind of partial or inhibited illusion might well lead us to the view, which can be regarded as its diametric opposite, that representation is a kind of code or convention. On this view, to see a drawing as a representation of something is no longer to take it, or to be disposed to take it, for that thing: it is rather to understand that thing by it. Now this view not merely avoids the grossness of assimilating all works of representation to *trompe l'œil*, it has the added advantage that it can allow for the way in which we are able simultaneously to take in, or admire, a drawing as a configuration and as a representation. For when we turn to other cases which are indubitably those of a code or convention, there seems to be no difficulty over any analogous bifurcation of interest. Can we not attend at once to the typography of a book and to what the book says? Do we have to deflect our attention from the beauty of the script to appreciate the melancholy of the poetry it conveys?

But this view of representation has its defects too. For we could

18. Gombrich, op. cit., pp. 24, 236–8.

imagine a painting of a landscape in which, say, the colours were reversed so that every object – tree, river, rocks – was depicted in the complementary of its real colour: or we could imagine, could we not?, an even more radical reconstruction of the scene, in which it was first fragmented into various sections and these sections were then totally rearranged without respect for the look of the landscape, according to a formula? And in both cases it seems as though there is nothing in the present view that could relieve us from classifying such pictures as representations. Yet ordinarily we should not be willing to concede that this is what they were, since it is only by means of an inference, or as the result of a 'derivation',[19] that we are able to go from the drawing to what it is said to depict. There is no longer any question of seeing the latter in the former. We have now not a picture that we look at, but a puzzle that we unravel.

A good way, I suggest, of bringing out the typical defects of each of the two views I have been considering would be via two phrases that are used – interchangeably it seems – to characterize our perception of drawings, paintings, etc. For if we are looking at a drawing, say, of a lion and looking at it as a representation, then this fact can be conveyed by saying that we see it as a lion:[20] alternatively, it can be conveyed by saying that we see it as the representation of a lion. Now though (as I say) these two phrases can be used in this context interchangeably, each, when concentrated on exclusively, gives rise to characteristic misunderstandings of its own: and my suggestion is that the error of the illusionistic theory of representation might be expressed by saying that the theory leans too heavily on the first of

19. Ludwig Wittgenstein, *Blue and Brown Books*, p. 129.

20. Wittgenstein seems to suggest that it would be quite erroneous for us to talk of seeing a drawing of e.g. a lion 'as a lion' unless we were aware of something else which the drawing could be seen as a representation of. So, for instance, imagining himself to be in the position of someone who was aware only of the rabbit-aspect of the duck–rabbit figure, he writes: 'It would have made as little sense for me to say "Now I am seeing it as . . ." as to say at the sight of a knife and fork "Now I am seeing this as a knife and fork"' (*Philosophical Investigations*, p. 195). But surely the 'seeing-as' terminology would be in place here just because there is another way in which Wittgenstein can see the drawing, i.e. as a configuration, even though there is not something else of which he can see it as a representation. This fact seems to be concealed by Wittgenstein's introduction of the clumsy phrase 'picture-object', which he uses to cover the configuration, the representation, and the object represented.

these phrases, in that it brings seeing a lion in a drawing too close to seeing a lion in the jungle, whereas the conventionalist theory leans too heavily on the second phrase, in that it over-emphasizes the difference between a lion and a representation of a lion, even to the point of suggesting that quite unrelated visual experiences attach to the seeing of each.

24. Students entering the studio of Hans Hofmann, the father of New York painting, were told as their first assignment to put a black brush-stroke on a white canvas, and then to stand back and observe how the black was on the white.[21] Now what these boys had certainly done was to place some black paint on a white canvas, but it was not this – though it was something contingently dependent on this – that they were asked to observe, when they were asked to observe that one thing was on another.

For, in the first place, in the sense in which the black paint is on the white canvas, it follows as a consequence that the white canvas is behind or underneath the black paint. If the paint were rubbed off, the white canvas would be revealed. But there is no analogous supposition that the young painters were required to entertain when they were invited to see the black on the white. They could accompany their perception with, for instance, phantasies about there being a yellow patch behind the black, or there being another black patch behind it, or there being a deep orifice behind it, and they would still have accepted their teacher's invitation.

Secondly, in the sense in which the black paint is on the white canvas, this follows as a consequence from the fact that the black paint has been applied to the canvas. But what the young painters were asked to observe stands in no such connection to the contact of brush and canvas. The putting of paint on canvas is a necessary but it is not a sufficient condition for our seeing one colour on another: even when the first colour is that of the paint and the second that of the canvas. For we could imagine a case in which the paint was put on very thin and the edges of the stroke carefully indented, and the effect might then be as of a cut or slice across the canvas, opening on to darkness. In this case, if this is what Hofmann had asked his students to do, he could then have asked them to observe how the

21. I am indebted for this piece of information to Mr Larry Rivers.

black was behind the white. In other words, if black paint is applied to white canvas, the paint must be *on* the canvas: but of the black we need only say that it *could* be on the white, for it could also be *behind* the white and it could presumably also be *level with* the white.

In other words, there are two distinct dimensions here along which 'on', 'level with', and 'behind' are values: a physical dimension, and what we might call a pictorial dimension. It is along the first that the paint is on the canvas, it is along the second that the black is (or, at any rate, is when Hofmann's students did what he wanted them to do) on the white.

Now I have used the word 'pictorial' here, and used it deliberately and in preference to another word, which entered my mind briefly, as it may have yours: that is, that word 'visual'. I rejected this word, because it might tend to obscure one very important point: and that is, that not merely can we see the black on, level with, behind, the white, as the case may be, but we can also see the black paint on the white canvas. The physical fact is also something visible. Indeed, that we can see it is just what I have been endeavouring to draw your attention to, whenever I talked of seeing a drawing, painting, etc. as a configuration.

25. Which brings me to the one general point of a positive kind that I have to make about representation: and that is, that to see something as a representation is intrinsically bound up with, and even in its highest reaches is merely an elaboration or extension of, the way in which, when the black paint is applied to white canvas, we can see the black on the white, or behind the white, or level with it.

Now, there are two objections that could be raised at this stage, both designed to show that my view of representation is much too liberal: in that it will let in far more than is acceptable on intuitive grounds. The first takes as its *point d'appui* the figure-ground hypothesis of Gestalt psychology. For according to this hypothesis, our very capacity to discriminate any element in the visual field depends upon our power to see it on something else. Accordingly, it would be wrong to use this power to explicate what it is to see something as a representation or to think that we could define the seeing of representations in terms of the power. Now, whatever may be the

proper application of the figure-ground hypothesis to the perception of three-dimensional objects, I am sure that, in the case of the perception of configurations (to which, for some reason or other, it is usually applied), all that the hypothesis relevantly asserts is that, in so far as we are able to discriminate a visual element, we see it as opposed to, or in contrast to, or over against, something else. In other words, for an element to be figural is a far more general characteristic than for it to be pictorially on something else or, indeed, than for it to be at any specific point along the pictorial dimension: and we should not be misled over this by the contingent fact that, in most cases where the figure is contrasted with the ground, it is so by means of being localized in front of it. It is, after all, significant that the figure-ground relation has been asserted to hold in cases where the 'on' relation could not hold or could hold only metaphorically, e.g. within the domain of auditory elements. What I have called the generality of the figural characteristic has even encouraged some thinkers to regard the figure-ground hypothesis itself as purely tautological, in that all it does is to define the property of being a perceptually identifiable object.[22]

The second objection that I want to consider is one that superficially is more empirical in that it takes as its starting-point specific examples: things like diagrams, arabesques, doodles, which are cases where we see one thing on another, and which surely are not representational. We see one line cross *over* another, we see one edge of the cube stick out *in front of* another, we see the key-pattern *on* the course along which it runs. I agree: but then I do not see why we should not regard these as cases where we see something as a representation. Indeed, the only reason I can think of for not doing so is a prejudice which, if we had not been cured of by our early lessons in geometry, we should have been by our experience of the pictorial art of the last twenty years: that is, the crude identification of the representational with the figurative. For, of course, we cannot see the diagram of a cube, or a grid-like doodle, or the ornament on a frieze, as something figurative. But this doesn't mean that we cannot see them as representational. Indeed I want to claim that just this is what we generally do: we generally see each one of those diagrams or details as the representation of whatever it is of which the lines that

22. David Hamlyn, *The Psychology of Perception* (London, 1957), pp. 55-7.

constitute it are the projection on to a plane surface. That this is so becomes apparent when we realize that, alongside the way in which we generally look at them, there is another way, which we seldom employ but always could, and which could appropriately be described as looking at them as configurations.

That this is true even for the simplest case can be brought out by considering something which might at first brush be thought to be minimally representational: a straight line drawn in pencil across a white sheet of paper. For what are we usually aware of in such a case? Is it not something stretched out, and in front of, and across, something else? And isn't being aware of this seeing the line as a representation? Which stands in contrast to what we could do if we were merely to attend to the pencil mark as it lies on the page: *on* the page, in the sense that rub it off, you have the page underneath it. Indeed the real difficulty in a case like this, after we have concentrated on it a while, becomes not so much to understand how we can see the line as a representation but even to make sense of the suggestion that we can see it in any other way, i.e. as a configuration.

26. But now it might be asked whether my argument has not come full circle, and whether the account I offer of representation is in any way distinguishable from that in terms of illusion which I rejected a short while back. I am sure that it is.[23]

For in the first place, my account allows for the fact which the illusionistic account does not, that we can see a picture simultaneously as a configuration and as a representation. For there is no general reason why we should not at one and the same moment see one element in a picture as physically on, and, say, pictorially behind, another: whereas we cannot, at one and the same moment, see a picture as configuration and as *trompe l'œil*. There may be some cases where we cannot, in fact, see a drawing or painting along these two dimensions without a deliberate switch of set or attention, which

23. The distinction on which I insist is in many ways similar to that made between '*tridimensionalité*' and '*réalité*' in A. Michotte, '*L'énigme psychologique de la perception dans le dessin linéaire*', *Bull. Acad. Belg.* (*Cl. lettres*) 5e série, vol. 34 (1948). See also Margaret Phemister, 'An Experimental Contribution to the Problem of Apparent Reality', *Quarterly Journal of Experimental Psychology*, III (1951), pp. 1–18.

must take place over time, but such an inability is always going to be grounded in the particular conditions or occasion.

Secondly, illusion (as we have seen) always involves some subversion of belief. But seeing one thing on another in the sense that I claim is relevant to representation has no such epistemic consequences or presuppositions.

Indeed the real difficulty concerning the distinction between my account and the illusionistic account of representation is not so much to find the grounds of the difference, as to bring the grounds together or to assign them their respective weight. For I have made the distinction, you will observe, partly by reference to a difference in experience, partly by reference to a difference in belief. But how do experience and belief connect? Could we imagine, say, the experience of illusion totally divorced from the correlative belief? Or is the belief here just a peculiarly vivid kind of experience: or does it still retain, even if in a phantom or attenuated mode, links with action?

27. I end on a question which I have neither the means nor the time to answer. But I have no doubt that the answer if it came would only take us a little further along the path we have been pursuing.

For, though I have, I know, presented nothing this evening that even resembles a demonstrative proof, I nevertheless like to think that the various arguments and considerations I have been advancing do possess a unity over and above that of having been compressed by me into a single lecture.

For all are calculated to disturb a certain picture of the mind, still in circulation, which can only lead to error or vulgarity wherever it asserts itself: in philosophy, in art, in our efforts towards self-knowledge. According to this picture, the thoughts, passions, beliefs, perceptions, sensations, actions that constitute a human biography, form a hierarchy, in which the orders are comparatively distinct, and to each of which attaches its own appropriate degree of certainty. A truer picture seems to be one on which it is only by means of matching perceptions against actions, passions against beliefs, characteristic modes of concealment against characteristic modes of expression, that we can slowly, painstakingly, painfully build up any sort of conception of the human individual that is worth the name of knowledge.

2 The Mind and the Mind's Image of Itself

In one of his less ephemeral moments Lytton Strachey claimed for himself that he had destroyed for ever that famous institution of historiography, the three-volume biography. One can see what he meant. Those great memorial structures, contrived out of chill marble prose, sitting upon a man as heavily as a tomb, as though to prevent him from walking abroad, from re-entering life – these would no longer be erected. And Strachey contributed to this.

It was left to Ernest Jones, after a life's work of the highest distinction, at an age when many men might be thinking of their own monument, to revive what Strachey had set out to destroy: but with a difference. Jones revived the three-volume biography because he managed to make of it a home in which a man could survive, not a tomb in which he was interred. In his life of Freud Freud lives.

We know how Jones did this. His biography of Freud is the story not just of one great man, but also of an enterprise: of what is, to my mind, the most exciting, the most courageous, the most poignant adventure in the history of Western ideas. And in this adventure Ernest Jones had played a major role. And, again, Jones as a biographer had the enormous advantage of possessing a technique that biographers have increasingly come to realize is indispensable to their work: psychoanalytic understanding. Jones's deep experience, his inner relation to the technique, taught him two things: how to apply psychoanalysis, and when not to. His discretion, his lack of presumption, his respect for Freud are everywhere in evidence, and they have their reward in the delicacy, the *sfumato* they give to the portrait.

My thoughts turn to one passage in the first volume where Jones discusses the central curiosity in Freud's life: how someone who was deeply imbued in high nineteenth-century ideas, who throughout his life adhered to the strictest notions of decorum – ideas and notions, it must be said, that some of us today find almost incomprehensible

– should have been the first person to draw man's attention to the pervasiveness, from the earliest days, of sexuality. Jones suggests that the fascination that the topic of sexuality exercised for Freud, what constantly kept it under his gaze when so much in his upbringing and in his mental attitudes might have inclined him to look elsewhere, was the way in which here the meeting of mind and body is so strikingly, if mysteriously, effected.[1]

From its earliest days psychoanalysis has had much to say concerning this obscure union on which the human being rests. The topic is traditional in philosophy, and if much of what philosophy has said is wrong and misguided this should be a reason not for philosophers to abandon the inquiry but for them to make amends.

I cannot fully express my own indebtedness to psychoanalysis for all that, in many ways, I have learnt from it on this dark issue. I cannot express my indebtedness to your Society for the opportunity it has given me for drawing upon these lessons. In trying to discharge one debt I incur another.

2. In contemporary philosophy, it has frequently been emphasized that there is a radical difference between reports or characterizations of mental states and reports or characterizations of states of affairs in the external world: a difference that cannot be overlooked without serious consequences for our understanding of the mind. Yet, as so often in philosophy, it has proved easier to point to a difference disregarded, and to what supposedly follows from that in the way of error, than to say how, on a clearer view of the matter, this difference should show up.

It has, for instance, been held to be a distinguishing feature of our reports of mental states that, when made autobiographically, or, more precisely, when made in the first person singular present tense, they are incorrigible or not subject to error.[2] I find many difficulties in this: as well as an element of truth.

In the first place, the view presupposes that we can effectively distinguish between those mental states which are immediate, or at

1. Ernest Jones, *Sigmund Freud: Life and Work* (London, 1953–7), vol. I, p. 299.
2. e.g. Sidney Shoemaker, *Self-Knowledge and Self-Identity* (Ithaca, N.Y., 1963); Norman Malcolm, *Knowledge and Certainty* (Englewood Cliffs, N.J., 1963). cf. Ludwig Wittgenstein, *Philosophical Investigations*, I, §288.

any rate very short-lived, and those which lack immediacy or cannot be contained within a sizeable span of time but are enduring – for it can only be to the former, the states of immediacy, that the view applies. And, secondly, the view presupposes that we can effectively distinguish between the assertions that we make about our mental states and the beliefs that these assertions are held to express – for it can only be to the latter, the beliefs, that the view applies. But, in both cases, I am, for reasons that could not be rehearsed here, uncertain whether the distinction can be made. And, finally, even if these difficulties could be resolved, and the incorrigibility thesis given a clear and unambiguous formulation, it seems to me most unlikely that the thesis could be true: if, that is, in its formulation it stopped this side of mere truism. For even within the confines of the conscious mind, there seem too many factors, like inattention, confusion, rationalization, for the thesis to be able to discount them all and yet retain content.

The element of truth in the incorrigibility thesis is this: that the fact that we are prompted to make a certain report upon our mental state, that we are inclined to assert this rather than that, cannot be set aside. The prompting, the inclination has its own authority; though how far its writ runs is not always manifest. Indeed, on the evidential side psychoanalysis is grounded on the principle that everything we say says something: but not necessarily the truth about a present, conscious, mental state. From the junk of our sayings something may always be recovered – but this does not mean that the junk is in order as it stands.

3. I now want to suggest – and this will be my principal theme this evening – that it is a distinctive feature of our reports of mental states, and indeed of our reports of mental states in general, not just of our own, that they presuppose a conception of the mind itself. This conception provides the background against which we identify mental states as of this or that kind, as directed upon this object or that.

To establish this thesis in anything like the complexity or detail that the topic demands would be a vast undertaking, well beyond the resources of this evening. But the argument may be abridged – I hope not too arbitrarily – by making an assumption which I believe

to be true, with only possible minor qualifications. The assumption is that every mental state is identified by reference to a thought – a thought, that is, on the part of the person whose mental state it is.[3] The possible qualifications I have in mind concern what, if we imagine the whole range of mental states laid out in their variety before us, on exhibit as it were, we might call the 'raw' or immediate end of the spectrum. For amongst sensations – like, say, pain, or the pangs of thirst, or a thrill – there may be unmediated states of mind, states in which thought plays no constitutive role. Though even here, it must be observed, as soon as we start to localize the sensation to a part of the body – the pain to a hand or foot – or to associate it to possible satisfaction – the pangs of thirst to drinking – or to set it inside a familiar cycle or experience – we recognize the sexual thrill to be a preliminary to, or a forepleasure of, orgasm – already we invoke the intermediary of thought. And then the question must arise, To what degree, outside this context, which thought alone can supply, are these sensations identifiable, even by the person who has them? So I must be doubtful whether there are any mental states that are fully identifiable without reference to a thought. (Throughout, it must be recognized that, in talking of 'thought', I am not necessarily restricting myself to verbal thought.)

Once we assume the connection between mental states and thought, then my thesis that mental states, or our reporting of them, presuppose a conception of the mind, can be more readily demonstrated. For it is an intrinsic feature of thinking that we can distinguish between cases in which a thought merely occurs to us, or comes into our head, or breaks in upon us, and cases where we think the thought. And by saying 'intrinsic', I have in mind that, if we were merely to report the thought and give no indication, implicit or explicit, whether it merely occurred or whether we thought it, we should not be reporting a mental state at all. We should be reporting a constituent of a mental state, but not the mental state itself: just as if we were to report the object of our perception – say 'a building with a Doric colonnade' – we should be reporting a constituent of a mental state, this time of a visual experience, but not the state, the visual experience itself. To put it generally: where a mental state has a

3. cf. Richard Wollheim, 'Thought and Passion', *Proceedings of the Aristotelian Society*, LXVIII (1967–8), pp. 1–24, where I have argued the point at greater length.

'how' as well as a 'that', we must report both if we are to report the state.

The distinction that I have just made, between thoughts occurring or merely occurring in the mind, and thoughts being thought – what might be called, without prejudice to further understanding, the distinction between mental passivity and mental activity – comes out, phenomenologically, with greater clarity, when we consider one of the oldest elements in the theory and practice of psychoanalysis: free association. For when a patient undertakes to associate to a dream or a recollection, he may characterize what is going on in his mind as a succession of thoughts that come into his mind or pour in upon him or rise up. Alternatively he may say that, perhaps despite all his efforts to the contrary, the thoughts that succeed one another do not do so freely, or spontaneously, they are, rather, the result of contrivance, of his putting them together – in other words, in my words that is, he *thinks* them.

Now I want to say that this distinction involves a conception of the mind, so that any application of the distinction in a given case presupposes that conception. When the mind is passive, thoughts are conceived of as effecting an entry into it, from the outside: on occasions, when the thoughts are obsessional, doing so with the use of force. There is something or somewhere that they enter. And when the mind is active, the presumption would be – though the presumption here is fainter – that it is in this same place that the thoughts arise or are generated.

I foresee two immediate objections. The first would be that I have taken what is no more than a sustained metaphor as though it were, or were intended as, a literal description. We may speak of thoughts entering the mind or breaking in upon the mind or just being in the mind, but when we do so, the phrases that we use do not reflect what we actually believe. They are mere turns of speech. Now whatever sympathy we may have with the general impulse of this argument – which I shall return to later – the argument as it stands is tendentious. For it assumes that we have a clear distinction between what is metaphorical and what is not: which we do not have. As a minimum someone who uses this argument must show that there is an alternative way of describing the facts in question – here it would

be, of reporting the relevant mental states – which could make a good claim to be a literal description.[4] And I do not see that in the present case this condition can be fulfilled. There is no more reason for holding that the assertion that, say, thoughts are in the mind is a metaphor, than there would be for making the corresponding claim about the assertion that fictional characters are in a novel: a parallel we might remember.

The second objection would be that I am wrong to distinguish between thoughts that occur to me and thoughts that I think: for both kinds of thought originate with, derive from, me. They are all my thoughts, and I cannot, by a phrase, escape responsibility for any of them. But, of course, it is no part of my case to deny that both kinds of mental state are my states. On the contrary, that was my starting point. But, equally, this furnishes no reason for denying the difference in constitution or internal structure of these two kinds of state. It was, indeed, by appeal to this difference, not by neglect of it, that Freud called our attention to 'the alien guests' in the mind, which he cited as the most lucid evidence for unconscious mental processes.[5]

A parallel here may serve my point. A mental capacity that we have – vital, I suspect, to much of our self-knowledge, to our recognition of our own feelings, though overlooked by philosophers – is that of envisaging a scene or situation, in which the participants are either familiar or imaginary, invented characters. In such scenes words may be spoken, and these words, as in a play, will be distributed between the *dramatis personae*. Now it is evident that all these words originate with, derive from, the person who envisages the scene. Nevertheless, this is perfectly compatible with some of these words being spoken by others, indeed with their being spoken to him: just as the fact that the author of a play writes all the words does not impede, indeed it necessitates, these words being attributed to others – necessitates it, for otherwise we would not have a play.

4. Ludwig Wittgenstein, op. cit., II, ix. cf. Stuart Hampshire, Critical Notice of Gilbert Ryle, *The Concept of Mind*, *Mind*, LIX (1950), pp. 237–55, reprinted in Stuart Hampshire, *Freedom of Mind* (London, 1972), pp. 87–113.

5. Sigmund Freud, *Complete Psychological Works*, ed. James Strachey (London, 1953–), XVII, p. 141. In future all references to this edition will be given as e.g., Freud, XVII, p. 141.

Equally, we would not have an envisaged scene or situation unless the words were attributed to different characters, and some of them were referred away to others.

This new phenomenon – envisagement, as we might call this variant of the imagination – has a more than local interest as far as the development of my theme is concerned. Its local interest (as we have seen) is that it parallels one of the two terms to the distinction that I have drawn between thoughts occurring and thoughts being thought: in that, both in envisagement and in thoughts occurring, thoughts or words originate with us, though they then undergo a characteristic vicissitude, which serves to distance them from us. I stress this, for it is also observable that the difference between the two kinds of mental state in which thoughts are a constituent can break out within envisagement, in that sometimes the words that are attributed to others may merely occur to us and sometimes we think them, or, as we would say more naturally, we think them up. The more than local interest of envisagement is that it provides us with further evidence for the thesis that our reports of mental states presuppose a conception of the mind. It provides evidence for the thesis, and also amplifies, elaborates it.

When I envisage a scene or situation, it is no longer simply that there is a thought before my mind – of which I may ask whether it occurs to me or whether I think it – there is now, let us say, a person or group of persons before my mind. What is meant by this is that I am now able to say how the person looks, what he is doing or wearing here and now, what present feeling he arouses in me – not necessarily all these things, but some of them, or something like them – in a way which is not open to me if I am merely thinking of him. I am not, of course, denying that envisaging someone or something is a form of thinking: but it is a form of thinking that may be distinguished or defined precisely by reference to these possibilities which it opens up to me. It is a form of thinking (we may say) in which I report what I am thinking by saying what someone else is doing or saying. Now, the fact that I can report a mental state of mine by talking about the doings or sayings of someone else pre-supposes, I want to contend, a conception of the mind. For suppose someone was to misunderstand what I was doing and was to think

that I was in point of fact reporting what someone else was doing or saying, I could put him right, I could explain to him that this was not what I was reporting though it was what I was talking about, only by making some higher-order assertion, in which I clarified the nature of my mental state. And this higher-order assertion would make reference – not perhaps in so many words, but in effect – to the mind.

Perhaps, at this stage, my thesis can best be advanced, first, by introducing an alternative account of the matter, then by considering a possible misunderstanding of the thesis. The alternative account would run that when I report what I envisage by saying such things as that a friend is on the verge of tears, or that my father upbraids me, or that I hear my father upbraid me, I am using words in a further or secondary sense. There are a number of forms such an account might take,[6] depending on which word or group of words in any such report is held to change its sense, and each form of the account could doubtless be met on its own terms. But there is also a comprehensive objection to the account: and that is that it is vacuous to talk of a further or secondary sense of a word unless we can specify a further way in which this sense is learnt or taught.[7] In the present case there is no such way, and moreover there could be no such way. For suppose we were trying to teach someone the alleged further sense of, say, the word 'father'; then the only assurance we could have for thinking that the moment was ripe to do so, would be when he had reported to us what he was envisaging and that it was his father: and to do this, he would *ex hypothesi* have to use the ordinary sense of the word, which must therefore be adequate to the task.[8] The objection I am raising to the alternative account is indeed the linguistic counterpart to the truth, long recognized as necessary, that the world of the imagination totally reduplicates the real world.

But, it might now be argued, if the world of the imagination does indeed reduplicate reality, if I can equally well report a fact in the world and a mental state of mine by saying that my father upbraids

6. e.g. Gilbert Ryle, *The Concept of Mind* (London, 1949), ch. VIII; E. J. Furlong, *Imagination* (London, 1961).

7. cf. Ludwig Wittgenstein, *Blue and Brown Books*, pp. 135–41.

8. I have benefited from many discussions on this and related topics with Richard Damann, now of the University of Sussex.

me, using the words univocally, then surely I might confuse envisaging a scene with actually seeing it, alternatively I might confuse saying that I envisaged a scene with saying that I actually saw it. Furthermore, on my view, the possibility of such a confusion would have nothing strained or unlikely to it, the confusion would be in no way pathological: whereas if someone did make such a confusion, his condition would be pathological.

This would be the misunderstanding of my thesis to which I referred a moment back. For this argument assumes, and assumes that I also assume, that the difference between my seeing someone before me and my envisaging him, my bringing him before the mind, is an empirical or observable difference. For it is on this assumption that the argument charges me with reducing the difference to zero – hence of raising the likelihood of confusion between the two kinds of mental state. But, on the contrary, it is central to my thesis that this is not where the difference lies, that we are not to find it in, as it were, observable minutiae. By contrast, I hold that to envisage something is an activity to which a certain conception is essential: we invoke or employ this conception, even if only implicitly, in envisaging something: and that is why, if we then come to believe that something which is before the mind is really there, in front of us, we do not simply make an error in observation, we evince derangement or disturbance. (I am talking, I must remind you, of a confusion not between hallucination and perception, but between imagination and perception.) For we have not just misidentified something in the world, we have radically misconceived our own mental activities.

Again, a parallel may clarify my thesis. Suppose a man is bilingual. He speaks, and speaks equally well, English and Hindi. Now such a man could not slide uncertainly, unwittingly, from one language to another. It is true that he might momentarily introduce, say, English words into a string of Hindi words. But such mistakes could occur only peripherally, and, significantly, they would be called cases of forgetting: the man forgot which language he was speaking. For in speaking the two languages, now one, now the other, the man employs or invokes the concept of a language. And this fact is attested to by the further fact that the man couldn't discover, as a mere chance fact about himself, that he did speak two languages, as

he might discover, by observing himself in the mirror, that one day he was pale and another day of healthy complexion. For the relevant thing that the bilinguist might observe – namely his verbal behaviour – presupposes that he has at once a criterion of sameness of language and a criterion of difference of language. The possession of such criteria attests to the fact that the man has the concept of a language.

It is in a similar way that the man who envisages a scene or situation, who can bring persons and their words and deeds before his mind, has a conception of the mind. And if to make the parallel with bilingualism hold, I must restrict my thesis to those who are capable both of envisaging a scene and also of perceiving it, I regard the restriction as vacuous. For unlike, say, Sartre,[9] I regard perception and imagination as inextricably linked, either way round. We could not have one without the other – though we might have a mixture of the two, or perhaps a severely diminished version of either in isolation. Now I hope it will be apparent why, properly understood, my thesis, so far from enlarging the probability that we might confuse envisaged with real persons or scenes, explains why this possibility does not arise – except, as I have said, pathologically.

And now I must pause and answer a question. For you may wonder what I mean by talking of a conception of the mind. You may feel uncertain – your uncertainty only increased by the last discussion, of bilingualism – how the phrase is to be taken. For I might mean, simply, the concept of the mind. Alternatively, I might mean a particularized picture or representation of what the mind is or is like: and if it is the latter, I might more specifically mean the picture of the mind as a place or area in which mental events occur, or (as a more embellished view would have it) a theatre upon whose stage the figures of fancy or imagination make their appearance.

My position will be fully manifest only by the end of this lecture, but I shall give some indication where I stand.

First, I evidently want to maintain that, in certain reports of mental states (and hence in all others dependent on them), the concept of the mind is involved. But I further want to maintain, that, in conse-

9. J.-P. Sartre, *The Psychology of the Imagination*, trans. anon (New York, 1948), where it is argued that the possession of imagination over and above perception is a mark of human freedom.

quence of the way in which this concept occurs in such reports, it also introduces or brings with it a more specific picture or representation of the mind. Hence my word 'conception'. But I would not identify this picture or representation with that of the mind as a place. Our ordinary conception of the mind is not fully spatial: but it is, I shall say, tinged with spatiality.

Whether we ever employ the concept of the mind without this specific colouring I shall leave unexamined this evening. I am more concerned to show that, sometimes, we employ that concept attended by a picture or representation higher in colour: that we have, for use, a fully spatial conception of the mind. This more extreme conception of the mind underlies, in many ways, the ordinary conception, the conception with which I have so far been concerned.

In pursuance of this point, I shall now ask you to follow me in considering briefly certain phenomena that occur characteristically on the unconscious level and that constitute the topics of two pieces of psychoanalytic theory.

4. The first is an account deriving from Freud, of the origins of thought or judgement. It gives the prehistory of thinking, and also indicates a characteristic disorder to which thinking, having such a past, is susceptible. In 'Formulations on the Two Principles of Mental Functioning'[10] and, at greater length in his papers on narcissism[11] and negation,[12] Freud advanced a bold and speculative theory – ultimately none the weaker for the philosophically rather dubious terms in which it is cast – of how we emerge from the fused or hallucinated condition in which phantasy and reality, the wish and its fulfilment coalesce, and we begin to think. The impetus to thought comes from excessive accretions of stimuli, which Freud long identified with unpleasure. As direct discharge in behaviour or physiognomic change becomes impossible or inadequate or undesirable, these accretions find indirect discharge in the working-over of the stimuli in the mind, in the new activity of thought. Thought is, in other words, an answer to frustration. And the working-over, in

10. Freud, XII, pp. 218–26.
11. Freud, XIV, pp. 73–102.
12. Freud, XIX, pp. 235–9.

which thought consists, also has its roots in an earlier situation. For the two modes of thought – the acceptance of a thought present to the mind, or its rejection, that is, affirmation or denial – can be seen as a development out of the two ways in which the earlier ego, acting uniquely under the pleasure principle, deals with elements in its immediate environment, either introducing them into itself or expelling them. And so we have 'perhaps for the first time' Freud says, 'an insight into the derivation of an intellectual function from the interplay of the impulses'. But the grip that such a derivation maintains over thinking is this: that, if libidinal attachments once decline in significance and destructiveness becomes predominant, denial asserts itself as the natural attitude of the intellect. Indeed Freud regarded the 'negativism', or passion for universal negation, evinced by many psychotics, as confirmation for his account of thinking and its origins.

Freud's account has recently been taken up and elaborated in certain distinctive ways by Wilfred Bion.[13] I shall consider only one such elaboration. According to Bion, for thinking to emerge, the stimulus to be worked over must first be subsumed by the mind under some corporeal or quasi-corporeal conception – the precise form of the corporeal reference sometimes arising from the source of frustration, say the breast, sometimes given by mere attendant phantasy. For unless some such subsumption is effected, how could the stimulus be experienced as a fit or suitable object for the processes of introjection or expulsion in which, on Freud's theory, thinking has its origin? The point becomes clearer and more cogent, when it is appreciated that these processes are themselves grounded in the biological processes of feeding and excretion or rather their psychic representation – the experiences, that is, of feeding and excretion.

Of course, the subsumption of a stimulus under a bodily conception relates to the dawn of thinking. For, ultimately, intellectual activity is inhibited, rather than encouraged, if the corporeal character of a thought remains emphatic. In its own terms Bion's account closely parallels Freud when it depicts the schizophrenic as so overwhelmingly assimilating a thought to a bit of the body, a bad and persecuting bit, that the only course feasible to him is to evacuate

13. W. R. Bion, *Learning from Experience* (London, 1962), and *Second Thoughts* (London, 1957).

the thought, conceived of now either as a faeces or as totally fragmented and dissolved into a stream of urine. The terminal condition is, as Bion puts it, one of thoughts without thinking: the mind is aware of – what shall we say? – elements, but has no confidence in its power to use or operate them. And so the distinctive answer that thinking is qualified to offer to frustration, that of modifying it, rather than merely evading it, through the characteristically intellectual means of detachment and procrastination, has to be given up.

The second piece of psychoanalytic theory that I want to consider in elaboration of my thesis is the theory of internal objects or an inner world, which we owe to Melanie Klein. In fact I shall consider only one aspect of the theory, and that is the distinction that it requires between an internal object and the (internal) thought of an external object. For it was obviously not Mrs Klein's point that we are able to think, to think inwardly or to ourselves, about the inhabitants and furniture of the outer world: nor was she merely concerned to show that very often our thoughts about the outer world are distorted and tranformed under the influence of our aggressive impulses and the consequential anxiety that arises in us. It is not that we think, nor even how we think, about outer reality that is at stake: it is rather that sometimes the objects of our thinking are themselves internal, that we think about an inner reality. As early as 1927[14] Mrs Klein had called for a distinction, within the objects of our thought, between, say, the parents or loved ones and the *imagos* of those persons which we contain within ourselves. And the way in which the two are to be distinguished is that the thought (or phantasy) of an *imago* or inner figure is linked, in a way in which the thought of the corresponding outer or real-life figure is not, with a phantasy of incorporation, of taking the figure into one, archaically through the mouth. And this way of making the distinction recurs as a point of psychoanalytic technique in the following note in the *Narrative of a Child Analysis*: 'I do not interpret in terms of internal objects and relationships until I have explicit material showing phantasies of internalizing the object in concrete and physical terms'.[15]

14. Melanie Klein, *Contributions to Psycho-Analysis 1921–1945* (London 1948), pp. 140–51.

15. Melanie Klein, *Narrative of a Child Analysis* (London, 1961), p. 31. cf. Melanie Klein, *Contributions to Psycho-Analysis 1921–1945* (London, 1948), p. 303.

Even so this point is susceptible to misunderstanding. For it might be thought that the appeal to a phantasy of incorporation is primarily an attempt to *justify* the attribution of an internal figure to a patient, that the relation of the oral phantasy to the interpretation is evidential: somewhat in the way in which, say, in a traditional society the claim to power and office might be legitimized by the establishment of a particular historical descent. But this cannot be the way in which the link between the two elements is to be taken. For, if it were, it would still leave the distinction that I have said the theory requires – that between the thought of an inner object and an inner thought – unexplicated. Accordingly, I take the link to be necessary or essential, so that the concept of an internal object rests conjointly upon two criteria of application: a phantasy of incorporation, and the thought of a person. In effecting this conceptual link, Mrs Klein puts us in mind of a similar innovation, which lies at the very dawn of psychoanalysis. It was by interlocking the concepts of resistance and repression, that Freud stamped upon his new science of the mind its distinctive dynamic character.[16]

A parallel may clarify my point: We attribute to a novelist in the course of writing his book thoughts about some fictional characters: we think of Proust thinking about Charlus. But we cannot make such an attribution intelligibly without also attributing to the novelist the mental activity of making up or having made up this character. Furthermore, if the fictional character is derived from a real life character, there will be no method of distinguishing in the novelist's stream of experience thoughts about the fictional character from thoughts about the real character without reference to this original piece of invention: thoughts of Charlus and thoughts of Robert de Montesquiou differentiate themselves via Proust's 'creative act'. The 'creative act' parallels the oral phantasy as it figures in the theory of internal objects.

And this parallel is useful because it alerts us to two crudities that might insert themselves into our understanding of the psychoanalytic account. The first is this: that we might too lightly equate the view that an internal object presupposes a phantasy of incorporation with the view that the latter by some identifiable period of time precedes the former. But even apart from the obscure question how the

16. Freud, II, pp. 268–9.

unconscious is to be associated with temporality, the equation is not evidently correct. Must a novelist make up a character at some time prior to when he starts to introduce this character into incidents or interior monologue? And the second crudity is this: that, having conceded that the attribution of an internal object cannot be made on the basis of a single thought or mental state, but must be linked with a phantasy of incorporation, we might then go on to think that this phantasy itself was a discretely identifiable event. And once more the parallel may save us. Is the making up of a fictional character so clearly an act contained within the span of an immediate experience? I am prepared to think that in both cases, in the case of the oral phantasy and in that of the creative act, we shall need to invoke multiple criteria, perhaps distributed across time, to sustain the attribution.

5. The two pieces of psychoanalytic theory that we have just been considering I introduced, you will recall, with a particular aim. In the elaboration of the general thesis that reports, or certain reports, of mental states presuppose a conception of the mind, the point was reached at which I had to make clear whether by 'a conception' I meant merely 'the concept' or something more. I said that I meant something more; I meant a particular way in which the mind was pictured or represented; and I went on to say that the conception of mind that we ordinarily employ is one tinged with spatiality. It was to justify this description that I ventured into psychoanalytic theory, there to consider two phenomena, both topics of the theory, and which presuppose a conception of the mind that is truly spatial.

But, once again, I must pause. A while back, you may have felt uncertain what I meant by talking of a conception of the mind: now you may feel uncertain what I mean by describing a conception of the mind as spatial. And in each case you may feel that I have left a question too long unanswered. I should rather say that in each case I have delayed until we have material for an answer.

It is clearly not enough, for a conception of the mind to be reckoned spatial, that we should attribute to the mind states which have as their objects, or are directed upon, things that are themselves spatial: for instance, the fact that we attribute to the mind thoughts about people and scenes, which are three-dimensional, does not by

itself justify us in thinking that we represent the mind to ourselves in any way as a space. For the mind to be conceived of as spatial, it is required, I suggest, either that we should have some specific view about mental states, assigning to them an extended or quasi-extended character; or else that we should have some specific view about the relation in which objects of mental states stand to the mind, assigning to this a positional character. Here we have something like a disjunctive criterion for spatiality.

That the conception of the mind presupposed by the two phenomena that I have been considering as characteristically occurring on the unconscious level satisfies this criterion can, I hope, be readily seen.

In the case of thoughts subsumed under a corporeal concept, the conception of the mind involved is spatial according to the first part of the criterion: for such thoughts are evidently credited with extension. In the case of internal objects, the conception of the mind involved is spatial according to the second part of the criterion: for the relation of the internal object to the mind is represented positionally. Indeed, I dwelt on precisely this feature in distinguishing the phantasy of an internal object from the internal thought of an external object. The positional character of the relation in which the internal object stands to the mind is stamped upon it, quite ineradicably, in the oral phantasy of incorporation in which, as we have seen, the internal object originates.

And now I want to point to a correspondence that holds between the two sets of phenomena that I have been considering in the course of this lecture, one recently, the other earlier on: what we might call, for short, the unconscious set and the conscious set. For we may pair off the thought subsumed under a corporeal concept with the thought that is such that it may break in on us or forcefully enter our mind, 'the alien guest' in Freud's phrase, the 'mind in passivity' in my phrase: and we may pair off phantasies of internal objects or the inner world with that variant of the imagination which I have called envisagement.

So far the correspondence is purely intuitive. But I think that, if we look more carefully in each case, we shall find further facts to support it. We have already noted that it is an explicit feature of Bion's account of thinking and its origins in impulse that, as the

assimilation of a thought to a bit of the body becomes preponderant or totally engrossing, amounting indeed to an equation of the two, so the capacity to think, to be mentally active, is said to be correspondingly impaired. Under the influence of the equation, the mind is quite given over to passivity. In other words, the thoughts that cannot be thought, and that encumber, penetrate, bombard the mind, fill the same role, they achieve – though with monstrously greater effectiveness – the same kind of mental dislocations as the counterparts I have assigned them on the ordinary level of consciousness: as the alien guests that stray, more gently, into the conscious mind. As to internal objects and envisagement, it is not merely that the latter is so naturally the representative on the conscious level of the former, so that we might be tempted to think of the unconscious as though it were formed in accordance with Henry James's famous advice to the novelist, 'Dramatize, dramatize'; but, historically, we may observe that Freud himself was, in the first instance, led to the postulation of inner figures – in his case the ego-ideal, then the super-ego – by noting in certain experiences, clinically observed, a feature that I have identified as central to envisagement – that is, the referring away to others, dramatically and grammatically, of pieces of inward speech. The experiences that attracted Freud's attention were delusions of observation: delusions, that is, of being observed. In such delusions the sufferer becomes aware of the internalized figure who watches him, by hearing, in Freud's words, 'voices which characteristically speak to [him] in the third person'. 'Now she is thinking of that again ... now he is going out' are the sorts of thing the voices say.[17] The same connection between the super-ego and envisagement has been preserved in a fragment of childhood experience recorded for us by Yeats in the following words:

One day some one spoke to me of the voice of the conscience, and as I brooded over the phrase I came to think that my soul, because I did not hear an articulate voice, was lost. I had some wretched days until being alone with one of my aunts I heard a whisper in my ear, 'What a tease you are!' At first I thought my aunt must have spoken, but when I found she had not, I concluded it was the voice of my conscience and was happy again. From that day the voice has come to me at moments of crisis, but now it is a voice in my head that is sudden and startling. It does not tell

17. Freud, XIV, p. 95.

me what to do but often reproves me. It will say perhaps 'That is unjust' of some thought; and once when I complained that a prayer had not been heard, it said, 'You have been helped.'[18]

The correspondence between the two sets of phenomena, the unconscious and the conscious as I have called them for short, is not just a fortuitous or idle one. For the correspondence occurs, it will be observed, just in respect of those features of the unconscious phenomena which I picked upon for saying that the conception of mind that they presuppose is a truly spatial one. In the corresponding conscious phenomena we may observe, in each case, a shadow of that feature. What I mean by 'shadow' is that with the conscious phenomena the possibilities now open to us for making assertions or for asking questions, couched in spatial terms, are severely diminished. This, incidentally, is what lies behind, though it does not justify, the contention, already met with, that phrases like 'in the mind' or 'before the mind', when predicated of thoughts occurring or envisaged characters, are mere metaphors. What is true is that, in their application to the conscious phenomena, these phrases stand more or less alone, they are isolated. I have preferred to record this fact by saying that the conception of mind these phenomena pre-suppose – that is, our ordinary conception of the mind – is one tinged, merely tinged, with spatiality.

I have argued for this character of our ordinary conception of the mind obliquely: that is, by comparing it with another conception which has this same character to a higher, more marked degree. The obliquity is not accidental, it does not pertain only to my idiosyn-cratic development of a theme. The more extreme conception of the mind, which I have spoken of as underlying the ordinary conception in more ways than one, enjoys at once a genetic and an exegetic priority. Genetic: in that it belongs to a more archaic or infantile consciousness from which the adult mind is a development. Exegetic: in that it provides that in terms of which the ordinary conception is best explicated. I should reckon it both proper and illuminating to say that our ordinary conception of the mind, while not that of a place, is one which, when distorted, becomes that of a place. This

18. W. B. Yeats, 'Reveries over Childhood and Youth', *Autobiographies* (London, 1955), pp. 11–12.

distortion is the story of our life read in reverse: as such, it marks the path of a regression.

And now I may have suggested that the conception of the mind involved in the unconscious states we have been considering in detail is a fully spatial conception: which would be wrong. For there are conceptions that go beyond it in spatiality: conceptions, in other words, more distorted yet. I now want to suggest that it might be possible to characterize the varying stages of mental disturbance, or the stations on the path to psychosis, by the degree to which the patient conceives of the mind, supremely *his* mind, as a place. But let me make one point clear. The characterization I am suggesting would not be one in terms of a new symptom, or based upon a fresh piece of evidence. For the varying conceptions of the mind it would cite are those implicit in the mental states that currently form the basis for diagnosis or the material for interpretation. That is why, if such a characterization were possible, it would provide some kind of indirect support for my most general thesis, that our identification of mental states presupposes a conception of the mind. I am concerned – let me emphasize this – solely with the implications, the conceptual implications, of existing knowledge, of theory otherwise established.

That conceptions of the mind might be arranged on a spectrum, according to their degree of spatiality is a point I want to illustrate by considering two further pieces of psychoanalytic theory, both drawn from the work of Mrs Klein.

In a paper of 1946, Mrs Klein[19] introduced the term 'projective identification' as the name for a mechanism of the ego which needed to be distinguished from the ordinary projective processes. How then do projective identification and projection differ? There seem to be two main differences, at first sight comparatively unrelated, but which come together in the pattern of my argument. The first is that the processes differ in their formal objects – in the kind or category of thing upon which they are directed. For the objects of projection are properties or qualities, say anger or curiosity: the objects of projective identification are substances, or things, or bits of

19. Melanie Klein and others, *Developments in Psycho-Analysis* (London, 1952).

of view, which we conceive ourselves to occupy *vis-à-vis* them.[21] And if it is objected that the imagery of such an envisagement will be from a definite point of view – indeed, being visual it must be – no matter what we think, this overlooks the fact that, in the internal case, we cannot fully separate the imagery we have from the thought we have about it. In imagination, unlike perception, the imagery (roughly) receives its content from the thought, not vice versa.[22]

If we now take the second criterion for therapeutic progress, the bringing together of inner and outer reality, one aspect of this complex phenomenon is that the internal figures now increasingly derive their characteristics and their general tone or colouring from the real-life figures that in origin they represent. They relinquish the savage persecuting stringency, alternatively the idealized radiance, in which their prototypes never shared: and they relinquish these characteristics – and this is the important thing – not for reasons derived from the inner drama, out of guile or placation, but in response to reality. The phantasies in which these figures occur increasingly become *of* these figures rather than merely derived from them. With the approximation of phantasies to thoughts – a process which neither could nor should ever be complete – the background phantasy to the effect that the internal figures do actually endure independently of the more specific phantasies in which they occur is necessarily mitigated. The oral incorporation no longer leaves behind a literal belief as its trace.

And now if we consider these two criteria together, we see that they have this in common: that, as they come to be satisfied, so the possibilities of making assertions or asking questions about the mind in spatial terms diminish. The question of our point of view *vis-à-vis* specific contents of the mind, whether these be thoughts or figures before it, the question of the persistence somewhere or other of internal figures, no longer arise. There is no longer a need for, nor a sense to be attached to, such characterizations. And by now, you will, I

21. Bernard Williams, *Imagination and the Self*: Henrietta Hertz Lecture (London, 1966), reprinted in *Studies in the Philosophy of Thought and Action*, ed. P. F. Strawson (London, 1968), pp. 192–213.

22. J.-P. Sartre, *The Psychology of the Imagination*; Hidé Ishiguro, 'Imagination', Supplementary *Proceedings of the Aristotelian Society*, XLI (1967), pp. 37–50. cf. Richard Wollheim, 'Imagination and Identification', collected in this volume, pp. 54–83.

hope, appreciate that the most natural way for me to express this is by saying that we have here a conception of the mind in which the spatial element has been considerably attenuated.

The use of the word 'attenuate' will remind us of one thing: that the conception of the mind, here identified, still receives only a relative description – relative, that is, to other pictures, other representations, other forces, whose sway over the mind may be relaxed, but is never wholly abdicated. And the word 'conception' reminds us that we are dealing with the overall ways in which a man's reports of his mind, conscious and unconscious, interlock. For to a man who held to such a conception, there could still occur the thought, perhaps jealously safeguarded, that the mind is, after all, a place. Only by now such a thought would be discrepant with the preponderant condition of his mind.

6. We have already seen, an hour back, how in Ernest Jones's opinion the topic of sexuality meant for Freud the meeting-point of mind and body. It is in large part due to the insights, to the experience of psychoanalysis that today we have a view, at once larger and more complex, of this matter than was open in the days of the young Freud. I have talked this evening of our conception of the mind as tinged with spatiality. I have set this beside other conceptions of the mind heavier with history and heavier with spatiality. All such conceptions derive ultimately from an assimilation of the mind to the body, of mental activity to bodily functioning, of mental contents to the parts of the body. So the mysterious union of mind and body occurs also at a stage further back than the traditional philosophers apprehended. It is not merely that we are at home in our body: we are at home in our mind somewhat as in a body. This, we may say, is the mind's image of itself. But if it is, if this is the image that the mind sees when it sees itself, this is, in part at least, because it is this image that the mind draws when it draws itself.

3 Imagination and Identification

If individual men are sometimes found wanting in imagination, the imagination of man itself seems to suffer from no deficiency. There is nothing that it cannot encompass. So, to the philosophers of the seventeenth and eighteenth centuries, it seemed no more than a natural step to take, to insist upon a strict equation of what is possible with what is imaginable and, as for the opportunity that this opened up of building metaphysics and the theory of knowledge upon the philosophy of mind, they saw in it only a fitting tribute to the peculiar place, and power, of the human imagination. Nowadays, the equation, or the thesis involving it, appears less acceptable. But, if this is so, it is not because the thesis has proved false, it is only that it has turned out less informative than it promised. For, at any rate in the hard cases – and it is the hard cases that are the interesting ones – it seems at least as plausible to regard what is unimaginable as determined by, as it would be to regard it as determinant of, what is impossible.

2. However, if the objects of the imagination are not to be circumscribed, they can be classified. And I mean this not just in the uninteresting sense in which it follows from the fact that objects in the world, or possible objects in the world, can be classified, but in some more constructive sense in which the classification would be effected by reference to the imagination itself, or, to put it another way, the different types of object imagined would correspond to, or could be correlated with, what, independently, could be thought of as different types of imagining.

Let me give as an example of the classification I have in mind – and the types here are certainly not intended to be exhaustive, and whether they are exclusive is a question to which we shall have to return – something represented by the following three examples:

I imagine doing something or other

I imagine myself doing something or other

I imagine someone else doing something or other

or (to fill in the examples):

I imagine setting foot on the moon

I imagine myself setting foot on the moon

I imagine Goethe setting foot on the moon

'Doing something or other', 'myself (or my) doing something or other', 'someone else (or someone else's) doing something or other' would, on the view I am suggesting, instantiate three different types of object imagined, and the different types of object would in turn be objects of three different types of imagining.

3. Two preliminary remarks about this classification:

The first concerns a restriction that needs to be placed upon the possible values of 'doing' in the phrase 'doing something or other', where this is, or is part of, the description of what I may imagine, if the purely grammatical method that I have suggested for arriving at the types of imagining is to work. What verbs can we, and what verbs can we not, legitimately substitute here, and retain coherence of classification? And I shall initially suggest – though this suggestion will turn out to be far too sweeping – that verbs of perception are to be excluded. In the course of showing why some such restriction is necessary, I shall indicate why this way of putting the restriction is too sweeping, and what qualification it requires.

Let us take, for instance, the verb of perception 'to see'. Now, in what is the most common, and I would say, the standard, sense of the phrase 'to imagine seeing' – which is also that in which it contracts into 'to visualize' – it cannot be assimilated without error to phrases like 'to imagine building', or 'to imagine hitting'.

The crucial consideration here, to my mind, is that, when I imagine building something or other – say, the façade of St Peter's – it does not follow that I am building the façade of St Peter's, but, when I imagine seeing the façade of St Peter's, then, necessarily, I see the façade of St Peter's. Of course, seeing the façade of St Peter's when I merely imagine seeing it, or visualize it, is not the same as seeing it when I am face to face with it. Indeed, the two ways or modes of seeing an object seem to have some measure of incompatibility. Within certain limits it seems impossible that I should

simultaneously see St Peter's face to face and imagine seeing it; whereas no such difficulty seems to arise – that is, if there is a difficulty, it is of a purely contingent nature – in the case of, say, building St Peter's and imagining building it. But, I would argue, this incompatibility only confirms the view that imagining seeing is seeing.

A crucial step in elaborating this last argument would be to try to formulate the limits within which the incompatibility holds. This is no easy task: but roughly – very roughly – it might be claimed that what I cannot simultaneously do is to see St Peter's in a certain place from a certain position and imagine seeing it in that place from that position. Now, if this account of when the incompatibility holds is correct, it suggests a reason why the incompatibility holds. It suggests that why we cannot at one and the same moment see something face to face and imagine seeing it is because to do so would involve the superimposition of one piece of seeing upon another such piece.

In arguing for the view that 'imagining seeing something or other' is not a proper substitution-instance of 'imagining doing something or other', I have been urging that imagining seeing is seeing. To some this may seem too frontal a way of going at the problem, so I should now like to draw support from an argument oblique to mine. The source is Bernard Williams' *Imagination and the Self*.[1] In this lecture Williams argues that, when I visualize something, or imagine seeing it, the seeing itself is not necessarily an element in what is visualized. The seeing may be such an element, but it need not be. It is because it need not be that I can visualize something unseen: a fact denied by Berkeley but surely irrefutable for anyone who approaches the matter without preconception.

At first it might seem unclear how Williams' argument supports mine: indeed it might even be doubted how the two are compatible. To get straight on this, the prerequisite is to appreciate what Williams' argument is an argument about. It is not about the nature of visualization (like my argument): it is about the objects of visualization. Is there anything that we must imagine ourselves seeing when we

1. Bernard Williams, *Imagination and the Self*, Henrietta Hertz Lecture (London, 1966); reprinted in *Studies in the Philosophy of Thought and Action*, ed. P. F. Strawson (London, 1968), pp. 192–213.

imagine ourselves seeing something? To answer this question Williams invokes a more general principle about the imagination and its objects: according to which, in any given case, the object of imagination, or what I imagine, is determined by what I imagine it as. Now, when I imagine seeing something, I do not necessarily imagine it as seen. Hence the seeing (or the being seen) is no necessary part of what is visualized.

Another consideration is this: Though the phrase 'to see *x*' can ordinarily be modified in a number of different ways, e.g. I can try to see *x*, or I can barely see *x*, these modifiers cannot be retained within the phrase 'to imagine seeing *x*' – unless, that is, one departs from that sense of the phrase in which I have up till now been considering it. For, though I have so far said nothing about it, except to hint that it exists, there is another, though I should argue not a standard, sense of the phrase, to which none of the remarks I have been making apply, and to which I should now turn. In this sense – in which, incidentally, the phrase cannot be contracted to 'to visualize' – to imagine seeing *x is* to imagine doing something, for it is to imagine the characteristic experience of a spectator along with the activity in which he engages. So in this sense the imperative 'Imagine seeing St Peter's' is an invitation to consider some part of the experience, and perhaps not exclusively the visual part, of an unspecified agent who, say, strolls along the Bernini colonnade, with his face turned towards the great church and with his eyes open. And it is in just this sense that we could go on to say 'Imagine trying to see St Peter's, or barely seeing, St Peter's' – for now the invitation would imply that there were various difficulties or hazards that might impede the spectator's view of the church, and we would be asked to imagine his surmounting them as best he could.

And this leads on to one way in which the general restriction upon verbs of perception as values of 'doing' in the phrase 'doing something or other', where this describes or partly describes the object of imagination, turns out to be sweeping and needs to be qualified. For the restriction applies only to the first of the three types of imagining and not to all cases of it. But in all cases where I imagine myself seeing something or other (the second type of imagining) or where I imagine someone else seeing something or other (the third type of imagining), there is an activity in which I imagine myself or the

other engaged. Seeing, in these cases, is what I imagine someone doing, not what I do. And, interestingly, the linguistic guide that we have so far been using brings us to the same conclusion. For with the second and third types of imagining, as with the special case of the first type, 'to imagine seeing' does not, of course, contract to 'to visualize'.

Another way in which the restriction upon verbs of perception has probably to be qualified relates to the difference between the different sense-modalities. What I have said about seeing applies doubtless to hearing and possibly to smell, but there seem to be some difficulties in the way of applying it to taste, and even more in the case of touch.

4. I promised two preliminary remarks on my classification: the second will be briefer.
Whatever may be the ultimate justification for distinguishing between imagining myself doing something or other and imagining someone else doing something or other as different types of imagining, there is one way in which the distinction might be disputed that needs to be put aside at the outset. If, say, I imagine myself hurling defiance at the enemy, or if I imagine myself being bribed, then I am also likely to imagine, say, the enemy writhing under my insults, or the intelligence agent slipping me the money. Whenever I imagine myself doing something or other, I invariably imagine someone else doing something or other. And something of the same seems true the other way round. Though it is not invariable, it is certainly quite familiar, that, when I imagine someone else doing something or other, I also imagine myself somehow involved in the action. So, the objection runs, there are not here two different types of imagining, but, at best, a distinction which can be sustained by reference to the point of view from which I choose to describe what I imagine. I can describe the action from my point of view – that it is myself I imagine doing this or that – or I can describe it from someone else's – then it is him whom I imagine as the active principle.

This objection is useful if it leads us to make a further distinction not so far registered: that is, between imagining someone else doing something *as part of imagining myself doing something*, and *centrally* imagining someone else doing something, or, again, between

imagining myself doing something *as part of imagining someone else doing something*, and *centrally* imagining myself doing something. And where, so far, I have talked of myself doing something or someone else doing something as different types of object imagined, I have had in mind the cases where these are what is centrally imagined: it is by reference to what is centrally imagined that the different types of imagining are to be individuated. Now, it would, on the face of it, be permissible to think of the difference between imagining myself, and imagining someone else, doing something or other as a difference in the point of view from which I describe what I imagine. But it must not be concluded that the point of view from which I make such a description is one that I am free to choose or can adopt at will. Sometimes this may be so, but not always. For sometimes the point of view from which I describe what I imagine is already given by the point of view from which I imagine it. In such cases, to shift the point of view would be to falsify what I imagine. We are here, indeed, dealing with just another implication of the principle, already considered, that what I imagine is given by what I imagine it as. For, whenever I imagine something from a point of view, the point of view from which I imagine whatever it is is part of what I imagine it as.

However, as I have made clear, there will also be cases where I imagine someone doing something or other – it may be myself, it may be someone else, it may be someone unidentified or even unidentifiable – and there will be no one whom I centrally imagine doing anything. Such cases are, I think, best treated as extensions of the first type of imagining, where I simply imagine doing something or other. Cases where I imagine someone doing something, but where no one is centrally imagined, I shall think of as cases where I imagine that . . .

However, the notion of what is centrally imagined is clearly not without its difficulties, and as a start I shall suggest that it is a mark of the character whom I centrally imagine that in imagining what he does I also imagine what he feels and thinks: that his actions are liberally and appropriately interleaved with his inner states in the flow of what I imagine. And I must emphasize 'appropriately' as well as 'liberally', meaning by 'appropriately' something like 'as and when they come'. For I could centrally imagine myself doing something

and intersperse this with imagining what someone else felt or might feel in reaction to me: but if these other imaginings crop up only randomly or as, say, I imagine my thoughts turning to another and what he feels, this, I would think, does nothing to disturb the centrality of myself in my imagination.

5. If it is true that when I centrally imagine myself, or someone else, doing something, the flow of what I imagine must include that person feeling something or other, the question arises what it is to imagine someone feeling something or other and how this is related to feeling that thing. Is it, for instance, the case that when, say, I imagine Goethe being terrified or being disgusted on his arrival on the moon, *I* feel terrified or disgusted? It is to this question that I shall address myself. Strange and awkward as it is, it has, I feel – and here, of course, I only echo traditional opinion – many consequences for the theory of morals, for the theory of art, let alone for the theory of the person.

In pursuing this question, I shall follow the advice given us by Wittgenstein: that, in trying to understand the nature of an inner state, we do well to begin by considering an external counterpart of that state. And I shall begin by taking the external counterpart of imagining someone doing something or other to be acting someone doing something or other: and so, more specifically, I shall take the external counterpart of imagining someone feeling something or other to be acting someone feeling something or other – now using 'someone' in a way which is indifferent between 'myself' and 'someone else'.

6. The most famous, and probably the most effective, challenge to the view that acting involves feeling what the person whom one acts would feel is contained in Diderot's essay, *Le Paradoxe sur le Comédien*. *Sensibilité*, or the capacity to experience a range of feelings, is, he claims, no part of the actor's essential endowment.

The essay, it is true, suffers from a diversion of aim, for some of the time Diderot seems concerned to establish not that *sensibilité* does not belong to the essence of acting, but that it is not the mark of greatness in acting. And when he keeps to the central aim of the essay, or what is from our point of view its central aim, his arguments

are not all of equal relevance. For instance, he thinks it significant to point out that an actor can portray a range of characters which far exceeds his own sensibility. But then it is not necessary for Diderot's opponent – or the upholder of the emotionalist hypothesis, to give it a name – to deny that the feeling that an actor might experience in playing a certain part might well be a feeling that he would never, or perhaps could never, have experienced if he had not played that part. In other words, someone who believes that feeling contributes to acting, might also believe that acting contributes to the development or education of feeling. Again, Diderot attaches significance to the fact that an actor can, while acting a person in the throes of a great passion, coolly attend to a practical detail of the stage or the setting; and he quotes as typical and crucial the story told of the contemporary actor Le Kain who, in the part of Ninias in *Sémiramis*, emerges from his father's tomb, where he has cut his mother's throat, blood-stained and trembling, crying out 'Where am I?' and, noticing a diamond drop which had fallen off an actress's ear, kicks it towards the wings. However, there seems no reason why someone should not feel two different things simultaneously if the different feelings are directed upon quite different objects. Indeed, if we press the point and try to find the case that would be embarrassing for the emotionalist hypothesis, this seems to be, paradoxically, just the case that is supposed by Diderot, and by others in this controversy, to be for that hypothesis the paradigm of acting: the case exemplified when a jealous husband acts opposite his wife in the role of a jealous husband. For how in such a case would one be able to distinguish between the feelings that the actor has anyhow towards his wife and the feelings that, according to the emotionalist hypothesis, he has as an actor towards his wife? There seems to be here a difficulty rather like that which we considered a short while back, of imagining seeing x when actually face to face with x. However, in the present case the situation may be saved by the fact that, though aside from the play the actor is jealous of his wife, in the play he is jealous, not of his wife, but of the character that his wife plays. The general point that emerges is that the real difficulties that confront the emotionalist hypothesis relate not so much to different assignments of feeling to one and the same actor, as to similar or seemingly identical assignments of feeling to him.

However, if we take the best of Diderot's arguments, we see that they all assume, to a material degree, that acting is a dependent activity. It is a bridge between the work of the dramatist and the reaction of the audience. As Diderot puts it, the actor is 'the man who, having learnt the words set down by the author, fools you thoroughly'. Nor is the dependence of the actor on writer and audience simply a matter of his place in a causal chain: that what he says and does is caused by what the writer has written, and that it has an effect upon the condition of the audience.

There are also two other forms that the dependence takes. First, the criteria of success for acting are both backward-looking and forward-looking. Roughly – and this would be a very rough way of putting it – a necessary condition of the actor's success is that the writer has performed well, and a sufficient condition is that the audience will react appropriately. Secondly – in general, if not in particular – the activity of acting is identified as something that derives from a piece of dramatic writing and is intended to be taken in a certain way, i.e., as a piece of representation, by an audience.

It is, of course, this last point that is significant in the context of my general argument. For it suggests that, if we want an external counterpart of imagining someone doing something or other, we do wrong to look for it narrowly in acting someone doing something or other. The analogue to imagination must include not only the role of the actor but also those of the dramatist and the audience. Alternatively, if imagination is compared to acting, the actor considered must be one who writes his own part and plays it for his own benefit.

(Before leaving Diderot, it is worth observing that, though he argues that *sensibilité* is inessential to the role of the actor, he thought it to be essential, to some degree or other, both to the role of the dramatist and to the role of the audience. The actor is successful only if the audience is moved, and the audience will be moved only if the dramatist is sufficiently acquainted with emotion. Indeed, Diderot's view that feeling is inessential to acting depends upon the view that feeling is inessential, perhaps even detrimental, to the transmission of feeling. For *that* is the essence of acting. In other words, Diderot's denial of feeling to acting is bound up with his view that it is essential to that to which acting is essentially connected.

Diderot's views have sometimes been compared to Brecht's. But, if it is true that the two writers agree on what they hold to be the relation of acting to feeling, they derive their views from contrary premisses.)

7. Suppose we accept the essential connections just raised. Suppose we think that for the external counterpart of imagination we should look not just to the role of the actor, but also to that of the dramatist and to that of the audience, what implications does this have for my central problem: that of the relations between imagining someone feeling something or other and feeling that thing?

Offhand it would look as though support for the view that imagination involves feeling is most likely to come from the inclusion of the audience in the enlarged counterpart of the imagination. For in watching someone acting someone feeling something or other, the audience is often induced to share in that feeling. If, however, we take up this suggestion, does it not lead us to the view that, if feeling associates itself to imagination, it does so as conse-quence – in that my feeling what I do is a consequence of my imagin-ing what I do? For clearly what the audience feels it feels as a consequence of what it watches.

Our preparedness to accept this view will be tempered by instant caution. For problems attach to the notion of consequence here in use.

Most obviously, the notion must not be in contrast with that of essence, or of the phenomenon itself. For if we take seriously the view that the external counterpart of the imagination includes an audience, then anything that accrues to the imagination through reflection upon the role or reaction of an audience watching the acting of whatever it is that is being imagined must be regarded as part of the imagining. So, in talking of the consequences of imagina-tion, we should have to mean not something that follows on in the wake of imagining but, rather, wherever it is that the imagining leaves me. We must mean something that stands to the exercise of the imagination somewhat as sorrow does to disappointment, not as the morning's hangover to the night's indulgence.

However, the view that, if feeling associates itself to imagination, it does so as consequence gives further reason for caution. And this

further reason arises out of reflection on the form of the overall
argument, which now needs reconsideration. For the argument
purports to throw light on the nature of a mental state by examining
something which we can think of as its external counterpart. But if
it is true that mental states can often be illuminated by examining
their external counterparts, it does not follow that, in any given case,
it will always be quite unproblematic to know what would be the
internal version of the external counterpart. On the contrary:
having externalized the mental state in the form of a counterpart, the
argument must then take seriously the question what it is for the
counterpart to be internalized. And this is particularly so when, as
in the case of imagination, the counterpart of the mental state is, or
includes, an audience.

If we consider the external counterpart of the imagination, the
situation we find is something like this: The actor acts someone
feeling something or other, the audience watches what the actor
does, then reacts accordingly, say, by experiencing that feeling. But
the internalized version of this cannot be the following: I act to
myself someone feeling something or other, I watch what I do, and
then react accordingly, say, by experiencing the feeling. It must
rather be that I act to myself someone feeling something or other,
and then react to this, say, by experiencing the feeling. And if this
is right, then obviously the view of feeling as consequential upon
imagination gets further attenuated.

It might be an advantage to put this last point more generally, so
as to cover all the cases, and I have already indicated that there are
a number of them, where I might be thought to stand to what I do
internally, or to my mental processes, as an audience. Consider, for
instance, the case when I say to myself something that I intend to
make use of later, say, in a political address, and don't like the sound
of it: or when I have forgotten a line from a favoured poem, and I
start reciting the poem over to myself until I come to the words,
'*Aux yeux de souvenir que le monde est petit!*' and then I have recalled
what previously I could not remember. For in all such cases it is
neither necessary nor plausible to interpose as a mediating event my
listening to what I say to myself, where this is held to be distinct
from my saying whatever it is to myself. The truth seems to be that
I take against my carefully turned phrase, or I remember the line of

Baudelaire, in saying it to myself. And in the case of imagination, when I imagine someone feeling something or other and feel that thing, the truth seems to be that I feel what I do in imagining someone feeling it, not through watching myself imagining someone feeling it. Where the external counterpart of a mental state contains an audience, the internal version of this is an internal audience, not an internal spectator – though, of course, there are states (for instance, the delusions of observation referred to by Freud in his earliest writings on the super-ego)[2] in which we do stand to our mental processes pretty much as spectators.

The two reasons that I have been considering seem to me sufficient to temper the notion that, if feeling attaches itself to imagination, it does so as consequence. For they show that the notion of consequence that would be employed here is unduly stretched. And to those two reasons a third can now be added. And that is that there seem to be many cases where we need to talk of the consequences of imagination in an ordinary, or empirical, sense. A man may imagine something, and in consequence he may find himself in a certain condition which is no part of the imagining. A man may imagine Goethe setting foot on the moon – and then be surprised that the thought should have occurred to him: a man may imagine himself engaging in some sexual practice which he finds exciting – and then feel worried that he should have. These are the true consequences of imagination.

At this stage the argument might now take a fresh turn. For it might be maintained that the two facts on which I have depended so far in this section – one, that the audience often reacts emotionally to the depiction of emotion on the stage, and, two, that imagination contains an internalized version of an audience as well as of the actor – give no support to the view that in imagining someone feeling something or other, I share in that feeling. They may support some connection between imagination and feeling, but not in the specific form with which we have been concerned. For what is overlooked – the argument goes on – is that the emotion experienced by the audience and the emotion depicted on the stage need not be identical. Indeed, over a specifiable range of cases, in which it is undeniable that the one emotion is a direct reaction to the other, there will nevertheless be a systematic discrepancy between them. So, for instance, when

2. Freud, XIV, pp. 93–8; XVI, pp. 418–19.

the hero experiences courage, the audience will experience admiration; when the hero experiences rage, the audience will experience terror; and when the hero experiences terror, the audience will experience pity.

Now what this argument points out is perfectly correct, the audience will often react in this way, and the argument is therefore effective against certain crude applications or interpretations of the theory of *catharsis*. Nevertheless, all that follows for our purposes is that we should not take the members of the audience who react in this way to the hero as any part of the external counterpart to imagination – or, to put it the other way round, as providing the model for the internal audience – given, that is, that the hero corresponds to the person whom I centrally imagine doing or feeling this or that. If it is true that in imagining Gloucester as he passes through the events of his blinding I am in part actor and in part audience, then, just as the counterpart to me in the role of actor must be the actor acting Gloucester and no one else, so the counterpart to me in the role of audience must be that part of the audience which feels what Gloucester feels, not that part which feels for Gloucester. It must be (to exploit a familiar contrast) the emphatic audience, not the sympathetic audience. For if it were the sympathetic audience – or perhaps we should say, more generally, the reactive audience, to take in the case of the audience that responds to the villain's emotions, discrepantly from them but also differently from the hero's – then this audience when internalized would clearly disrupt the centrality of Gloucester in my imaginings. At some crucial point in my imaginative project I would find myself imagining someone feeling not terror, which is Gloucester's emotion, but pity, which is what Gloucester's emotion can arouse in a sensitive breast.

Having distinguished these two types of audience and having connected the emphatic audience peculiarly with imagination, I should now like to relate the distinction to imagination in a further way. For I should like to explain the difference between the two types of audience by reference to imagination. The suggestion I want to make is this: that the reason why the empathic member of the audience reacts as he does to the incidents of Gloucester's fate is that he not merely watches the actor acting Gloucester enduring his

blinding but he also imagines Gloucester enduring his blinding. It is because he imagines Gloucester enduring his blinding that, if he feels anything, he feels terror, which is what Gloucester would feel, instead of pity, which is what the person who merely watches the actor acting Gloucester would feel. Of course, the empathic member of the audience proper differs from the internalized audience – for whom, as we have already seen, he provides the model in respect of what he feels – in that, though both feel what they feel, not through watching something, but in imagining something, he is controlled in what he imagines by what he watches. He feels what he does not because of what he watches but because of what he imagines: but he imagines what he does because of what he watches.

It will be clear, I hope, that, in trying to explain imagination in terms of the empathic audience, and then trying to explain the empathic audience in terms of imagination, I have not been guilty of any obvious circularity. For, in so far as the analysis of imagination does make use of the notion of the empathic audience, the empathic audience can be identified solely by reference to the fact that it feels with, not for (or against), the hero – and, consequently, its internalized version feels with, not for (or against), the person centrally imagined. There is no need at this stage to bring in the imaginative project of the empathic audience, which is what explicates what it feels.

However, there is, I am aware, a real difficulty in what I have been saying, if we put it together with the analysis I have been offering of the imagination. For that analysis has been conducted in terms of internalized versions of the dramatist, the actor, and the audience. And the difficulty I have in mind comes from the inclusion in that analysis of something corresponding to the dramatist. For, if it is true that the empathic member of the audience, when watching the actor acting Gloucester enduring blindness, also imagines Gloucester enduring blindness, then (it follows) we must say of him that he is *inter alia* the internalized dramatist of what he imagines. But how can the man who imagines Gloucester being blinded because of watching someone acting Gloucester being blinded, in any sense be said to be the dramatist of his imaginings? That is the difficulty.

The point must certainly be conceded that, if we do have here something that can be looked upon as an internalized version of the

dramatist, we are also at a limiting case in the application of such a notion. The notion is exemplified only in its most attenuated form. Nevertheless, it seems to me that it is exemplified and we can see this in the fact that the empathic member of the audience selects who it is whose deeds and inner states he will centrally imagine. Watching *King Lear* he rewrites the text of Shakespeare so that it can be acted from the point of view of Gloucester. (And, incidentally, here we have enough to go on to see why the empathic audience does not provide the model for the understanding of the drama, and why any theory of the drama that puts him in the forefront is to that degree wrong.) Whether there is further support for the postulation of an internalized dramatist in the case of the empathic audience is something we shall be in a better position to assess when we have considered a bit more what that role amounts to.

8. It has not been claimed, and how could it be?, that the audience invariably reacts emotionally to the depiction of emotion on the stage. In consequence, in so far as the claim that imagination involves feeling rests upon the fact that the external counterpart to imagination includes an audience, the claim is not that imagination invariably involves feeling. It is only that imagination can, or may, involve feeling. So the question arises, when it actually does and when it doesn't; and there might seem implicit in the preceding discussion, of the empathic versus the sympathetic or reactive audience, some indication, admittedly oblique, how this question should be resolved.

The empathic member of the audience, watching *King Lear*, Act III, scene vii, will at once watch the actor acting Gloucester being blinded, imagine Gloucester being blinded, and experience the terror that Gloucester also experiences. He experiences terror because he imagines Gloucester being blinded, and he imagines Gloucester being blinded because of what he watches the actor do. However, it will be appreciated that it is only in a weak sense of 'because' that he is said to experience terror because of what he imagines. Given that he experiences terror, this is how we might set out to explain it.

But there are, of course, people who might imagine Gloucester being blinded and experience nothing – so how are we to account for the difference between such a person and the empathic member

of the audience? And we might grope for the explanation in the rest of what we know about the empathic member of the audience: namely, that he imagines Gloucester being blinded because of watching the actor acting Gloucester being blinded. Are we, then, to say that for the empathic member of the audience imagination involves feeling because, in his case, what he imagines is controlled by what he watches?

As an explanation of why the empathic member of the audience feels as he does, let alone as the beginning of a general account of when imagination involves feeling, this seems far too narrowly based. Yet perhaps we should not altogether despair of finding here a clue to what we are after. For might it not be, much more generally, that, if we imagine someone feeling something or other, then whether we share in that feeling or not is bound up with the way in which we come to imagine what we do? More specifically, it is the involuntariness of what I imagine, my passivity in imagination, that conduces to the accompaniment of imagination by feeling. Hence, in the case of the empathic member of the audience, the function of watching the actor: for watching the actor determines both the nature and the order of what he imagines. He cannot, or is unlikely to, drift off into imagining Gloucester, now miraculously liberated from the clutches of Cornwall, setting off to Dover, unmutilated, to greet the arrival of Cordelia and the army of France.

At this stage, however, we must take account of what I have been postponing: namely, the third element in the analysis of imagination, or the requirement that, in any adequate account of the imagination, place should be found for an internal version of the dramatist as well as of the actor and of the audience. For, it might be asked, how can this requirement be reconciled with the possibility that our imaginings, either in their nature or in their order, are experienced as anything other than voluntary? The requirement itself may be obscure, but surely on no possible reading can it permit imagination as something passive.

I shall, at various points in the rest of what I have to say, return to this requirement and what it amounts to. I fear that to the end it will remain obscure, and it may also be that the metaphorical garb in which I have presented it does, ultimately, as much to conceal it as to set it off. Nevertheless, in this last question and the raising of it,

we are brought up against so crucial and fundamental a misconception of our mental processes that it is necessary first to say something in dissipation of it.

The misconception in its most general form consists in thinking this: that, if something is a mental activity of mine, or an inner process that I initiate, then no constituent of it can occur passively or involuntarily in the flow of my experience, that every part of any project of mine is itself one of my projects. We have, however, already considered a clear counter-example to this view, in the case where I recite the Baudelaire poem to myself. For if I initiate the saying of this poem, then I must say, first '*Pour*', then '*l'enfant*', then '*amoureux*', then '*de*', and so on. If I deviate in any respect, or assert myself at any stage, I depart from my project. The whole is an activity of mine, though the nature and the order of what I do is predetermined. Indeed, the latter is a condition of the former.

And we can see how with imagination analogous situations can arise: when, that is, I set out to imagine someone doing something or other, and the various stages through which my imagination passes, or my successive imaginings, are not themselves something that I initiate. For instance, I try to imagine how a friend would behave in certain circumstances, and my knowledge of him is such that at each stage I seem not to be at liberty in what I imagine him doing or feeling next. If it is my friend John whom I imagine entering a room, filled with such and such people, painters and old ladies, then I have no choice in what I must imagine him doing, and what he will say to each group, and when. My knowledge of him establishes a repertoire for him in my imagination. And the same can happen with someone whom I have made up, or a fictitious character of my own invention, when, having placed him in a certain situation, I then try to imagine how he will be. For once the cluster of properties I have endowed him with is sufficiently profuse – once it takes in, let us say, his attitude towards himself, his marital situation, his relations to his father, his memories and aspirations – then I am likely, at any rate for much of the time, to find myself lying as it were passive to my imagination. In such cases also, my imaginings will form themselves out of a repertoire – though, of course, in both cases, the real and the fictitious, my knowledge of the repertoire may be latent, and I may be quite surprised by the wealth of it when it

finds expression. Indeed, for reasons interesting in themselves, but which we may not go into here, it looks as though the occasions, rising above the briefest, on which I am most untrammelled in my imaginings, when the repertoire is least in evidence, are when it is myself whom I centrally imagine doing or being done to. When I fashion a new life for myself, in the world of the daydream.

And now having said a little about how and when it is that I am passive in my imaginings, and the compatibility of this with my initiating my imaginings, I am perhaps in a better position to suggest what gives such plausibility as there is to associating an involuntary flow of imagination with feeling – or more specifically, with sharing in the feeling of the character whom I centrally imagine. The plausibility derives, I think, from a variety of sources, or rather from their confluence. First, there is the fact that in such cases imagining someone feeling something comes over me in much the same way as my feeling it would, or would have. The match between the way in which the two mental states occur may, in a Hume-like way, lead to an elision between the states themselves. Secondly, what I imagine in such cases will be to a low degree predictable: for though it comes out of a fund of knowledge, it comes out of a very general fund. And, thirdly, my involuntarily imagining someone feeling something occurs inside a large associative web of thoughts and feelings, characteristic of that person, and so, to some degree, the situation to which the feeling imagined would be appropriate is itself reconstructed. – I offer these suggestions for what empirical worth they will be found to have.

However, I have so far presented the question of activity versus passivity as though it only arose, or could be considered purely, on a phenomenological basis: of how the flow of imagination strikes one. And I have suggested as being crucial here whether what I have come to call a repertoire is involved. However, I do not think that this approach to the question of activity and passivity is exhaustive or even adequate. I think that it needs to be supplemented. For this reason I plan a new start upon the whole matter, coming at it from a different angle. But, first, I want to say something more about the bearing that the fact that the external counterpart to a dramatist is included has upon the relations between imagination and feeling.

9. To say that I am the dramatist of my own imaginings is (we have seen) to say something to the effect that I initiate what I imagine: where this means not simply that I start it off, but that I determine in an overall way what it is that I imagine, or the theme of my imagination. But to be able to fill this role, there is at least one condition that I must satisfy. If what I imagine is Gloucester suffering at the hands of Cornwall, or Goethe experiencing disgust on setting foot on the moon, then this implies that I have some knowledge of these feelings, upon which I am able to draw in imagining what I do.

Knowledge of those feelings, which in point of fact are those which Gloucester or Goethe would, or would according to me, feel in certain conditions is, of course, to be distinguished from knowledge of what feelings Gloucester or Goethe would feel in these conditions. I have already said something about the latter kind of knowledge. I have said that it is something that I may have to varying degrees, the limiting case being where I have none at all and simply make it all up – though I may also make it up, in cases where I do have knowledge but choose to disregard it, as in my daydreams about myself. But I cannot similarly be ignorant of, or have no use for my knowledge about, what it is to experience the feelings which I attribute to the characters whom I centrally imagine. For if in this respect my imagination outstrips my knowledge, then it would seem that I imagine nothing – or perhaps, more accurately, there is nothing that I imagine someone *feeling*. I may imagine someone in a certain situation, but not his reacting emotionally to it. Of course, the knowledge of the feelings involved, upon which I draw, can, like knowledge of what feelings are involved, be to varying degrees overt or latent, so that I may be acutely aware what it is to feel disgust at the sight of technological extravagance and waste, or again, I might come to recognize what it is to experience total terror only through imagining what Gloucester passes through.

However, I can so far see no reason to correlate the knowledge of what it is to experience a certain feeling with any tendency to experience that feeling. The knowledge will, in many cases, though not all, be grounded on such a tendency, but it does not seem to me that it gives rise to such a tendency. I am inclined – therefore – to think that the thesis that imagination involves feeling can draw no support from the fact that the external counterpart to imagination

contains a dramatist: though, as I argued a while back, it is an error to suppose that it is weakened by this fact.

And now for the fresh start that I promised.

10. Freud, in a number of passages,[3] all to be found in his mature work, describes and contrasts two ways in which the infant – and, subsequently, the adult as formed by his infantile experience – may establish a libidinal attachment. One of these is object-choice proper, the other is identification. Identification is the more primitive of the two, – or, from the adult's point of view, the more regressive – and it is treated by Freud as, in origin, a kind of lateral extension of what he called primary narcissism. The infant begins to love another as, until then, he had loved himself. And the difference between the two types of attachment Freud expressed in the following way: When the young boy chooses his mother as his first love-object, he wishes to *have* her: when he identifies himself with his father, he wishes to *be* him.[4]

It is clearly tempting to connect identification and imagination. Indeed, already, on more than one occasion in discussing imagination I have felt – and possibly you have too – how natural it would be to introduce identification, and to make the connection between the two phenomena: for instance apropos of the empathic audience. The truth about the empathic member of the audience in *King Lear*, Act III, scene vii, you may well have felt, is best put by saying that he identifies himself with Gloucester. And if I have so far resisted the temptation, it is for two reasons, which are related. In the first place, it has not seemed right to try to explain imagination in terms of identification, which is what the introduction of identification at any earlier moment would have amounted to: rather the explanation should go the other way round. Secondly, the ordinary notion of identification is peculiarly loose and unarticulated, and I have therefore preferred to wait until it seemed suitable to introduce the psychoanalytic notion, where these defects are to some degree made good. And with the psychoanalytic notion, the case seems even stronger for attempting an explanation of identification in terms of imagination, rather than vice versa.

3. Freud VII, p. 222n.; XI, pp. 98–100; XVIII, pp. 105–8, 230–1.
4. Freud, XVIII, p. 106; XXII, p. 63.

When Freud talks of identification, he is, of course, thinking not of some transient mental phenomenon; something which could, in a theatre, at moments of high dramatic intensity, as when Gloucester is blinded, or Bérénice parts from her lovers, strike the audience: but, rather, of something that constitutes a pattern of emotion and behaviour. The question that then arises is, Can we think of this pattern as having as its core a piece of imagination, either protracted or dispositional? And, if we can, how would such a piece of imagination fit into the classification that I have suggested for the various types of imagining?

Let us consider a simple case: that of the young Leonardo who, threatened with the loss of his mother's love, in which he had hitherto enjoyed such intense bliss, identifies himself with her, and from then onwards loves boys, as she had loved him, and moreover loves them in an idealized fashion, as she had loved him. The result of the identification is that Leonardo's actions and feelings will increasingly match the norm of action and feeling exhibited by, or that he believes to be exhibited by, his mother. We might then suppose that what inspires this is a piece of imagining in which Leonardo imagines himself behaving in a certain kind of way – that is, protectively towards young men who answer to a certain ideal of beauty – and also he imagines himself feeling in a certain kind of way – that is, tenderly or lovingly towards them.

If we do postulate such a piece of imagining – it would, of course, be a dispositional piece – on the part of Leonardo, then we must note how powerful an effect this imagining has. The internalized audience, we might say, is singularly responsive. This, however, though it needs accounting for, raises no issue of principle.

When, however, we turn to the internalized version of the dramatist, we do observe a departure from what we have so far taken as regular. For the imaginings of Leonardo clearly conform to a repertoire: that is, the flow of imaginings is bound, in that so long as Leonardo is engaged in his central imaginative project, he will not be free, at each moment, in what he imagines himself doing at the next. However, what binds Leonardo is not what we have so far taken as binding someone in his imaginings: that is to say, his knowledge of, or his beliefs about, the person whom he centrally imagines. In identifying himself with his mother, Leonardo imagines

himself doing this or that, but what he imagines himself doing is determined not by his knowledge of himself, but by his knowledge of her. And this goes for all cases of identification: in all such cases the person who identifies himself with another may be assumed to imagine himself doing those things the other would be expected to do, or would naturally do.

It is, however, clear that this conjunction of elements – that is to say, a certain type of imagining and a repertoire more appropriate to another type of imagining – do not by themselves account for the nature of identification; even if we now throw in the peculiar influence that the imaginings exercise over the behaviour of the person who engages in them. As things stand, identification still looks too close to a mere species of supposition.

I now want to suggest that we should add to this analysis a third element, which, though of some significance in all mental phenomena, gains in importance as we approach or move towards the pathological. The new element is very difficult to characterize, but, roughly, it may be said to be the way in which we conceive of the mental process itself, or the conception under which the mental process occurs. In the identification of himself with his mother, the imaginings in which Leonardo indulges, and which, as we have seen, are modelled not upon his but upon her thoughts or upon her feelings, are conceived of as a means by which he can take her into himself and thus lovingly merge with her. Such a conception I shall call the master thought in Leonardo's imaginings: meaning thereby not merely that it is because he thinks of imagining in this way that he sets out to imagine what he does, but, more directly, that this is what he thinks he is doing when he imagines what he does.

The notion of the master thought is difficult and complex and, before I say anything to develop it, one consequence of it, simply as far as identification itself is concerned, might be pointed out: and that is that the master thought can be invoked to explain one feature of identification which has already been remarked. And that feature is the peculiar effectiveness of the imaginings: or the fact to which I drew attention by saying that in identification the internalized audience is so singularly responsive to the internalized actor. This fact can now be connected with the way in which the internalized acting has itself been conceived. That it has been conceived of as a

way of modifying or transforming oneself can be used to account for the fact that it does so. Just as – to draw a parallel from the phenomena of ordinary mental life – the fact that I come to criticize some phrases of mine, or that I come to remember a line of Baudelaire, must be connected with the different ways in which I conceive of the internal recitations: that is, as a trial run in the one case, or as a mnemic device in the other.

11. The thesis that imagination can occur as a constituent of mental phenomena in such a way that the overall nature of the phenomenon is partially determined by the way in which the imaginings themselves are conceived, or, more generally the notion of the master thought, are clearly of great importance, and, in this address, I can barely hint at what that importance might be. But, first, I shall look at a further occurrence of the master thought, or at another application of the thesis that I have just attempted to formulate around it.

In talking of identification Freud very closely linked it to introjection – a fact that would have to be done justice to if a full account of identification were to be given. The infant identifies himself with certain figures of the early environment, and the identification itself is consummated in an act, in a phantasied act, that is, of oral incorporation, in what we might call a piece of psychic cannibalism. Through her more direct study of infantile development, Melanie Klein was led to believe that, alongside the form of identification that Freud isolated, there is also in use another form of identification in which projection is ascendant. Indeed, she claimed that there are hints of this already in Freud's own work, that the suggestion is not a totally new departure, and in a paper of 1946 entitled 'Notes on some Schizoid Mechanisms',[5] she postulated a psychic process for which she invented the term 'projective identification'. 'Identification by introjection and identification by projection' she wrote, 'appear to be complementary processes'. In projective identification the individual experiences, first, a splitting off of a part of the person and then the forcing of it – in the form of a set of feelings, or a piece or a product of the body – into another object, characteristically the mother's body, with the aim of possessing it and controlling it, whether in hate or in love. This process is closely linked in its results

5. Melanie Klein and others, *Developments in Psycho-Analysis* (London, 1952).

with such altogether pathological phenomena as claustrophobia, hallucinatory confusion, and states of depersonalization.

We might now benefit from the analysis suggested for identification proper, and I should like to propose that projective identification could very schematically be linked to imagination in the following way: First, the individual imagines (this time) someone else behaving or feeling in a certain way. Secondly, the repertoire to which the individual's imaginings conform is determined by his knowledge of how *he* would, or would tend to, act or feel. So far the internal structure of projective identification, or what lies at its core, is the mirror-image of that proposed in the case of identification. And now we must add to the conjunction of these two elements a master thought, or an indication of how these imaginings are conceived. In the case of projective identification, the master thought is peculiarly complex, and correspondingly difficult to formulate. In an earlier assault upon this topic,[6] I attempted to do justice to that part of the master thought which suffices to distinguish projective identification from ordinary projection. Since it is not with the empirical detail of the subject that we are expressly concerned, let me say that in projective identification the individual conceives of his imaginings as a method by which he rids himself of certain thoughts and feelings and also – that is, thereby – takes over and masters, either, as we have seen, lovingly or aggressively, another. And this – to repeat the point – is not only why the individual engages in these imaginings, it also gives us what he thinks he is doing when he does.

12. The location of a master thought in identification and then again in projective identification does not exhaust the applicability of this notion. In more acutely pathological phenomena the master thought plays a yet bigger role, and I have already suggested (at the end of section 10) how we might double back on our tracks and find an application for the notion or something like it amongst mental phenomena that lie on the other end of the spectrum: towards what we might call the extreme of normality.

I cannot however pursue this subject here, and I shall confine my

6. Richard Wollheim 'The Mind and the Mind's Image of Itself', collected in this volume, pp. 31–53.

remarks to the bearing that this new notion has upon two questions that we have already considered: the internal structure of imagination, and imagination as active or passive.

On the first point, I should simply like to point out how the introduction of the master thought gives a new dimension to what might seem badly to need it. For it considerably enlarges the role assigned to the internal version of the dramatist in imagination, which has seemed so far unsatisfactorily narrow. For – to preserve the metaphor – in being the dramatist of our imaginings, we are not merely responsible for the text of what we imagine, we also settle upon the genre within which it is conceived.

But on the second point, on the bearing of the master thought upon the distinction between activity and passivity in imagination, I shall have more to say. So far the criterion I have employed has applied exclusively on the minute or atomic level – that is to say, to the constituent imaginings in the flow of my imagination – and as such it has involved merely an appeal to the repertoire, or lack of repertoire, from which the imaginings derive. I have been maintaining that, if at any stage I am at liberty in what I imagine next, I am active: otherwise I am passive. Though I have also indicated, without explaining how, that passive constituents can occur within an activity. However, it may now seem that, with the introduction of the master thought, and the emergent picture of certain mental processes as in part deriving their character not just from their constituent states but from the way in which these constituents are conceived, we have a new, and perhaps an overriding, dimension in which activity and passivity can be assessed. For the imaginative project itself can now be considered active or passive.

In calculating activity here, we must, however, not make the mistake of thinking that what is decisive is whether the imaginings have an aim, whether, that is, they are conceived of as achieving something. For the mere presence of the master thought ensures that this is so. The crucial question is what aim they have or what they are conceived of as achieving. (cf. Freud on the instincts: 'Every instinct is a piece of activity: if we speak loosely of passive instincts, we can only mean instincts whose *aim* is passive.'[7]) If the imaginings are conceived of as a way of achieving domination or mastery over

7. Freud, XIV, p. 122.

another, or even the evacuation of one's own feelings, then the imaginative project has a claim to be considered active. If, however, the imaginings are entertained with the aim of bringing about a mergence of oneself with another, the obliteration of self in another, then the imaginative project has a claim to be considered passive. And in each case the claim matches the way in which the project itself was experienced.

Given this more broadly based conception of activity and passivity, would it still be plausible to associate feeling, as a concomitant of the imagination, with imagination in its passive appearance? I think so: and indeed the plausibility is raised by empirical considerations. For it is characteristic of projective identification that the individual contrives not to experience those feelings which he imagines someone else as experiencing, whereas in identification he expressly experiences those feelings which he imagines himself as experiencing. Such, in each case, is, in some further sense of that phrase, his imaginative project: such is his mental design.

13. There is one point on which I have so far preserved what may seem an unaccountable silence. I have talked about identification and about projective identification, and I have suggested connections between each of them and the imagination. But one particular form that these connections might be thought to take I have not mentioned, nor have I even allowed room for it, since to all appearance I have not introduced the type of imagining that it would involve. For it might be thought that, in so far as identification in its various forms involves imagination, it involves typically a type of imagining in which I imagine myself to be, or in which I imagine my being, someone else.

Now it is true that we often report what we imagine in this way. Nevertheless, we should be prepared for the fact that imagining myself to be someone else is possessed of a complexity beyond what meets the eye. Let us see whether this is so.

A while back, in discussing visualization, I accepted the principle roughly to be expressed as that what I imagine is given by what I imagine it as. Spelt out, this would seem to suggest that the content of any of my imaginings corresponds to a thought, and that, when I imagine something or other, I in effect imagine the corresponding

thought to hold or be true. And, in general, this suggestion seems perfectly acceptable. However, if we take the case of my imagining myself to be someone else, a difficulty arises. For, applying this suggestion, we appear to arrive at the view that such an imagining has a content which would be rendered by the thought 'I am someone else'; for instance, if I am imagining myself to be Goethe, the content of my imagining would correspond to the thought 'I am Goethe'. But any such thought is necessarily false: given, that is, that the thought is obtained by taking the words in their most obvious sense, where 'I' and 'Goethe' figure as referring expressions or names, and that, which is *ex hypothesi* the case, I am not Goethe. And, as far as I can see, there is no accessible sense in which a thought that is necessarily false can give the content of my imagining, or in which I can imagine a thought that is necessarily false to be true.

Someone might object that this is so only if I know that the thought is necessarily false. Leaving aside the relevance of this to the present context – leaving aside, that is, the question whether I could be in doubt whether I might be someone other than myself – I would reply that, if I did not know that a thought was necessarily false, then indeed I might think that I imagined it to be true, or I might think that it gave the content of my imagining. But it would not follow from this that it did. And against thinking that it did, the argument from impossibility would still hold. We are often mistaken, and yet more often confused, about the contents of our mental processes: about, that is, as well as in.

However, I think that there is a conclusive reason for thinking that, when I imagine myself being someone else, say being Goethe, what I imagine does not correspond to the thought 'I am Goethe'. For even if I could – and I have maintained that I can't – have such a thought as the content of my imagining, still that specific imagining – that is, the imagining that did have this thought as its content – would not be the familiar imagining myself being Goethe. For the thought 'I am Goethe' is identical with the thought 'Goethe is me', but it is evidently one thing to imagine myself being Goethe and quite another thing to imagine Goethe being me. (Indeed, as an extension of this, we may observe how difficult it is to attach sense to the notion of 'imagining x being y' in those cases where I am a

value neither of x nor of y: though no similar restriction upon its substitution-instances holds for the schematic thought 'x is y'.[8] And this shows that there is something peculiar about any case of imagining where what I imagine is supposed to correspond to a thought asserting identity.)

If it is wrong to try to understand what it is to imagine myself being someone else in terms of the thought 'I am someone else' or some substitution-instance of this, then it might look as though there are two possibilities open. One is that the whole enterprise of trying to explicate the content of my imaginings, or what I imagine, by reference to some corresponding thought should be abandoned. The other is that, in the case of those imaginings where the obvious choice of thought for being that which gives their content proves unacceptable, as, for instance, with imagining myself being someone else, we should simply look further afield for the corresponding thought. More specifically, we should (perhaps) look to a complex thought. There are, I believe, certain very general considerations, connected with the nature of the mind itself, why the overall enterprise of matching mental states with thoughts should not be given up, at least without more of a struggle: and furthermore, I would say that there is enough encouragement to be found in the kind of analysis that has proved feasible for identification and for projective identification for us to think that, when we cannot find a simple thought that will do as a match, we do right to go on to look for a match with a thought possessed of complexity.

Accordingly, I should now like to suggest the following analysis of what it is to imagine myself being someone else: As a minimal requirement, I imagine myself doing a number of things or a number of typical things that the person I imagine myself to be is believed by me to do or to have done: or, more generally perhaps, I imagine myself being things that I believe he is or was. So if I imagine myself being Goethe, I imagine myself living comfortably in Weimar, being possessed of high lyrical powers, being endlessly curious about natural phenomena, enjoying the love of many women, communing effortlessly with the famous, etc. And, of course, this (or this sort of thing) might be all there is to it. This might be the full content of what I imagine. And, if I haven't introduced this possibility before,

8. cf. Bernard Williams, op. cit.

it is only because it seems to provide a sense of imagining myself being someone else which is quite unproblematic. In this sense I merely imagine myself possessing the properties of someone else. And we might add, this is in no way to his detriment.

If this last phrase seems in need of elaboration, the point might be put like this: That if I imagine myself being someone else in this sense, I am not thereby committed to imagining anything about the existence or non-existence of this someone else. In fact, I think that it would be right to say that I could (in this sense) imagine myself being Goethe and in the course of doing so imagine myself meeting Goethe. Of course, for this piece of imagination to work, it might be that I would have to imagine Goethe possessing certain properties other than those which the historical Goethe possessed: as a minimum, I couldn't imagine Goethe possessing those properties which are, or are thought by me to be, uniquely instantiable, and which I was meanwhile, in the course of imagining myself being Goethe, imagining myself possessing.

And yet there is a sense in which I may imagine myself being someone else, and it seems that this is to his detriment. This happens when it follows from the fact I imagine myself being him that I imagine him not otherwise to exist. How is this to be accounted for? What must we add to the requirements that we have already specified? And to put the matter in this way seems to raise a difficulty. For to go back to the general enterprise of trying to explicate the content of my imaginings by reference to thoughts, it seems impossible to think of a single thought such that, when I imagine myself being Goethe, this thought can simultaneously account both for a range of properties that I imagine myself possessing and also for the denial of existence to Goethe. And yet it seems wrong to say that, in imagining myself to be Goethe where this is to his detriment, I imagine two independent things. It is just at this point that we can derive assistance from the analyses of imagination proffered in the cases of identification and projective identification. For those two analyses show us that the choice is not exhaustively between a simple thought and a conjunctive thought, but that the complexity might lie in structure. In other words, I now want to suggest that, in the cases under consideration, in order to arrive at the full sense of imagining myself being Goethe, we should supplement my imagin-

ing myself having various Goethean properties with an appropriate master thought.

Precisely what this master thought is is likely to prove, of course, a difficult phenomenological question, and we certainly must not be influenced by the foregoing discussion into concluding that it will inevitably be of such a kind as to render the overall mental phenomena pathological or quasi-pathological. We must allow the possibility that this should be so, but not insist on its universality. At its most extreme, the master thought may well be that in investing myself with someone else's properties I thereby obliterate him. But there is, of course, room for a number and variety of weaker, or less destructive, conceptions of the imagination under which I might imagine myself possessing the properties of another.

There are, I think, a number of consequences of analysing in this way what it is to imagine myself being someone else. I shall mention only one. At the very beginning, you may remember, while disclaiming exhaustiveness for my classification of types of imagining, I said that I would return later to the question of its exclusiveness. Now, one way of challenging its exclusiveness would be to claim that imagining someone else doing something or other (my third type of imagining) could be reduced to imagining myself doing something or other (my second type). For (the argument would run) to imagine someone else doing something or other is really to imagine myself being someone else doing something or other. To imagine Goethe setting foot on the moon is to imagine myself being Goethe setting foot on the moon. (The grounds for this would be, I suppose, something to the effect that I could not centrally imagine anyone but myself.) But the analysis that I have offered of what it is to imagine myself being someone else seems incompatible with this argument. So, if my analysis is true, the argument lapses, and with it one objection to the exclusiveness of the different types of imagination that my classification proposes.

4 Expression

Whether the word 'passion', as indicating the suffering or affection from without of a soul, is by now no more than a dead metaphor, surviving from an antique conception of the mind; whether, indeed, there is any way open to us of determining the passivity or otherwise of our inner life, apart, that is, from how it strikes us, from how we are prompted to describe it, are not questions that I can take up this evening. It is enough for my purpose that for much of the time our feelings, our emotions, our inclinations are as fluctuating or as imperious as if they were not totally under our control. We are elated: we are dejected: we get angry, and then our anger gives place to a feeling of absurdity: we remain in love with someone who is lost to us but whom we cannot renounce: we are interested in something, and suddenly we are bored, or frightened that we will be bored: we see a stranger, someone who is nothing to us, who is poor or crippled, and we feel guilt: someone does something wrong or foolish, and we are unaccountably transported by laughter, by 'sudden glory' as Hobbes called it, knowing what it was about, and then, as unaccountably, we are thrown down. Man is, in Montaigne's famous phrase, *une chose ondoyante*, a creature of inner change and fickleness.

As we pass through these alternating states, these moods and reverses, which make up our inner life, there are, roughly, three things that we can do about them. We can put them into words: we can manifest them in our actions: or we can keep them to ourselves. We can conceal them, or we can reveal them: and if we reveal them, we can do so in behaviour or in language. If later this evening we may find reason to modify this way of classifying the possibilities, in that it overlooks, on the one hand, differences, on the other hand, similarities, to which attention is necessary, nevertheless for the moment it will do.

It will do, if only because it has done for so many others. The assumption that in this classification we have the three fundamental

ways in which man, or at any rate man as a social animal, can stand
to his inner life, provides the normal or conventional background
against which an account of expression is set. For if we take the two
ways in which a man is said not to keep his feelings to himself, and
the two media to which he then resorts, namely behaviour and
language, we can then establish, corresponding to this distinction, a
dichotomy between expression and what is indifferently called
communication, description, assertion. Now it is within this dicho-
tomy, or, to put it the other way round, by contrast to the notion
of, say, assertion, that the notion of expression acquires its signi-
ficance. In behaviour a man expresses his feelings: in language he
asserts or describes them.

That is stage one of the conventional account of expression. But
the account generally goes beyond this. For it is then recognized that
just what is distinctive of the way in which we reveal our feelings
when the medium is behaviour can also be found when the medium
of revelation is language. The case of interjections is customarily
cited. The dichotomy between expression and assertion does not
neatly correspond to the distinction between behaviour and language.
For there can also be expressive language: or, to put it perhaps in a
finer way, an expressive use of language. Nevertheless – and this is
where stage two of the account is firmly grounded in stage one – the
notion of expression remains derived from, or finds its paradigmatic
instance in, the behaviour of a man in the grip of feeling: even if it
is then, under the influence of the analogy between such a man's
behaviour and what his language might be like, extended to his
language, or to a fragment of his language. Language is regarded as
expressive if and only if it displays certain characteristics that in the
first instance pertain to behaviour.

The fundamental distinction between expressing and asserting or
describing a feeling or emotion is a commonplace of eighteenth-
century criticism: there linked, as it is at the first stage of the fore-
going account, with the distinction between behaviour and language.
We find it, for instance, in Lessing's *Laocoon*, where it is not unrelated
to his famous principle of division between the arts. 'It is a different
impression', Lessing writes, 'which is made by the narration of a
man's cries from that which is made by the cries themselves.'[1] For

1. Gottfried Lessing, *Laocoon*, IV.

the subsequent attempt to take up or collect this distinction, once it has been firmly established in the contrast that behaviour and language by and large offer one another, and to transplant it inside one of the terms of this contrast, thus making a division within language, our thoughts most naturally turn to the work of I. A. Richards.[2] His distinction between the scientific and the emotive uses of language was the first systematic attempt of our day to record the fact that we can express as well as assert our feelings in language. It was, of course, to Richards's work that the author of *Language, Truth and Logic* was indebted when he framed the famous emotive theory of ethics: a new account of language was invoked in order to redress the balance against the old morality.

But what, we must now ask, are these peculiar or distinctive characteristics of the way in which we reveal our feelings in behaviour, such that, when we find these same characteristics recurring in our linguistic utterances, we feel it right to regard them too as expressive? We need, it would seem, to look at behaviour and how it stands to our inner life, or to that part of it which it reveals, to find the answer to our question. But there is a difficulty here, which, when taken care of, gives us stage three of the conventional account of expression. And that is that, just as not all the occasions on which we reveal our feelings in speech can be regarded as assertive or declaratory of those feelings, in that our utterances may so approximate to the way in which we reveal our feelings in behaviour that they are better thought of as expressive: so now, there are occasions on which we reveal our feelings in behaviour, but what we do is not to be thought of as expressive, in that our behaviour so approximates to the way in which we reveal our feelings in language that it is better classified as assertive. The kind of thing that would be cited here is gesture or ritualized behaviour.

But the effect of this reservation, it might be thought, is now such as to close us up in so narrow a circle that there is no issue from it. For what have we been told, to date? First, that we assert or declare our feelings when we reveal them in language: except in certain circumstances. Secondly, that we express our feelings when we reveal them in behaviour: except in certain circumstances. Then,

2. C. K. Ogden and I. A. Richards, *The Meaning of Meaning* (London, 1923), and I. A. Richards, *Principles of Literary Criticism* (London, 1924).

when we go on to ask, what are the circumstances that constitute the exceptions, we learn that they are, in the first case, when we express our feelings, and in the second case, when we assert our feelings. So we assert our feelings in language unless we express them, and we express our feelings in behaviour unless we assert them. And to assert our feelings is to reveal them as we do in language unless we happen to express them: and to express our feelings is to reveal them as we do in behaviour unless we happen to assert them.

But the situation is not really as bleak as this suggests. For this way of putting the matter depends on there being no method to hand of separating off the central from the deviant cases of either the behavioural or the linguistic mode of self-revelation. When the conventional account of expression took its second step, it had a method of distinguishing the two kinds of case within the linguistic mode: by reference, that is, to (respectively) divergence from, and similarity to, the unitary kind of case exhibited by the behavioural mode. But when at the third step the behavioural mode lost its unity, are we to take this as indicating that we now have no method of picking out a characteristically behavioural and a characteristically linguistic way of revealing our feelings?

I shall waste no time before saying that I think we definitely have such a method: though unfortunately I cannot here go on to defend my contention.

The most familiar way of introducing my point would be to begin with the contrast between language as something rule-governed and behaviour as something law-like, or, rather, at best something law-like: so that, when we reveal our feelings in language, we should expect what we say to be connected with the feeling we reveal by means of a rule, whereas, when we reveal our feelings in behaviour, we should expect what we do and the feeling to be connected as instances of a constant conjunction. That, at any rate, should account for the central cases in the two modes: and the deviant cases in each mode can then be identified by their approximation to the central cases of the other. If we now link this up with the dichotomy between assertion and expression, as we have so far gone along with it, we can now say: when I say 'I am angry', this is characteristically an assertion or declaration of my anger, in that what I say and my anger are joined by a rule: when I scowl or bite my lip, this is

characteristically an expression, in that the scowl or biting of the lip and my anger instantiate a constant conjunction. We now add the two reservations: that if I scream out 'I am angry' or if I scowl in a charade or some kind of organized dumb-show, deviation will occur.

Recently an argument has been advanced against this classification: not so much as to the lines it draws, but (what is really more significant for our purposes this evening) as to the nomenclature it attaches to these lines, and all that that involves. More specifically, though it is undoubtedly right to distinguish between the different ways in which 'I am angry' and a scowl stand to the anger revealed, and indeed right to do so as I have done, this by itself doesn't give us an account of expression: or if it does, it doesn't give us the account in the interests of which it is usually invoked – for example, in this lecture. For it is not of the man who scowls and says nothing, but of the man who says 'I am angry', that we say that he 'expressed' his anger. Expression is, in other words, where the conventional account would set up description or assertion or declaration.

True enough (the argument goes on), the word 'expression' is used in connection with the revelation of feeling in behaviour. A scowl, for instance, is a facial expression. We call it such. Nevertheless it is worth observing, a shade more closely, just how the word 'expression', more specifically the verb 'to express', is used in these cases. Of the man who scowls, we say that his scowl expressed anger, not that he expressed anger. It is the expression, not the person, that expresses the feeling.

Professor Alston, from whom I derive this argument,[3] is rightly not insistent on its philosophical potential. 'It would be an act of folly', he says, 'to place too much reliance on the word "express" in this connection.' Nevertheless it is worth staying with the argument a little longer: to make three comments on it.

First, assuming the premise of the argument to be correct, I want to make an observation which may do something to take away from what must seem to anyone brought up on the conventional account of expression the totally unprepared-for character of the conclusion. To such a person it must seem incredible that a man's saying something can express something: except deviantly. For to him expression

3. William S. Alston, 'Expressing', in *Philosophy in America*, ed. Max Black (London, 1965), pp. 15–34.

goes with behaviour, not with language. But expression of what?, we might ask: surely not expression of thoughts? No, it will be agreed, not expression of thoughts: we characteristically express our thoughts in words: it is our emotions, our feelings, our moods, that we characteristically express in behaviour. But once this is conceded, we are half-way, or some way, to removing the strangeness of the argument's conclusion. For at the core of every feeling is a thought. It is, for instance, a thought that by and large secures a feeling its object: it is a thought that gives to feeling much of its elaboration and refinement. So part of what justifies the usage 'He expressed his anger', said of the man who puts it into words, is that we may regard what he does as expressing the thought that gives his anger its distinctiveness or inner elaboration.

Secondly – and here I come to question the premiss of the argument – it is far from clear that just any utterance by a man of the form 'I am angry with X' justifies us in saying of that man that he expressed his anger with X. I suspect that certain further requirements are imposed upon the conditions of utterance; requirements, I would suggest, taken from either end of the spectrum of conditions in which I may say 'I am angry'. Roughly, it seems that the utterance must either verge upon the ceremonial use of language or else be highly impassioned or emotive in its overall character – and it is worth noting that these are precisely the two kinds of occasion when it has been held that language takes on much of the nature of behaviour.

Thirdly, it is worth noting that, though 'He behaved angrily' does not entail 'He expressed his anger', the contrapositive would seem to hold. 'He didn't express his anger' or 'He expressed no anger' entails 'He didn't behave angrily' or 'He didn't exhibit his anger'. This suggests that the point is very narrowly verbal. Alternatively it may mean that (as they like to say) there is a great deal more work to be done here; of a largely unpromising kind, we might add.

However, to many it will seem that the cogent objections to the conventional account of expression come not from specifically linguistic considerations, like those Alston advances, but from a rather different area. For it will be felt that to understand by the expression of a feeling the piece of behaviour that is constantly – constantly, that is to say, as opposed to conventionally – conjoined

with that feeling utterly fails to account for, or do justice to, one indubitable and highly important feature of expression: what we might call its appropriateness, or its physiognomic character. By this I mean the way expression seems so finely matched or adjusted to the inner state of which it is the outer correlate, that we can see the one in the other. Phenomenologists and Wittgenstein and Stuart Hampshire are all agreed that any philosophical account of perception that requires us to place physiognomy outside the pale of what we see is to that extent inadequate. And, indeed, if we continue to take ordinary language as our guide in these matters, the fact of physiognomic perception is most certainly reflected in the idioms and turns of common speech. We say of a scowl not merely that it expresses anger but that it is itself angry: a smile can be the expression of pleasure, and, when it is, it is a pleased smile.

To spell out the argument: If a scowl is the expression of anger simply because it is the constant correlate of anger, then, if something other than a scowl were the constant correlate of anger, then that piece of behaviour, rather than a scowl, would express anger. Any constant conjunction could be other than it is. Therefore any (or almost any) other piece of behaviour could be the expression of anger. Therefore it cannot be that we see anger in a scowl unless we are prepared to say that we can see anger in any other (or almost any other) piece of behaviour. In point of fact, however, we see anger in a scowl and such-like things to the exclusion of all other pieces of behaviour. Therefore, the understanding of expression, or the expression of feeling, in terms of constant conjunction is false: at least in that it is not the whole truth.

I want to consider a number of objections to or comments on this argument.[4] If we imagine them for a moment laid out according to the part of the argument to which they relate, I shall then take them in the inverse order.

The first comment would be that the argument ignores the well-established cultural relativity of expression. Since this contention is very large, and not perhaps all that easy to interpret, I shall put it aside: using only as much of it as comes out in the remaining comments.

4. cf. Richard Wollheim, 'On Expression and Expressionism', *Revue Internationale de Philosophie*, nos. 68–9, fascs. 2–3 (1964), pp. 270–89.

Secondly, it might be said that the argument is wrong to suggest that the constant conjunction theory of expression requires that we are able to see, that we can see, anger in every other piece of behaviour that could be correlated with anger. All it requires is that we should be able to see, that we could see, anger in any particular piece of behaviour were it actually, that is in point of fact, correlated with anger. If it is now retorted that this comes to the same, for if we can see some characteristic of a piece of behaviour in one connection, when the behaviour enters into one specific correlation, then we must also be able to see it in another connection, for either the piece of behaviour has that characteristic or it hasn't, this retort would exhibit very well precisely what is wrong with the original argument. For it treats physiognomic properties as though they were physical characteristics either had or not had by something, and, if had, then there to be seen. In reality, however, physiognomic properties are, or are close to, what Wittgenstein in the second part of the *Philosophical Investigations*[5] called 'aspects': whose existence, it might be said, depends upon their being seen, rather than, as the argument suggests, vice versa.

Thirdly, with this last comment in mind, it may now seem less implausible than the argument suggests to hold that we could see anger in any piece of behaviour: for this means only that we should see it were that behaviour correlated with anger. And if we now think that there are many pieces of behaviour that we just could not imagine ourselves seeing as angry, the explanation for this may be that we cannot, or perhaps just do not, imagine their being correlated with anger. Of course if we do not or cannot imagine the correlation, the physiognomic perception will remain inconceivable. And there is a further difficulty here, to which perhaps insufficient attention is paid in the philosophical discussion of imagination: the difficulty of what it is to imagine something like a correlation, of which only one of the correlated items is present to us, for is not imagination ordinarily thought of as being, like perception, intractably particular in its operation?

Nevertheless, a problem remains. For if it is dogmatic to assert that we could never see anger in any piece of behaviour except that currently correlated with anger, it seems equally unwarranted to

5. Ludwig Wittgenstein, *Philosophical Investigations*, II, xi.

assert, without further demonstration, that there is no piece of behaviour that we could not see as angry were it correlated with anger. For this seems to suggest that physiognomic perception, the seeing of anger in a bodily gesture or movement, is nothing over and above bare intellectual awareness, the awareness that anger and the bodily gesture or movement in question are correlated. Physiognomic perception must be more than that. So perhaps there is more to the argument than we have given it credit for.

This brings us to the last, the most important, comment that I have to make. And that is that the supposition, said to be intrinsic to the constant conjunction theory of expression, to the effect that any piece of behaviour could come to be the expression of, say, anger, needs to be taken seriously. And in the argument before us it noticeably is not. It is not, because of a slipperiness in the way in which the notion of behaviour, of a piece of behaviour, is handled.

For when we are asked to suppose that, say, a smile rather than a scowl might become the expression of anger, through becoming its correlate, the words 'scowl' and 'smile' as they occur in this supposition are not intended simply to pick out differing ways in which the face might be pulled or might crease: they do not refer just to the lie of the face, as we might call it. For that by itself is not expression. A particular lie of the face expresses a feeling when and only when it comes about as the result of something that we do. A frown expresses anger when we frown: a smile pleasure when we smile. To put the matter the other way round: even as things stand we can smile or scowl in a purely configurational sense, in that our face can become dishevelled in this or that way, and thus express nothing. As, for instance, foolish parents discover when a baby 'smiles' with wind. It is precisely because the baby doesn't smile, though there is a smile on its face, that no constant conjunction is upset.

And having got only so far, we may pause for a moment. For we may already have in our possession a small bit – as we shall see later, it is no more than a small bit – of the reason why we feel that we can see anger in a scowl: where by 'scowl', we mean simply what I have called a particular lie of the face. For in seeing the scowl we are immediately made aware of the activity whereby it came into being. And from the activity we are led, a stage further back, to the feeling. The activity is a bridge which we may traverse in our imagination

from face to feeling. In *Feeling and Expression* Professor Stuart Hampshire made great use of this idea.[6] Indeed slightly transposed, this same idea became crucial to his philosophical account of how we come to acquire knowledge of other minds. The transposition, which may have somewhat obscured the similarity, was that, instead of the imaginative reconstruction of the scowl to which I make reference, Hampshire introduced the far more overt method of mimicry or imitation. We come to learn the feelings or sentiments of others through an inner mimicry of their natural expression, he argues: thereby reviving a late nineteenth-century view of the matter.[7] Neither in his terms nor in my terms, would I go as far as Hampshire goes: he being undoubtedly influenced here by the view, to which he subscribed at this stage, of the inner life as the residue or shadow of once open, now inhibited, behaviour. Nevertheless, the distinction made here between the two sides of expression, activity and trace as we might think of them, certainly has its bearing upon our knowledge of others; if only indirectly, through helping us to understand physiognomic perception.

Let us now return to the main argument. I have maintained that the supposition that a different piece of behaviour might be correlated with anger from that which now expresses it, is not conveyed by some such thought as that, when we are angry, a smile, say, might appear on our face. For this seems compatible with the supposition that, when we are angry, we should scowl and a smile should appear on our face: equally, with the supposition that, when we are angry, a smile should appear on our face from nowhere, or absent-mindedly. The supposition, taken seriously, as I have been insisting that it should be taken, seems to need some such thought as that, when we are angry, we should smile. We may later have to revive this formulation, but it will do for a start.

But now we have a difficulty: and that, of course, is to understand what is meant here by 'smiling'. It is naturally no part of my case to suggest that 'smile' must mean 'produce such-and-such a lie of the face'. But the trouble is that what looks like the other way in which we can understand the word 'smile', the other leg on which

6. Stuart Hampshire, *Feeling and Expression* (London, 1961); reprinted in Stuart Hampshire, *Freedom of Mind* (London, 1972), pp. 143–59.

7. The main proponent of this view was Karl Groos.

the meaning of the word rests, is not available to us either. For this other way of understanding 'smile' is where to smile is to express pleasure. Put more generally, having isolated things that we do with our body or parts of our body both from the feelings that they express and from the bodily modifications in which they issue, we now find it impossible to identify them without making reference to at least one of these things. Yet the supposition of a change in correlations of feeling and behaviour seems to require that we refer to neither.

The precise nature of the difficulty must be firmly grasped. For nothing has been said to suggest that we could not express our inner states other than as we do: which is all to the good, since any such suggestion would be empirically false. The difficulty is rather that, as things stand, we seem to have no way of indicating how we would express ourselves differently: since the terms that we use to identify or pick out the expressive activities seem so firmly rooted in the two circumjacent conditions from which, for the purpose of this argument, we need to detach them.

I now have a suggestion as to how we might extricate ourselves from this impasse, which will roughly occupy us for the rest of this lecture. I suggest that we turn to a rather different kind of activity from either smiling or scowling, but which has this in common with those activities: that it is regarded, and surely rightly, as expressive. I am referring to the activities upon which the visual arts repose: for instance, painting. Whether all painting is expressive or not, or whether the expressiveness of painting is a distinctively modern conception, I shall leave undiscussed. In our culture, in the context of the late bourgeois world, painting is certainly a mode of expression. But now we must ask in the light of all that has already been said, How can this be? How can painting be expressive, when it seems so contrived, so sophisticated and self-conscious an affair, so remote from the movements of the mind and the body?

We are not yet in a position to answer this question. To our existing account of the matter, we need to add another element before we can take in this further aspect of expression. And that is the tendency, operative in us (we are to believe) from the earliest experiences, to find objects in the outer world that seem to match, or correspond with, what we experience inwardly. This tendency is

particularly sharp or poignant for us when we are in the grip of a strong feeling, but it is never long out of operation. A broken tree or tower will represent for us the sense of power or strength laid waste: the blue of the distant sky suddenly realizes a feeling, a lost feeling perhaps, of happiness. The objects, of course, have originated quite independently of us: they are parts of the environment, which we in some broad sense appropriate, because they have this special resonance for us. Once again we find a reflection of this phenomenon in ordinary speech. For the correspondence between inner feeling and outer object leads us to characterize the object in the language of feeling. The landscape is cheerful, the sky is grim, the estuary is melancholy. And indeed it is only a piece of theory, an epistemological presupposition, that leads us to think that there is available a neutral description drained of emotion that fits the original perception we have of such objects. I shall call this tendency, following a famous nineteenth-century usage, the finding of 'correspondences'.

Now, it is upon this foundation that the function of painting as an expressive activity in part depends. Not wholly, but in part. For the concept of expression in painting, properly understood, would seem to lie at the intersection of two constituent notions. One notion, which is where painting joins itself most obviously with scowling or smiling, is that of a bodily activity – in this case, more specifically, a manual activity – whose variations coincide with variations of inner state. If we find this thought surprising, this is of course only because we are not painters. To put the matter the other way round: the manual activity of painting acquires expressiveness in this sense only when the activity itself has become habitual. It is, in other words, only in the hands of painters that painting is expression. It is useful to recall that we do not have a more general phenomenon than this that we are called upon to explain.

The other notion constituent of the concept of expression in painting is formed upon what I have called 'correspondence'. There is, however, now a difference. I have introduced the notion of correspondence by reference to the selection or isolation of natural objects as matching our feelings. We are now to envisage that these matching objects are made, not selected. So we bring into being, where previously we discovered, correlates to our inner states.

Of course we cannot simply think of this as an extension of the original notion and imagine that there will not also be differences that accrue to the notion when it is extended in this way. As a minimum there will be aspects of the notion that were so unproblematic in the original context as to escape detection, and that only rise to prominence in the new context. The thinker who has most powerfully drawn our attention to the difficulties that arise when we pass from natural correspondences to the deliberate construction or assemblage of elements in the interests of expression is, of course, Professor Ernst Gombrich. That part of his argument which bears directly upon the present issue may be summarized as follows: When in nature we find something that corresponds to an inner feeling, what we do is that we select something out of a pre-existent range of elements as being the closest match to that state. It is the selection – that is, the picking out of one object rather than another – that gives the notion of match or closeness its significance: but just because the range out of which the selection is made is pre-existent, we do not need to insist on this point. When, however, we turn to the bringing into being of expressive elements, the range, which can no longer be equated simply with the bounty of nature, needs explicit formulation. Unless the repertoire, as the range is called in this context, is defined and known, we cannot talk of anything being selected in preference to anything else, and hence expression becomes a vacuous notion.[8]

The details of this argument deserve careful attention. But not here this evening. For you will recall that I invoked this further notion of correspondence, only so as ultimately to throw light upon expression taken in a more general sense than that of artistic expression. I chose to introduce this notion in the context of art, for there the gap between the bringing into being of an element that corresponds to a certain inner state and the inner state itself is so wide that I can survey the phenomenon in comfort: but that does not mean that I need examine the mechanism by which such elements are brought into being in the area of art, in any detail. So I shall now turn back to my main subject this evening – the expression of feelings

8. E. H. Gombrich, *Art and Illusion* (second edition, London, 1962), ch. XII, and *Meditations on a Hobby Horse* (London, 1963), *passim*. See on this Richard Wollheim, *Art and its Objects* (London, 1970), secs. 28–31.

in behaviour – and see how the account I have given can be enriched by the notion of correspondence.

At first it might seem surprising that it could be. For we seem to find no application for the notion. We cannot, say, equate painting out of anger with scowling, nor the angry painting that we thereby paint with the scowl that results, without total absurdity: as though we might start to scowl, and then observe the scowl, and then experience dissatisfaction with the scowl as it is, and so scowl a little differently, and eventually get the scowl we want. Of course this conception is absurd: but that is because it overlooks the narrowness of the gap between the activity and the trace, not because it conceives of a gap at all. Accordingly, to arrive at a less absurd, at a more realistic, conception, what we have to do is to imagine the process spread out across time and barely obtruding into consciousness. We postulate, that is, merely some kind of negative feed-back that occurs from perception or thought to the expressive activity, which ultimately brings about a change in what I have earlier on called 'the lie of the face'.

If we can accept this insertion of the new element into the account of the expression of feeling in behaviour, we may now return to the impasse into which our examination of the constant conjunction theory of expression led us. For that theory seemed to require us to suppose that any particular feeling could find expression in any other piece of behaviour than that in which it does, were that piece of behaviour to be correlated with it. So, for instance, anger could be expressed by smiling rather than by scowling. But the difficulty we had in understanding this supposition was how words like 'scowling' or 'smiling' were to be taken. For it seemed inadequate to define them in terms of a certain lie of the face: and it seemed inviting self-contradiction to define them in terms of the feeling that they currently express. But now perhaps we have a third way open to us of taking them, directly derivative from the foregoing discussion. On this reading, to scowl would be 'to produce an angry lie of the face': to smile would be 'to produce a happy lie of the face'. In other words, smiling and scowling would be intentional verbs having as their aims the bringing about of something in so far as it fell under a certain description.

How does this help us? More specifically, does it or does it not

98 On Art and the Mind

make it possible for us to understand the supposition that is allegedly implicit in the constant conjunction theory of expression? That is, that we could express our inner states other than as we do. The answer is, I think, that it does: on a certain assumption. I shall first of all try to show how it does, and then turn and look at the assumption.

At the outset it must be said that the way in which physiognomic change is made intelligible is not by equating this, as I earlier suggested we should, with the possibility that a man might, say, be angry and smile. For if we employ this new intentional notion of expression, then it is clear that a man could not be angry and smile. Or rather he could be angry and smile: but in such an eventuality his smile would not be the expression of his anger. He might be angry and smile, just as he might be angry and cough.

However, though a man could never express his anger other than by scowling, nevertheless there might be physiognomic change in this way: that the configuration on his face might be different. The man might be angry, and scowl, and the lie of his face might be that which currently appears on the face of a man who smiles.

But this, it will be said, is surely just the possibility that I rejected earlier on in the lecture. I considered that physiognomic change was not achieved simply when, say, a smile in the sense of a lie of the face appeared on the face of an angry man. I said it was also necessary that the man should smile. And now I appear to have abandoned that claim.

I think, however, that the new intentional notion of expression should allow us to see how that claim can be abandoned and yet the spirit that animated it be retained. For what we are now to insist upon in the case of the man who is angry and expresses this in a smiling lie of the face is that he should see the lie of the face as angry and should bring it about just because he does. What I was insistent upon was activity, and this element of activity is now adequately safeguarded. The difference between my original claim and the present formulation is that, since the activity is now identified by reference not to the lie of the face itself but to what the lie of the face can be seen as or as expressive of, the appropriate word for the activity is not 'smile' but 'scowl'.

I said just now that this attempt to make sense of the notion of

physiognomic change rests upon a certain assumption. And the assumption is that there is a basis for physiognomic perception independent of the constant conjunctions that hold between behaviour and inner state. For if there was no such independence, then the lies of the face that any man would see as angry would be those, and just those, which appear on the faces of angry men. So we could not appeal to his attempt to assume an angry face as any kind of explanation of the deviant or unorthodox way in which he might express his anger. But I think that the phenomenon of correspondences does seem to suggest that in man there is some independent base of physiognomic perception.

One way in which the suggestion can come to seem absurd is if we assume that, if there is such a basis, it could be of any breadth whatsoever: that if our physiognomic perception is not totally derived from our familiarity with the correlations of inner state and behaviour, then we should in principle be able to see, even as things stand, any phenomenon in any emotional light. The argument from parody is a much-used weapon in the philosophy of mind. It is not only use that accounts for its bluntness.

I am very conscious that at this stage my argument displays a yawning gap. Even if I cannot close this gap, I should like at least to bridge it. The gap originates in my assertion that an inner state is expressed when and only when there is activity: again, that only if I do something, can someone else see my feelings in my behaviour. This, it will be said, is manifestly false. Do we not indisputably see embarrassment in a confused countenance?

Well, let me first make a concession. I am prepared to concede that an activity should be insisted on only where there is a possible activity. It is only when I can bring about a certain lie of the face that the lie of the face is not expressive if it merely appears. But having said this, I must now ask how much I have conceded. More specifically, how do I determine when there is and when there isn't an activity? Why, for instance, is laughing an activity and blushing, presumably, not?

Part of this question must lie enmeshed in the question with which I began this lecture: where much the same issue was raised concerning our inner states and the determination of their activity or passivity. I wish, however, to lay aside as much of my question

as cannot be dealt with independently of those highly 'inward' issues.

Here I would like to suggest simply three criteria of an activity. They are, it will be apparent, criteria for only a weak sense of activity: nevertheless it is one we use. First, that it can be inhibited. I can stop laughing at will, anyhow on occasions: but I cannot stop myself blushing. The Empress Eugénie, it is said, had herself bled so that she should not blush at her husband's stories. But this is not the kind of case I have in mind. To define direct inhibition, or stopping oneself doing something in the requisite sense, has its difficulties. But one requirement would be that there should not be some identifiable thing that we do, of which in turn we could ask whether it can be inhibited or not, in order to bring about the desired inhibition. We stop ourselves: we do not do something so as to stop ourselves.

Secondly, I would suggest that another requirement of an activity is that it should not be identifiable solely by reference to a bodily change: like, say, a hiccough. In order to tell, for instance, whether a man is smiling, where this is an activity, we must take into account the whole of, or a large part of, the rest of what he is doing and of what is happening to him. And as the description of this changes, so likewise our attribution of activity changes.

And, thirdly, I would suggest that an activity is something for which we can always cite beliefs in explanation or justification.[9] If we find something funny, and are amused, and laugh, the laughter it seems expresses the amusement, only if we can cite some belief, interchangeably with the emotion, as the reason for our laughter. This is perhaps what philosophers like Dewey have had in mind when they insisted that all expression was not just expression of emotion but expression of a particular emotion.[10] For when we cite the belief it is to the effect not simply that there is something or other that is funny, but that some particular thing is funny. I have brought you to one of those many points where we can see so clearly the intersection of the various aspects of the human being that the philosophy of mind has traditionally taken delight in isolating. I can think of no better place to stop.

9. cf. Charles Darwin, *The Expression of the Emotions in Man and Animals* (London, 1872), ch. XIII.

10. John Dewey, *Art as Experience* (New York, 1934).

5 Minimal Art

If we survey the art situation of recent times, as it has come to take shape over, let us say, the last fifty years, we find that increasingly acceptance has been afforded to a class of objects which, though disparate in many ways – in looks, in intention, in moral impact – have also an identifiable feature or aspect in common. And this might be expressed by saying that they have a minimal art-content: in that either they are to an extreme degree undifferentiated in themselves and therefore possess very low content of any kind, or else the differentiation that they do exhibit, which may in some cases be very considerable, comes not from the artist but from a nonartistic source, like nature or the factory. Examples of the kind of thing I have in mind would be canvases of Reinhardt (Plate 1) or (from the other end of the scale) certain combines of Rauschenberg or, perhaps better, the non-'assisted' ready-mades of Marcel Duchamp (Plate 2). The existence of such objects, or rather their acceptance as works of art, is bound to give rise to certain doubts or anxieties, which a robust respect for fashion may fairly permanently suppress but cannot effectively resolve.

In this essay I want to take these doubts and anxieties seriously, or at least some of them, and see if there is anything they show about the abiding nature of art.

In a historic passage Mallarmé describes the terror, the sense of sterility, that the poet experiences when he sits down to his desk, confronts the sheet of paper before him on which his poem is supposed to be composed, and no words come to him. But we might ask, Why could not Mallarmé, after an interval of time, have simply got up from his chair and produced the blank sheet of paper *as* the poem which he sat down to write? Indeed, in support of this, could one imagine anything that was more expressive of, or would be held to exhibit more precisely, the poet's feelings of inner devastation

than the virginal paper? The interest for us of such a gesture is, of course, that it would provide us with an extreme instance of what I call minimal art.

Now there are probably a lot of reasons any one of us could find for regarding the gesture as unacceptable: that is to say, for refusing to accept *le vide papier* as a work of art. Here I want to concentrate on one. For it has some relevance to the more general problem.

Suppose that Yevtushenko sits down in Moscow and writes on a sheet of paper certain words in a certain order, and what he composes is accepted as a poem; now further suppose that someone in New York, a few weeks later, gets up and reads out those same words in the same order; then we should say that what the person read out in New York was the poem that Yevtushenko wrote in Moscow. Or rather we should say this provided that certain further conditions, which might be called, very roughly, continuity-conditions, were satisfied: that is to say, provided the man read out the words he did read out because Yevtushenko had previously written them down, and that he hadn't quite independently got the idea of conjoining them in Yevtushenko's order, etc.

A poem (one and the same poem) can, then, be written in one place, read out in another, printed in yet another, appear in many copies of the same books, be learnt by generations of children, be studied by critics in different countries: and all this without our having to assume that the poem somehow reproduces itself indefinitely by some process of division or fissure. For the poem, though it is, say, printed on a certain page, is not to be identified with those printed words. The poem enters into all the different occurrences – recitations, inscriptions, printings, punishments, memorizings – not because some common stuff is present on all these occasions, but because of some common structure to which the varied stuff on the different occasions (different paper, different ink, different noises) conforms. It is this structure, which originates with the poet's act of creation, that gives the poem its identity.

Now we can see one overwhelming reason why Mallarmé could not have produced the blank sheet of paper as the poem he had in fact composed. For there is no structure here on the basis of which we could identify later occurrences as occurrences of that poem. We would have no right to say of anything, 'Here is Mallarmé's poem.'

Alternatively, we should have to regard every blank page in the world, or every blank space, or indeed just every blank, as carrying not potentially but actually Mallarmé's poem. It would have to be seen as inscribed in the interstices of every inscription in the world.

And now suppose that Rauschenberg in New York conjoins a bicycle and a wooden culvert, and this combination (Plate 3) is accepted as a work of art; and further suppose that someone in Moscow, again after a period of time, also gets hold of a bicycle and a wooden culvert and brings them together in the same way as Rauschenberg did, and (for the sake of argument) exhibits it. Now I think it is evident that no one would say that what had been exhibited in Moscow was the combine that Rauschenberg had constructed in New York. And this would be so, even if something analogous to what I have called the continuity-conditions in the case of Yevtushenko's poem, were satisfied: that is to say, if the Russian artist put the objects together as he did because Rauschenberg had done so first, and he hadn't independently hit on the idea of doing so, etc.

Now all this, it will be appreciated, derives directly from the criteria of identity that we employ for distinguishing works of art (not 'visual' art, for the criteria are evidently different in the case of, say, engravings or lithographs). What it has nothing to do with are purely artistic or aesthetic considerations. It has, for instance, nothing to do with what we think about the merits of copying: all it relates to is the question whether if copying does issue in works of art, the copy is or isn't an instance of the same work of art as the original.

And the identity of a work of pictorial art resides in the actual stuff in which it consists.

From which we can see that Mallarmé could, in principle, have got up from his desk and produced the blank sheet of paper as the painting or drawing on which he had been engaged. For then there would have been an actual object which we could have identified as Mallarmé's painting, even though there was nothing to be identified as Mallarmé's poem. The production of the blank sheet of paper as the poem on which he was engaged would find its parallel in the area of the pictorial arts not in the production of a blank canvas, but in something like the gesturing toward the content of an empty studio.

In philosophical language, a literary work of art is a *type*, of which your copy or my copy or the set of words read out in a particular hall on a particular evening are the various *tokens*: it is a type like the Union Jack or the Queen of Diamonds, of which the flags that fly at different mastheads and have the same design, or the cards in different packs with the same face, are the tokens.

But what *would* we say about the combine that the Russian Rauschenberg put together in Moscow to the exact specifications of the American Rauschenberg in New York? We have seen so far that we couldn't say that it just is Rauschenberg's combine, in the sense in which the thing read out in New York *is* Yevtushenko's poem. But could we treat it none the less as a work of art: that is to say, as a *new* work of art?

At this historical juncture it seems hard to pronounce definitively on this point. But certainly there would be tremendous resistance to our accepting this suggestion: resistance which we could perhaps break down in this case or that, but not universally I suspect without the total disintegration of our concept of 'art' as we have it. The recognition of variants or copies within traditional Western art; the precedent of alien art traditions in which change or stylistic modification has been at a minimum; the parallel existence of etchings and lithographs which come in states and editions – all these provide us with temptations to capitulate, but temptations to which we are unlikely to succumb in any permanent way.

Now, it will be apparent from what I have said about types and tokens, that the genuine Rauschenberg and the pseudo-Rauschenberg are tokens of the same type – though the type itself is not a work of art. If this is so, then it would seem that our existing concept of a work of art has built into it two propositions, of which the first can be expressed as:

> *Works of pictorial art are not types, of which there could be an indefinite number of tokens;*

and the second as:

> *There could not be more than one work of pictorial art which was a token of a given type.*

This second proposition needs to be carefully distinguished from another proposition with which it has a great deal in common: i.e.

> *There could not be a work of pictorial art which was of a type of which there was more than one token*

which, I want to suggest, is clearly false.

For this third proposition would have such sweeping and totally objectionable consequences as that a work of art, once copied, would cease to be a work of art. It is indeed only when this sort of possibility is quite artificially blocked, by, say, a quasi-empirical belief in the inimitability of genius, that this Draconian principle could even begin to acquire plausibility.[1]

Yet there are occasions when the more moderate principle seems no less arbitrary in its working; indeed just because of its moderation, it seems, if anything, more arbitrary. In 1917 Marcel Duchamp submitted a urinal as a contribution to an exhibition of art. To many people such a gesture must have seemed totally at variance with their concept of art. But I am not concerned with them. If, however, we confine ourselves to those who found the gesture acceptable, then I want to suggest that what would have seemed quite at variance with *their* concept of art is that accepting the gesture committed them to rejecting in advance any of a similar kind subsequently made. Yet precisely this seems to be the consequence of our principle. By a simple action Duchamp deprived all objects of a certain kind save one of art-quality; and it might seem more arbitrary that he should have been able to do this than that he was able to secure it for that one.

Nor is this particular ready-made of Duchamp's likely to be a unique case. The problem then arises, How are we to delimit the cases where our principle gives rise to anomalies? For unless we can in some way delimit them, we shall find ourselves led back to the Draconian principle that we have already rejected. We shall find ourselves asserting that what was wrong with Duchamp's urinal is that it is one of a type. But this, as we have seen, is not what is wrong with it.

Another and more specific suggestion might be that it is not just that there are other urinals exactly like Duchamp's, but that

1. On these points, see also Richard Wollheim, *Art and its Objects*, secs. 4–9, 35–7, and 'On an Alleged Inconsistency in Collingwood's Aesthetic', collected in this volume, pp. 250–60.

Duchamp's does not owe its differentiation from them (*it* is a work of art, *they* aren't) to any temporal priority to which it can lay claim. It isn't just that there are other tokens of the same type, but that there are, or very well might be, other tokens which preceded or anticipated it. And this indifference to time-order, respect for which is so carefully enshrined in the 'original'/'copy' distinction of traditional thought, serves to single out a whole class of cases where we feel concern about accepting one but no more than one token of a certain type as a work of art.

Consideration of this kind of case suggests another. And this is where, though the facsimile does not in fact antedate the object that is accepted as a work of art, this fact seems to have very little significance. For the art-object, or what passes for one, is so readily reproducible. The other tokens that aren't there *could be* with such little disturbance to anything. In such cases the object is not one of a stream of identical objects from which it has been arbitrarily abstracted. But there would be no difficulty in imagining such a stream to flow out: the object is a natural tap for its own likenesses.

And possibly there could be other kinds of case where we might be tempted to feel the same kind of reserve. But I shall pause on these two kinds, and it will be apparent, I imagine, why they are of interest to me: for they totally overlap with the two sorts of object that at the beginning of this paper I identified as objects of minimal art.

But now, we might ask, why should objects of these two kinds give rise to any peculiar difficulties? Or, to put it another way, is there any common difficulty that we can see as lying in the way of accepting as works of art either artifacts of which there are or are likely to be pre-existent facsimiles or highly undifferentiated objects? We don't mind, as we have seen, reproducibility; so why should we mind facile reproducibility? Or is the whole matter, as Arthur Koestler once suggested, in a singularly unperceptive essay, just 'snobbery'?

I suspect that our principal reason for resisting the claims of minimal art is that its objects fail to evince what we have over the centuries come to regard as an essential ingredient in art: work, or manifest effort. And here it is not an issue, as it was in certain

Renaissance disputes, of whether the work is insufficiently or excess-
ively banausic, but simply whether it took place at all. Reinhardt or
Duchamp, it might be felt, *did* nothing, or not enough.

The connection between art and expression, which has been so
elaborately reinforced in the art of the recent past, has, of course, in
turn reinforced the connection between work and art. But I do not
think that the former link is necessary for the latter, which quite
independently (and I should say, quite rightly) enjoys such prestige
in our aesthetic thinking that it is hard to see how objects of minimal
art can justify their claims to the status of art unless it can be shown
that the reason for holding that they inadequately exhibit work is
based on too narrow or limited a view of what work is – or, more
specifically, of what work is as it occurs in the making of a picture.

And my claim, to which the rest of this essay will be devoted, is
that this can be done. Indeed the historical significance of the art-
objects I have been concerned with is largely given by the way in
which they force us to reconsider what it is to *make* a work of art:
or, to put it linguistically, what is the meaning of the word 'work'
in the phrase 'work of art'. In different ways the ready-mades of
Duchamp and the canvases of Reinhardt challenge our ordinary
conceptions on this subject – and, moreover, challenge them in a way
which makes it clear where these conceptions are insensitive or
deficient.

The system upon which Marcel Duchamp selected his ready-mades
he codified in the theory of '*rendez-vous*'. At a certain time, at a
certain place, he would chance upon an object, and this object he
would submit to the world as a work of art. The confrontation of
artist and object was arbitrary, and the creation of art was instanta-
neous.

Now if we ignore the whimsical, and equally the more disturbed,
aspects of these gestures, we can see them as isolating one of the two
elements that traditionally constitute the production of an art-object,
and, moreover, the one which is often, indeed almost consistently, in
ordinary reflection, overlooked in favour of the other. For the
production of an art-object consists, first of all, in a phase which
might be called, perhaps oversimply, 'work' *tout court*: that is to say,
the putting of paint on canvas, the hacking of stone, the welding of

metal elements. (In the next section we shall see that this picture even
of the initial phase is too crude; but for the moment it will do.) But
the second phase in artistic productivity consists in decision, which,
even if it cannot be said to be, literally, work, is that without which
work would be meaningless: namely, the decision that the work has
gone far enough. Since the first phase is insufficient without the
second, the whole process might in a broader sense be called work.

Now in Duchamp's ready-mades or in any form of art which
directly depends upon pre-existent material for its composition, it is
this second phase in the total process of production that is picked out
and celebrated in isolation. The isolation is achieved in the starkest
fashion: that is, by entrusting the two phases to quite different hands.
But, then, even this finds some kind of precedent within traditional
art, in the role of the pupil or the *bottega*.

However, what might be objected to in Duchamp's practice, at
any rate as we get it in the system of '*rendez-vous*', is that not merely
is there a division of labour between the construction of the object
and the decision that the object is in existence, but that the decision
taken about the object is not based on the appearance of the object
at all. In other words, Duchamp makes a decision like an artist, but
the decision that he makes is not like the artist's.

But even here, it might be claimed, Duchamp's gesture displays
some kind of continuity with traditional or accepted practice: it
picks up something that the artist does. For though the artist may
make his decision on the basis of what the object looks like, the
decision is not fully determined by the look of the object. The artist
is always free to go on or to stop, as he pleases, and though we may
sometimes criticize the judgement he reaches by saying that it leaves
the work still unresolved or alternatively that he has overworked it,
the criticism that we make is not purely aesthetic. There enters into
it a measure of identification with the artist. To put it another way,
when the artist says 'That's how I want it,' in part what he means is
'That's how you're going to have it.' What I have called Duchamp's
whimsical gestures do serve to bring out this 'master' aspect in the
production of art.

But when we turn to the second kind of object whose acceptance
as a work of art I have cited as problematic, the situation becomes

more complex. For the challenge that these highly undifferentiated objects present to the conception we ordinarily have of work or effort as this goes even into what I have identified as the first phase of object-making, is very searching.

Roughly it might be said that in so far as we think these objects to exhibit to too low a degree the signs of work and on this basis come to dispute their fitness as art, work is conceived somewhat as follows: A man starts with a blank canvas; on this canvas he deposits marks of paint; each mark modifies the look of the canvas; and when this process of modification has gone on long enough, the painter's work is at an end, and the surface of the canvas bears the finished picture. Now, of course, it will ordinarily be the case that the marks, by and large, differ one from another. But there is in principle the possibility that the marks will be totally repetitive. However, this would naturally be thought to be a mere limiting case of constructivity, and therefore to the extent to which an art-object is required to be a *work* of art, the resultant picture, which will be a mere monochrome surface, will be regarded as having a claim to the status of art that is only minimally ahead of the *tabula rasa* which it supersedes.

But the question arises whether this account, which is evidently all right as far as it goes, goes far enough. For is there not a further notion of work that we may bring to our perception of art, one which is quite distinct from that which I have set out, which stands indeed in stark contrast to it, and between the two of which there is a fruitful tension? So far I have spoken of constructive work: work which consists in building a picture, in 'working it up' from the blank canvas in which it originates into an artifact of some complexity. But now I want to suggest that in our contemplation of art we often envisage another kind of activity as having gone on inside the arena of the painting and which has also made its contribution to the finished state of the object. And this work, which is at once destructive and yet also creative, consists in the dismantling of some image which is fussier or more cluttered than the artist requires.

Perhaps I can clarify this point by considering briefly the notion of 'distortion', or at any rate the use to which it is implicitly put even in traditional criticism. For if we take cases inside the historical canon where it is universally agreed that distortion has occurred and

occurred fruitfully – say, mannerist portraiture, or Ingres, or (to come to modern times) the *Demoiselles d'Avignon* – what do we intend by saying this? Now, all we might be thought to mean is that in these works of art there is a discrepancy between the actual image that appears on the canvas and what would have appeared there if an image had been projected on it in accordance with (roughly) the laws of linear perspective. But what I want to suggest now is that in these cases there is a further thought that insinuates itself into our mind, and that is inextricably involved with our appreciation of the object: and that is that the image before us, Parmigianino's or Picasso's, is the result of the partial obliteration or simplifying of a more complex image that enjoyed some kind of shadowy pre-existence, and upon which the artist has gone to work. The 'pre-image', as we might call it, was excessively differentiated, and the artist has dismantled it according to his own inner needs.

My suggestion, now, is that the canvases of Reinhardt exhibit to an ultimate degree this kind of work, which we ordinarily tend to think of as having made some contribution to the object of visual art. Within these canvases the work of destruction has been ruthlessly complete, and any image has been so thoroughly dismantled that no *pentimenti* any longer remain.

But there is still a powerful objection. For, it might be said, though there may (or perhaps must) go into the making of a picture work of the kind we have been considering, what reason is there to suppose that such work can legitimately be abstracted from conventional picture-making, and as I have put it, 'celebrated in isolation'. Now, even if we allow for the hyperbole contained in this last phrase of mine, there is obviously a challenge here. To some degree, it can, I think, be met. Here I can only sketch how.

In conceptual thinking we fragment the world, and we isolate from the continuum of presentation repeated things, categories of object, sorts. We are led to concentrate upon similarities and differences in so far as these are expressed in terms of general characteristics; and this tendency is cemented in us by many of the practical exigencies of life. In the visual arts, however, we escape, or are prised away from, this preoccupation with generality, and we are called upon to concentrate our attention upon individual bits of the world: this

canvas, that bit of stone or bronze, some particular sheet of paper scored like this or like that.

It has, over the centuries, been, at any rate within the tradition of the West, a natural concern of the artist to aid our concentration upon a particular object by making the object the unique possessor of certain general characteristics. In other words, by differentiating the work of art to a high degree, the artist made its claim to individuality intuitively more acceptable. For it was now, in an *evident* way, not merely quantitatively but also qualitatively distinct from other objects.

Now this differentiation was, as we have seen, by and large achieved by placing in the object a great deal of what I have called 'constructive' work. It was by means of a very large number of non-repetitive brush-strokes that the highly individuated masterpieces of Van Eyck or Poussin were brought into being. But in the phase I am considering, where work of this kind recedes into the background and the elements of decision or dismantling acquire a new prominence, the claim of the work of art to individual attention comes to rest increasingly upon what lies right at the other end of the spectrum: its mere numerical diversity.

Inevitably a point will be reached where this claim, which is so abstractly couched, can no longer be found acceptable, or even taken seriously. But until then, as we merely move closer into the area of bare uniqueness, we have progressively brought home to us the gravity, the stringency of art's demand that we should look at single objects for and in themselves. A demand which is not fortuitously reminiscent of that involved in a certain conception of love which Pascal knew of:

> On n'aime donc jamais personne, mais seulement des qualités. Qu'on ne se moque donc plus de ceux qui se font honorer pour des charges et des offices, car on n'aime personne que pour des qualités empruntées.

6 The Work of Art as Object

If we wanted to say something about art that we could be quite certain was true, we might settle for the assertion that art is intentional. And by this we would mean that art is something we do, that works of art are things that human beings make. And the truth of this assertion is in no way challenged – though some preferred analyses may be put in doubt – by such discoveries, some long known, others freshly brought to light, as that we cannot produce a work of art to order, that improvisation has its place in the making of a work of art, that the artist is not necessarily the best interpreter of his work, that the spectator too has a legitimate role to play in the organization of what he perceives.

Precisely what is involved in saying of something that it is a thing we do and not a thing that merely occurs, how exactly we are to analyse the concept of an activity, are complex and difficult issues in the philosophy of mind. I shall disturb them as little as possible, but one general warning seems in order. And that is that the dangers in analysing the concept lie largely on the side of taking too exacting or rigorous a view of the matter: so that when, for instance, we think of painting as an activity, we are likely to presume too much of the painter – too much, that is, in the way of conscious intention, of preconception, of foreknowledge, of direct and articulated control, at the various stages in his manufacture of the object. The corrective to this tendency, as in similar cases, is to broaden the range of cases under review, so that we have a better and a fairer idea of the varieties of activity to which our concept of activity must be adequate. We make jokes as well as make plans: we make decisions, but we also make scenes: and in none of these cases does it seem to me that either the concept of activity, or the more specific concept of making, is extended beyond its proper limits or employed in a metaphorical manner.

However, though much is unclear about the notion of activity,

one thing seems clear. From the fact that art is something that we do, it follows that art is, in some further and perhaps philosophically more technical sense, intentional. And this further sense is best brought out in the claim that in the making of art a concept enters into, and plays a crucial role in, the determination of what is made: or, to put it another way, that when we make a work of art, we make it under a certain description – though, of course, unless our attention is drawn to the question, we may not be in a position to give the description.

The arguments for thinking that every activity – except, perhaps, for a small class that we may need to mark off as primitive or basic actions, to which none of this applies – involves a concept are varied, and I can only enumerate them. First, that an activity cannot be engaged in, except inadvertently, unless the agent possesses the concept of that activity: A man could not boil an egg, say, unless he knew what it was to boil an egg. Secondly, two different activities might for some part of their course coincide in what they ask of the agent: nevertheless, there is reason to think that, even over this part, the agent is engaged in one activity rather than another, and the answer, which one it is, is supplied by the description under which he acted. So boiling an egg and making tea coincide for the early part of their course, yet, even while the agent is still waiting for the water to come to the boil, we can say, and so can he, which of the two he is doing. Thirdly, an agent may, of course, simply fail to do what he sets out to do. However, given that he succeeds, he may do so because of what he sets out to do, alternatively he may succeed (once again I use the phrase) inadvertently – for instance, after he has given up trying or in the course of doing something else. And the difference between the two forms of success may be explicated by reference to the efficacy or non-efficacy of a concept in what is brought about. Finally, divergences in the way in which the concept of the activity is understood – or disagreement as to the nature of the activity – can lead to differences in the way in which the activity is carried out. Or to put the matter the other way round: Deviance or eccentricity of behaviour can be explained by differences in conceptual grasp. A point to which we shall substantively return.

2. In this series of lectures, you will hear much about various

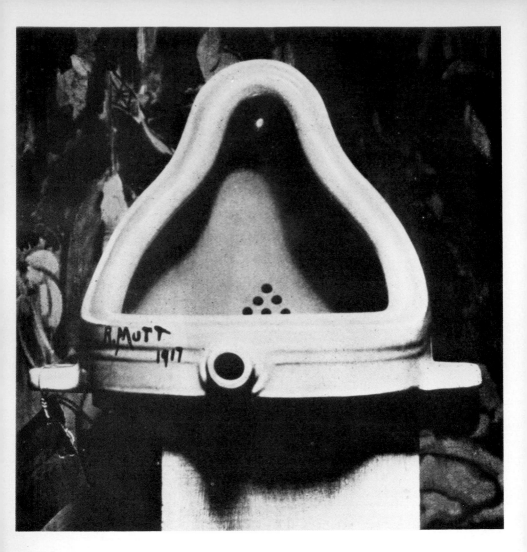

2. Duchamp, *Fontaine*

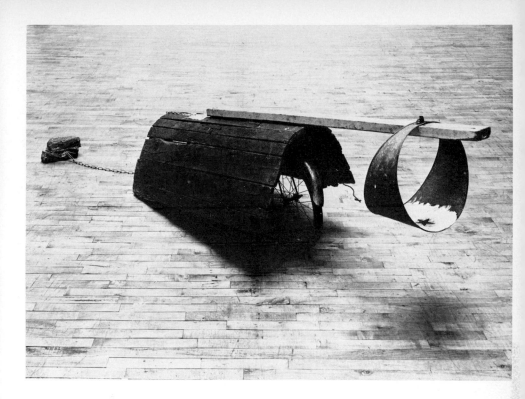

3. Rauschenberg, *Empire I*

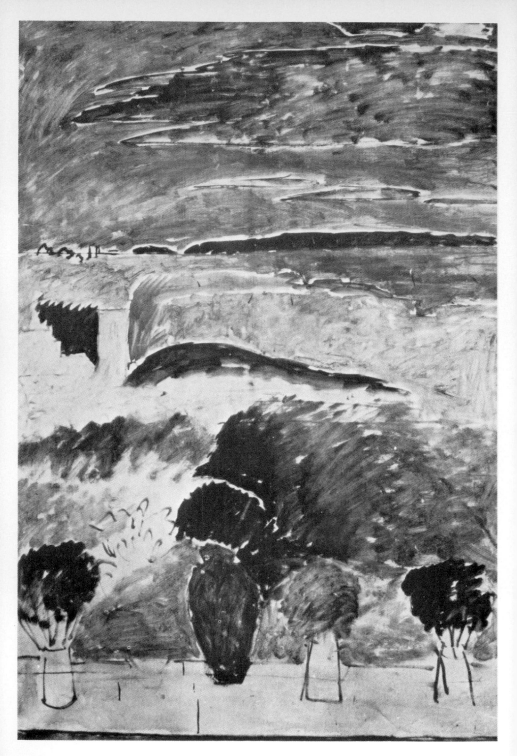

4. Matisse, *La Fenêtre Ouverte*

5. Louis, *Alpha Phi*

6. Rothko, *Red on Maroon*

7. Giorgione, *Sleeping Venus*

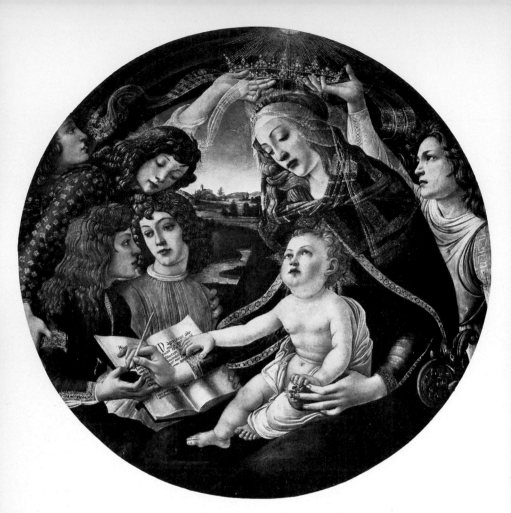

8. Botticelli, *Madonna of the Magnificat*

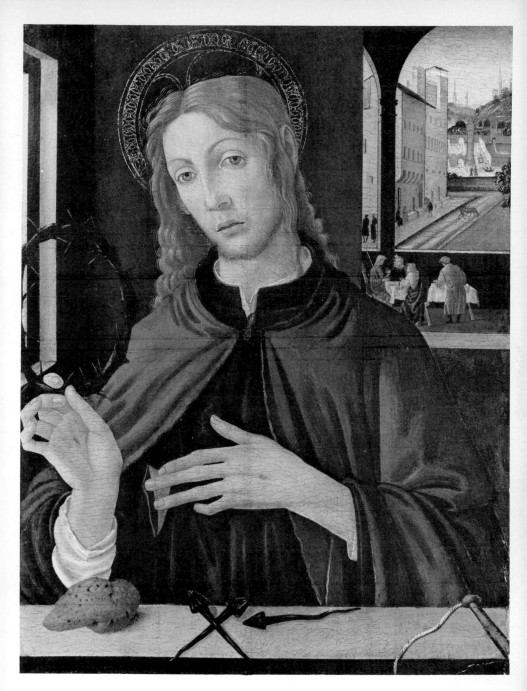

9. Jacopo del Sellaio, *The Redeemer*

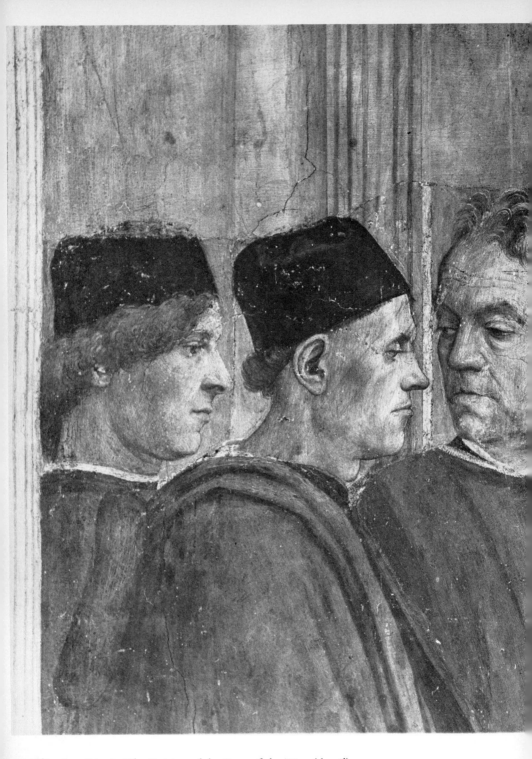

10. Filippino Lippi, *The Raising of the Sons of the King* (detail)

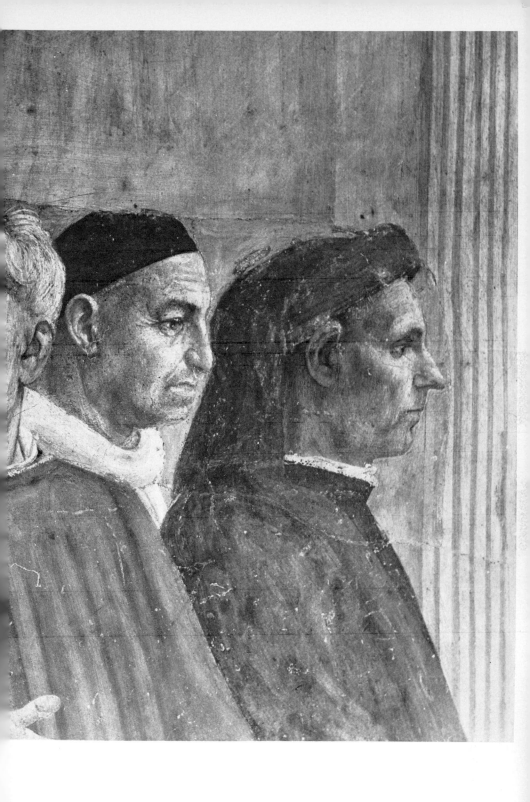

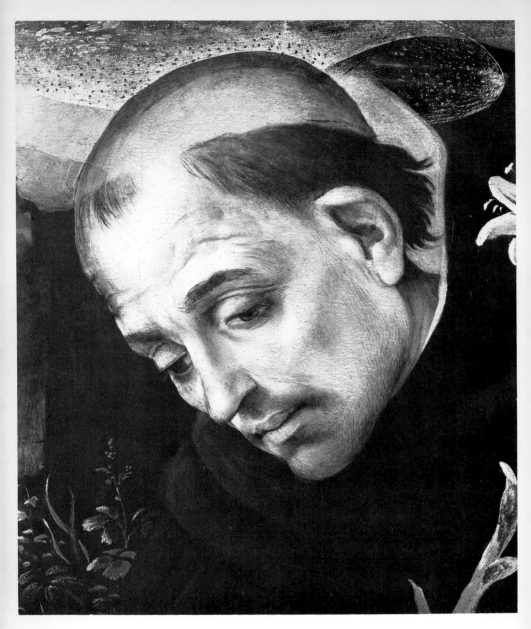

11. Filippino Lippi, *St Dominic*
(detail from *The Virgin and Child with St Jerome and St Dominic*)

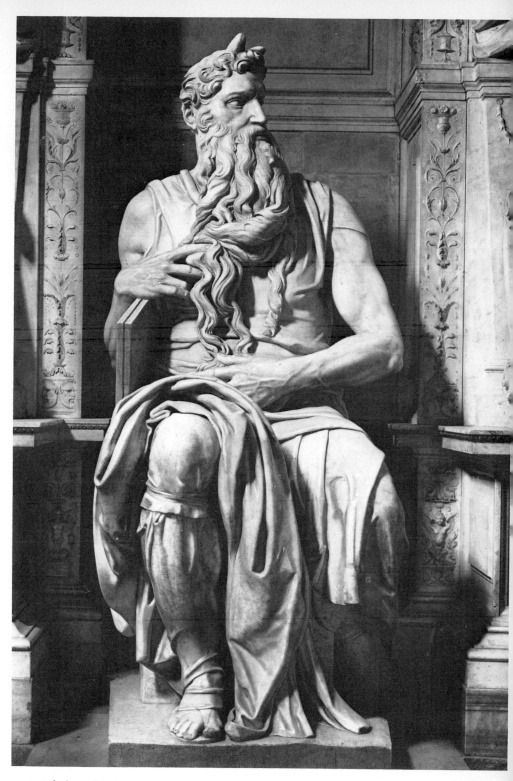

12. Michelangelo, *Moses*

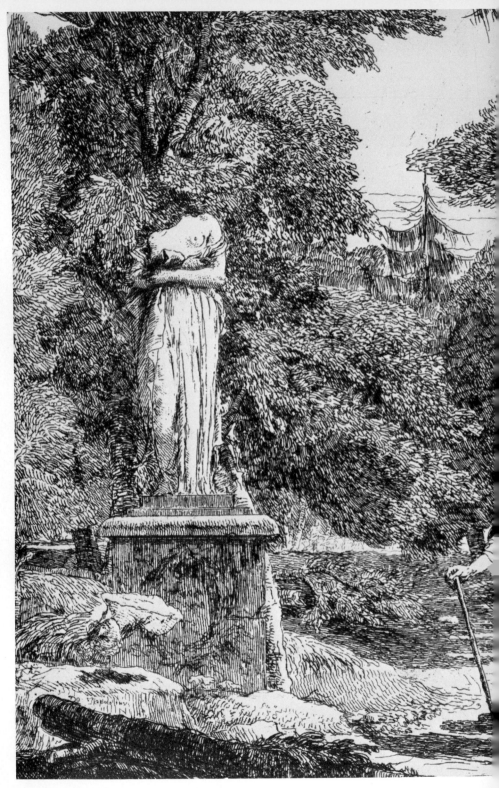

13. G. D. Tiepolo, *The Holy Family Passing Near a Statue*

to a lower, or more specific, concept merely opens up a range of possibilities within which the artist's activity may fall, and in acting under the lower concept the artist takes up one of these possibilities to the exclusion of the others. For instance, if an artist makes a work of art under the higher concept of a painting and also the lower concept of spotting the canvas, it is only the lower concept that substantively enters into his activity. The higher concept regulates his activity in no way which is not overlapped by the lower concept: whereas the converse is not true. Where an artist might be thought of as acting under two descriptions, one of which falls under the other, there is nothing added by thinking of him as acting under the latter.

Now, what both these objections presuppose – namely, that the relations that hold within a given set of concepts are timeless – is true. Nevertheless, these relations can at different periods or under different conditions be thought or be felt to change, largely because the concepts themselves can be differently experienced. And by talking of a concept being differently experienced, by using this provocative phrase, I have in mind something of the following kind: that a part of the concept that had remained implicit becomes explicit, or a part of the concept that had seemed merely one part amongst others becomes dominant. Consider, for instance, the vicissitudes of expressiveness as a constituent of the concept of art. Now, the different ways in which at different times a concept may be experienced is of great significance when we think of concepts in their regulative role, that is, in so far as they enter into activity. Indeed, we might say that the force of the two objections I have been considering against the funding of a theory of art in the concepts under which art is produced derives from thinking of concepts exclusively as they enter into description of art – more specifically, what I have called description 'after the event'. But once the prescriptive role of concepts is recognized, or it is appreciated how concepts regulate our behaviour – because, when we act, we act under concepts – then it is possible to give due recognition to the fact that concepts are thought of or experienced differently at different times.

The two objections can now be met. The first, by pointing out that, as the concepts under which art is produced are differently

experienced, so the relations between them will be differently envisaged, and how they are envisaged will substantively enter into the production of art. And the second, by pointing out that, as the relations between higher and lower concepts are differently envisaged, situations will arise in which it will seem to the artist imperative or essential to work under some particular lower concept *if* he is to work under the higher concept, and in that case the higher concept will be operative as well as the lower concept. So, for instance, the element of figuration may become so dominant within the concept of art that it seems necessary to artists that they work under the concept of figuration if they are to work under the concept of art, and in that case the concept of art as well as that of figuration will be relevant to their work. Both concepts, as well as the relations between them, and the way in which these relations are envisaged, would have to enter into the theory of mainstream European painting up till, say, the beginning of this century.

It is a view beloved of connoisseurs of art – indeed nothing so effectively divides the amateur from the practitioners of the arts as this comfortable belief – that at all periods the full possibilities of art are admitted, even though not all are employed: that, in my terminology, the timeless relations that hold between the various concepts under which art is or may be produced, are always timelessly apprehended. The view, however, seems false to the facts of history: false, for instance, to the way in which so often, quite unenviously but quite decisively, artists have felt compelled to reject the art of the immediate past, even on its own terms, as being a betrayal of art; or again, false to the way in which, often, artists have felt that they were working, not just out of their own nature, but out of the nature of art itself.

3. Much more remains to be said about the connections between art, the concepts under which art is produced, and theories of art. But not by me on this occasion: though I should like to draw your attention to the subtle and penetrating treatment afforded these issues by Stanley Cavell in some of his essays, collected under the title *Must We Mean What We Say?*[1]

Nor will I spend time in trying to justify the more particular

1. Stanley Cavell, *Must We Mean What We Say?* (New York, 1969).

contention: that modern art, or the painting of our age, exhibits, across its breadth, a common theory; where this means, as I have said, a theory such that the majority of modern works of art can be seen either as an expression of it or, over a sizeable range of cases, as a reaction against it. I shall jump over this point. Instead I shall suggest what seems to me most likely to be this theory. My theory will have little novelty. And accordingly, for the rest of this lecture I shall be concerned not to argue for the theory but rather to argue against certain misunderstandings of it, which have been prevalent both amongst critics and amongst artists, and which have adversely affected not only our understanding of modern art but also, interestingly, the progress of that art itself. How this very last point should be so raises, of course, once again most delicate and perplexing issues about the relations between art and theory, which, once again, I can only draw your attention to and then put aside.

My suggestion then is this: that for the mainstream of modern art, we can postulate a theory that emphasizes the material character of art, a theory according to which a work of art is importantly or significantly, and not just peripherally, a physical object. Such a theory, I am suggesting, underlies or regulates much of the art activity of our age, and it is it that accounts for many of the triumphs and perhaps not a few of the disasters of modern art. Within the concept of art under which most of the finest, certainly most of the boldest, works of our age have been made, the connotation of physicality moves to the fore.

The evidence for such a theory at work is manifold, the inspiration of the theory can be seen in a wide variety of phenomena which it thereby unifies: the increasing emphasis upon texture and surface qualities; the abandonment of linear perspective, at any rate as providing an overall grid within which the picture can be organized; the predilection for large areas of undifferentiated or barely fluctuating colour; the indifference to figuration; the exploitation of the edge, of the shaped or moulded support, of the unprimed canvas; and the physical juxtaposition of disparate or borrowed elements, sometimes stuck on, sometimes freestanding, to the central body of the work, as in collage or assemblages. These devices have, beyond a shadow of a doubt, contributed decisively to the repertoire of European art since, say, 1905: and any dispute about the presence of

some such theory as I have produced would, I imagine, confine itself to the issue of how central these devices, and the modifications in art that they have brought about, are thought to be.

4. I want therefore to turn away from any central discussion of the theory to the qualifications that need to be entered if the theory, or the formulation of it, is to be adequate: or, as I put it just now, to misunderstandings of the theory that have, I think, gained a baneful circulation. I shall bring what I have to say under three general considerations. But in doing so, I shall give the theory itself, more for ease of exposition than anything else, a small twist towards greater specificity. I shall consider it exclusively in relation to painting, and I shall understand it as insisting upon the surface of a painting. In the context of a painting, for 'physicality' read 'possession of a surface'.

The first consideration, which may seem trivial, is this: The theory that I have been suggesting emphasizes or insists upon the physicality of the work of art, or the surface of the painting – emphasizes or insists upon them, but (this is the point) the theory did not discover or invent them. I am not, of course, making the self-evident point that even before 1905 paintings had surfaces. I am making the somewhat less evident point that before 1905 the fact that a painting had a surface, or the more general fact that works of art were physical, were not regarded as accidental or contingent facts about art. Or, to put it another way, when traditional painters observed the material surface upon which they worked undergo modifications, they thought that, as this occurred, thereby the work of art came into being.

The force of this point can easily be lost if we forget much of what is written about the older art where this is explicitly contrasted with the art of our day. For to read certain critics, certain philosophers of art, even certain contemporary artists, one might well think that before the beginning of the twentieth century the concept of art was totally without any connotation of materiality. Of course – it is conceded – in making their pictures earlier artists recognized that they were making physical objects. But for them the picture and the physical object were not equated, and the manipulation of the medium was seen more as a preliminary to the process of making

art rather than as that process itself. For the picture was conceived of as something immaterial that burgeoned or billowed out from the canvas, panel or frescoed wall that provided its substrate. These things – canvas, panel, wall – were necessary for its existence, but it went beyond them, and the concept of it bore no reference to them.

Such a view of the past, which is artificially sustained by the very careless and utterly misleading use of the term 'illusionism' to characterize all forms of figurative painting, indeed all forms of representational painting, seems supported neither by empirical nor by theoretical considerations. Furthermore, there is a body of evidence against it. There are various moments in the history of European painting since the high Renaissance, when artists have shown a clear predilection for the values of surface, and they have employed selected means to bring out the physical quality of what they were working on or with. Take, for instance, the emergence of the brush-stroke as an identifiable pictorial element in sixteenth-century Venetian painting; the free sketching in of landscapes in the background of seventeenth- and eighteenth-century painting; or the distinctive use of cropped figures set up against the edge of the support in late nineteenth-century Parisian art. Now, of course, there is this difference: that to the earlier painters these devices were no more than a *possible* employment of painting, and for them the constraints of art lay elsewhere. It was, for instance, optional for Velazquez or for Gainsborough whether they expressed their pre-dilection for the medium. What was necessary within their theory of art was that, if they did, it found expression within the depiction of natural phenomena. For, say, Matisse or Rothko, the priorities are reversed. But none of this suggests that the earlier painters thought that what they were doing was ancillary to painting. Between them and us what has happened is that some connotations of art that were previously recessive have moved to the fore, and vice versa.

5. The second consideration that touches upon the theory of modern art I have proposed seems to strike somewhat deeper. But, interest-ingly, it connects with the first consideration in such a way as to give that too a measure of depth. It is this: The theory emphasizes the physicality of art; it insists upon the fact that a painting has a surface. Indeed, by a ready trick of exaggeration the insisted-upon fact that

a painting *has* a surface – a fact which, as we have seen, earlier generations did not overlook – can convert itself into the thesis that a painting *is*, or is no more than, a surface. Which gives us an extreme version of the theory, though not one unknown. However, a necessary modification is effected – most evidently for the extreme version of the theory, but correspondingly for any version less extreme than that – once it is recognized that, in talking of a surface, the theory is irreducibly or ineliminably referring to *the surface of a painting*. In formulating the theory we can safely drop the phrase 'of a painting' only when the dropped phrase is understood. If the phrase is not merely dropped, but drops out of mind, the theory becomes incoherent. For to talk of a surface, without specifying what kind of surface it is, which means in effect what it is a surface of, picks out no kind of object of attention.

Perhaps one way of bringing out this consideration is to go back to the nature of the theory. For the theory, as we have seen, provides us, if it is adequate, with those concepts under which a certain form of art – the art of our day – has been produced. However, it is clear that no one could set himself to produce a surface, unless he had some answer to the question what it was the surface of: nor could he endeavour to accentuate or work up a surface unless, once again, he thought of himself as accentuating or working up the surface of this or that kind of thing. To put it another way round: The instruction 'Make us aware or conscious of the surface' given in the studio, would take on quite different significances, if said, say, to someone throwing a stoneware pot, to someone painting in oil on primed canvas, to someone carving in marble, or to someone working in fresco. (Think, for instance, whether, in conformity to the instruction, the surface should be made smooth or rough.) Each of the recipients of the instruction would, in effect, fill it out from his knowledge of what he was doing, before he obeyed it. And, if he didn't know what he was doing, if, for instance, he was a complete beginner who hadn't as yet grasped the nature of the activity on which he had launched himself, he could not obey the instruction at all. It wouldn't be, simply, that he wouldn't know how to do what he had been asked to do: he wouldn't know what he had been asked to do. For him the instruction would mean about as much as 'Make it average-sized'.

The examples I have given might be misleading in one respect: for they might suggest that the further specification that is required before it becomes clear how the surface is to be worked refers exclusively to the material. The artist, in other words, needs to know what the surface is of just in the sense of what it is made of. This, however, would be erroneous. Not merely is this no more than a part of what is required, but it is misleading even as to that. The distinction we need here is that between a material and a medium. A medium may embrace a material, though it may not, but, if it does, a medium is a material worked in a characteristic way, and the characteristics of the way can be understood only in the context of the art within which the medium arises.[2] 'Fidelity to material' is not so much an inadequate aesthetic, as some have thought, it is rather an inadequate formulation of an aesthetic: Bernini and Rodin were not faithful to marble, though they may have been faithful to marble as a material of sculpture. Given this distinction, the barest specification of the surface must be by reference to the medium which makes up or is laid on the surface.

However, it is one thing to recognize that our theory in insisting upon a painting's surface is insisting upon it as the surface of a painting, and another thing to see what is involved when we expand the ellipsis. Perhaps the best way to try to get a view of this is to shift our standpoint somewhat and to consider the matter in the perspective of the spectator. A spectator looks at a painting – more specifically, a modern painting. He looks at its surface. And he looks at its surface as the surface of a painting. What is involved in his looking at the painting's surface as the surface of a painting?

The first point that can be made is this: If a man looks at a surface as the surface of a painting, he must also look at that whose surface it is as a painting. Just as if a man looks upon an action as the action of a friend, he must look upon him whose action it is as a friend. (Of course, he might look upon him as a friend solely in virtue of his action, and the same thing goes in the case of the painting.)

Now, if we don't find this point sizeable, this can be only because of a dangerous attrition, in our contemporary thinking, of what it is to look at something as a painting – or, more generally, as a work of art. The attrition occurs in two stages: first, from thinking of

2. Stanley Cavell, op. cit., pp. 220–21.

something as a work of art to thinking that it is a work of art; then, from thinking that something is a work of art to (something like) saying to oneself that it is a work of art. And the consequences of this attrition, or trivialization, we can see, for instance, in some of the banal pronouncements characteristic of Conceptual Art.[3] It may well be that some version of the theory that to be a work of art is to be recognized as such is true. But no version of the theory could possibly be acceptable – though paradoxically, it is in some such version that the theory gains acceptance – on which recognition is equated with a mere nod of recognition.

The truth is that we acquire and possess a concept of art, again a concept of painting, and when the spectator looks at a work of art or at a painting, this must mean amongst other things that he brings it under one of these concepts. Now, whether he does so or not depends on whether he can do so or not, and though his ability depends on a variety of factors, one thing that cannot be effective here is mere decision. The spectator can say at will of something that is a painting, but what he cannot do at will is to say this and mean it. And this is why it is no nugatory point to insist that, when the spectator looks at a surface as the surface of a painting, he must look at that whose surface it is as a painting.

Of course, there are interested spectators or curious spectators, and there are dull spectators. If the spectator is curious – and there are good reasons why we should confine our interest to him – then one influence that will affect whether he does or doesn't, can or can't, bring the object before him under the concept of painting is his knowledge whether the object itself was produced under that concept. Of course, even if he knows that it was, this won't settle the issue whether he can bring it under the concept – any more than, if he can, this settles the issue whether it falls under the concept, i.e. whether it is a painting. For, as we have noted, an action can be performed under a certain description and not satisfy that description: for the action may miscarry.

However, once the spectator has recognized that the surface he is looking at is that of a painting, or he is able to look at the thing whose surface it is as a painting, then, for him to look at the surface as the surface of a painting, he must also have some ideas how the

3. e.g. *Studio International*, vol. 180, no. 924 (July–August 1970), *passim*.

surface of a painting should look. And this is where the second consideration links itself with the first: for, if what I have just been saying is true, then it seems quite incontrovertible that the concept of a painting was never without the connotation of physicality. It was always true not just that a painting had, but that it had to have, a surface. For how else could we have any idea how the surface of a painting should look – or, to spell out the matter, how a surface should look given that it is the surface of a painting?

Of course, in what I have just been saying there is no implication that, for instance, simply on the basis of the visual description of a surface ('what it looks like'), I could rule out that thing whose surface it is as a painting. It is not in this simplistic way that we have a notion of how the surface of a painting should look. If I am to rule out a surface as impermissible for a painting, then I must also know what the painter's intention was or what he was trying to achieve. For a painting does not take on the surface that it has simply through being *a* painting; nor to put the matter the other way round, does the painter simply set out to paint *some painting or other*. The surface is as it is because the painter sets out to paint a specific painting: and our judgement that what is before us isn't a painting because its surface doesn't look as the surface ought to look, must generally be against this background. Though, of course, there may, as an extreme case, be surfaces which could not be the surfaces of paintings because (we are sure) there could be no intention which would justify a painting having one of them as its surface. I am inclined to feel this about the black canvases of Ad Reinhardt: assuming these, that is, to belong to art, and not to art-history.

6. The third consideration that I want to raise in connection with the theory of modern art is this: The theory insists upon the physicality of the work of art – upon for instance, the surface of the painting. And this I have equally put by saying that the theory insists upon the fact that the painting has a surface. But from this it does not follow that a painting produced in conformity with this theory will insist upon the fact that it has a surface. Yet this is sometimes thought to follow both by critics and by artists: and consequential distortions are produced both in criticism – so that for instance, it is thought good enough to say of a painting that it insists upon the fact of its

surface – and in art itself – so that we are confronted by objects which seek to acquire value from this insistence.

The confusion may be put briefly by saying that in a modern work there is an asserted surface, but this does not mean that the assertion of the surface forms part of the picture's content.

Perhaps the best way of bringing out this consideration is to show how the theory, as it stands, can lead to interesting art, whereas the theory, as misunderstood, is unlikely to lead to anything but boring art. For the theory, in asserting that a painting has a surface, draws the painter's attention to the surface, and encourages him to make use of the surface in a way or to a degree not contemplated by his predecessors. But if the theory were that the painting should assert that it has a surface, then not merely would no premium be placed on the use of the surface but the effect of the theory might well be to work against the use of the surface. For it might be felt that any such use would only interfere with the clarity or the definitiveness of the painting's assertion. The fact of the surface might become eclipsed, wholly or partially, by the use of the surface. And in an aesthetic situation where the fact of the surface is reckoned the important thing, the use of the surface begins to look diversionary at best and probably hazardous.

To talk of the use of the surface and to contrast this with the fact of the surface, and to identify the former rather than the latter as the characteristic preoccupation of modern art, attributes to modern art a complexity of concern that it cannot renounce. For it is only if we assume such a complexity that there is any sense in which we can think of the surface as being used. Used, we must ask, for what? And the answer to this has to lie in that complexity of concern. – The point, I must emphasize, would not be worth making were it not for the widespread confusion which equates the autonomy of modern art with its single-mindedness, even with its simple-mindedness. To talk of the autonomy of art is to say something about where its concerns derive from, it is to say nothing about their number or their variety.

7. To talk of the surface being used, rather than of its existence being asserted, as a characteristic of modern painting, is not a point to make in the abstract. The point cannot be grasped without some kind of

incursion into the substantive issue. What therefore I should like to do for the rest of this lecture is to consider three paintings, and try to make the point in relation to them. It is no accident that these paintings are amongst the masterpieces of twentieth-century art.

The first painting is *La Fenêtre Ouverte* (Plate 4) painted by Matisse in Tangiers in 1913. Some of the things that I shall say about it will apply to the other great open-window paintings of Matisse, for instance the sombre *La Porte-fenêtre* of 1914 or the painting entitled *La Fenêtre*, or *Le Rideau Jaune*. In this painting we discern, amongst other things, Matisse's recurrent concern with the nature of the ground. Now, if we consider what is not so much the earliest painting we have, though it is often called that, as the precursor of painting – I refer to the cave art of the early Stone Age – there is no ground, there is simply the image.[4] With the introduction of the ground, the problem arises, How are we to conceive of the ground in a way that does not simply equate it with the gap between the figures or the absence of depiction? In the history of European painting we can see various answers to this question. One answer is for the painter to equate the ground with the background or, if this term is taken broadly enough, with the landscape, and then to organize the detail that this equation is likely to impose upon him in a hierarchical fashion, detail subsumed within detail, in a Chinese box-like fashion. This answer we can see as given in some of the finest achievements of European art – for instance, in such different kinds of work as the masterpieces of Van Eyck and Poussin. Another answer is to regard the ground as providing, still through representation, not so much content additional to the central figures, but a space in which the central figures are framed. Now for a variety of reasons neither of these two classic answers is open to Matisse. For Matisse – and here he exhibits two of the main thrusts of twentieth-century art – dispenses both with the notion of detail in the traditional sense and also with the commitment to a unitary and ordered spatial framework. And so the question returns, How is the ground to be conceived of except in purely negative terms? How – which is an extension of this question – is the frontier of the ground, or the line which encloses it, not to seem quite arbitrary? And it is at this

4. On this, see Meyer Schapiro, 'On Some Problems in the Semiotics of Visual Art: Field and Vehicle in Image-Signs', *Semiotica*, vol. I, no. 3 (1969), pp. 223–42.

point, to find an answer to this question, that Matisse resorts to the surface. It is here that he *uses* the surface. For what he does is to associate the ground so closely with the surface – by which I mean that he charges the surface in such a way that it barely involves a shift of attention for us to move from seeing a certain expanse as ground to seeing it as surface – that we fully accept the size of the surface as determining the extent of the ground. To understand Matisse's use of the surface, we might say that through it he reconciles us to the ground without our hankering after any of the classic ways of treating the ground that Matisse has forsworn.

There is perhaps another line of thought in *La Fenêtre Ouverte* which is worth pursuing. What we see through the open window is a view. Now, at any rate for a painter there is, perhaps, a certain absurdity in thinking of a view as a view on to – well, a view on to nothing, which is rather what treating what is depicted through the frame of the window as mere ground implies. The view is – of course in a rather special, one might say in a rather professional, sense – an object. And now we can see a secondary use that Matisse makes of the surface. For by emphasizing the surface where it coincides with the ground, he leads us towards this painter's way of looking at or considering the view. Of course, Matisse isn't a clumsy painter, and he avoids that use of the surface which would make it look as though the open window were filled with a solid object. It is made clear, at one and the same time, that the view isn't an object but that it is as though it were.

The second painting I want to consider is one of Morris Louis's later canvases (Plate 5). Louis's work at this stage was largely dominated by one preoccupation – apart, that is, from his interest in the physical look of the picture or how the surface looks. And this preoccupation can be described from two different points of view. From one point of view, it is a concern with colour: from another point of view it is a concern with patches – where patches are contrasted both with volumes, which are three-dimensional, and with shapes, which, though two-dimensional, are seen as suspended in, or visibly inhabit, three-dimensional space. Louis, in other words, wanted to introduce colour into the content of his paintings, but to as great a degree as is humanly possible – or, better, visibly possible – he wanted consideration of the spatial relations between the

coloured elements, or the bearers of colour, to recede. Now, I do not think that it is quite correct to say – as Michael Fried does in his otherwise perceptive account of these paintings[5] – that Louis's patches are non-representational: that is to say, I do not think that Louis wants us exclusively to see stained parts of the canvas. He seeks a form of representation where the representation of space or of anything spatial is at a minimum. And to achieve this effect, he uses the surface in such a way that so long as we look centrally at one of the patches we see it representationally. But, as our eyes move towards the edge of the patch, the representational element diminishes, and we become dominantly, then exclusively, aware of the canvas. In other words, representation gets negated at the very point where questions of spatiality – how does this patch stand to the next? – would begin to arise. The overall effect is that, in looking at Louis's patches, we seem aware of them as though they were embedded in, or pressed down upon, the surface – an effect, which, incidentally, we find, in a highly figurative context, in some of Goya's paintings. The surface, then, is used to control or to limit the operation of representation, so that colour can be encountered in what we might call a 'pure' mode: as predicated of extended but non-spatial elements.

The third painting that I want to consider is one of Rothko's canvases from the Four Seasons series, now hanging in the Tate (Plate 6): to my mind, one of the sublimest creations of our time. In comparison with Louis, even with Matisse, Rothko uses the surface in a highly complex way. And I shall only give one hint of how we might think of this. The greatness of Rothko's painting lies ultimately, I am quite sure, in its expressive quality, and if we wanted to characterize this quality – it would be a crude characterization – we would talk of a form of suffering and of sorrow, and somehow barely or fragilely contained. We would talk perhaps of some sentiment akin to that expressed in Shakespeare's *Tempest* – I don't mean, expressed in any one character, but in the play itself. However, the immediacy of Rothko's canvas derives from the way in which this expressive quality is provided with a formal counterpart: and that lies in the uncertainty that the painting is calculated to produce, whether we are to see the painting as containing an image within it

5. Michael Fried, *Three American Painters* (Boston, 1965), pp. 19–20.

or whether we are to see the painting as itself an image. Whether we are to see it as containing a ring of flame or shadow – I owe this description of the fugitive image to the brilliant description of the Four Seasons paintings by Michel Butor in his essay 'Rothko: The Mosques of New York'[6] – or whether we are to look upon it as somewhat the equivalent of a stained glass window.[7]

Now, it is to bring about this uncertainty, as well as to preserve it from, or to prevent it from degenerating into, a mere oscillation of perception, which could, if I am right, be highly inimical to Rothko's expressive purpose, that he uses the surface as he does. For the use of the surface, or the way it manifests itself to us, simultaneously suggests forms within the painting and imposes unity across the painting. It suggests light falling upon objects and light shining through a translucent plane. Wherever a definitive reading begins to form itself, the assertion of surface calls this in doubt.

8. It is only now, when we have taken note of other, or more working, aspects of the theory of modern art as I have suggested it, that it seems to me appropriate to observe an aspect that might have seemed to some worthy of earlier attention: I mean the way it is likely to give rise to objects that manifest the only kind of beauty we find acceptable today.

6. Michel Butor, *Inventory*, trans. Richard Howard (London, 1970).
7. I have benefited greatly from conversations with Peter Larisey, S.J.

7 The Art Lesson

The title of this lecture stands in need of explanation: no less because it means just what it says. My topic this evening is the art lesson: a period of time, or a portion of a course of instruction, in which art is taught. That is what I want to talk about.

But I am aware that I may have clarified my subject only at the risk of making my motivation seem obscure. For to some of you, most of you, it might seem quite implausible that I should have chosen to come and talk on this subject to such a place at such a time: that is, to a school of drawing and painting, and at a moment in history when the formal teaching of art has been quite widely abandoned and everywhere feels itself in difficulty. I would say, myself, that these facts in no way make my choice of subject implausible, though they might well make it rash. In my rashness I have been sustained by two general considerations, both of which weigh heavy with me. Let me present them to you.

2. The first consideration comes from philosophy. It is this: In his later philosophy Ludwig Wittgenstein came increasingly to discuss a phenomenon which, I think it would be true to say, had never been regarded, at any rate explicitly, by previous philosophers as particularly or specifically a philosophical topic: and that phenomenon is the way in which we learn or are taught language. Of course, the phenomenon had been talked of by other philosophers: in the writings of (say) Plato, St Augustine, Locke, Russell (to name just a few), there are references to the way in which language is transmitted, and many of the things that these philosophers find to say are of great interest: but it was left to Wittgenstein to see, with a distinctness that was not open to his predecessors, the true significance of the phenomenon and, in consequence, the central place that it could reasonably assume, or perhaps must assume, within philosophy. How this came about concerns us.

It was nothing new for Wittgenstein to be interested in language. On the contrary, the nature of language, where language is conceived of as, roughly, the essential medium of thought, had long been Wittgenstein's central philosophical concern, and the shift or the expansion in interest occurred when he came to realize that a proper understanding of the way in which we learn or are taught language, a full reflection upon what is involved, will give us an insight into the nature of language of a kind not attainable by any other means. Such reflection will at one and the same time lead us to reject certain false views of language, some of which hold a vast fascination for us, and ease our passage to a true view of language: though, as a characteristic complication, Wittgenstein would seem always to have remained of the opinion that, whereas the various false views of language can be stated or lend themselves to assertion, the true view is something that has to be seen – it remains a *view*.

For Wittgenstein the fundamental problem posed by the nature of language – and perhaps this is so generally for philosophers, thereby distinguishing them from others, and there are many others, who also have a theoretical interest in language – is how to account for the particular amalgam in which language consists: how to account for it, how to interpret it, or perhaps just how to describe it. For to the hurried eye, language offers the prospect of two distinct elements which somehow or other have got stuck together. The fact that they have got stuck together is to their mutual benefit – as well as, of course, to the inestimable advantage of mankind: nevertheless, the principle of union, the glue, remains a mystery. And, as we shall see in a moment, differing views about how the two elements are united will also have the effect of throwing the nature of each somewhat in doubt. And differing views about the nature of each will, of course, mean differing views about the nature of the whole that they constitute – that is, differing views about language.

The two elements in which language consists can initially be identified in this way: (1) the word or words, (2) meaning. And now here are two typical views of how the two elements are stuck together:

Language consists essentially in words. Words are things that we utter or write down or say to ourselves. There are, however, rules which relate these words to things or bits of things in the world. It

is these rules that secure meaning for our words, and they secure it in that the meaning of a word is whatever is related to it by such a rule. Accordingly, once the rules have been established, then, in uttering or writing down or saying to ourselves a word, we thereby speak about something. The core of this first view might be put by saying, When we use words, we find ourselves meaning something or other, or, We mean what our words mean.

Quite opposed to this view is a second view, which totally rejects the idea that the essence of language lies in the word-element. Mere words do not, do not even begin to, make up language. Words, whether uttered out loud, or written down, or said to oneself, are in themselves inert, and to be otherwise they must have life breathed into them from some accompanying volition or thought. It is this volition or thought on the part of the language-user, on our part, that allows words to refer to something in the world. Meaning is in the first instance an experience – a reaching out of the mind towards something presented to it – and the essence of language lies in this experience. The core of this view might be put by saying, When we use words, we express what we mean, or, Our words mean what we mean.

We might bring out the difference between the two views by seeing what they would make of a very simple linguistic occasion. For instance, here and now, dressed as I am, I say, 'My jacket is brown'. On the first view, to get at the essence of the occasion, it is necessary for us, first, to observe the words that have been used, and, secondly, to invoke the rules that tie these various words to the different aspects of reality. Having done this, we would have an understanding of what I have said, in the sense both of the words used and of what they meant. On the second view, the essence of the occasion is got at by considering, first, what I meant, and then whether the words that I in fact used conveyed my meaning. Both things having been done, we would, once again, have a total under-standing of what I had said.

If this seems to you a little elusive or if, more specifically, each of these two accounts seems to merge somewhat into the other, this might have to do with something of which Wittgenstein was quite convinced – convinced beyond all reasonable doubt. And that is that not only are these two typical views of language, but they are also

false views of language. It was to bring out their falsity, and, for that matter, that of other views of language which share in this falsity that Wittgenstein suggested that we should reflect upon how language is learnt. Reflection upon the language lesson will liberate us from these views which otherwise, as Wittgenstein puts it, 'bewitch' us. Actually, the truth, as it emerges from Wittgenstein's argument is slightly more complex and considerably more interesting. Superficially, or still to the hurried eye, both these false views of language in their own ways derive support from reflection upon the language lesson: though, if the reflection is more considered or goes deeper, it reveals their utter inadequacy, even their internal incoherence.

Wittgenstein's starting-point is to consider the language lesson in its simplest or in its most basic form: or in what to some philosophers has always seemed its one true form, of which all other seemingly different forms are really disguised instances. I refer to teaching by ostension; when, that is, we at one and the same time utter a word and point to some appropriate thing in or part of the world. We say, for instance 'paper', and point to the page from which I am reading: or we say 'brown', and point to what I am wearing. Through such rituals the words 'paper' and 'brown' are said to be ostensively defined. Now, on the face of it, the fact that words can be taught and learnt ostensively might well seem to confirm one or other of the two views of language that I have laid out – for all I know you might actually feel this too, and only be divided amongst yourselves about which of the two views it does confirm. I shall in a few minutes return to and rehearse the arguments that Wittgenstein used to show that teaching by ostension, properly understood or fully reflected upon, reveals the bankruptcy not just of one but of both of these views. But I hope that I have already said enough to give you an idea of one consideration that has weighed with me in thinking that the art lesson is still an intellectually vital topic. For might it not be reasonable to assume – or at any rate is not the assumption worth testing – that, if there is an important and powerful connection between the language lesson and the nature of language, so that a proper understanding of the one gives valuable insight into the other, there might very well be some sort of analogous connection, perhaps not so strong but of some strength, between the art lesson and the

nature of art? And if that were so, then I would be right to believe that my topic this evening deserved another look.

3. I said that there were two considerations that have sustained me in this belief. The second does not come from philosophy. It is local. It is this: You have done me the great honour of asking me to give the first Maurice de Sausmarez Memorial Lecture. I am vividly aware of the honour, and I would like to take this moment to express to you my gratitude for the invitation as well as my sorrow over the tragic event that made it possible.

I met Maurice de Sausmarez only twice. The impact that he made upon me was powerful. I felt greatly drawn to him as a person, but, above all, I was aware of being with someone of extreme intensity, for whom every issue, every topic, small, large, either did not exist or else had become, or became even as he considered it, part of his inner life. I know of no other way to describe the effect. I have nothing more to say of a personal kind. Evidently my own experience of Maurice de Sausmarez was too limited, and I am amongst too many people who knew him well, for it to be appropriate that I should draw upon it further. But you must judge how significant it would be for me if I could feel that someone so altogether concentrated, inwardly and outwardly, could be thought of as lending his support to my choice of topic, or to the presumptive connection upon which that choice depends.

Maurice de Sausmarez was a great teacher. That is a fact of history, which we this evening can only affirm. And anyone who worked with him, either as colleague or as student, will tell you why this was so. He was a great teacher because he put so much not merely of his time and of his energy but of himself into his teaching. And I just find it hard to believe that he would have done this, and on the scale on which he did, if he had not somewhere sensed that in teaching art he was all the while learning about the nature of that which he taught. And for this supposition there is direct testimony in his pedagogical writing. *Basic Design: The Dynamics of Visual Form*,[1] published in 1964, is a significant contribution to the literature of art education: it continues a tradition to which Kandinsky,

1. Maurice de Sausmarez, *Basic Design: The Dynamics of Visual Form* (London, 1964).

Malevich, Klee and Josef Albers have been proud to belong: but it is something else as well. In addressing itself to the question, What should be the content of any course of instruction in the visual arts today?, *Basic Design* is in effect an inquiry into the nature of modern art. I insist that the coincidence of these two aims, that one fulfils itself through the other, is not an accidental feature of the book, nor one read into it by an interested reader.

4. But it must not be thought that, in talking of the connection between the art lesson and the nature of art, I have in mind such things as this: that, in teaching something (whatever it may be), we first have to get ourselves straight about what it is we are teaching, that teaching clears the mind like nothing else. Such familiar observations may be true, they may not, but they have nothing directly to do with the connection that I wish to consider and which, if established, could justify me in my choice of topic. For that connection occurs, if at all, on a higher level: that is, it holds between, on the one hand, understanding what is involved in teaching something – not just, teaching it properly – and, on the other hand, knowledge of the nature of that which we teach – not just, knowing what we teach. And we might be able to teach something very well without understanding what is involved in teaching it, and equally we might be quite clear about what we are teaching without having any real knowledge of its nature. Perhaps this explains what I mean by the difference in level between the connection I am interested in and the connection that might be confused with it. But I suspect that the best way of bringing out the connection that is my concern is to return, as, a few minutes ago, I said that I would, to the arguments that Wittgenstein employed to establish this connection in the case of language.

5. Wittgenstein's starting-point is the fact that teaching by ostension does undoubtedly account at any rate for some part of our knowledge of language – including (and this is most important) knowledge of our own, of our native, language. Sometimes, it is true, Wittgenstein appears to be denying this and to be saying that teaching by ostension is never effective as a device, that is, for teaching us our own language. But on such occasions he would seem to be referring

– and the context makes this clear – not to teaching by ostension as such but to teaching by ostension as its nature is misunderstood by this or that thinker. Again, Wittgenstein clearly thought that teaching by ostension could not account for as much of our knowledge of language as some theorists would have us believe. But once again this need not delay us. The quantitative issue is not relevant at this stage, once it is conceded that sometimes ostensive definition can provide the method for the language lesson. The questions that arise are, How does it do so?, and, What does this show us about language?

Well, what happens seems clear enough. There is, for instance, a sheet of paper, a teacher, and a pupil. The teacher says the word 'paper', once or more than once, in front of the paper, in the hearing of the pupil: the pupil hears the word, sees the paper, and after a while – a short while, a long while, depending on him – learns the meaning of the word 'paper'. And something similar happens with the word 'brown': only this time we suppose a teacher, a pupil, and this brown jacket of mine to be the *dramatis personae*. The teacher says the word 'brown' in front of the brown jacket, in the hearing of the pupil: the pupil hears the word, sees the brown jacket, and comes to learn the meaning of the word 'brown'. So far, so good. But what *really* happens when this happens?

An obvious answer would be this: An association is set up in the pupil between the word 'paper' and the thing paper, or between the word 'brown' and the colour brown: and this association suffices for the pupil to learn the meaning of the word because this association reproduces internally the connection that holds in the outer world between the word and the thing, or the word and the colour, which is that in which the meaning of the word consists. Now you will observe that this account of what really goes on in the language lesson encapsulates the first of the two views of language I considered. But, Wittgenstein goes on, the account is wrong. If what it says of the language lesson were true of it, then the language lesson would be an inadequate vehicle for the teaching or the learning of language. For it is possible to set up in the mind of a pupil an association between the word 'paper' and the thing paper, or between the word 'brown' and the colour of my jacket – so that, for instance, he will be prepared to say 'paper' whenever he saw paper, or 'brown'

whenever he saw the colour of my jacket – and yet the pupil remain ignorant of the meaning of either word. For he might think that the word 'paper' meant 'something written on', or that the word 'brown' meant 'suede' – and if that which the word means and that which the pupil mistakenly thinks it means are constantly conjoined, or one is never found without the other, then no matter how often the language lesson was repeated or what variation was effected in its circumstances, the pupil would be no closer to getting it right. So far from being corrected in his ways, he would be reinforced in their errors.

We might now think that this first account of the language lesson could be rectified if we were only allowed to insert into the original description of what actually happened in the course of the lesson a small item which seems to have a natural place there. Could we not add the fact that the teacher points to that which the word means? He points at the paper, he points at the brownness of my jacket. And if he does this, he will thereby establish the correct connection in the pupil's mind, and not just one which happens in point of fact to coincide with it.

But a moment's reflection might lead us to ask how could this be so; how could pointing make the required difference or be a means of eliminating misunderstanding from the language lesson? For the teacher in pointing at the paper is also pointing at something written on it, in pointing at something brown is also pointing at something suede. If we project the line of his finger, are we not led equally to that which the word does, and to that which it is only mistakenly thought to, mean?

But the objection put in this way reveals its inadequacy, and it also places one in a better position to understand that to which it is an objection. It allows us to appreciate the motive behind the introduction of pointing into the language lesson. For the objection holds only if we equate pointing with a mere disposition of arm and finger, with a movement of the limbs. In that case, it is true, its introduction serves no purpose. Pointing can be thought to contribute significantly to the language lesson, only if we no longer concentrate upon the externals of the gesture, but also take in its inner core or the intention behind it. For if we do include the inside of the pointing gesture, then we can distinguish between, say, pointing to something brown

and pointing to something suede. In both cases the teacher's arm and finger adopt, or may adopt, the same pose, but the difference between them lies in the fact that, in the one, the teacher intends the colour of my jacket and, in the other, he intends the material of which it is made. His mind, as it were, points through the pointing finger and clarifies the ambiguity that surrounds its direction. Now we can see how pointing makes a difference and restores efficacy to the language lesson. – But at a price.

For what at first sight seemed a minor addition to the language lesson, a trifling emendation in the description of what happened in the course of it, has turned out to be something very much more. For once this addition is properly understood, once we see how the introduction of pointing can restore efficacy to the language lesson, a completely new account of what really happens in the language lesson is on the brink of being given. For it no longer seems correct to say that the aim of the language lesson is to set up an association in the pupil which allows him to pair off word and thing. If we bear in mind the role that pointing plays in the revised description of the lesson, if we also bear in mind what is meant by 'pointing' as it figures in this description, then it looks as though we are now com- mitted to saying something like the following: The aim of the language lesson is to establish in the pupil a certain experience or state of mind; namely, that experience which the teacher has when he utters the word 'paper' or the word 'brown' and which provides what I have called the inner core to his gesture as he points to the sheet on which something is written, alternatively to the colour of my jacket. If only the experience that complements the gesture and that secures that the index finger is on target can be transmitted intact to the pupil, then we may be certain that the pupil really has learnt the words uttered for his benefit. Thus, and only thus, will the dangers of misunderstanding be averted.

But if this is so, if this is not only how the language lesson could work but how it must work, then there seems encapsulated in this account too a view about the nature of language, and this view turns out to be, of course, the second view of language that I considered: that which located the essence of language in certain subjective states of meaning which the words employed are then calculated to express. But further reflection on the language lesson will show that

this account of it too is wrong, and accordingly the view of language that it encapsulates must be rejected.

If we now ask what is wrong with this new account of the learning situation – as centrally the transmission of a certain kind of experience – or how Wittgenstein faults it, the answer is twofold. In the first place, Wittgenstein denies that the learning lesson could ever be consummated simply by the pupil's having a certain experience, where having an experience is something mental, occurring over a short or shortish period of time. There might be an experience, a specific or recognizable kind of experience that is, which always accompanied the language lesson, the experience varying with the word involved, but it could not be that the language lesson just consisted in arousing this experience. And this is because, when the teacher teaches a word, the pupil learns that word – these are simply two aspects of the same process. And, if the pupil learns a word, this involves that he can go on to use that word, that he has a certain capacity, which will be confirmed in his life. But there could be no experience which entailed that the person who had that experience possessed a certain capacity. There could be no experience that in this way closed up the future. Secondly, Wittgenstein argued that if we look more closely at the experience that is said to be transmitted in the language lesson, not only is it – as we have just seen – insufficient to account for the skills and capacities that the possession of language involves, but it presupposes those skills. If, for instance, we want to distinguish between the man who, when my jacket is pointed to, sees that its colour is meant, and the man who sees that its material is meant, how could we do so without attributing to them the possession of at any rate something very like language? For how, without language, would either of them be able to make that discrimination on which our distinction between them depends? Of course, this is not to deny that there are discriminations that can be made prior to language, or prior to anything like language. Animal psychology shows this beyond doubt. But it must also be beyond doubt that not all the discriminations that are made in language could be made in anticipation of it, that language does not simply christen our natural classification of the world. Accordingly, if the language lesson did always require that the pupil had a certain experience, that of meaning what a certain word meant, before he could learn that

word, this would have the implication that learning a language presupposed knowing it.

6. I have led you, somewhat reluctantly – that is with some reluctance on my part – through the detail of Wittgenstein's argument: for I felt that I had to do this in order to make two of his findings, both vital for the theme of my lecture, seem compelling to you. It was only with some argument behind us, that I could rely, as I need to, on their plausibility.

The first, on which I really feel that I need to say no more, is the connection that Wittgenstein believed to hold between the language lesson and the nature of language. I characterized this connection a while back by saying that for Wittgenstein a proper understanding of what is involved in the language lesson gives us a unique insight into the nature of language. I only hope that I have said enough to convince you that this is how Wittgenstein saw the connection – and perhaps enough to make you sympathize with my view, that his seeing it in this way constituted a profound and important discovery.

The second finding, on which I shall spend a little more time, though not so much as I surely would have had to if I had not already spent so much on what Wittgenstein thought wrong with those views of the language lesson and of the nature of language which he rejected, is what he thought to be the correct view of these matters. But before embarking on this, just a word more, I fear, on the wrong views.

Wittgenstein, as we have seen, had detailed criticisms to make of two views of language, both of which hold a natural and, as we might say, a pre-philosophical appeal. We have been considering these criticisms. However, I think it would be right to say that for Wittgenstein more important than the criticisms specific to each view – though not readily comprehensible except in the light of these criticisms – is a general criticism, which was common to both views. The two views differ in many ways. But they concur in what is, in the last analysis, the weakest part of each. Let me find a way of putting this fundamental error.

Both views treat language as though it could be broken down or analysed into innumerable ordered pairs of elements, each pair consisting of a word and its meaning – rather like, for instance, the

way in which the married population of a country, or at any rate of a monogamous country, could be analysed without remainder into many many couples, each couple consisting of a husband and his wife. That is the sort of picture of language that each view presents. So it looks, according to them, as though learning language is always a matter of working one's way through these ordered pairs – language lesson after language lesson, as it were. Now, though it might seem plausible – I shan't say whether it ultimately is correct, because the issue isn't all that straightforward – to think that language on the word side, as it were, can be analysed into lots of distinct and separately identifiable words, no plausibility whatsoever attaches to the thought that the corresponding thing is true of language on the meaning side: that we can regard meaning as totally divisible, with each word carrying its own load of meaning on its back. Wittgenstein brings out the error of any such view by asking us to consider the following case. Someone learns the word 'slab' and uses it to give an order to a fellow-workman. Now, when he says 'Slab,' does he mean, or does the word he uses mean, exactly the same as what would be meant by someone who has learnt and uses the more elaborate form of words 'Bring me a slab'? Or are we to say that the meaning of what the first man says is contained in – being, say a quarter of – the meaning of what the second man says? Neither answer seems intelligible, and yet we should surely have to settle for one or the other if we thought that meaning was divisible or atomistic in the way that the two views that Wittgenstein rejects assume.

And now we are in a position to turn to what is Wittgenstein's positive account of the language lesson and hence of the nature of language: provided, that is, we remember – a point I mentioned earlier on – that for Wittgenstein the idea that such an account could be baldly stated, in so many words, remained something of an absurdity, and that he was always of the opinion that with something so intimate and so pervasive as language the truth is more like what is left when the veils of error have fallen away. Nevertheless, I think that we could say that his view amounts to something like this: Teaching by ostension is a way of teaching a language. But it is a way of teaching a language from which only a pupil who already knows something about language can learn.

Two questions immediately arise. The first is this: How much

about language must the pupil know before he can benefit from being taught by ostension? Of course, the question can't be precisely answered, but I think that the necessary equipment he must have can be brought under two general headings. The pupil must know what it is to follow a rule, for rule-following – where this is encompassed in the purely formal maxim, 'Do the same in similar circumstances' – lies at the very heart of language. And he must also know – though without necessarily knowing that he knows – how to bring the words that he learns under the most general categories of language. He must be able to attach to them some such marker as 'subject' or 'noun phrase', alternatively 'predicate' or 'verb phrase'. Let me give an example of such knowledge in action. A man, once again, is being taught the word 'brown' ostensively by a teacher who points to the colour of my jacket as an essential part of the lesson. Now, if the pupil is to have a chance of learning the meaning of the word as a consequence of this procedure, he must have two capacities. In the first place, he must be able to use the word regularly, to apply it (in the case of 'brown') to the same colour. In Wittgenstein's phrase he must know how 'to go on'. Secondly, he must be able to categorize 'brown' so that, in its normal employment at any rate, it will be used by him, not to pick out something, but to say something of something first picked out. He must recognize that the word is to fill the gap in such frames as 'My jacket is . . .' rather than the gap in such frames as '. . . is made of suede'. In Wittgenstein's phrase, he must be able to give the word 'its place in the language game'.

The second question that arises out of Wittgenstein's account of the language lesson is this: If the pupil must have the kind of knowledge of language that I have just indicated before he can learn ostensively, or benefit from the language lesson, does this not entail that, contrary to what I said earlier, teaching by ostension cannot be employed as a technique in the language lesson if the language that is to be learnt is one's native language? Teaching by ostension may be a way of teaching a language but it isn't a way of teaching language.

Now, it cannot be said that Wittgenstein faces this issue as squarely as he might. Nevertheless I think he would think that there is an implication to this last question that must be rejected. And that it

must be rejected, and the reason why, will be important considerations when we come, as we will very shortly, to turn our attention from language, where it has been held over-long, to art, where by now it belongs.

The crucial consideration is this: Teaching by ostension could be a method of teaching a pupil his native language, even though it requires on his part some knowledge of language, if we grant the further possibility that he might acquire this knowledge through being taught by ostension. For ostension to be successful, certain presuppositions must be satisfied. All right. But why should not the pupil discover what these presuppositions are in the course of ostension and so bring it about that they are satisfied? The only objection, as far as I can see, would be if learning language were an instantaneous process. But that it isn't.

The point is sufficiently important to look at parallel situations where we may note some such possibility as I have talked of realized. Consider, for instance, the case of so-called direct language teaching: where, say, we are taught German and taught it systematically – that is, we are taught its grammar – but we are taught this in German. Who will raise the objection that this process is in principle impossible because it requires us first to know what we are then to be taught? Or – perhaps a better example, because a clear parallel – might we not learn a game, say a card game, and indeed learn what a card game is – for assume we had never come across one before – through just plunging in and playing it? Slow processes, you may say – but not beyond the bounds of possibility.

Of course, I have said nothing about precisely how the pupil may learn, through being taught by ostension, that which is presupposed if he is to learn from ostension. Certainly we must not assume that one process is altogether complete before the other can even begin. That would be absurd. For instance, it would be absurd to assume that one could learn what a rule of language is save in the context of specific rules of language.

As some of you will know, of recent years a traditional hypothesis has returned to favour with certain contemporary theorists of language and of human intelligence as a means of accounting for certain universal capacities that we have, and in particular for the capacity of language. This hypothesis postulates 'innate ideas' to

cover or match these remarkable human dispositions. The mind, through its substrate the brain, brings to earliest experience a set of categories or a conceptual structure with which it has been genetically endowed. The most general features of language – such as those which I have said are involved in our benefiting from the language lesson – are amongst the kinds of thing that would correspond to these innate ideas. I cannot, of course, discuss here the hypothesis of innate ideas in its revived form. I shall just say this: that, if this or some similar hypothesis about the natural resources of the mind were true, it would go some way towards explaining how we are able, in such a comparatively short period of time and at such a tender age too, to benefit from our original language lessons. But, even without such a hypothesis, the process as I have described it is quite plausible, even if it still lacks an explanation.

7. And now at last I feel free to turn to the subject of art: more specifically, to take up the topic of this lecture – the art lesson. In doing so, I shall assume that what Wittgenstein thought true of the language lesson also holds good for the art lesson: that is, that an understanding of what really happens in the course of it allows us a special insight into the nature of that which it is a lesson in. By 'assume' here, what I mean is that I shall advance no further arguments in favour of the connection. Nevertheless, I hope you will be generous enough to feel that, given what I have already found to say about Wittgenstein's argument, and given the powerful analogy that exists between the two cases, I am being rather hard on myself in calling the transposition of Wittgenstein's finding from the domain of language to that of art an assumption.

And now I can foresee an objection. For someone might argue that it seems plausible to transpose Wittgenstein's finding from the language lesson to the art lesson only if we remain on a quite objectionable level of abstractness. For what the transposition takes for granted is that there is something that can be called 'the art lesson', which stands on all fours with the language lesson. But (the objection runs) there is no such thing. For whereas we may plausibly think that language has been taught in much the same way since the days of the Tower of Babel, we know that this is not the case with art. There has been demonstrable variety, and of a radical kind, in

the teaching of art over the centuries. Art pedagogy, we might say, has exhibited as much diversity as art itself.

I accept the argument, but the last clause betrays its irrelevance to the present issue. For the case for saying that there is nothing identifiable as the art lesson, on the grounds that the content of such a supposed lesson would have changed out of recognition within the history of our culture, lapses, if it can be shown that, in synchrony with this kind of change, the content of art itself has changed out of recognition. For is not the first kind of change precisely what we would expect, given the second? Indeed, if, despite the radical changes that art exhibits, we are still prepared to think of the older art, of classical art or of gothic, as continuous with, say, the art of today, if we are prepared to accept the art of our culture in its long evolution as self-identical, this by itself provides some reason for thinking that there is such a phenomenon, continuous over historical time, as the art lesson. For what more likely place to look for the links of continuity in our art than in the method by which it has been transmitted from one generation to the next?

8. Let it then be supposed that my procedure is correct: suppose that it is legitimate to transpose Wittgenstein's finding to the domain of art: suppose that a proper understanding of the art lesson will give us an insight into the nature of art – where does this lead us? What in point of fact do we learn about the nature of art from the art lesson? What does go on in the art lesson? Or, to try and put this last question a little more searchingly: What continues to go on in the art lesson when its content changes? What is its perennial character?

The question seems forbidding, and is. And in many ways I would feel more pleased with myself if I could leave you simply with the question rather than with my fumblings towards an answer. However, I suspect that you would not be pleased with me if I did, and for that reason I shall go on – also in the hope that if I make some sort of start on answering the question, here, publicly, in front of you, it may encourage you to go on trying to answer it yourselves, where it matters, privately, in your reflective consciousness.

To gain the courage necessary for facing the question, we may, virtually for the last time, look backwards over our shoulder at the

language lesson and ask, in the light of what we have found out, What really goes on in the language lesson? And I think that some very general answer along the following lines would be in order: In the language lesson, certain elements, which are parts of the language to be taught, are transmitted; and, if all goes well, these elements are then acquired as parts of that language, or in the awareness that they are parts of that language. And in talking of parts of a language being acquired *as* parts of a language, what I have in mind is that the pupil has an idea where they fit in or how they work together.

And so we might begin by asking of the art lesson whether it exhibits the same pattern, whether it is possessed of the same structure.

The first problem that requires consideration is whether it is correct to think of the art lesson as involved with the teaching, and the learning, of elements. Of course, I am not conceiving that the art lesson might be involved with the teaching and learning of elements in anything except the qualified sense in which this is true of the language lesson – but is it true of the art lesson even in this sense? The correct answer, I am sure, is no. The art lesson does not consist in a teacher teaching his pupil how to operate with identifiable elements – and if this is so, then, on what I have called the assumption of this part of my lecture, something important follows about the nature of art.

The issue whether there are elements in art has, of course, been fiercely debated in the studios, the art-schools, and the salons of this century. But the argument on which those who have rejected an elementalist account of art have tended to rely is not that which seems most convincing to me. For the usual argument has been to point to the fact that, if we take the most obvious contenders for being the elements of art – say, line, or dot, or the colours of the spectrum – we cannot assign them a constant meaning. Those who have tried to work out a significance for them, like some of the Expressionist pedagogues, have failed: for such significance as these putative elements have, they acquire only in the context of a total composition, or perhaps (if we are to accept Ernst Gombrich's argument on this point) only in the context of an artist's complete *œuvre*. This may be so, but I do not think that the argument is

so conclusive in establishing the point for which it is invoked as do apparently many of its advocates, largely because the sharpness of the contrast between what goes on in language and in art, on which the argument depends, seems rather exaggerated. For in many cases the meaning of a word too will vary with its context, and, to make the argument effective, it would have to be established that we have here a real difference of order of magnitude between the way in which significance in language is context-dependent and the way in which significance in art is context-dependent.

But there is, I think, a more powerful argument against an elementalist account of art: or, more immediately, against the view that in the art lesson it is elements that are taught. And that is that there does not exist a set of categories or markers by reference to which the pupil could be expected to classify the elements as he is introduced to them. There is nothing corresponding to such general distinctions as 'noun phrase' or 'verb phrase'. I don't mean, of course, just that these words or analogous words aren't used, but there is no corresponding categorization that they might serve to express. In the absence of such a categorization, there are no general rules telling us how we must or how we may put the elements together: there is no general procedure for marking off licit combinations of elements from illicit combinations. And this is so because any such rules, or any such procedure, must be stated in terms of categories of element. Without grammatical categories, grammar would be impossible. Now, if the elements of art are not subject to rules of combination, if we cannot lay down, as overall constraints, ways in which they can and cannot be put together, then, unless some further considerations are advanced, it seems quite arbitrary what we pick out as the elements of art. Where one element ends and another begins is a matter of mere whim or decision unless there is something that we intend to do with these elements, and our capacity to do something with them depends on the existence of general categories under which we can classify them.

9. I expressed admiration earlier on for Maurice de Sausmarez's *Basic Design*. You may now be inclined to think that that was an act of mere piety, since what I have just been saying goes so clearly against what he urged in that book. I do not think that it is merely

pious to admire that with which we do not agree. But, more fundamentally, I think that it would be a misreading of *Basic Design* to think of it as proposing an elementalist aesthetic, or an account of art in terms of something analogous to the elements of language.

The first thing to be noted about the 'exercises', as we might call them, in which *Basic Design* consists is that they are given by way of example. By this I do not mean that they are not given in the spirit of conviction. That they certainly are. But they are given not because of the specific lesson that they teach but because of the kind of lesson that they teach. Or to put it the other way round, the specific lesson that each exercise teaches is held to be important because of the kind of lesson to which it belongs. And if a preference has been shown in the compilation of the book for some exercises rather than others, which have accordingly been omitted, the reason for this is to be found in such facts as that some are simpler to execute than others, or the lessons that they teach emerge in a peculiarly striking fashion.

So the question arises, What is the kind of lesson that these various exercises teach? And for a general answer I do not think that one could do better than say that it is a lesson in discovery. Whether it is a matter of texture, or some spatial effect, or a way of representing movement, what in each case the exercise teaches is how to find in a particular material or instantiation of a material some characteristic that the uninquisitive eye might pass over. If there is some principle according to which the author of *Basic Design* concentrated upon this or that material, upon this or that mark or set of marks, as the proper object for one of his exercises, if he had any procedure for identifying a pictorial item, it would be as something to which there was more than had met the eye.

But if each exercise is a lesson in discovery, that is, a lesson in how to discover, the further question must arise, What is the significance of this process of discovery? I do not think that Maurice de Sausmarez was one who subscribed to the easygoing view that art-teaching is a good thing because it alerts us to the variety of the world: that, like travel to the mind, it broadens the eye. Of course, he thought that too, but the ultimate end of heightening for the pupil the visual interest of the materials or the marks upon which he is asked to

concentrate is that he will then learn to combine them in wholes or units that have some other function than that simply of whetting curiosity. Put most broadly, this function might be described as that of saying what one means.

And now we appear to have come full circle. For, if what goes on in the art lesson cannot be described, as I am sure it cannot, as imparting or transmitting something like a language, it now looks as though it might be described in this way: as imparting or transmitting a way of making something like a language. In the art lesson, the pupil does not learn the elements of art: but he learns to make elements out of what he studies. If such a description were offered, I would not find it difficult to accept. It would be a simplification, but no worse.

But I would have to enter this proviso. That if the pupil learns from the art lesson the capacity to make for himself a language, that language is not art. We have a phrase for that language: that language is a style. The pupil has forged for himself a style, and the style he has forged for himself is his, his style.

But are we to conclude from this that the art lesson is exclusively concerned with the teaching of style, and hence by implication that the nature of art is itself to be resolved into a disjunction of styles, some already realized, others yet to be formed? I do not think that this would be the right conclusion to draw, but for the corrective to it we must – definitely for the last time – return to the language lesson.

It is inadequate, we have seen, to equate the language lesson with the mere transmission of linguistic elements. For, if the lesson is to be effective, the pupil must already have some general knowledge of language, into which he can fit that which is transmitted to him – though we have also seen that to think of these two pieces of acquisition on the part of the pupil in such a way that one must be complete before the other can begin is quite misguided. I went on to say something about how we must envisage these preconditions of the language lesson's efficacy. I stipulated, you will remember, the notion of rule and also the capacity to apply grammatical categories.

And now, if we look more closely at the art lesson, we shall, I suggest, see something similar. Once again, it would be inadequate

to equate the art lesson with the transmission to the pupil of the capacity to construct pictorial elements, or with, as I have called it, the teaching of style. There is certainly that. But that is only the analogue to the transmission of linguistic elements. And now I want to suggest that, if we look more closely, we shall find to the art lesson too some general precondition of efficacy. The pupil, in other words, must have some general knowledge of art. For how else could he catch on to what is offered to him, how else could he see what was required of him, what was a legitimate aim, in the formation of style? I think that the requirement that the art lesson too be credited with some such preconditions is irresistible – even though we may gladly concede the point that the pupil can learn what these pre-conditions are, and so come to satisfy them, through or in the course of the art lesson. Once again, the only powerful objection to looking at the matter this way would be if in practice learning art were an instantaneous process.

And now you might ask me to spell out this knowledge of art that is presupposed by the art lesson. If you do, I have no answer. Indeed I think I have the right to ask the question of you. What is it?

10. Monsieur Jourdain was ridiculed by Molière as one who all his life had spoken prose without knowing it. Personally I suspect that the error here lay with Molière, not with Monsieur Jourdain. Either way round, we can at least say of Monsieur Jourdain that he had the concept of prose, for, if he had not had it, the probability of his at some moment breaking into verse would have been so high that it is not possible to see how he should have averted it so success-fully. Monsieur Jourdain had, then, the concept of prose. It directed his speech, though he never consciously applied it to his speech in description of it. Similarly I shall choose to think of the pupil in the art lesson who can benefit from the lesson as having the concept of art. For, just as concern with the concept of art quite outside any context of working with the material is likely to be of little profit – witness the aridity of much academic aesthetics, or, again, the closely related inanities of Conceptual Art – so to work with the material, undirected by the concept of art, will never lead to the formation of style.

But for the better understanding of the role of this concept, I shall leave you with an image. We may think of the concept of art as a protective parent. It is in its shadow that the vast oedipal conflict that is known as the history of art is fought out – a conflict in which the sons win, if they do, by becoming parents. Then they bear the concept that has borne them.

PART II

8 Walter Pater as a Critic of the Arts

'Pater valued things primarily for their appeal to his sense of beauty.'[1] This quotation, taken (as we somewhat disingenuously say) 'at random' – it comes in fact from a Rede lecture delivered in Cambridge in 1955 by a then distinguished Professor of English Literature from Oxford – could be matched by many others, all giving the same picture of the man and the critic: or, perhaps better, the man as critic. I shan't burden you with other quotations, with other examples of this view. Once a certain error has got into circulation, the diffusion of that error is not surprising, nor is the extent of its diffusion of inherent interest. For this is the point which I wish to establish in the course of this lecture: that the view of Pater as a man entirely devoted, at any rate within the limitations of his temperament, to the purely surface-values of literature and painting is a complete error. To think of Pater as a 'low-spirited hedonist'[2] – another phrase from Lord David's lecture – is to be in error about both his achievement and his interests in relation to the arts.

I shall begin by suggesting one way in which, or so it seems to me, the view of Pater as the total aesthete, what I shall call the traditional misinterpretation, got going.

As a preliminary I shall ask you to think of Pater's writings on art as falling into two very broad groups: the critical and the theoretical. The division is one that is not all that difficult to make, even though the dividing line will sometimes run through individual books, through individual essays – perhaps when it comes to it, through individual paragraphs. Nevertheless it runs. And if, straight off, you find mention of Pater's *theoretical* writings on art unexpected, and that what it naturally occurs to you to think of is his critical writings, that is just another instance of the traditional misinterpretation at work. *Marius the Epicurean*, some of the individual essays in *Studies*

1. Lord David Cecil, *Walter Pater, the Scholar-Artist* (Cambridge, 1955), p. 4.
2. ibid., p. 20.

in the History of the Renaissance, the book on Greek art, are all laden with theory. If then we can accept, as I claim we must, this distinction within Pater's writings on art, my explanation of the way in which they have come to be misinterpreted could be expressed as follows: First, the theoretical writings were misunderstood. More specifically, they were taken with a literalness that, as I shall try to show, is quite inappropriate. Secondly, the critical writings were then read in such a way as to make them at once cohere with and confirm the false understanding imposed upon the theoretical passages. When this process was complete, when both stages had been accomplished, direct access to the text of Pater and what this could show had been more or less sealed off.

In this process there is one passage that has inevitably a large part to play; great weight is attached to it. It is this:

The service of philosophy, and of religion and culture as well, to the human spirit, is to startle it into a sharp and eager observation. Every moment some form grows perfect in hand or face; some tone on the hills or sea is choicer than the rest; some mood of passion or insight or intellectual excitement is irresistibly real and attractive for us, – for that moment only. Not the fruit of experience, but experience itself is the end. A counted number of pulses only is given to us of a variegated, dramatic life. How may we see in them all that is to be seen in them by the finest senses? How can we pass most swiftly from point to point, and be present always at the focus where the greatest number of vital forces unite in their purest energy?

To burn always with this hard gem-like flame, to maintain this ecstasy, is success in life. Failure is to form habits; for habit is relative to a stereo-typed world; meantime it is only the roughness of the eye that makes any two persons, things, situations, seem alike. While all melts under our feet, we may well catch at any exquisite passion, or any contribution to knowledge that seems, by a lifted horizon, to set the spirit free for a moment, or any stirring of the senses, strange dyes, strange flowers, and curious odours, or work of the artist's hands, or the face of one's friend. Not to discriminate every moment some passionate attitude in those about us, and in the brilliance of their gifts some tragic dividing of forces on their way is, on this short day of frost and sun, to sleep before evening.[3]

How, the traditional interpreter of Pater will ask us, could someone

3. Walter Pater, *Studies in the History of the Renaissance* (London, 1873), pp. 210–11.

who wrote this passage be in his criticism anything but a collector of sensuous experience, a devotee of the immediate, an 'impressionist'? How is he likely to set store by any aspect of art except that which exhibits a kind of beauty to be caught and comprehended in the moment? Is not this passage as direct, as blatant, an invitation to radical aestheticism as one could imagine oneself to find? It is, of course, in response to this sort of question, more or less rhetorically posed, that the portrait of Pater as the total aesthete has come into being: though this portrait, I argue, exhibits a very bad likeness.

Already I see one difficulty in the way in which I have tried to explain the genesis of the traditional misinterpretation of Pater. In describing the process as it gets going, initially upon the theoretical part of his writings on art, I have said that these writings are taken with an inappropriate literalness. But how can this be? How could it ever be inappropriate to take what someone wrote literally, and how could taking it this way be a form of misunderstanding? What sort of disservice could it be to a writer, moreover to a writer of theoretical pretensions, to take him as meaning what he says?

In the course of finding an answer to these questions, which certainly deserve to be raised, we shall have the opportunity to get much closer to what I am sure is one of Pater's central projects: we shall get a much better view of what he was most concerned to achieve in his work. But this will involve, from the point of view of this lecture and its subject – Pater as a critic of the arts – something of a detour. For in order to understand how Pater's theoretical writings on art could be taken with an inappropriate literalness, to see what that would mean, I suggest that we first look at that area of his total work where theory comes purest: that is, his writings on philosophy.

To anyone entrenched in the traditional view of Pater, it will, I know, seem an absurdity to start with his philosophical writings. At the present juncture this is something I must put up with, though even now there are facts I can point to – facts, that is, as opposed to the issues of ultimate interpretation, which must wait – that speak in favour of my procedure. First, it seems to fit in with Pater's own view of his work. His biographer, A. C. Benson, records how a friend asked Pater whether he thought *The Renaissance* or *Marius* his best work. 'Oh no, neither,' Pater is reported to have said, 'If

there is anything of mine that has a chance of surviving, I should say it was my *Plato*.'⁴ That is, *Plato and Platonism*. Benson shows himself puzzled by this remark: but, coming as it does from the last months of Pater's life, it must be taken as at any rate *his* overall estimate of his literary achievement. And, secondly, there are the most general facts of Pater's life, and how he spent it: facts which I shall briefly rehearse. In 1864, at the age of 25, Pater was elected to a fellowship in Literae Humaniores at Brasenose College, Oxford. In 1867 he became a college tutor and took his first pupil in Lent term 1868 and he started to lecture to the college around this time. In 1870 the system of combined (as opposed to college) lectures was introduced, giving a greater formality to the lecture itself. In the Hilary term 1872 Pater's name appears for the first time on the university lecture list, and from 1872 to 1883, when he more or less withdrew from Oxford to London for a period of literary life, it is one of the most prominent and most constant on the lists. Except for one year (1873), he lectured two terms in three. Generally he took as his subject a book of Plato's *Republic* or else, in part or in whole, the *Nichomachaean Ethics*: though, on occasions, he moved outside the ordinary Oxford requirements and gave lectures on mental philosophy, on the *Phaedrus*, on the *Protagoras*, or (we wonder what he had in mind) on *Philosophical Questions*. In other words, by the standards of his time, though barely of ours, Pater lived the life of a professional philosopher. And, finally, it is right to remember that Pater's interest in philosophy preceded that in art, which, at any rate in its more evolved form, would seem to date only from 1869, the occasion of his first visit to Italy in company of his close friend, C. L. Shadwell, later Provost of Oriel.⁵

Now, to understand Pater's peculiar concern with philosophy, we must take account of two separate elements in his attitude towards it, both of which make their contribution. There is, first, his sense of the folly, of the futility of metaphysical speculation. He wrote in *Marius the Epicurean* of 'the *ennui* of systems which had so far outrun positive knowledge'⁶ and this phrase finds many echoes throughout his writings. And, secondly, there is Pater's awareness of

4. A. C. Benson, *Walter Pater* (London, 1906), p. 162.
5. ibid., pp. 9–10.
6. Walter Pater, *Marius the Epicurean* (London, 1885), vol. I, p. 141.

the fascination that such systems have always had, perhaps always would have, for the human mind: moreover, for the human mind in its most refined and sophisticated manifestations. For instance, himself.

Some critics have tried to argue that the first of these two elements, the scepticism, belongs only to a phase in his development, and that he outgrew it.[7] But there is no biographical or textual evidence of any reliability to support this view. The most that could be made out – and the evidence here comes from the successive revisions that Pater made in the published text of his writings – is that in one specific area of thought or speculation – that is, religion – Pater shifted his express attitude from one of hostility to that of indifference. But on metaphysical issues taken more generally Pater remained always the champion of the 'relative' as against the 'absolute' spirit: to use a distinction he introduced into his first published work, the essay on Coleridge as a theologian, and which he continued to employ to the end. He never abandoned what he called 'the wholesome scepticism of Hume and Mill'.[8] In the preface to *The Renaissance* we find a remark that expresses this attitude succinctly. Making reference to 'the abstract question what beauty is in itself, or its exact relation to truth or experience', Pater says that these questions are 'metaphysical questions, as unprofitable as metaphysical questions elsewhere'.[9]

Aware, then, of the futility and of the fascination of metaphysics, Pater felt that the problem that confronted him was how to reconcile these two perceptions, how to do justice to both, and in his efforts to resolve this problem he arrived at not so much a theory about metaphysics as something more in the nature of suggestion. And the suggestion is that we should always look at metaphysical speculation as an exaggeration, or as a projection, of certain recognized ways we have of feeling, or thinking, of talking about the world around us. Metaphysics derives from emotion, from thought, from language. Though – and the point should be made at the outset – strictly speaking, we have here not three different sources, but only two: for in this context at least, within as it were the determinants

7. e.g. Helen Young, *The Writings of Walter Pater* (Lancaster, Pa., 1933).
8. Walter Pater, *Plato and Platonism* (London, 1893), p. 24.
9. *The Renaissance*, p. viii.

of metaphysics, we do not have to distinguish between thought and the language in which it finds expression. 'From first to last our faculty of thinking is limited by our command of speech.'[10] Language gives us 'the most intimate physiognomy of thought'.[11]

Of the two sources of metaphysical speculation primacy clearly goes to emotion or feeling, to the way in which metaphysics gives expression to the most deep-seated human desires and fears. But, this is important, not just to disparate desires and fears but to these as they come structured in human personality. Each great system can, Pater says on a number of occasions, be paired off with a particular constellation of feelings, it is the intellectual counterpart of (and these are terms which acquire a special significance at this point) a 'temperament' or 'type of mind'. Empiricism reflects one type of mind, transcendental philosophy another: and the characterization of those clusters of attitudes, or temperaments, which match not only philosophical systems but any of the more articulated products of culture, becomes one of the main preoccupations of Pater's work. Indeed, it was in pursuit of this aim that Pater came to make his most significant literary invention: that of the Imaginary Portrait. For the Imaginary Portrait – and I here use the phrase in an extended sense, as Pater himself did at times, to cover not just the essays collected in the volume of that name, but also works such as *Marius the Epicurean*[12] and *Gaston de Latour* – is a literary genre peculiarly adapted to bring out this kind of correspondence that Pater saw as holding between a type of mind and varying aspects of culture.

To apprehend fully Pater's suggestion about philosophy as we have it so far, we must realize just what it is that he thinks is effected through recognizing the motivation or the psychological roots of a metaphysical system. It is not simply that we need this knowledge in order to explain the system, to see why it came about. We need it – more fundamentally – in order to understand the system, to see what it is. Without this knowledge the system necessarily lacks meaning for us: this follows from Pater's scepticism. But once we have the

10. *Plato*, p. 129.

11. Walter Pater, *Gaston de Latour* (London, 1896), p. 102.

12. See e.g. his letter to Violet Paget (Vernon Lee), 22 July 1883, printed in an abridged version in Benson, op. cit., pp. 89–90, and in full in *Letters of Walter Pater*, ed. Lawrence Evans (London, 1970), pp. 51–2.

knowledge, once we have the insight into its source, the system comes alive. 'What seems hopelessly perverse as a metaphysic for the understanding' Pater writes, 'is found to be realisable enough as one of the many phases of our so flexible human feeling.'[13]

However, human feelings, or the emotional demands of a particular temperament, never fully determine the character of a metaphysical system. Under their influence speculation may take hold of familiar lines of thought and project them far beyond any point at which they remain recognizable. But the projection is never wholly arbitrary, never wholly perverse, never wholly wilful, for the direction is already indicated in the forms of ordinary speech. We, as it were, have a tendency to say what the metaphysician at once exaggerates and asserts. The finest examples of insight into this collusion between speculation and language are, quite naturally, given in *Plato and Platonism*, and there we find varying estimates of the weight to be attached to language or turns of speech as a determinant of metaphysics. At one extreme the suggestion is made that language not merely fixes the form of a metaphysical system but provides the very principle for its construction. At such moments in Pater's thinking the role of temperament seems totally to recede. But the more usual suggestion is that the two types of determinant operate together.

To my mind, despite the wealth of illustrative material in *Plato and Platonism*, or, again, in *Marius the Epicurean* and *Gaston de Latour*, the most interesting single case-history that Pater provides for a piece of metaphysical speculation, fixing its roots, on the one hand, in natural feeling, on the other hand, in our native speech, is his sustained attempt to characterize solipsism. It is a very subtle achievement. On the face of it what Pater produces is essentially an exposition of solipsism, and this is how we might be content to take it. Nevertheless, by a variety of touches, Pater shows us that there is another aspect to what he is doing. By (as it were) pressing on the surface of the theory, by accentuating certain features that it bears, he manages to reveal what forces have shaped it, what lies under the surface. Without in any way being seduced by the theory, we are made to feel its seductiveness: and we are made to feel it not the less but the more so for our comparative detachment or distancing. Initially we

13. *Plato*, p. 40.

might take the passage I have in mind as though it asserted the very theory it was about: but, as we read on, the passage puts itself into inverted commas for us.

Solipsism is for Pater primarily an attack upon the common-sense view of the world, according to which the world consists in solid objects, impenetrable and enduring: and in launching this attack, solipsism finds an ally in modern thought, in science and modern philosophy, for these, in their efforts to understand how things are, dissolve them either into the atoms of physical theory or into the impressions of empiricism. Solipsism, thus introduced, has its unmistakable roots in temperament: in boundless curiosity, in the rejection of what is stable or accepted, in the glorification of experience or immediacy. Nevertheless, such a temperament would not readily find philosophical expression for itself if there were not already existent in language metaphors and verbal imagery which, when taken quite seriously, conjure up a picture of the world that sets itself over and against the common-sense view. Of course, the common-sense view, which is also something of a metaphysic, has *its* roots in language: Pater talks, as we shall see, in a moment, of 'objects in the solidity with which language invests them'. But there is a richer, an incomparably richer and more varied, armoury of adjective and phrase on which solipsism can draw. We speak of 'external objects' which we contrast with 'a swarm of impressions', 'impressions unstable, flickering, inconsistent'; we use such images as the 'thick wall of personality', the 'chamber of the individual mind', 'the individual in his isolation' or the mind 'keeping as a solitary prisoner its own dream of a world'. And now let us read the passage straight through: from the point, that is, where Pater shifts from the influence of scientific (which concerns us less) to that of philosophical analysis in the dissolution of the common-sense view of the world:

... if we begin with the inward world of thought and feeling, the whirlpool is still more rapid, the flame more eager and devouring. There it is no longer the gradual darkening of the eye and fading of colour from the wall, – the movement of the shore side, where the water flows down indeed, though in apparent rest, – but the race of the midstream, a drift of momentary acts of sight and passion and thought. At first sight experience seems to bury us under a flood of external objects, pressing

upon us with a sharp importunate reality, calling us out of ourselves in a thousand forms of action. But when reflection begins to act upon those objects they are dissipated under its influence; the cohesive force is suspended like a trick of magic; each object is loosed into a group of impressions, – colour, odour, texture, – in the mind of the observer. And if we continue to dwell on this world, not of objects in the solidity with which language invests them, but of impressions unstable, flickering, inconsistent, which burn and are extinguished with our consciousness of them, it contracts still further; the whole scope of observation is dwarfed to the narrow chamber of the individual mind. Experience, already reduced to a swarm of impressions, is ringed round for each one of us by that thick wall of personality through which no real voice has ever pierced on its way to us, or from us to that which we can only conjecture to be without. Every one of those impressions is the impression of the individual in his isolation, each mind keeping as a solitary prisoner its own dream of a world.

Analysis goes a step further still, and tells us that those impressions of the individual to which, for each one of us, experience dwindles down, are in perpetual flight; that each of them is limited by time, and that as time is infinitely divisible, each of them is infinitely divisible also; all that is actual in it being a single moment, gone while we try to apprehend it, of which it may ever be more truly said that it has ceased to be than that it is. To such a tremulous wisp constantly reforming itself on the stream, to a single sharp impression, with a sense in it, a relic more or less fleeting, of such moments gone by, what is *real* in our life fines itself down. It is with the movement, the passage and dissolution of impressions, images, sensations, that analysis leaves off, – that continual vanishing away, that strange perpetual weaving and unweaving of ourselves.[14]

But by now you will be in a position to exclaim, Is this not the famous Conclusion to *The Renaissance* – the very passage in which Pater is thought to have exhibited, with a boldness, a frankness he never afterwards attained, his own perspective upon the world, his philosophy of life? Is this not the very passage that Pater was later to withdraw for fear of its corrupting influence on the minds of young men? With what right do I cite it as an example of Pater's oblique or 'meta'-attitude towards philosophy? But, at any rate from our vantage point in time, I do not think that we can read this passage, with its hesitancies, its self-conscious use of imagery, its striving to

14. *The Renaissance*, pp. 208–10.

capture and display the emotional force that lies behind the cool argumentation – but to display it lucidly, for our understanding – without a sense that we do right to take the passage obliquely and not literally. It does not address us, we overhear what it says. And if any residual doubt remains, it surely must be dispersed by the way the passage continues: by the clear indication it gives that what has come before should be bracketed off, be held at a distance from us, appreciated for its insidious efficacy. For Pater goes on:

> *Philosophiren*, says Novalis, *ist dephlegmatisiren, vivificiren*. The service of philosophy, and of religion and culture as well to the human spirit, is to startle it into a sharp and eager observation . . .[15]

And now, of course, we have come full circle. For here we are at the beginning of the very passage which I quoted a while back as one of the texts central to the traditional misinterpretation of Pater as a critic of the arts. I was then claiming that this misinterpretation arose from insisting on reading the critical writings in a way that makes them cohere with this and similar theoretical passages when these passages are taken literally. If you have by now been persuaded that this passage is not to be taken literally, then it might look as though we are in a good position to look afresh at Pater's criticism. Having cleared away what would otherwise obscure our view, can we not now return and establish the truth about him as critic? But we are not quite ready to do so: almost, but not quite.

For we have not as yet the whole of Pater's suggestion about metaphysical speculation and how it should be envisaged. The truth is that for Pater all metaphysics is essentially Janus-like. It faces two ways. It faces backwards to its origins in feeling and thought or language. But it also faces forward towards its consequences in practice. For, just as metaphysical theories arise out of habits of thinking or feeling, so they in turn confirm us in these habits and in the behaviour in which the habits find expression. 'Metaphysical formulae' Pater writes, 'have always their practical equivalents.'[16] And throughout his writings, wherever this idea is repeated, he gives varied examples of what this practical equivalent might be: a scientific theory or method of description; an ethical precept or

15. *The Renaissance*, p. 210.
16. *Plato*, p. 40.

code; often, in the most general sense, a way of talking or feeling about the world. And once again, as with its earlier part concerning the genesis of metaphysics, we must be sure that we do not miss the full significance of Pater's suggestion. To discern the practical equivalent of a metaphysical theory is not just to be in a better position to predict its consequences: it is integral to assessing, indeed to understanding, it.

When thus translated into terms of sentiment – of sentiment, as lying already half-way towards practice – the abstract ideas of metaphysics for the first time reveal their true significance. The metaphysical principle, in itself, as it were, without hands and feet, becomes effective, impressive, fascinating, when translated into a precept as to how it were best to feel and act; in other words, under its sentimental or ethical equivalent.[17]

And now – at last – we are in a better position to turn and consider Pater's writings on art. Indeed, I should like to argue, we are in an even better position than we might have anticipated. Let us look back at the route we have taken, and see where it has got us.

The detour that we have just made through Pater's philosophical writings – a topic, on the face of it, alien to the subject of this lecture – was undertaken with the intention of dispelling a particular misinterpretation of Pater's critical writings on art. This misinterpretation, I argued, derived from an erroneous reading of Pater's theoretical writings on art: the theoretical writings having been read in this way, it was only natural to twist the criticism so as to make it fit the theory that they were supposed to have been advancing. Accordingly, what better way could there be of rescuing the criticism from this traditional misinterpretation than by looking generally at what Pater was doing when he wrote theoretically? And what better place to start on this than where such writing is at its most profuse: that is, on philosophy.

However, I have, I hope, done more than simply liberate a part of Pater's writing on art from misreading. For, in arguing that Pater's theoretical writings provide a poor clue to his criticism if they are taken literally, I have tried to show how his writings on theory should be taken. And since Pater's writing on art consists partly of

17. *Marius*, vol. I, p. 136.

criticism, partly of theory, we should now be able to get a correct view of it in its totality.

I shall, for reasons which I hope will be found convincing, start with the theoretical constituent.

For Pater all theory, as we have seen, has a dual character. On the one hand, it can be looked on as the expression of feeling or emotion, we can discern in its contours the reflection of a human mind or type of mind. On the other hand, it can be looked on as something essentially practical: as offering encouragement or reinforcement to some specific attitude towards that which it is a theory of, an attitude towards science or morals or life itself. Looked at one way theory is expressive, looked at another way it is directional or regulatory, and if we ask which way of looking at theory is the more fundamental, the answer will depend on the kind of theory that is under consideration.

However, we do not have to leave the matter there. We can be more specific. For, if in the case of philosophical or metaphysical speculation, the first way of considering theory seems more appropriate, when we come to aesthetic theory there is surely good *prima facie* reason for thinking the second way more in place. Theories of art seem unlikely to hold any rich expressive content, but they might well be significant to the degree to which they lead us on to a better appreciation, a better understanding, of art. Formulated as they are in typically abstract language, they nevertheless gain their meaning from the way in which they sharpen our perception of art in this or that concrete embodiment. To put the matter aphoristically, but in a way that really seems to do justice to Pater's thinking on the subject, all theories of art are theories of art-criticism. And they are to be accepted or rejected accordingly.

But this, of course, only shifts the problem. For if theories of art are really, or in the last resort, theories of art-criticism, how, according to Pater does this help us in choosing between such theories? Theories of art will be acceptable, or unacceptable, in so far as they lead us to confront particular works of art perceptively, or (alternatively) without true sensibility? But what is the criterion by which our perception of art is to be judged for its sensibility? A favoured phrase of Pater's to characterize the aim of the true lover of art is *la vraie vérité*. But how do we set about catching this property,

and when, or by what marks, do we know that it has eluded us?

Not surprisingly Pater's prime concern here is to avoid dogmatism or undue generality. For any such dogmatism could find its justification only if he were ready to select one particular theory of art, and assert it in just the very way that, all this time, he has been warning us against i.e. literally. Nevertheless, Pater does have some sort of an answer to give, and the answer is – when we think of it – one for which we are already prepared. Philosophical theories, according to Pater, we should look on in part as the reflection of human temperament; and, if this way of regarding things seems to lose in appropriateness when it is a question of theories of art, it surely comes back into its own when it is art itself that is at issue. If the meaning of philosophy lies in some measure in its expressiveness, the same must be true, and to at least the same degree, of art.

This is how we might expect Pater to think. And it is how he does. The most important single criterion by which art theory is to be assessed is whether it helps us to see or whether, more obliquely, it encourages art-criticism that will help us to see, individual works of art as expressions of human temperament or of types of mind.

And here we have, incidentally, another consideration against taking the Conclusion to *The Renaissance* as Pater's personal affirmation. For if we do take the Conclusion in this way, and regard Pater's critical commitment as being to a form of thinking or writing about art in which the sensuous or immediately perceptible features of art are paramount, how are we to account for the fact that very little of his criticism can even be forced into this mould? If the traditional misinterpretation of Pater rests on a misreading of his theoretical writings, it must also rest on a non-reading of his criticism. But now, you may feel, I go too far. For am I really prepared to maintain that the kind of criticism that Pater favoured was one not concerned with surface qualities, with line and colour? For cannot that view too be refuted from Pater's text?

It is not my view that Pater favoured a form of criticism that ignored surface qualities. On the contrary he certainly thought that criticism should concentrate on surface qualities: but – this is the

point – not on surface qualities *as such*. He thought that criticism should concentrate on surface qualities as expressive. For in thinking that works of art were expressive, he thought, of course, that they were expressive through their surface qualities. How else could they be so? But how they were so was something for the critic to explore.[18] In the fine essay on 'The School of Giorgione', added to the second edition of *The Renaissance* in 1877, Pater has an expression for the surface qualities of pictures – colour or drawing – seen in this way. They are 'pictorial qualities', and pictorial qualities were conceived of by Pater as the principal objects of critical inquiry.

Perhaps the clearest illustration of this conception is to be found in Pater's essay on Sandro Botticelli included in the original edition of *The Renaissance*. Pater asks at the outset

What is the peculiar sensation, what is the peculiar quality of pleasure which his work has the property of exciting in us, and which we cannot get elsewhere? For this, especially when he has to speak of a comparatively unknown artist, is always the chief question which a critic has to answer.[19]

Of course we could misconstrue what Pater is saying here. We might think that what he is asking us to do is, first, to consult our own experience of Botticelli's work, find what is distinctive of it, and then look at the work itself to see if we cannot find in it some character or property, commensurate with this, which we had never come across elsewhere, and which could therefore be regarded as responsible for the uniqueness of our experience. And the character or property – on this view – would be something we could identify or apprehend without reference to Botticelli's intentions or what is distinctive of them. But there are two reasons for thinking that this is not what Pater was saying. In the first place, if it were, what right would he have had for thinking that his question admitted of a general or definitive answer – which is certainly what he assumes? Surely each critic, each spectator, would answer it according to his own sensibilities and to the course of his own experience. And,

18. The only account of Pater that I know of that comes anywhere close to apprehending the nature of his art-criticism and the material on which he thought criticism should be exercised is to be found in Solomon Fishman, *The Interpretation of Art* (Berkeley and Los Angeles, 1963).

19. *The Renaissance*, p. 40.

secondly, we would do well, in trying to grasp the sense of Pater's question, to see how he proceeds to answer it. So let us consider, for instance, his discussion of the *Birth of Venus*. To understand this picture, he says, we must understand the sentiment with which Botticelli infused it. But we can understand this only through a knowledge of the colour which is such a distinctive characteristic of the picture. But to be led from a knowledge of the colour to an understanding of the sentiment behind requires that we know what colour – colour, that is, as used by a painter, colour, we might say, as a pictorial quality – actually is.

The more you come to understand what imaginative colouring really is, that all colour is no mere delightful quality of natural things, but a spirit upon them by which they become expressive to the spirit, the better you will like this peculiar quality of colour: and you will find that quaint design of Botticelli's a more direct inlet into the Greek temper than the works of the Greeks themselves even of the finest period.[20]

In other words, to understand a work of art we must understand what it expresses: to understand what it expresses, we must look at its expressive features: and it is the perception of the expressive features, or the 'pictorial qualities' in the sense I have just explained, that Pater has in mind when he talks of 'the peculiar sensation' that the work gives us.

It will follow that the theoretical and the critical constituents of Pater's writings on art are in equilibrium when both point, the former indirectly, the latter directly, towards the expression of mind in art: although it is also part of Pater's undogmatic approach that he allows that there are other virtues to art which it would be right, at any rate sometimes, for theory or criticism to try to capture. However, in so far as expression, or expression of temperament, remains to the forefront, the theory that held the strongest appeal for Pater was one which derived from Hegel's aesthetic. *The Philosophy of Fine Art*, as Hegel's lectures on aesthetics are often known, was a work with which Pater was extremely familiar. He adapts some of its central themes in the essay on Winckelmann, but there are many literal borrowings from it, on the level of direct observation of works of art as well as on the more theoretical level,

20. ibid., p. 48.

throughout Pater's writings.[21] But for Pater's purposes the single most important contribution that Hegel had to make was the sustained attempt to understand the whole art of our culture, across the centuries, in terms of a division into Form and Content and of the fluctuating relations to be observed between these two elements. Such a method of analysis seemed to Pater to provide the ideal structure within which to elaborate a systematic account of art as expression: 'the constant habit' as he called it, 'of associating sense with soul'.[22] However, in appropriating the Hegelian structure Pater felt little obligation to respect its creator's purposes in anything except the broadest terms.

For Hegel the Content of a work of art is roughly equivalent to the most general intention that lies behind it – where this is always, at any rate if we choose to take a historical enough view of the matter, a moment in the development of the Absolute Idea: and the Form is whatever in the way of sensuous embodiment the Content is endowed with so that it can become a perceptible object. However, in the correspondence, or lack of correspondence, between Content and Form, Hegel saw a way of characterizing the various great periodic styles as well as of explaining their succession or how each necessitates the next. With suitable further assumptions, the distinction behind Form and Content was made to supply the mechanism in terms of which the essentially historical character of art could be exhibited.

More particularly, Hegel saw the art of our culture as falling into three distinctive phases – and when the third of these phases had run its course, art, he prophesied, would come to an end. In the first phase, which is what Hegel called Symbolic Art, the relation of Form to Content is defective or under-determined. The Idea, being as yet in an unspecific condition, cannot find appropriate representation in any physical embodiment, for this of its nature is always specific. In the second phase, which Hegel called Classical Art, the relation of Form to Content is one of perfect match. The Idea has by now acquired the right degree of determinacy to find for itself complete

21. On the influence of Hegel on Pater, see Bernhard Fehr, *Pater und Hegel*, *Englische Studien*, Band 50 (Leipzig, 1916), and Hans Proesler, *Walter Pater und sein Verhältnis zur deutschen Literatur* (Freiberg im Breisgau, 1917).
22. Walter Pater, *Greek Studies* (London, 1895), p. 231.

physical expression. In the third phase, which Hegel called Romantic Art, the accord of Form and Content is annulled. The Idea, which was once anterior to, has now passed beyond, the stage at which it can find appropriate representation, and any kind of embodiment with which it is endowed is torn apart or fragmented in the effort to give expression to the new 'inwardness' of content, its spirituality.

However, for Pater – though he draws on Hegel's schematization of art history – the appeal of the Hegelian distinction between Form and Content is registered predominantly on a more psychological level. His favoured use of the distinction is to point the contrast between the immediate qualities of a work of art and that which lies behind them, and to exhibit how the former gains life for us, the spectators or amateurs of art, through its connection with the latter. The Hegelian theory of art seemed to Pater to encourage the most rewarding form of criticism, by encouraging the framework in which that criticism could be expressed.

If we now ask, more specifically, about the criticism itself and the rules or methods it observes, we cannot come up with any very definitive answer. The most general characterization is probably the most illuminating. To get at the work of art as it really is, to describe its surface in such a way as to display the match between surface and depth, to apprehend the formation of 'pictorial qualities', Pater relies most heavily upon the technique of association: the placing of the work firmly in the web of association where it belongs. The associations that Pater collects to the object are varied in origin: associations from cultural history, from mythology, from the biography of the artist, or just associations of feeling and sentiment. The delicacy and ingenuity with which Pater did this earned him, appropriately, the praise of Freud, who in his description of the Mona Lisa drew directly upon Pater's.[23]

However, what is to my mind Pater's finest work of criticism is not expressly a work of criticism. It is, which should not surprise us, an Imaginary Portrait. The portrait in question is entitled 'A Prince of Court Painters', the sitter is Antoine Watteau, and the portrait takes the form of a diary kept by the sister of Watteau's follower, Jean-Baptiste Pater – with whom Pater was prepared to claim

23. Freud, XI, pp. 110, 111, 115.

kinship.[24] The diary is, of course, invented, and yet nearly everything set down in it can claim some factual source.

In an essay which originally appeared in *L'Artiste* in 1856 and was then incorporated as a chapter in *L'Art au 18e siècle* the brothers Goncourt gave to the public a hitherto unpublished MS of great historical interest. They had come across it, they said, in a second-hand bookseller's, and it was the missing life of Watteau – known to exist from references of the period – by the connoisseur and collector, the comte de Caylus, Watteau's friend. The Goncourts added a highly wrought introduction, with observations about the times and Watteau's artistic personality, and some scholarly notes.

There are many detailed points of comparison, down to the repetition of words and phrases, between Pater's text and that of the Goncourts' essay. These comparisons provide an interesting point of departure for the study of *A Prince of Court Painters*. Yet as in many, perhaps all, cases where criticism asks us to observe the resemblances between one work and another, wherever, in other words, the game of 'sources' is played, ultimately it turns out that it is the differences that are the important or the relevant thing. Though, of course, it may very well be that the differences could never have been perceived if we had not first observed, or been asked to observe, the resemblances.

For the crucial consideration is that in 'A Prince of Court Painters' Pater is not satisfied with the kind of description of Watteau's painting that he found in the sources upon which he drew. Through the writer of the diary – and this, as we shall see, is a literary device that he puts to work for him rather than, as one might have expected, one that stands in his way – he probes towards the true 'content' of the art, which is something that in one sense lies behind the surface of the painting, in another sense lies within its boundaries. And thereby he produces a view of Watteau undreamt of in its complexity by either Caylus or the Goncourts. In the Goncourts' essay Watteau is essentially the painter of theatre, of languor and gallantry and dreamlike states, the poet of Arcadian love: superior perhaps to much of his subject-matter but not really distanced from it. It is true that at the end of their introduction the Goncourts observe that Watteau, the man himself, was touched by melancholy, but they

24. Benson, *Walter Pater*, p. 124.

have nothing to say, in the light of this, about the relationship between the man and the seemingly so different character of his work.

It is just this that Pater sets out to explore: the subject-matter of the work as it stands, and the significance that Watteau imprints upon it. Through a series of approximations Pater establishes Watteau as the painter of ambivalence, of disengagement, of a delicate death-loving pessimism: also wishing for himself, and for the world too, a future in which he cannot get himself to believe. Let us observe the steps by which the portrait is constructed.

We are introduced to Watteau as a young man consumed by the love of art and beauty, restless, gifted to the point of genius: 'a dark-haired youth, whose large, unquiet eyes seemed perpetually wandering to the various drawings which lie exposed here'.[25] Next we see him attracted to harlequinades, to strolling players, with their emotionally ambiguous performances, 'a sort of comedy which shall be but tragedy seen from the other side'.[26] And he is also attracted to scenes or forms of life in which wealth and outward grace have a large part to play. But he is attracted to them, we are led to see, not in a direct or hedonistic way, as though he just wanted to get out of them what he could, to rifle them, but in a way that is at once more serious and more compulsive: 'as if truly the mere adornments of life were its necessaries'[27] is how the diarist puts it.

Already in assigning to Watteau this consciously exaggerated commitment to externals, this passionate longing for what those who do not have it desire for what it brings with it and those who have it take for granted or use to mark out their status or social position, Pater is able to suggest ways in which the painter might be related to a subject-matter of wealth and outward grace that would not be open to someone who took these things differently or more at their face-value. First of all, scenes of worldly life can be made to symbolize inappositely, but therefore more rather than less poignantly, the aspirations of the unsophisticated boy for beauty and delicacy. Secondly, just because of the inappositeness or the lack of match between aspiration and such fulfilment as the world has to offer,

25. Walter Pater, *Imaginary Portraits* (London, 1887), p.1.
26. ibid., p. 2.
27. ibid., p. 9.

these scenes can then come to symbolize the frustration inherent in all aspiration, a sense of the futility of passion.

But to appreciate just how Pater brings out this dual function of Watteau's subject-matter, or the way in which it can express, on one level, certain specific desires, and, on another level, a certain very general feature of, or fact about, desire, we have to look more closely at the form that this particular portrait takes: the fictitious diary. For Pater goes to some trouble to assign the diarist a variety of traits that make her the ideal detective to unravel the problem that confronts her. She has the endowment to decipher the pictorial qualities typical of Watteau's work: to discern what is expressed there, and how. She is, we learn, austere: and that means that she has little natural liking for the scenes of lightness and distraction, the 'gallant world'[28] that Watteau depicts. Like Watteau she cannot take this world at its face value, but neither can she take it as he takes it: ideally, we might say. And yet there is a bond of sympathy, unlikely at first, between her and so many of the characters in these summer games, the inhabitants of the gallant world. Like them she can find that time hangs heavy on her: though not out of boredom, as with them, but from melancholy, the melancholy of temperament and of unrequited love. For she is in love with Watteau. 'With myself,' she writes, 'how to pass time becomes sometimes the question – unavoidably: though it strikes me as a thing unspeakably sad in a life so short as ours.'[29] Tied as she is twice over to those *fêtes-champêtres* – to their creator by love, to their participants through identification – happy with neither link, she has become the perfect instrument on which to record the ambiguities of Watteau's temperament as these express themselves on the surface of his work. Add to this her heightened sensibility to the visual as expressive, whether in art or nature, and she is the natural vehicle of Pater's criticism.

By this time, then, we are ready for the girl's description of Watteau's paintings done while he was away in Paris, which for about two thirds of the diary is held back from us, just as the paintings have been held back from her. We have been brought to the point where we are ready to take her word for what she says, to follow her thoughts where they lead her:

28. *Imaginary Portraits*, p. 35.
29. ibid., p. 25.

And at last one has actual sight of his work – what it is. He has brought with him certain long-cherished designs to finish here in quiet, as he protests he has never finished before. That charming *Noblesse* – can it be really so distinguished to the minutest point, so naturally aristocratic? Half in masquerade, playing the drawing-room or garden comedy of life, these persons have upon them, not less than the landscape he composes, and among the accidents of which they group themselves with such a perfect fittingness, a certain light we should seek for in vain upon anything real. For their framework they have around them a veritable architecture – a tree-architecture – of which those moss-grown balusters, *termes* statues, fountains, are really but accessories. Only, as I gaze upon those windless afternoons, I find myself always saying to myself involuntarily, 'The evening will be a wet one.' The storm is always brooding through the massy splendour of the trees, above those sun-dried glades or lawns, where delicate children may be trusted thinly clad: and the secular trees themselves will hardly outlast another generation.[30]

And now a further twist becomes possible. For just as the depiction of elegant, trivial scenes, presented in a certain way, can come to express dissatisfaction with our world in which desire always comes to such a trivial outcome, so it can also be used to express another sentiment, which goes along with this original sentiment as its natural alternate, its manic counterpart: and that is a sense of the total grandeur, of the utter magnificence, of human desire or sentiment which all the evidence provided by a trivial world can now do nothing to refute. The girl is ready to suggest this too:

He will never overcome his early training: and these light things will possess for him always a kind of worth, as characterizing that impossible or forbidden world which the mason's boy saw through the closed gateways of the enchanted garden. Those trifling and petty graces, the *insignia* to him of that nobler world of aspiration and idea, even now that he is aware, as I conceive, of their true littleness, bring back to him, by the power of association, all the old magical exhilaration of his dream – his dream of a better world than the real one.[31]

And, as an epitaph on Watteau, she writes, 'He has been a sick man all his life. He was always a seeker after something in the world, that is there in no satisfying measure, or not at all.'[32]

30. ibid., pp. 33–4.
31. ibid., pp. 36–7.
32. ibid., p. 48.

A final observation. At one point in her diary, the young girl, standing back a little from her theme, writes:

Those coquetries, those vain and perishable graces, can be rendered as perfectly, only through an intimate understanding of them. For him, to understand must be to despise them; while (I think I know why) he yet undergoes their fascination.[33]

Pater – for we may believe it is he who speaks – is telling us that for Watteau the representation of certain subject-matter involves despising it. To understand his painting, we must to some degree share in this attitude. But for him and for us – for him initially, for us derivatively – this attitude stops short at the subject-matter, it does not carry over to the representation of it. To understand Watteau's painting, we must not only share in his attitude towards its subject-matter, we must also see why his attitude towards the representation of the subject-matter differs: we must see why, contrary to everything that Plato would have us believe, representation can exceed what it represents: and do so through representing it. Here we have what might be called the paradox of subject-matter in art. There is to my mind only one essay where this paradox is more subtly, more delicately, examined than in Pater's portrait of Watteau. It is the work of a far greater imaginative writer than Pater, but one much indebted to him. I think of Proust's essay on Chardin.

33. *Imaginary Portraits*, pp. 27–8.

9 Giovanni Morelli and the Origins of Scientific Connoisseurship

Giovanni Morelli[1] came of a family, probably Italian by descent, certainly Protestant, which after two centuries or so of asylum from religious persecution spent in the south of France and the Swiss cantons, returned to live, alternatively came to settle (according to which view we take of its origins), in Italy, during the lifetime of Morelli's grandfather. The family chose Verona, and it was there that Morelli was born in 1816. Very shortly afterwards the father, who had entered business with some measure of success, died, and Morelli was taken by his mother to Bergamo, the city of her birth, where he grew up to think of himself as a native of that city: it was a point with him in later years to be a Bergamesque. We shall see that in Morelli's case these dry facts, of birth and background, have perhaps more than a conventional significance.

Morelli was brought up to be a doctor. He received his early education in German Switzerland, and then he went on to study medicine at the University of Munich. There he caught the attention of the Rector of the university, Ignatius Döllinger, who was struck by this obviously gifted and versatile student, and brought him into his own class of comparative anatomy, first as a pupil, then as an assistant. Another teacher at the university whom Morelli impressed was von Schubert, the Professor of Natural History. On graduating Morelli moved to Berlin, where he entered the literary and scientific circles that centred round, at any rate included, Bettina von Arnim, the famous protégée and last love of Goethe. This was probably a distinguished and cultivated form of existence but it wasn't at all to

1. I have used throughout the two-volume edition of Morelli's works. This is Giovanni Morelli, *Italian Painters: Critical Studies of their Works*, [IP] (volume I) The Borghese and Doria-Pamfili Galleries in Rome; (volume II) The Galleries of Munich and Dresden, trans. Constance ffoulkes with an introduction by Sir A. H. Layard (London, 1892–3).

Morelli's taste, and the next thing we find him doing is, back in Switzerland, accompanying Louis Agassiz on his glacier expeditions. Morelli was obviously profoundly influenced, as were several generations of natural scientists, by this great scholar whose reputation would be firmly based on the enormous contributions that he made to the taxonomy of many forms of animal life, particularly reptiles and fishes, both living and extinct, had it not been somewhat tarnished by his later intransigent opposition to Darwin. In a footnote to his book on the galleries of Rome Morelli quotes with admiration a passage from the *Life and Letters of Agassiz* in which Agassiz is said to have impressed on his students, from the outset, that observation and comparison are indispensable to the naturalist: 'and', Morelli adds, in a bracket, 'to the art-connoisseur also'. He goes on, 'His first lesson was one in *looking.*'[2] To one student at least this first lesson remained the most important.

After Switzerland Morelli went briefly to Paris, to continue his scientific studies, but his visits to the Louvre, and what he found and experienced there, gave his life a new direction. From Paris he went to Rome and Florence and made himself familiar with their galleries. By this time what were to be the two passions of his life were established: the visual arts, and the liberation of his country. For this period was, of course, the great season of Italian nationalism, to which no sensitive young man of Morelli's background could fail to enthuse.

Morelli participated actively in the revolution of 1848. He commanded the Bergamesque volunteers, and his personal qualities as well as his knowledge of German made him an obvious choice as delegate of the Lombard government at the national German parliament assembled in Frankfurt. After the apparent defeat of the Piedmontese cause, he joined the defenders of Venice. When in 1849 Piedmont repudiated her treaty with Austria and reopened the fighting, he rushed to join her and was present at the disastrous battle of Novara. After this he withdrew to the country for a number of years, but he remained in constant correspondence with liberal political leaders. When victory finally fell to the nationalist cause, Morelli was elected deputy for Bergamo in the first Italian parliament, which assembled in Turin in April 1861. In 1865 we find him fighting in the

2. *IP*, vol. I, p. 74n.

last battles for independence. In 1873 he was elevated to the Upper House as Senator.

It is not surprising that, so heavily involved in practical life and action, Morelli found little opportunity for putting before the public the researches he had been conducting into the art of his country. His first published work, based on his detailed examination of two Roman collections, did not appear until 1874, when Morelli was nearly 60: then in a German periodical, and under a Russian pseudonym. The title of this book, *Italian Masters in the Borghese and Doria-Pamfili Galleries in Rome*, is, however, quite misleading as to its scope: for, like its successor on the Italian paintings in the German galleries, it is not just written on, it is written around, the pictures in these various galleries. Apropos of each attribution that Morelli considers, whether it is one that he accepts, or one that he is proposing, or (as is most likely) one that he challenges, he uses the occasion to establish the artistic personality of the painter he is considering by reference to the true corpus of his work. Accordingly, while pretending to be no more than an informal catalogue of this or that historical collection, each of Morelli's books is in reality a collection of little essays, brilliantly and ironically phrased, covering the major, and the minor, painters of his country. Studies of this kind, light though they may seem, are the products of years of slow, painstaking work: years passed in Morelli's case in examining all the great collections, public or private, of Europe, and in visiting, chiefly on horseback, every corner of Italy that, justly or unjustly, held out promise of artistic interest.

However, it would be wrong to think of Morelli's books as just another contribution to the historiography of the arts, a branch of study which had been developing fast throughout the nineteenth century. In his book on the galleries of Rome, Morelli included a very important introductory section, entitled 'Principles and Method', which is cast in the form of a dialogue between a young Russian sightseer, who is supposedly recording the conversation, and an elderly anti-clerical Italian patriot, who shows himself ready to pass on to his new acquaintance the fruits of years of study before works of art; and a constant theme of the dialogue is a contrast between art-history, for which Morelli has little time, at any rate in its current form, and connoisseurship, which is his real subject. The distinction

seems to exist for Morelli on two levels. In the first place, the art-historian is concerned with the broad sweep of art, seen by and large as just one aspect of culture or civilization, which develops according to its own laws: while the connoisseur prefers to concentrate on individual works of art, and to try and establish what they are and to whom they should be attributed. Secondly, in so far as the art-historian does concern himself with individual works of art and tries to answer questions of authorship, the evidence that he typically takes into account is likely to be more diffuse than that which appeals to the connoisseur. He will rely heavily on such external evidence as tradition and documents: whereas, as the old Italian patriot puts it, 'the only true record for the connoisseur is the work of art itself'.[3] Moreover, if the art-historian does condescend to look into the picture, he will go for the 'general impression', the *geistigen Inhalt*. 'All art-historians, from Vasari down to our own day, have only made use of two tests to aid them in deciding the authorship of a work of art – intuition or the so-called general impression, and documentary evidence: with what result you have seen for yourself.'[4]

From the existing state of affairs, Morelli concluded then that any sound art-history required the satisfaction of two conditions, which had so far not been formulated with sufficient clarity. First, it must base itself on properly controlled evidence, that is on reliable and well-tested attributions: and, secondly, these attributions must in their turn be based on an analysis of the characteristics of the works of art themselves, since, for any attribution, the negative evidence provided by the work of art itself must always outweigh the positive evidence provided by a document, particularly in view of the ambiguity or non-specificity of most of the documentary evidence itself.

Art-history must, in other words, rest on, and include, connoisseurship. Morelli, however, did not content himself with any such general declaration of position. To talk of reliable and well-tested attributions, or attributions based on the characteristics of a work of art, was empty unless one had an idea of how an attribution might be tested, or what characteristics of a work of art it should take into

3. *IP*, vol. I, pp. 26–7.
4. *IP*, vol. I, p. 21.

account. Morelli's real contribution to the study of art was that he devised a method whereby (according to him) the gap between attribution and work of art could be so effectively bridged that we could talk of its being virtually certain that a particular painting was the work of a particular artist. Morelli's contention was this: Every true artist is committed to the repetition of certain characteristic forms or shapes. If we want to determine the authorship of a work of art, we can do so only via recognizing the fundamental forms, the *grundformen,* of the artist to whom it is due. Moreover, these *grundformen* are not evenly distributed across the whole of the painting. For there will be certain domains, for instance, composition or the expression of the face, where the forces of school or tradition or convention are most likely to exert themselves: so that what a painter does in this area cannot be relied upon to distinguish his work from that of his predecessors or his pupils or mere copyists. To identify the characteristic forms of an artist, we must go to those parts of the painting where these conventional pressures are likely to be relaxed; even if this means that we shall have to consider what to an educated aesthete of the last century could only have seemed 'trifles'. We must take seriously the depiction of the hand, the drapery, the landscape, the ball of the thumb, or the lobe of the ear.

However, to talk of identifying the characteristic forms of an artist in some neglected area of his work is ambiguous. For it might mean that this is where we meet up with his forms again, where they most frequently impinge on us with a sense of familiarity: where, in other words, we reidentify his forms. Or it might mean that this is where we first pick them out, where they make their strongest impact on us of novelty and difference: where, now in a narrow sense of the term, we identify them. Morelli clearly saw the difference between these two stages, which later connoisseurs have not always been careful enough to keep apart, and he saw that the former must presuppose the latter. Reidentification of an artist's forms in disputed works must have as its base their primary identification in undisputed works. Until we know what forms we are looking for, it is no use trying to spot their reappearance.

Accordingly, Morelli thought that a prerequisite of connoisseurship was to draw up a series of schedules, each based on independently authenticated works of art, which would show either how one

FRA FILIPPO FILIPPINO SIGNORELLI BRAMANTINO

MANTEGNA GIOVANNI BELLINI BONIFAZIO BOTTICELLI

Fig. 1. Typical forms of ears, according to Morelli

artist drew, say, hand, foot, drapery, ear, or how one part of the body – say, hand, foot, or ear – was drawn by a number of different artists (Fig. 1). A less imaginative man than Morelli would have left his ideas in a more programmatic state. Morelli carried them into practice, and thereby scandalized the comfortable art-lover. 'For goodness' sake', Morelli makes his young Russian cry out as he is being instructed in the intricacies of Raphael's *grundformen*

leave such unsightly things as nails out of the question. The German and French critics would inevitably ridicule you if you were to tell them that even the nails were characteristic of a great master.' 'Everything may be turned to ridicule' replied the Italian rather testily, 'especially by people who understand nothing of the subject.'[5]

Morelli certainly did not make acceptance of his method any easier for the world by making it quite clear who in his opinion under-

5. *IP*, vol. I, p. 37.

stood nothing of the subject. Roughly, all art-historians who preceded him, and all museum curators of his own time. Particularly if they were German.

But perhaps at this stage it is worth trying to remove one common misunderstanding of the method. Freud in his famous essay on the *Moses* of Michelangelo refers very approvingly to Morelli whose works he had first encountered in their pseudonymous garb and by which he had been very obviously impressed. 'It seems to me' Freud writes,

that his method of inquiry is closely related to the technique of psychoanalysis. It, too, is accustomed to divine secret and concealed things from despised or unnoticed features, from the rubbish-heap, as it were, of our observations.[6]

Freud's comparison between his method and Morelli's is fascinating, but it might lead to a misunderstanding of Morelli's method, particularly in the minds of those who suffer from a prior misunderstanding of Freud's.[7] For it might lead to the view that Morelli considered only insignificant items: or that he concerned himself with details just because they were trivial. So, for instance, we find Berenson, who prided himself on being a Morellian, and who obviously thought that he was here paraphrasing Morelli, arguing that the scientific connoisseur naturally pays great attention to hands, because, as he puts it, 'the hands ... do not attract so much attention as any features of the face, excepting the ears, because the hands are not the rivals in expression of any of the features'.[8] But this was not Morelli's point of view. Asserting the importance for the connoisseur of how the hand is formed, he adds in a footnote:

Except the face, probably no part of the human body is more characteristic, individual, significant, and expressive than the hand: to represent it

6. Freud, XIII, p. 222.

7. See Richard Wollheim, 'Freud and the Understanding of Art', collected in this volume, pp. 202–19. See also Jack J. Spector, 'The Method of Morelli and its Relation to Freudian Psychoanalysis', *Diogenes* no. 66 (summer, 1969), pp. 63–83, and Hubert Damisch, 'Le Gardien de l'Interprétation', *Tel Quel*, vol. 44 (1971), pp. 70–84, and vol. 45 (1972), pp. 82–96.

8. Bernhard Berenson, *The Study and Criticism of Italian Art* (London, 1902), p. 134. Max Friedländer, *On Art and Connoisseurship*, trans. T. Borenius (London, 1942), perpetuates this view of Morelli.

satisfactorily has ever been one of the chief difficulties which artists have had to contend with, and one which only the greatest have been completely successful in overcoming.[9]

In other words, for Morelli a detail was important, if, first, it is free from conventional pressures and, secondly (and possibly just for this reason), it has a value or significance for the artist: just as, in Freudian analysis, a trait must first have acquired a meaning for the person (Freud would here add 'consciously or unconsciously') before it can do so for the analyst.

Before examining the method in detail, let me first conclude my account of the man himself. When Morelli died in 1891 he was equally famous as a Senator and as a connoisseur. An article in the *Quarterly Review* for that year, probably by Morelli's great friend Sir Henry Layard, the discoverer of Nineveh, who was to introduce his writings to the English public, is entitled appropriately enough, 'The Patriot and Critic'.[10] Nor were these two sides of Morelli's character distinct. Indeed, it was his love of Italy that inspired, if not his love of art, at any rate his love of the study of art. For how better, Morelli thought, could he show his devotion to the new Italy than by trying to remove the errors and misconceptions that threatened the history of Italian art and, in threatening the history, brought the works of art themselves into danger, at the mercy of vandals and speculators? It was, of course, an irony of history, quite unforeseen by Morelli, that the first and most sustained employment of Morellian method should have resulted in the systematic sack of Italian collections: I am thinking of the operations guided by Berenson in the early part of this century. And there was another way, according to Morelli, in which art-history could assist the cause of patriotism. One of the great obstacles to Italian unification was the spirit of parochialism, and this parochialism, *il campanilismo*, was in turn fed by many of the legends in which the history of Italian art had crystallized. As long as every city felt itself to be the cradle of a school of art, as long as it believed that it contained in its own gallery its Titian, its Bellini, its Raphael, the cause of separatism was going to be unnaturally fostered. In addressing the first Italian parliament ever to meet, Morelli did

9. *IP*, vol. I, p. 76n.

10. 'Giovanni Morelli: The Patriot and Critic', *Quarterly Review*, vol. 173, no. 345 (July 1891), pp. 235-52.

not think he was striking a note unworthy of the occasion in arguing for the more stringent supervision of galleries. 'To take our own gallery here' he exclaimed, referring to the Turin gallery, 'there are no less than six Titians in the catalogue but not one, I venture to say, in the gallery itself.'[11] When he came to write his notes on the German galleries, he punctuated it with scathing references to the municipal or local vanities of his own country, which encouraged, and were in turn encouraged by, the many false attributions which he thought it to be his way of serving his country to refute.

It would, however, not be inappropriate, and certainly not out of keeping with the speculative nature of Morelli's own mind, to suggest another, a 'deeper' interpretation of Morelli's devotion to connoisseurship. It does not seem to me fanciful to connect this continuing concern over questions of authorship, of the paternity of paintings, of who it was who with his *pennello* made the object before one, with the feelings and anxieties of the orphaned child, persisting into manhood, there to be experienced as the unconscious desire to repair and to retain the dead father. And this interpretation may seem more plausible when we compare Morelli's case to that of another man, over whom this concern had an even stronger, a more compulsive hold, though he spent much of his life denouncing it, trying (not so successfully) to resist it, (more successfully perhaps) to degrade it. For he was someone in whom, we may surmise, feelings about paternity were deep-rooted, often in a guiltier form, uncertain about his real name, for long periods in effect denying his parentage. I am referring, of course, once again, to Bernhard Berenson, whom I have already linked twice with Morelli. With Morelli, there is collateral evidence for this interpretation in the kind of strange playful liberties he was always taking with his own identity and, in particular, with that which bound him most closely to his father: his name. I have said that his writings were produced under a Russian pseudonym. The name he chose was 'Ivan Lermolieff', a kind of anagram of 'Giovanni Morelli'. Not content with this, he went on to account for the fact that the books were written in German by saying that they had been translated by a certain Johannes Schwarze, where *schwarz* involves a pun on Morelli ('*schwarz*' = '*moro*' = 'black').

11. ibid., p. 239.

2. Let us, however, now return from these speculative issues to more scientific ones. Scientific, I say: for in putting forward his method Morelli was self-consciously the heir to the scientific culture in which he had been brought up. He expressly refers to this on many occasions. In an ironical vein he suggests that his many differences of opinion with Dr Wilhelm Bode, the famous autocratic director of the Berlin Museum, whom he came closest to disliking of all his professional enemies, may be put down to a difference in their education: that Bode had been trained as a lawyer, whereas he, Morelli, had been trained as a scientist.[12] He makes the young Russian in the introductory dialogue to *Italian Masters* remark of the method in which his elderly Italian companion tries to instruct him that it 'savoured more of an anatomist . . . than of a student of art'.[13] In a more serious mood he allows himself this claim for his method: 'Even the most highly gifted and accomplished connoisseur will never attain to certainty of judgement without a definitive system of study, and this, I believe must be that so-called "experimental method" which, from the time of Leonardo da Vinci, of Galileo, and of Bacon, to that of Volta and Darwin, has led to the most splendid discoveries.'[14] So we must ask, To what extent is Morellian method genuinely the application of a scientific technique to the material of art?

On one view of the matter, the proper way of deciding the validity of a method or technique would be to examine the results arrived at on the basis of it. Is the proportion of true answers to which it gives rise significantly higher than chance? And what better way of answering this question than to examine Morelli's own attributions and observe how they have stood up to the test of time?

This, however, is not the tactic I shall pursue. One reason is that I am not competent to do so. Another reason is that this approach would be inappropriate. There can be no doubt that Morelli made some very revolutionary attributions, some of them indeed so revolutionary that, paradoxically, they now seem banal in that we cannot imagine how anyone could have thought otherwise. The so-called *Magdalen* of Correggio which was throughout most of the nineteenth

12. *IP*, vol. I, p. [47].
13. *IP*, vol. I, p. 35.
14. *IP*, vol. II, p. 2.

century the ornament of the Dresden gallery, twin only to the Sistine Madonna, he showed to be a late seventeenth-century copy. *En revanche*, he demonstrated that an obscure painting in the same gallery, which had been hitherto catalogued as a copy by Sassoferrato after Titian, was the most beautiful of all lost Giorgiones (Plate 7). 'This one fortunate discovery, which in a propitious moment I was enabled to make, will perhaps atone in some degree for many other shortcomings and mistakes.'[15] Before Morelli the name 'Ambrogio de Predis' was virtually unknown to art-historians. Morelli resuscitated it and constructed around it a group of pictures, of which the most famous is the profile portrait in the Ambrosiana. And he made some mistakes –

However, I have said that this is not really the way, not just for me but for anyone, to settle the validity or otherwise of Morellian method. For, even if we did decide that Morelli was right in substantially the greater number of attributions that he made, the questions would still arise, Were these attributions made in accordance with the method that Morelli advocated? Just as we could always ask whether in the attributions that he made that were false the error could, as he himself claimed, have been rectified if the method had been rigorously applied.

The issue here, of the relation between method and actual attribution, is complex. It is not simply a matter of deciding whether Morelli was or wasn't being honest about what he was doing – though it is worth observing that he is not always utterly straightforward. Few, for instance, would realize from the passage in which Morelli attributes the portrait in the Borghese gallery previously called Holbein to Raphael that this was in fact the traditional attribution.[16] But this is not really the point: for we are not concerned with what Morelli thought he was doing and whether he reported this correctly, but with what he was actually doing. If we are to determine whether his practice is truly in accordance with his method, our first inquiry must be not into what was going on in Morelli's mind but into what the method amounts to. This is what we must now do.

15. *IP*, vol. II, p. 224.
16. *IP*, vol. I, pp. 138–9. cf. Paolo della Pergola, *Galeria Borghese: I Dipinti* (Rome, 1959), vol. II, pp. 113–4.

I propose to conduct this examination by asking of Morellian method three questions. I shall not, of course, in this lecture be able to answer these questions definitively, but I shall be content if I can leave with you some lines of possible inquiry and the desire to pursue them. It is strange that, though Morellian method has for nearly a hundred years now been familiar to historians and connoisseurs of art, no thorough investigation of its assumptions has to my knowledge even been initiated. The three questions I want to ask of the method are, Is it coherent?, Is it complete?, and, How is it justified? I shall explain these questions as I go along. But one word of warning: the questions themselves are logically independent one of another, nevertheless there are, as we shall see, places where in order to answer one question we must presuppose some answer to one of the others.

Is Morellian method coherent? The answer to this question may seem obvious. For in essence the method would appear to consist in a matching operation: the matching, that is, of certain forms that occur in works of art against certain forms that appear on schedules. If the match is positive, the answer is yes – the work of art is by the painter whose schedule is consulted: if the match is negative, the answer is no. Surely we have here a method which, whatever its other faults may be, is perfectly coherent.

The trouble, however, arises when we ask how the schemata that appear on Morelli's schedules are to be applied. Are we in examining a work of art to look for forms that have the same configuration as these schemata: or for forms that have the same appearance? If our attribution is to be well founded, does this require that the forms in the picture are congruent with, or that they look like, the forms on Morelli's schedules? And the question is a very real one, because, depending on which interpretation we settle for, we shall get different results. Let me elaborate this.

It is, of course, not a discovery of the twentieth or even of the nineteenth century that the same configuration can in different circumstances, that is to say in different contexts or in different wholes, look very different. Artists and men of learning and sensibility in all ages have been aware of these facts. But since they are so neatly brought out in the experimental findings of the psychology of perception, I shall ask you to look at three diagrams that have

noticeably nothing to do with fine art. First, a case where we have a very simple configuration, two straight lines parallel to one another, but superimposed on a particular background which makes it very difficult indeed to perceive their actual configuration (Fig. 2). Then another example (Fig. 3), again very simple, doing for length what the last one did for direction. The two lines of dots are really the same length, but they have been so placed *vis-à-vis* the acute angle

Fig. 2. Effect of the field upon contained figure

Fig. 3. Effect of surroundings upon perceived length

that they do not look it. Finally, another example (Fig. 4) where we are introduced to certain configurations along the top row, and then along the bottom row these configurations are inserted into larger wholes; this time with the effect not just of making the original configuration look different, but, I should say, of making it virtually imperceptible.

Fig. 4. Submergence of smaller within larger structures

Now it is evident that findings of this nature have in principle a bearing upon Morellian method. But do they, we must ask, have a bearing in practice? Of course we could construct pictorial contexts such that, say, a Morellian schedule of an ear inserted first into one such context, then into another, would not look recognizably the same. But do we have to concern ourselves with such eventualities? Are they likely to arise in the practice of connoisseurship? In the actual testing of attributions will it in fact make any difference whether Morellian schemata are interpreted as configurational or as phenomenal models?

I have already expressed surprise that there should have been so little empirical testing of Morellian method. I have, however, endeavoured myself to construct an example which will, if it is found convincing, show that we do have a real problem here. Consider the schedules that Morelli provides for the hand and ear in Botticelli (Fig. 5). Morelli talks of Botticelli's hand as 'not beautiful',[17] he speaks of 'the bony unpleasing fingers'.[18] This seems to have been the

17. *IP*, vol. I, p. 35.
18. *IP*, vol. I, p. 83.

Fig. 5. Ears and hands of Botticelli, according to Morelli

conventional mid-nineteenth-century view of Botticelli,[19] and certainly I think that one might well feel that such a description was warranted by the schemata with which we are provided. For instance, one would not off-hand recognize a match between these schematic hands and, say, the hands in the Uffizi *Madonna of the Magnificat* (Plate 8): although after only a moment's scrutiny we recognize that this picture, more specifically the hand of the infant Jesus, must have been the source of Morelli's drawing. If we wanted to find a hand that looks like that in Morelli's schedule, would we not find something closer to it in the work of Botticelli's pupil, Jacopo del Sellaio: for instance, the Kress *Redeemer* (Plate 9). Now if we try to account for this discrepancy, the explanation lies, I suggest, in the fact that the particular configuration that Botticelli characteristically devised for the depiction of the hand acquires a kind of fluency when it is set inside the highly linear style in which he composed his pictures. Indeed, such a powerful context did Botticelli manage to create that this air of fluency still attaches to the hand even when it is comparatively isolated as, for instance, when we try to block out most of the rest of the painted surface with the aid of the hand or a sheet of paper. But make the dissociation complete, as on the Morellian schedule, and the closest phenomenal match for the schema now seems to be what is from a configurational point of view the far more exaggerated and elongated form of Jacopo del Sellaio.

So it looks as though we have here a case where it does make a difference how we take the schemata, that is to say, whether as

19. e.g. J. A. Crowe and G. B. Cavalcaselle, *A New History of Painting in Italy* (London, 1864), vol. II, ch. XVIII: Walter Pater, *Studies in the History of the Renaissance* (London, 1873), pp. 39–51. See on this subject, Michael Levey, 'Botticelli and Nineteenth-century England', *Journal of the Warburg and Courtauld Institutes*, vol. 23, no. 2 (1960), pp. 291–306.

configurational or as phenomenal models. Moreover, we can infer from this example, if it serves its purpose, how Morelli must have intended them to be taken: namely, as configurational models. In applying the schemata we are, I think, to imagine ourselves super-imposing them on the canvas or sheet before us, and then observing the degree of overlap or underlap between them and the forms on which they have been placed. If there is no overlap or underlap, the match is perfect: and we are then to disregard the fact that, set in the total context of the picture, the forms before us may not look like the schemata on the schedule. And as support for the view that this is how Morelli wished us to take his schemata, we have the evidence of how in the first instance he arrived at the schemata: that is to say, by the converse process from that which I have just described. For what Morelli did was to trace the forms of hand or ear from photographs of an indubitable (or what was for him an indubitable) autograph work.

Unfortunately, however, though we now have an answer to our question that is unambiguous, it is also an answer that will not do. For I shall argue that to apply the schemata in this way, configurationally, is incompatible with what would incline anyone initially to put faith in the method. But this point will have to wait. I said a moment back that our examination of the method could not progress smoothly because in some cases the questions that we need to ask, though independent, cannot be answered separately. Here is an instance. Why we would not be justified in applying the schemata if they are interpreted as configurational models is a matter that will have to wait until we come to consider the justification of the method: the third question on my list. But before leaving the question of the coherence of Morellian method I wish to observe that, if we ultimately find that we have to take the schemata as phenomenal models, two problems will arise. First of all, How are we to construct such schemata? – for the simple method of tracing them from originals clearly won't do, as the foregoing example shows. And, secondly, their application will have to be a more intuitive process than Morelli ever envisaged. The mechanical character that accrued to the method when it was in essence a matter of physically superimposing one shape on another, and which constituted a large part of its appeal, has now been lost.

Is Morellian method complete? The question of the completeness of Morellian method is the question whether the method is adequate to provide, unaided, a true decision in all those cases where, on independent grounds, we think that such a decision is called for: or whether we do not have to introduce quite independent criteria like, say, that of quality. The incompleteness of Morellian method has been a point commonly made against it: it is, for instance, the burden of Max Friedländer's attack upon Morelli.[20]

At the outset, let it be said that Morelli never intended his method to be complete in any strong sense: the method was for him a means of correcting or refining the judgement, not of superseding it. In a footnote to the volume on the German galleries, he writes

It has been asserted in Germany that I profess to recognize a painter solely by the form of the hand, the finger-nails, the ear, or the toes in his work. Whether this statement is due to malice or ignorance I cannot say: it is scarcely necessary to observe that it is incorrect. What I maintain is, that the forms in general, and more especially those of the hand and ear, aid us in distinguishing the works of a master from those of his imitators, and control the judgement which subjective impressions might lead us to pronounce.[21]

And in a letter dated 11 April 1884, which is included in the published correspondence of Morelli with his friend and disciple, Jean Paul Richter, Morelli asserts that his method was never intended to inject or infuse *die Divinationsgabe*, 'the gift of divination', into those who had not been granted it by Nature.[22]

So much for charges against Morellian method based upon ignorance. Nevertheless, it is still arguable that, though the method does permit of judgements of quality, either explicitly or implicitly, it circumscribes these judgements in a way that seriously limits the efficacy of the method. For it looks as though the only judgements of quality that Morelli was prepared to entertain were those very closely connected with those aspects of the picture upon which the method concentrated. In other words, Morelli seems interested only in judgements concerning the execution of those forms in which a true

20. Max Friedländer, *On Art and Connoisseurship*.
21. *IP*, vol. II, p. 2n.
22. *Italienische Malerei der Renaissance im Briefwechsel von Giovanni Morelli und Jean Paul Richter, 1876–91*, ed. Irma and Gisela Richter (Baden-Baden, 1960), p. 316.

artist reveals himself. There is no acknowledgement of qualitative judgements that make reference to such things as the inter-relations between the significant parts or the all-over properties of the work. It would be hard to say that Morelli thought all such judgements irrelevant, but, in so far as he appreciated their existence, he would not seem to have believed that they played any very significant role in empirical connoisseurship.

How is Morellian method justified? Morelli himself says very little about the justification of the method: that is to say, why the repetition of certain forms, for instance of the hand or ear or drapery, in different works should be taken as evidence that these works have a common origin. At times he writes as though his belief in the method is based in a very simple way on experience: that (for instance) he has found, in the course of going round the galleries and collections of Europe, that works of the same artist do in fact exhibit the same forms, where identity of form can be explicated by reference to Morellian schemata. But this argument is not really open to Morelli: for to assert it he would have to have independent evidence in each case that the works that exhibited these common forms were in point of historical fact produced by the same artist. But, of course, Morelli did not have such evidence: and it is, indeed, just because he did not have it that the need for his method, or something like it, arose. So there must have been some other reason on which he relied for believing in the validity of his method: or, at any rate, one is required if the method is to be found acceptable.

Morelli's answer would seem to have been psychological in character. At one point, it is true, he throws out the suggestion that the characteristic forms of an artist derive from his way of seeing the world, but I think that we are intended to take this metaphorically. Morelli's meaning is not that the forms are grounded in the artist's optical peculiarities but, rather, that they express his character or temperament. 'As most men, both speakers and writers, make use of habitual modes of expression, favourite words and sayings, which they often employ involuntarily and sometimes even most inappropriately, so almost every painter has his own peculiarities, which escape him without his being aware of it.'[23]

23. *IP*, vol. I, p. 75.

No one can deny that there are areas of human movement and activity in which a human being displays individuality. Morelli quotes speech habits, and of course we can think of many other examples. The question therefore arises, Should we also include amongst such areas of behaviour the way in which a man depicts a hand or ear?

Put like this, the question is too general. For no one could think that the depiction of certain items is necessarily, in this broad sense, 'expressive'. There must obviously be certain prior conditions that are satisfied before even the possibility can be entertained. In his writings Morelli specifies four such conditions, two of which we have already looked at. In the first place, the item must not be something whose representation has already been particularized or made conventional in the school or tradition in which the artist works. Secondly, it must not be something that the artist has depicted in a purely accidental or haphazard fashion: although, as I hinted earlier, we might nowadays have a very different notion of what it is for something to be accidental from what would have seemed plausible to Morelli. Thirdly, we must be dealing with a form or kind of art in which the expression of individuality is both acceptable and feasible. On this point Morelli himself is tantalizingly brief, and though I should like to develop it I will merely give his words:

> In the declining period of art in Italy, shortly after the death of Raphael, the painter lost all individuality; hence the forms, which are the expression of character, cease to be distinctive. We have, therefore, nothing left to guide us in recognizing his work, but the general impression and certain external and accidental signs. These mannerisms, which are like flourishes in calligraphy, are, however, very untrustworthy guides, and of small value for identifying pictures.[24]

To these three points, all of which Morelli acknowledges, we must add a fourth, which may have very sweeping consequences: and that is that there must not be any strong local countervailing influence, say compositional or narrative or aesthetic, which calls for a special treatment of the item concerned. Let me give you briefly an example. If we look again at the original Morellian schedule of the ears (Fig. 1, p. 182), we may note, top row, second on the left, the characteristic

24. *IP*, vol. II, p. 4n.

ear ascribed to Filippino Lippi. Now, we can certainly find in Filippino's work ears reasonably close to the Morellian schema (Plate 11). So let us assume that this is indeed usually an index of Filippino's work. But now I would like you to look at a detail from one of Filippino's frescoes in the Brancacci chapel (Plate 10). With several heads in profile, placed very close to one another, it is clear that aesthetic considerations made it impossible for Filippino simply to reiterate and juxtapose his characteristic forms. A special problem has been set him, and we can see that to solve it he had to move outside his repertoire.

We may now return to our original question, and ask, What evidence is there for believing that, if these conditions are satisfied, the delineation of hand or ear is a matter where we might expect individuality? By individuality we must mean two things: First, consistency within any one person's performance; and, secondly, distinctiveness as against the performances of different people. To answer this question we once more need to invoke the evidence of psychology. But, compared with the psychology of perception, the psychology of gesture is sadly underdeveloped. The classic study of Allport and Vernon of 1933[25] has barely been outdated.

For our purpose there seem to be three general findings of significance. In the first place, there is a very large number of activities, some psychologists indeed would exclude none, that can exhibit individuality. For instance, the eye blink reflex is a purely adaptive movement and as such is common to all men: nevertheless, it has been shown that there are individual manners of blinking which are distinctive of an individual and which serve to distinguish him from others.[26] Moreover, not merely do we see considerable consistency within each trait but there is a marked degree of 'transfer' or positive correlation, between one trait and another: for instance, between intensity of voice and pressure in handwriting. Once the hope was entertained that a general factor might be found common to all so-called expressive movement so that an individual could be given a single motility rating. However, though this hope has not been

25. Gordon W. Allport and Philip E. Vernon, *Studies in Expressive Movement* (New York, 1933).

26. E. Ponder and W. P. Kennedy, 'On the act of blinking', *Quarterly Journal of Experimental Physiology*, vol. 18 (1927), pp. 89–110.

realized, it has proved possible to find certain group factors each of which accounts for a number of different though meaningfully related traits. And what is true for those traits which simply consist in bodily movement or gesture is also, by extension, true for those traits which are of more interest to us, where along with the bodily movement is included the residue or traces of such movement, as in drawing.

Secondly, it is implausible that these infra-individual consistencies could be explained entirely in physiological terms: say, by reference to the use of the same muscles, or the conduction of impulses along the same nerve paths. Traits which exhibit consistency are, except for a few marginal cases, more plausibly regarded as psychomotor activities in which the movement of limb or gesture is constantly controlled, corrected, inhibited, by our awareness of it either through the receptors (the eye or ear) or through the proprio-receptive sense: alternatively, as the residues or traces of such activities. Certainly, if there are individual consistencies in, say, the graphic representation of some item, these could not plausibly be accounted for except in terms of some such interaction from which they result. Any explanation in terms of identical muscular or nervous elements seems most unlikely.

This point is significant for an issue raised earlier on, when I was discussing the coherence of Morellian method, and then shelved. For I said that, though Morelli appears to think that his schemata of hand and ear should be applied as though they were configurational models, this is inconsistent with what must be the justification of his method. We are now in a position to see why. For, if Morellian method is based on a belief in the consistency of certain traits of an individual, and if these consistencies result from an interaction between movements of limb or nerve impulses and perception, the consistencies themselves are surely going to be of a phenomenal kind. The feed-back from eye to hand that occurs in the draughtsman and makes him correct his drawing will serve to maintain not the same configuration but the same look: where, that is, the two diverge. For what the eye will notice are, of course, deviations from the phenomenal norm: it will notice, that is to say, cases where an ear is drawn in a way that looks different, no matter how it measures. This point is made obscurely but vividly by Merleau-Ponty writing on the

aesthetics of Malraux in a brilliant essay entitled 'Indirect Languages and the Voices of Silence', when he says that we draw not with 'a thing-hand' but with 'a phenomenon-hand'.[27]

Thirdly, and this is the point that is most challenging for Morellian method, the kind of consistency that is well conserved in a movement or gesture is usually not of a kind to be analysed in terms of the recurrence of identical or quasi-identical constituents of that movement or gesture. What is conserved, and what ultimately gives rise to an individual style or manner, are more likely to be certain invariant relations between features while these features themselves may display surprisingly large fluctuations. And, once again, what is true of the movement or gesture is also true of its trace. To borrow a term from a subject which, if it had been developed scientifically would throw considerable light on this whole problem, graphology, we recognize the writing of an individual on the basis of its *Form-niveau*. It is not that the tails of the *g*s are always the same length, or the loops of the *l*s the same shape, but the interrelations between these forms remain constant. Morelli unfortunately lived in an age when it looked as though talking about the perceptible properties of individual items taken in utter dissociation from their context was the only alternative to making a vague appeal, in the style of all the art-historians whom he most despised, to the 'general impression'. What he did not realize was that larger units or wholes can possess perceptible properties which are just as empirical as the perceptible properties of the units composing them and yet which cannot be reduced to these properties. We have already had occasion to consider such properties when discussing how Morellian schemata are to be applied. However, though Morellian method was formulated at a time when these properties had not been properly or scientifically investigated, it seems not impossible that the method could be liberalized to accommodate these findings: herculean though the task may seem.

3. So far I have talked about the famous Morellian method solely as a tool of scientific research: as the art-connoisseur's most valuable instrument. In a clever but perverse book, *Art and Anarchy*, Edgar

27. Maurice Merleau-Ponty, *Signs,* trans. Richard McCleary (Evanston, Ill., 1964), pp. 39–83.

Wind has argued that the Morellian method can be seen as more than this: 'What looks at first like the professional eccentricity of a specialized method is actually a refined, precise, and therefore valuable statement of a far profounder eccentricity in which many of us share.'[28] And he goes on to say that 'behind the Morellian method lies a strong aesthetic feeling of a very particular sort'. This feeling Wind then identifies with that desire for freshness as the supreme quality of art, which by the end of the century led to an exaggerated form of sensibility in which the fragmentary, the disjected, the capriccio come to occupy the centre of aesthetic attention. Morelli, according to Wind, is a symptom of that 'shift of perception' which made it possible for Mallarmé and Rodin, Valéry, Rilke and Stefan George to become heroes of the culture.

Historicist criticism of this kind can easily lead to new and exciting findings: the difficulty however is to sustain the excitement in the face of fact. I cannot see that anything is gained by presenting Morelli as a revolutionary of taste. His likes and dislikes as far as forms of art are concerned seem to have been remarkably unadventurous. He regarded the Sistine *Madonna* as the most sublime expression of European art, which he thought reached its apex at the time of Raphael. He saw no intrinsic merit either in the directness and expressiveness of earlier art or in the sophistication and ambiguities of later art. I do not mean by this that he was in any way blind to, or that he did not admire intensely, many of the Quattrocento painters. He did, but he retained, as jealously as any official High Victorian critic, a sense of their position in the historical progression.

And yet there is something of great originality and brilliance in Morelli the critic: Morelli the critic, that is, as opposed to Morelli the connoisseur, whose achievements we now have behind us.[29] For what Morelli perceived was that the essence of a work of art – by which he meant that upon which both its paternity and its aesthetic quality depend for their determination – lies not in some vague spirituality that it possesses but in certain quite specific and quite characteristic elements that the artist has inserted into it. Moreover,

28. Edgar Wind, *Art and Anarchy* (London, 1963), p. 35.

29. cf. Hubert Damisch, 'La Partie et le Tout', *Revue d'Esthétique*, tom. XXIII, no. 2 (1970), pp. 168–88, where the comparison between Morelli and Wölfflin is investigated with considerable insight and originality.

these elements cannot be defined uniquely in terms of either of the traditional categories of form or content: to understand them we must see that they involve a distinctive bringing together or fusion of these two aspects of style. If Morelli is sometimes thought of as a formalist, we should remind ourselves that his schedules are always schedules of hands, or of ears, or of feet; that is, they reveal characteristic formal manipulations of specific content.

In trying to elucidate this conception of the essence of a work of art, Morelli, like others who have held to a similar view of the matter, developed the analogy between a work of art and language. Perhaps it would be more correct to say that Morelli developed two analogies and his failure to distinguish between the two accounts for a weakness in his overall theory. Or, if it does not account for this weakness, it marks the spot at which it manifests itself.

On the first analogy, there is one comprehensive language within which all painters, or all painters possessed of individuality, work and express themselves: the difference is that each painter supplies his own vocabulary, his own preferred set of lexical items. On the second analogy, there is no common language, and it is the achievement of each painter who rises above the level of mere mannerism that he constructs his language for himself. Now, Morelli certainly uses the first analogy – he writes in various places of the 'language of art'[30] – but it would seem that it is the second analogy that best expresses his thinking. It was to the decipherment and rational reconstruction of the various languages of art – languages as various as there are coherent painters – that Morelli devoted himself. More specifically, Morelli located the analogue to language within art in style and he then went on to think that the understanding of art could be accomplished in the successive understanding of styles.

However, in working out this analogy, Morelli showed himself defective at one point. He had, we may say, little conception of what a language is over and above a mere set of words: a language turns out to be identical with its lexical items. In the analysis of individual styles, no reference is made – though it would be unfair to say that Morelli thought no reference necessary – to rules of combination or of significance: he had nothing to say about how the individual items in a particular painter's style may be concatenated into complexes, or

30. e.g. *IP*, vol. I, pp. 73, 76; *IP*, vol. II, p. 4.

how a meaning may be assigned to such complexes. There is, in other words, in Morelli's thinking no explicit recognition of either syntax or semantics. (It is interesting to note that Wölfflin, coming at the matter the other way round, fell into the complementary error. For he had no conception of how a style can be resolved into disparate constituents. When he suggests that a style is recognizable not only in a painting but in each and all its constituents, this is because each part is, stylistically at least, a microcosm of the whole.)[31]

Now in part Morelli's error can be forgiven by recognizing that at the time no one was likely to have done better. He failed just where the contemporary understanding of language gave out. It is also true that Morelli would have been highly suspicious of those parts of contemporary art-theory which might be thought in an approximate way to have fulfilled the tasks that he neglected: the current theories of composition or of expression would have struck him as certain to lead either into triviality or into pretentiousness. But there is a further possible explanation. And that is that at this point in his thinking Morelli was influenced by the other analogy he considers between pictorial art and language. For, pursuing this analogy, Morelli would not have felt required to produce for each individual style its own set of syntactical and semantical rules. For such rules are, on this analogy, not specific to style: they belong to the essence of art itself and thus are common to all artists.

It may be that, here again, Morelli's deficiencies can be made good. But it may be that they can't be. For it may be that problems about the identification of the elements of style, about the concatenation of these elements, and about the significance of the elements in concatenation, are inextricably linked: so that we cannot solve these problems piecemeal. And that would mean that we could not build on Morelli's work. If so, its value would lie not so much in what it achieved, but in the significance of what it left undone. Either way round Morelli showed us the problems. This may be the explanation why he has been so absurdly neglected.

31. Heinrich Wölfflin, *Principles of Art History*, trans. M. D. Hottinger (New York, 1932), pp. 1–13.

10 Freud and the Understanding of Art

Freud opens his ingenious and revealing essay on the *Moses* of Michelangelo (Plate 12) with a disclaimer. He had, he said, no more than a layman's or amateur's knowledge of art: neither in his attitude to art nor in the way in which he experienced its attractions was he a connoisseur. He goes on:

> Nevertheless, works of art do exercise a powerful effect on me, especially those of literature and sculpture, less often of painting. This has occasioned me, when I have been contemplating such things, to spend a long time before them trying to apprehend them in my own way, i.e. to explain to myself what their effect is due to. Wherever I cannot do this, as for instance with music, I am almost incapable of obtaining any pleasure. Some rationalistic, or perhaps analytic, turn of mind in me rebels against being moved by a thing without knowing why I am thus affected and what it is that affects me.[1]

And then, as if for a moment conscious that he might appear to be imposing his own personal peculiarities, a quirk of his own temperament, upon a subject with its own code, with its own imperatives, he hastens to concede what he calls 'the apparently paradoxical fact' that 'precisely some of the grandest and most overwhelming creations of art are still unsolved riddles to our understanding'. Before these works we feel admiration, awe – and bewilderment. 'Possibly', Freud goes on with that irony which he permitted himself in talking of established ways of thinking

> some writer on aesthetics has discovered that this state of intellectual bewilderment is a necessary condition when a work of art is to achieve its greatest effects. It would be only with the greatest reluctance that I could bring myself to believe in any such necessity.[2]

Anyone acquainted with Freud's style will at once recognize

1. Freud, XIII, p. 211.
2. Freud, XIII, pp. 211–12.

something typical in this whole passage, in the easy and informal way with which from the beginning he takes the reader into his confidence: typical, too, that Freud should be unable to renounce this natural way of writing even when, as here, the work on which he was engaged was ultimately to appear anonymously.

Nevertheless, for all its ease of manner, the passage that I have quoted is problematic. There are two questions to which it immediately gives rise, and to which some kind of answer is required, if we are to use it as providing us with an entry into Freud's views about art. The first is this: When Freud says that for him there is a peculiar difficulty in obtaining pleasure from a work of art if he cannot explain to himself the source of this pleasure, are we to take his words – as he says he wants us to – as a purely personal avowal? Or is it that what constituted for Freud the peculiarity of his situation is simply the deeper understanding he feels himself to have of human nature and human achievement: that the attitude to art from which he cannot free himself is one that must come naturally to anyone affected by psychoanalysis, and that it is only in ignorance of psychoanalysis that any other attitude – for instance, that of delight in bewilderment – could be conceived? And the second question is, What form of understanding or explanation did Freud have in mind? More specifically, we know that by 1913, the date of the Michelangelo essay, Freud had already subjected a large number of psychic phenomena, normal as well as pathological, to psychoanalytic scrutiny: dreams, errors, jokes, symptoms, the psychoneuroses themselves, phantasies, magic. And so it is only natural to ask which of these phenomena, if any, was to serve as the model, so far as the pattern of explanation it received, for the understanding of art?

The first question is one that I shall return to later. Meanwhile I should like to draw your attention to a passage from another and certainly no less famous essay that Freud wrote on a great artist, 'A Childhood Memory of Leonardo da Vinci', which dates from the spring of 1910. Writing of Leonardo's insatiable curiosity, Freud quotes two sayings of Leonardo's, both to the effect that one cannot love or hate in any but a faint or feeble way unless one has a thorough knowledge of the object of one's love or hate. Freud then goes on:

The value of these remarks of Leonardo's is not to be looked for in their conveying an important psychological fact; for what they assert is obviously false, and Leonardo must have known this as well as we do. It is not true that human beings delay loving or hating until they have studied and become familiar with the nature of the object to which these affects apply. On the contrary they love impulsively, from emotional motives which have nothing to do with knowledge, and whose operation is at most weakened by reflection and consideration. Leonardo, then, could only have meant that the love practised by human beings was not of the proper and unobjectionable kind: one *should* love in such a way as to hold back the affect, subject it to the process of reflection and only let it take its course when it has stood up to the test of thought. And at the same time we understand that he wishes to tell us that it happens so in his case and that it would be worth while for everyone else to treat love and hatred as he does.[3]

Now, it must be emphasized that the two sayings of Leonardo with which Freud takes issue do not refer simply to personal loves and hates: they are addressed to what we feel about anything in nature. Indeed, in the longer of the two passages that Freud cites Leonardo is – or at any rate Freud takes him to be – expressly defending himself against the charge that a scientific attitude towards the works of creation evinces coldness or irreligion. If, then, Leonardo's attitude, so understood, is thought by Freud to deserve these strictures, it is worth setting them by the side of Freud's own attitude to art, as we so far have it, and wondering why they do not apply to it.

Turning now to the second of the two questions, I shall anticipate the course of this lecture to the extent of saying that Freud seems to find in a variety of mental phenomena suitable models for the interpretation of art: that in attempting to explain art he assimilates it now to this, now to that, psychic phenomenon, for the understanding of which he had already devised its own explanatory schema. The richness of Freud's aesthetic lies in the overlapping of these various suggestions: though, as we shall see, how the suggestions are actually to be fitted together is an issue to which Freud barely applied himself.

However, before either of the two questions that arise out of the

3. Freud, XI, p. 74.

Michelangelo essay can be answered, there is a third which requires our attention. And that is the question of what texts we are to consult, and what relative assessment we are to make of them, in arriving at a considered estimate of Freud's views. In addition to its obvious priority, this question has the additional advantage that, if taken early on, it might save us time later. For a mere review of Freud's writings on art and of their relative weight could show us where his central interests lay: it could show us the kind or kinds of understanding he sought and the significance that he attached to this. It could save us from certain mistakes.

For the first thing to be observed about Freud's writings on art is that some of them are only peripherally about art. A fact that emerges from Ernest Jones's biography is that Freud, for all his lack of arrogance, felt himself, in a way that is perhaps vanishing from the world, to be one of the great, to belong in a pantheon of the human race: and for this reason it was only natural that his thoughts should often turn to the great figures of the past, and that to understand the inner workings of their genius should be one of his recurrent ambitions. Freud, we may think, wrote *about* Leonardo in much the same spirit as later, at one of the dark moments of European civilization, he was to write *to* Einstein: it was the conscious communion of one great man with another.

My claim is, then, that the essay on Leonardo – and much the same sort of claim could be mounted for the essay on Dostoevsky – is primarily a study in psychoanalytic biography: and the connection with art is *almost* exhausted by the fact that the subject of the biography happens to be one of the greatest, as well as one of the strangest, artists in history. For if we turn to the text of the essay, and ignore the straightforward contributions to psychoanalytic theory, which are inserted, as it were, parenthetically, we shall see that the study falls into two parts.

There is, first of all, the reconstruction of Leonardo's childhood, the evidence for which is recognized to be scanty: and then there is the history of Leonardo's adult life, which is, of course, adequately documented, but which is deliberately presented by Freud in such a way that it can be connected up with earlier events. In other words, seen as a whole, the essay is an attempt to exhibit – not, of course, to prove but, like the clinical case-histories, to exhibit – the dependence

of adult capacities and proclivities on the infantile, and in particular on infantile sexuality.

More specifically, the dependence of later on earlier experience is worked out in terms of fixation points and successive regressions. To Leonardo are attributed two fixation points. The first or earlier one was established in the years spent in his mother's house when, experiencing as an illegitimate child her undivided love, he was seduced into a sexual precocity in which intensive sexual curiosity and an element of sadism must have been manifestations. In time, however, a conjunction of internal and external factors – the very excess of the boy's love for his mother, and his reception into the nobler household of his father and his step-mother by his fifth year – brought on a wave of repression in which the blissful eroticism of his infancy was stamped out. He overcame and yet preserved his feelings for his mother by first identifying himself with her and then seeking as sexual objects not other women but boys in his own likeness. Here we have Leonardo's second point of fixation, in an idealized homo-sexuality: idealized, for he loves boys only as his mother loved him: that is, in a sublimated fashion.

It is against this childhood background that Freud then reviews and interprets the successive phases of Leonardo's adult life. First, there was a phase in which he worked without inhibition. Then, gradually his powers of decision began to fail, and his creativity became en-feebled under the inroads of an excessive and brooding curiosity. Finally, there was a phase in which his gifts reasserted themselves in a series of works that have become justly famous for their enigmatic quality. These last two phases Freud then proceeds to connect with successive regressions, in the manner that had become familiar since the *Three Essays on the Theory of Sexuality*. First, there is a regression to a strong but totally repressed homosexuality, in which the greater part of the libido, profiting from pathways laid down in a yet earlier phase, seeks and finds an outlet in the pursuit of knowledge – though, as we have seen, at a heavy cost to the general conduct of life. This, however, is then overtaken by a regression to the earliest attachment. Either through some internal transformations of energy or by a happy accident – Freud suggests a connection with the sitter for the *Mona Lisa* – Leonardo, now at the age of fifty, returns to enjoy his mother's love in a way that allows a new release of creativity.

Now it is in connection with this attempt to interpret Leonardo's adult life in the light of certain childhood patterns that Freud appeals to particular works of Leonardo all drawn from the later phase: the *Mona Lisa*, the Paris and London versions of the *Madonna and Child with St Anne*, and the late androgynous figure paintings. If we read the relevant section of Freud's essay (section IV) carefully, we see what his procedure is. He uses the evidence provided by the pictures to confirm the link he has postulated between this last phase of Leonardo's activity and a certain infantile 'complex', as Freud would have put it at that date. Note that Freud does not use the evidence of the pictures to establish the infantile complex – that depends upon secondary sources and the so-called 'infantile memory' from which the essay derives its title: he uses it to establish a link between the complex and something else. But, we might ask: In what way do the pictures that Freud cites provide evidence? And the answer is that the evidence that they provide comes from certain internal features plus certain obvious or seemingly obvious trains of association to these features. So in the Louvre picture Freud associates to St Anne's smile the caressing figure of Leonardo's mother: to the similarity of age between St Anne and the Virgin he associates the rivalry between Leonardo's mother and his step-mother: and to the pyramidal form in which the two figures are enclosed he associates an attempt on Leonardo's part to reconcile 'the two mothers of his childhood'.

I have said enough, I hope, to show how misleading it is to say, as is sometimes said, that in the Leonardo essay Freud lays down a pattern for the explanation of art based on the model of dream-interpretation. It is true that with certain very definite qualifications Freud does in the course of this essay treat a number of works of art in just the way he would if they were dreams: the qualifications being that the associations he invokes are not free, and that the trains terminate on an already established complex. But there is nothing to suggest that Freud thought that this is the proper way to treat works of art if one wants to explain them as works of art: all we can safely conclude is that he thought this a proper way to treat them if one wanted to use them as biographical evidence. There are, indeed, ancillary pieces of evidence to suggest that Freud's interest in the Leonardo's essay was primarily biographical. This certainly is in

accord with the reception that the original draft of the essay received – and presumably invited – when it was read to the Vienna Pyscho-analytic Society a few months before its publication.[4] The minutes reveal that in the discussion it was only Victor Tausk who referred to the paper as 'a great critique of art' as well as a piece of psycho-analysis, and his remark went unheeded. Again, both in the original draft and in the final essay the feature most emphasized by Freud in Leonardo's works is certainly not an aesthetic feature: that they are very largely left unfinished. And, finally, it must be significant that Freud made virtually no attempt to identify in the work of the last phase any correlate to the fact that, though this phase too marks a regression, nevertheless it was a regression that enabled a new release of creativity.

If we now turn back from the Leonardo essay to the essay on the *Moses* of Michelangelo, with which I began, we find ourselves involved with a totally different enterprise.[5] Indeed, if we consider both essays to be (roughly) studies in *expression*, then it looks as though they mark out the two ends of the spectrum of meaning that this term has occupied in European aesthetics. For, if the Leonardo essay concerns itself with expression in the modern sense – that is, with what the artist expresses in his works, or with Leonardo's expressive-ness – then the Michelangelo essay is concerned with expression in the classical sense – that is, with what is expressed by the subject of the work, or the expressiveness of Moses. (The distinction is, of course, over-simple: and it is significant that there has been a continuous theory of expression in European aesthetics.)

Let us look for a moment at the problem that Michelangelo's great statue sets the physiognomically minded spectator. We may express it in a distinction used by Freud – and, of course, our aim anyhow is to get as close as possible to the problem as he conceived it – and ask initially whether *Moses* is a study of character or a study of action. Those critics who have favoured the latter interpretation have stressed the wrath of Moses and contended that the seated figure is about to spring into action and let loose his rage on the faithless

4. *Minutes of the Vienna Psycho-analytic Society*, ed. Hermann Nunberg and Ernest Federn (New York, 1962–), vol. II, pp. 338–52.

5. On Freud's essay, see Hubert Damisch, 'Le Gardien de l'Interprétation', *Tel Quel*, vols. 44 (1971), pp. 70–84, and 45 (1972), pp. 82–96.

Israelites. The wrath is evident, Freud argues, but the projected movement is not indicated in the statue and would moreover contradict the compositional plan of the tomb for which it was intended. Those critics who have favoured the former interpretation of the statue – that is, as a study in character – have stressed the passion, the strength, the force implicit in Michelangelo's representation. Such an interpretation can remain free of implausibility, but it seemed to Freud to leave too much of the detail of the statue uncovered and it insufficiently relates the inner to the outer. Freud's interpretation is that we should see the figure of Moses, not as being about to break out in rage, but as having checked a movement of anger. By seeing it as a study in suppressed action, that is self-mastery, we can also see it as a study in character and at the same time avoid any inconsistency with the compositional indications.

'Here we are fully back', Ernst Gombrich has written of this essay, 'in the tradition of nineteenth-century art-appreciation':[6] and this tradition he partially characterized by referring to its pre-occupation with the 'spiritual content' of the work of art. The evident conservatism of Freud's method in the Michelangelo essay does in large measure warrant Gombrich's judgement, and yet I think that if we look carefully at Freud's text there are some scattered counter-indications that should warn us against taking it – what should I say? – too definitively.

It is a matter of more than local interest that in the Michelangelo essay Freud expresses his deep admiration for the critical writings of an art historian whom he had first encountered under the name of Ivan Lermolieff. This pseudonym, he later discovered, masked the identity of the great Giovanni Morelli, the founder of scientific connoisseurship. Now it was Morelli more than anyone else who brought the notion of 'spiritual content' in art into disrepute. Admittedly what Morelli primarily objected to was not spiritual content as a criterion of value or of interpretation but its employ-ment in determining the authorship of a particular painting: and it was to set this right that he devised his own alternative method, which consisted first in drawing up for each painter a schedule of forms, showing how he depicted the thumb, the lobe of the ear, the foot, the

6. E. H. Gombrich, 'Freud's Aesthetics', *Encounter*, vol. XXVI, no. 1 (January 1966), p. 33.

finger-nail and other such trifles, and then in matching any putative work by a given painter against his particular schedule item by item. Nevertheless, once Morelli's method had been applied to determine authorship, the old idea of spiritual content had received a mauling from which it could not hope to recover.

It is, then, worth observing that it was precisely for his method, with all that it involved in the reversal of traditional aesthetic values, that Freud admired Morelli so much.[7] Nor was Freud's admiration mere generality. Quite apart from the intriguing but quite unanswerable question whether the anonymity of the Michelangelo essay might not have had as one of its determinants an unconscious rivalry with Morelli, Freud would seem to have used in pursuit of physiognomy a method markedly like that which Morelli evolved to settle issues of connoisseurship. The somewhat self-conscious attention to minutiae, to measurement, to anatomical detail suggests that, even if Freud's critical aims were conservative, the methods he was prepared to envisage for achieving them were not so constricted. This point is one to which we may have to return. And, finally, it must be observed that Freud, both at the beginning and at the end of his essay, endeavours to link, though without indicating precisely how, the physiognomy of Moses with an intention of Michelangelo.

And now I want to turn to the third and only other extended essay that Freud wrote on art or an artist. (I exclude the Dostoevsky essay because, though almost the length of the *Moses* essay, it contains so little on its nominal subject.) In the summer of 1906 Freud had his attention drawn by Jung, whom he had not yet met, to a story by the north German playwright and novelist Wilhelm Jensen (1837–1911) entitled *Gradiva*. Though Freud later referred to the work as 'having no particular merit in itself', which seems a fair judgement, it evidently intrigued him at the time and by May of the following year it had become the subject of an essay, 'Delusions and Dreams in Jensen's *Gradiva*'. Unfortunately in the Standard Edition of Freud's works the practice of the original English translation, of printing Jensen's story as well as Freud's text, has not been followed. The reader who relies

7. See Richard Wollheim, 'Giovanni Morelli and the Origins of Scientific Connoisseurship', collected in this volume, pp. 177–201. See also Jack J. Spector, 'The Method of Morelli and its Relation to Freudian Psychoanalysis', *Diogenes*, no. 66 (summer 1969), pp. 63–83.

upon Freud's résumé is unlikely to appreciate fully the deftness and subtlety with which he interprets the text: in the résumé text and interpretation are in such close proximity that we may take the interpretation for granted.

Jensen's *Gradiva* is subtitled 'A Pompeian Fancy', and it tells the story of a young German archaeologist, Norbert Hanold, who has so withdrawn himself from the world that his only attachment is to a small Roman plaque of a girl walking with an elegant and distinctive step, which he had first seen in the museum of antiquities at Rome and of which he has bought a cast. He calls the girl Gradiva, he spins around her the phantasy that she came from Pompeii, and, after several weeks of quite vain research into her gait and its distinctiveness or otherwise, he sets off to Italy, heavily under the influence of a dream in which he watched Gradiva perish in the Pompeian earthquake. On his journey south life is made intolerable for him by the endless German honeymoon couples and by the flies. He hates, we may discern, the untidiness both of love and of life. Inevitably he drifts to Pompeii and the next day at noon, entering the house to which he has in phantasy assigned Gradiva, he sees the double of the girl who is represented in his beloved plaque. Are we to believe that this is a hallucination or a ghost? In fact it is neither; it is, as Norbert Hanold has to realize, a live person, though she continues to humour him in the belief that they knew each other in another life and that she has long been dead. There is another meeting, there are two further dreams, and all the while there is the pressure on Hanold of having to accept how much of his phantasy is proving to be real. Ultimately there is a revelation, by which time Hanold is prepared for the truth. The girl is a childhood friend of his who has always been in love with him. He, on the contrary, had repressed his love for her and had only allowed it to manifest itself in his attachment to the plaque, which, it now turned out, in so many of its treasured aspects, some of which had been projected by him on to it while others must have been the causes of his initial attraction to it, precisely reflected her. Even the name that he bestowed on the plaque, 'Gradiva', was a translation of her name, 'Bertgang'. By the end of the story his delusion has been cast off, his repressed sexuality breaks through, and the girl has restored to her 'her childhood friend who had been dug out of the ruins' – an image obviously of inexhaustible appeal to

Freud, who was to draw upon it over and over again each time he elaborated his favoured comparison between the methods of psychoanalysis and the methods of archaeology.

It is natural to think of 'Delusion and Dreams' as lying on the same line of inquiry as the later Michelangelo essay but at a point projected well beyond it. Both essays are studies in the character or mood or mind of the subject in a work of art, but in the Jensen essay the inquiry is pursued with what seems a startling degree of literalness. 'A group of men', is how it begins, 'who regarded it as a settled fact that the essential riddles of dreaming have been solved by the efforts of the author of the present work found their curiosity aroused one day by the question of the class of dreams that have never been dreamed at all – dreams created by imaginative writers and ascribed to invented characters in the course of a story.'[8] And Freud then proceeds to grapple with this question in such detail, giving a lengthy analysis of Hanold's two dreams, that the reader might feel, on reaching the last sentence of the essay, that it could profitably have come somewhat earlier. 'But we must stop here' Freud writes, 'or we may really forget that Hanold and Gradiva are only creatures of the author's mind.'[9]

But such a reaction on the part of the reader – or the feeling that Freud here is guilty of misapplying his technique of dream-interpretation because he has falsely assimilated characters of fiction to characters of real life – would be inappropriate. For it overlooks one important, and indeed surprising, fact: that Hanold's dreams *can* be interpreted, that there is sufficient evidence for doing so. Of course this fact is purely contingent, in that we could have no general reason to anticipate it. Nevertheless, it is so. The overall point might be brought out by comparing the dream-interpretations in the Jensen essay with that part of the Leonardo essay where, as we have seen, Freud sets out to interpret some of the late works of the painter somewhat on the analogy of dreams. Now, the former, it might be argued, compares unfavourably with the latter. For anyone who accepts the leading ideas of Freudian theory will agree that there must in principle be a way of eliciting the latent content of the Leonardo works: the two open questions being whether the evidence permits

8. Freud, IX, p. 7.
9. Freud, IX, p. 93.

this to be done in practice and, if so, whether Freud succeeded in doing it.[10] However, there can be no corresponding assurance that it is possible to elicit the content of Hanold's dreams: for Hanold's dreams are not actual dreams. Now, this argument is perfectly acceptable if what it points out is that there need not have been evidence adequate for the decipherment of Hanold's dreams. But Freud's discovery is that in point of fact there is: and this discovery is not only the presupposition on which the various dream-interpretations in the Jensen essay are based but also the most interesting feature about that essay.

Once this point is accepted, then Freud's effort to decipher the delusions and dreams of Norbert Hanold, so far from being merely the product of confusion between fiction and reality, can be seen as a genuine contribution to criticism. For it indicates the steps by which, explicitly to a certain kind of reader, implicitly to others, Hanold's beliefs and wishes are revealed – and in this respect it clearly refers to an aesthetic feature of *Gradiva*. And now an analogous point can be made for Freud's physiognomic researches into the Michelangelo *Moses*. For in this study Freud is to be seen, not simply as revealing to us the deepest mental layers of a particular representation, but as indicating how these layers, particularly the deepest of them, are revealed in the corresponding statue. And now perhaps we can see one way in which Freud diverges, if only in emphasis, from nineteenth-century appreciation. For Freud is at least as interested in the way in which the spiritual content of a work of art is made manifest as in the spiritual content itself: and when we take into account the 'trivial' ways in which he thought deep content was most likely to manifest itself, the divergence visibly grows.

Let us stay for a moment with those arts in which revelation of character – of the character, that is, of the subject of the work, not as yet that of the artist – is a significant aesthetic feature. Now this feature cannot be unconstrained, otherwise it would cease to be of aesthetic interest. There must be some element in the work that at any rate slows down, or controls, the pace of revelation. Does Freud

10. For discussion of the detail of the Leonardo essay, see Meyer Schapiro, 'Leonardo and Freud, An Art Historical Study', *Journal of the History of Ideas*, vol. XVII, no. 2 (April 1956), pp. 147–78, and K. R. Eissler, *Leonardo da Vinci, Psychoanalytic Notes on the Enigma* (London, 1862).

say anything about this other controlling factor – and the interrelation of the two? In *Gradiva* the controlling factor is not hard to identify: it is the growth of Norbert Hanold's self-consciousness or, as Freud calls it, his 'recovery', which is in part an internal process and is in part effected through the agency of Gradiva. Now, Freud had an affection for this particular artistic compromise: it has a natural poignancy, and it also exhibits an obvious affinity with psychoanalytic treatment. As to the interrelation of the two factors, or how far the omniscient author is entitled to outrun his confused or unselfconscious characters, Freud has, implicitly at any rate, some interesting observations to make when he writes about the ambiguous remarks that abound in *Gradiva*. For instance, when Hanold first meets the seeming *revenant* from Pompeii, he says in reply to her first utterance: 'I knew your voice sounded like that'.[11] Freud's suggestion is that the use of ambiguity by an author to reveal the character of his subject ahead of the process of self-knowledge is justified in so far as the ambiguously couched revelation corresponds to a repressed piece of self-knowledge.

Freud, however, has no desire to impose the pattern of revelation controlled by the rate of self-knowledge upon all art for which it makes sense. In perhaps his most interesting piece on art, a few pages entitled 'Psychopathic Characters on the Stage', written in 1905 or 1906 but only published posthumously, Freud writes of those literary compositions in which the alternate current is supplied by action or conflict.

A relevant question that Freud deals with in this brief essay is, How explicit is to be our understanding of what is revealed to us? Freud's view is that it need not be explicit. Indeed, even in the most deeply psychological dramas, generations of spectators have found it difficult to say what it was that they understood. 'After all,' Freud writes engagingly, 'the conflict in *Hamlet* is so effectively concealed that it was left to me to unearth it.'[12] Indeed Freud's point goes beyond this. It is not simply that our understanding need not be explicit but that in many cases there are dangers in explicitness, for explicitness could give rise to resistance if the character suffers from a

11. Freud, IX, p. 84.

12. Freud, VII, p. 310. See also Jean Starobinski, 'Hamlet et Freud' in Ernest Jones, *Hamlet et Oedipe*, trans. Anne-Marie Le Gall (Paris, 1967).

neurosis which his audience shares with him. So here we have another virtue of what I have called the alternate current – namely that it serves what Freud calls 'the diversion of attention'. And one effective way in which it can do this is by plunging the spectator or the reader into a whirlpool of action from which he derives excitement while yet being secure from danger. And another contributory factor to this same end is the pleasure in play that is provided by the medium of the art: the element of 'free play' that had been so heavily stressed in Idealist aesthetics.

And perhaps at this point we should just look back again for a moment at the Michelangelo essay. For we can now see a reason why in certain circumstances it might be, not merely just as acceptable, but actually better, that the revelation of expression should be achieved through small touches, through the trifles to which both Morelli and Freud, though for different reasons, attached such weight. For these trifles can more readily slip past the barriers of attention.

And now once again it is necessary to switch our point of view. For the diversion of attention as we have just been considering it would seem to belong to what might be called the 'public relations' of the work of art. That is, its aim seems to be to secure popularity for the work or, more negatively, to avoid disapproval or even to evade censorship. However, if we now look at this process from the artist's point of view, we may be able to see how it can be regarded as contributing to the aesthetic character of the work. But first we must broaden our analysis somewhat. In the *History of the Psycho-Analytic Movement* Freud wrote: 'The first example of an application of the analytic mode of thought to the problems of aesthetics was contained in my book on jokes.'[13] We have now grown familiar with the idea that *Jokes and their Relation to the Unconscious* could be made use of in explicating some of the problems of art, but it is perhaps insufficiently appreciated that the credit for this initiative must go to Freud himself.

Freud distinguished three levels to the joke, each marking a successive stage in its development. All three levels rest upon a primitive substrate of play, which initially comes into operation with the infantile acquisition of skills – specifically, so that we may single it out for attention, the skill of speech. Play generates what Freud calls

13. Freud, XIV, p. 37; cf. XIII, p. 187.

functional pleasure, the pleasure derived from using idly, and thus exhibiting mastery over, a human capacity. Rising on this substrate, the lowest level is the *jest*, a piece of play with words or concepts with one and only one concession to the critical judgement: it makes sense. A jest is a playful way of saying something, but the something need be of no intrinsic interest. Where what is said claims interest in its own right, we move on to the second level and we have the *joke*. For the joke is constructed round a thought, though the thought, Freud insists, makes no contribution whatsoever to the pleasure that is specific to the joke. The pleasure – at any rate on the level with which we are concerned – derives entirely from the element of play, and the thought is there to give respectability to the whole enterprise by falsely claiming credit for the pleasure. And now we move to the third level – the *tendentious joke*. With the tendentious joke the whole machinery that we have so far considered – namely, the jest with a thought to protect it – is now used itself to protect a repressed purpose, either sexual or aggressive, which seeks discharge. But if we are to come to grips with this complex phenomenon, we must discriminate roles. Both jests and untendentious jokes are social practices, but their social side raises no real problems, nor is it of great significance. But with the tendentious joke it is significant. Let us see how this comes about. The joker makes use of the joke in order to divert his attention from the impulse that seeks expression, and the joke is expected to achieve this for him by the discharge of energy it can secure. But, unfortunately, the one person for whom the joke cannot perform this service is the joker: it is something to do with the fact that the joker has made the joke that prevents him from indulging freely in the possibility of play that it offers. The joke is incomplete in itself or, more straightforwardly, the joker cannot laugh at his own joke. Accordingly, if the joke is to fulfil the purpose of the tendentious joker, he requires a hearer to laugh at the joke – though, of course, the hearer, for his part, could never have laughed at it if he had made it himself. However, with the hearer, too, there is a danger, though the other way round: for it is the very openness of the invitation to play that might meet with censure if it is too blatantly extended. Hence the presence of the thought which is required to divert his attention from the play so that he may laugh at the joke. And his laughter licenses the joker in his ulterior purpose. In

so far as the joke falls flat or is denied acclaim, the joker will feel unable to afford the repressed impulse the release he had surreptitiously promised it.

How far this analysis of the tendentious joke may be applied to art is uncertain, and perhaps it would be out of place to demand a general answer. There would seem, however, to be two respects in which a parallel holds. In the first place, what Freud calls the 'radical incompleteness' of the joke parallels in psychological terms what is often called the institutional character of art – as well perhaps as suggesting the psychological machinery on which that institution rests. Art is (amongst other things) what is recognized as art, and Freud's account of the tendentious joke may allow us to see an extra reason why this should be so, as well as to make a new assessment of its importance. Secondly, there is a parallel between the uncertainty in the hearer of the joke about the source of his pleasure, and the diversion of attention that is predicated of the spectator of the work of art. And this should help to make it clear why 'diversion of attention' should be an aesthetic aspect of the work of art, and not just a cheap bid for popularity.

At this point it is worth observing that we are now in a somewhat better position to consider the first of the two questions that arose out of my opening quotation – when I said, you will recall, that it was unclear how far Freud's emphasis on understanding as a prerequisite of appreciation was a purely personal avowal, or whether it indicated a theoretical position. We have now gone far enough to see that part of understanding how it is that a work of art affects us is recognizing the confusion or the ambiguity upon which this effect in part depends. One of the dangers in psychoanalysis, but also one of those against which it perennially warns us, is that in trying to be clear about our state of mind we may make the state of mind out to be clearer than it is.

Indeed, it looks as though the 'diversion of attention' required of the spectator of the work of art is far more thoroughgoing than the corresponding demand made on the hearer of the joke. For the spectator not merely uses the overt content of the work of art to divert his attention from the element of play, he may also have to use the element of play to divert his attention from the more disturbing or latent content of the work of art. In this respect he

combines in himself the roles of the maker and the hearer of the tendentious joke. Freud, in dissociating himself from the traditional theory that 'intellectual bewilderment' is a necessary ingredient in the aesthetic attitude, may have prepared the way for an account of art and our attitude towards it more thoroughly and more deeply challenging to a naïvely rationalist view.

And this leads us to a large question, to which so much of this lecture has pointed. We might put it by asking, Is there, according to Freud, anything in the work of art parallel to the purpose that finds, or seeks, expression in so many of the other mental phenomena that Freud studied, and which variously provided models for his examination of art: the tendentious joke, the dream, the neurotic symptom? To this Freud's answer is, No. The artist certainly expresses himself in his work – how could he not? But what he expresses has not the simplicity of a wish or impulse.

Freud was guided in this by two rather elementary considerations, none the less important for that. The first is that the work of art does not have the immediacy or the directness of a joke or an error or a dream. It does not avail itself of some drop in attention or consciousness to become the sudden vehicle of buried desires. For all his attachment to the central European tradition of romanticism, a work of art remained for Freud what historically it had always been: a piece of work. And, secondly, art, at any rate in its higher reaches, did not for Freud connect up with that other and far broader route by which wish and impulse assert themselves in our lives: neurosis. 'We forget too easily' Freud is reported as saying, 'that we have no right to place neurosis in the foreground, wherever a great accomplishment is involved.'[14] The Minutes of the Vienna Psycho-analytic Society reveal him over and over again protesting against the facile equation of the artist and the neurotic.[15] But once we abandon this equation, we lose all justification for thinking of art as exhibiting a single or unitary motivation. For outside the comparative inflexibility of the neurosis, there is no single unchanging form that our characters or temperaments assume. There are constant vicissitudes of feeling and impulse, constant formings and reformings of phantasy, over which it is certain very general tendencies pattern themselves: but

14. *Minutes*, vol. II, p. 391.
15. ibid., pp. 9-10, 103, 189, 224-5.

with a flexibility in which, Freud suggests, the artist is peculiarly adept.

And, finally, we must remember that for Freud art, if expressive, was not purely expressive. It was also constructive. But here we come to a shortcoming or a lacuna in Freud's account of art which reduplicates one in his more general account of the mind, which was only slowly filled in. To understand this we have to look cursorily at the development of Freud's notion of the unconscious and unconscious mechanisms. Initially the notion of the unconscious enters Freud's theory in connection with repression. Then the notion proliferates, and the unconscious becomes identical with a mode of mental functioning called the primary process. Finally, Freud recognized that certain unconscious operations had a role which was not exhausted either by the contribution they made to defence, or by the part they played in the ongoing processes of the mind. They also had a constructive role to play in the binding of energy or, what is theoretically a related process, the building up of the ego. It was the study of identification, in which Freud included projection, that first led him to revise his views in this direction. But no shadow of this new development was cast over Freud's views on art, for the simple reason that there are not extended studies of art from this period. The unconscious appears in Freud's account of art only as providing techniques of concealment or possibilities of play. In a number of celebrated passages Freud equated art with recovery or reparation or the path back to reality.[16] But nowhere did he indicate the mechanism by which this came about. By the time he found himself theoretically in a position to do so, the necessary resources of leisure and energy were, we must believe, no longer available to him.

16. Freud, IX, p. 153; XI, p. 50; XII, p. 224; XIII, pp. 187–8; XVI, pp. 375–7; XX, p. 64.

11 Eliot and F. H. Bradley

And I am accustomed to more documentation: I like to know where writers get their ideas from.

Letter in The Egoist, *IV (11 December 1917), from Charles Augustus Conybeare, Carlton Club, Liverpool (presumably composed by the Assistant Editor, T. S. Eliot)*

Since 1916 there has reposed, first in the Eliot House, Harvard, then in the Houghton Library, the typescript of a dissertation submitted by Eliot for the doctorate of philosophy under the title 'Experience and the Objects of Knowledge in the Philosophy of F. H. Bradley'. When Eliot consented to publish this dissertation,[1] along with two related articles which originally appeared in the *Monist* for 1916, he spoke of his early academic philosophizing as 'a curiosity of literature',[2] 'a curiosity of biographical interest':[3] the curiosity of the work lying in its remoteness from the contemporary concerns of philosophers, let alone those of the poet himself, and its interest (according to Eliot, that is) in the evidence it furnished as to the formation of his prose style. 'My own prose style' Eliot asserted in the Preface,[4] 'was formed on that of Bradley': a style which he had

1. T. S. Eliot, *Knowledge and Experience in the Philosophy of F. H. Bradley* [K & E] (London, 1964). The two reprinted articles are 'The Development of Leibniz' Monadism' which originally appeared in the *Monist*, XXVI, 4 (October 1916), pp. 534–56, and 'Leibniz' Monads and Bradley's Finite Centres', which appeared in the same number of the *Monist*, pp. 566–76. The text throughout was edited by Professor Anne Bolgan, of the University of Alaska.

2. Letter of T. S. Eliot to me, dated 22 March 1962. 3. *K & E*, p. 10.

4. *K & E*, p. 11. It is worth observing that there are at least two versions of this preface, one of which was set up in proof before it was also decided to reprint the *Monist* articles, the other being the published version. The change in tone between the two versions indicates a growing seriousness with which Eliot was prepared to take his philosophical writings. In the early version there is, for instance, whimsically inserted after 'a junior master at the Highgate Junior School', the phrase 'where a small boy in the lowest form, who had heard that the "American master" wrote poetry, submitted for my consideration a small sheaf of manuscript verse entitled *Best Poems of Betjeman*'.

already⁵ described as 'perfect' – perfect, he was careful to explain, in its match with content, in the way it was 'perfectly welded with the matter'.

It is possible – in fact, not hard – to disagree with Eliot's comparison of his style to Bradley's: just as it is possible to disagree with the other comparison Eliot makes in the same essay, of Bradley's style to Arnold's. Indeed, the passages he cites serve his case none too well. However, with the dissertation now in print, criticism is unlikely to confine itself to the problem that Eliot himself isolated: the stylistic problem will be only one amongst many for the sake of which students of Eliot will resort to *Knowledge and Experience*. Even before the text became publicly available, attempts had been made to trace ideas, both in Eliot's poetry and in his criticism, to their origins in his philosophical education.⁶ It might therefore seem as though such a

5. Review of second edition of F. H. Bradley, *Ethical Studies*, in *Times Literary Supplement* (29 December 1927); reprinted in *Selected Essays* [*SE*], (London, 1932), pp. 392–403.

6. Eliot in the Preface to *K & E* says that Professor Hugh Kenner 'drew attention' to the doctoral thesis in a chapter in his *The Invisible Poet: T. S. Eliot* (New York, 1959). Kenner, however, did not obtain permission to examine the dissertation at Harvard. Reference to the dissertation is also to be found in Kristian Smidt, 'Poetry and Belief in the work of T. S. Eliot', in *Skrifter av det Norske Videnskaps-Akademi i Oslo* (II. *Historisk-Filosofisk Klasse*) (1949), no. 1; Grover Smith, *T. S. Eliot's Poetry and Plays* (New York, 1955): and E. P. Bollier, 'T. S. Eliot and F. H. Bradley: A question of influence', in *Tulane Studies in English*, vol. XII (1962), pp. 87–111. All these studies depend for their knowledge of the dissertation on the far from luminous summary provided by R[alph] W[ithington] C[hurch], 'Eliot on Bradley's Metaphysics', in *Harvard Advocate*, CXXV (December, 1938), pp. 24–6. A more extended paraphrase of the dissertation is to be found in Eric Thompson, *T. S. Eliot: The Metaphysical Perspective* (Carbondale, Ill., 1963). Lewis Freed, *T. S. Eliot: Aesthetics and History* (La Salle, Ill., 1962), which attempts to show that Eliot's theory of poetry derives from Bradley's philosophy of experience, subject to certain scholastic qualifications, reveals no knowledge of the existence of the dissertation. A detailed examination of the place of the dissertation in Eliot's thought is contained in an unpublished thesis submitted in fulfilment of the requirement for candidates for the doctorate of literature in English literature in the University of Patna by D. P. Singh entitled 'The influence of F. H. Bradley on T. S. Eliot', dated November 1964. There is a highly intelligent but very general or impressionistic treatment of the relation between Eliot's philosophy and his poetry in J. Hillis Miller, *Poets of Reality* (Cambridge, Mass., 1965).

project can now enter into a cooperative, and hence more progressive, phase.

At the outset – it must be said – optimism on this score needs to be heavily qualified. One immediate reason is the density, indeed the obscurity, of Eliot's philosophical writing. Whether or not this is inherent, residing in the prose itself, or whether time has not done as much as Eliot to cloud his meaning from us, we must accept the fact that *Knowledge and Experience* is a painfully dark work. Criticism that sets out to understand Eliot's achievement as a poet and as a critic by reference to it is likely, fairly soon, to be brought up short, or else, overtly or covertly, to reverse the enterprise and to find itself using the poetry and the criticism as a gloss on, or as a key to, the philosophy.

2. Poetry, we know, was amongst Eliot's earliest interests: he was writing poetry at the age of 16,[7] and circulating it amongst his friends and family from much the same time. However, there was a period when philosophy appeared to challenge poetry in Eliot's estimation, and he was even led for a period to suspend poetical work. His doctoral dissertation not only is a very sophisticated work, but it reveals an acquaintance with the contemporary philosophical literature, American, English and continental, far in excess of what might ordinarily be expected in a graduate student. In addition to Bradley and Meinong, who form the centrepiece of the thesis, Eliot shows a good familiarity with the ideas of Russell, Bosanquet, Stout, G. E. Moore, William James, Samuel Alexander, H. W. B. Joseph, Theodor Lipps, Sigwart, Prichard and the New Realists.

Eliot entered Harvard in 1906.[8] As an undergraduate he concentrated upon classical studies – though he also took some classes in philosophy from Santayana and G. H. Palmer. It was only after obtaining his master's degree in 1910, that he became primarily a student of philosophy. Eliot spent the year 1910–11 in Paris at the Sorbonne, where he listened to Bergson, on whose concept of the

7. T. S. Eliot, 'Byron', in *From Anne to Victoria*, ed. Bonamy Dobrée (London, 1937), p. 602.

8. For the facts of Eliot's student life, the reader is referred to Herbert Howarth, *Notes on some Figures behind T. S. Eliot* (London, 1965), on which I have drawn heavily. Howarth has almost nothing to say directly about Eliot and Bradley.

durée réelle he is said to have written a long essay, no trace of which survives.[9] Back at Harvard, in the autumn of 1911, he enrolled as a graduate student in the philosophy department, though, as was the practice, he did not embark on his dissertation for another two years. In this preliminary period Eliot studied, amongst other things, Indian philosophy. 'Two years spent in the study of Sanskrit under Charles Lenman,' he was later to write, 'and a year in the mazes of Pantjali's metaphysics under the guidance of James Woods, left me in a state of enlightened mystification.'[10]

From 1912–14 Eliot was employed as an assistant in the philosophy department. In the autumn of 1913 he selected the topic for his dissertation, and what precisely led him to choose as he did we do not know, though it was a choice well in keeping with the philosophical environment in which he lived. Eliot, it is recorded, bought his copy of *Appearance and Reality* on 12 June 1913,[11] but not only would he have been already familiar with Bradley's ideas, but the term 'the Absolute' makes an ironical appearance in one of Eliot's undergraduate poems that had been published in the *Harvard Advocate*, three and a half years earlier:[12] whether, however, the term is used in Bradley's sense, or in the more local sense, derived from the Harvard philosopher Josiah Royce, we cannot tell.

In the spring of 1914, Russell, who was at Harvard primarily to give the Lowell lectures, which were later published as *Our Knowledge of the External World*, gave a seminar on symbolic logic. Eliot attended Russell's seminar, and the impact that the two men made on each other was to be the foundation of a friendship of considerable importance in both their lives. At the time Eliot recorded his impression of Russell in the figure of Mr Apollinax. Russell, who had a low opinion of the rest of his students, singled out two for their ability: Raphael Demos, a professor of philosophy at Harvard until his death in 1970, and Eliot.[13]

However, of the state of Eliot's philosophical development at this period, we have a vivid, though somewhat intermittent, picture in

9. F. O. Mathiesen, *The Achievement of T. S. Eliot* (London, 1947), p. 183.

10. T. S. Eliot, *After Strange Gods* (London, 1934), p. 40.

11. Grover Smith, op. cit., p. 299, n.3.

12. *The Undergraduate Poems of T. S. Eliot* (Cambridge, Mass., 1938), p. 5.

13. Alan Wood, *Bertrand Russell, The Passionate Sceptic* (London, 1958), p. 94.

the published transcript of another seminar that Eliot attended in the same academic year.[14] This was Josiah Royce's famous seminar, which, officially listed as 'A Comparative Study of Various Types of Scientific Method', in fact ranged over as many topics as Royce's curious and energetic mind naturally took in. The philosophy graduates attended, and often some distinguished visitor, a philosopher or scientist, would be brought along. With Royce sitting at the head of the table, the meeting began with the reading of a paper, either a student's or a visitor's, and, even from the rather staccato notes taken by Harry Costello, the 'recording secretary' for the year, it is possible to reconstruct the animated and adventurous discussion that ensued and that made 'Philosophy 20C', as it was generally referred to, the centre of Harvard philosophy.

Amongst the graduate students who attended in his year, there were two, Costello observed in his 'Recollections of Royce's Seminar' (which have been printed along with the notes he kept) who were reckoned 'geniuses': E. E. Southard, the psychologist, and Leonard Troland, a chemist, and later co-inventor of Technicolor. And then there was one

whom none of us thought of as a genius. I spelt his name 'Elliot' instead of 'Eliot' in my early notes, and knew him later as Tom Eliot from St Louis. But in the course of time he was to make the name of T. S. Eliot more famous than all the rest of ours put together.[15]

Eliot presented four papers to Royce's seminar. Two were mere notes: one on 'description and explanation', read on 24 February 1914, and another on causality, read for Eliot by another graduate student, Sen Gupta, on 17 March. Whether the fault is Eliot's or Costello's, it is impossible to reconstruct from the précis that we have any coherent or developed argument in either case.

Of the two more substantial papers, the first, read on 9 December 1913, is on the role of interpretation in the social sciences, particularly in the study of primitive religions. The major interest of this paper is ancillary: for it shows us much about Eliot's absorption, even at this date, in issues and forms of erudition that were later to

14. *Josiah Royce's Seminar, 1913–14, as recorded in the Notebooks of Harry T. Costello*, ed. Grover Smith (New Brunswick, 1963).
15. ibid., p. 193.

colour *The Waste Land*. Basing himself on a reading of Durkheim and Lévy-Bruhl, Eliot also gave consideration to the ideas of Frazer, Jane Harrison, Max-Müller, Tyler, and Andrew Lang. His problem, if we are to trust Costello – for Eliot later gave himself a somewhat different account of the matter[16] – is this: If we study a phenomenon like, say, primitive ritual, it becomes clear that an intrinsic feature of what we study is how the person who is engaged in it interprets it. Accordingly, we must attend not merely to the outward behaviour but also to this interpretation placed upon it at the time by the agent. But, in doing this, we have necessarily to rely upon our interpretation, made now, of what this was. Accordingly, Eliot argued, the classical view of science, as successively approximating to the truth, does not hold good of the social sciences, and we must see them rather as the mere accumulation of interpretations. In answer to an objection made by Royce that interpretation was itself a self-correcting process, Eliot maintained that each new interpretation merely adds a new 'point of view': an argument which he somehow connected with the Bradleian thesis that no judgement is 'more than more or less true' i.e. the doctrine of degrees of truth.

The second paper that Eliot read, which was on 5 May 1914, was ostensibly on the subject-matter of psychology. The paper is, in detail as well as in its central concern, very close to the main part of his doctoral dissertation, and for that reason I shall not at this stage consider the actual arguments that Eliot deploys. What I shall do is simply to state the problem to which he addresses himself, for that, as we shall see, provides the background to much of Eliot's philoso-phizing.

The problem, which was much in the air at the time, is best seen as consequential upon the breakdown of the empire, or the intellectual hegemony, of traditional empiricism. For the empiricists, everything that constituted the life of the mind – where this stretched from imagination or fantasy through memory and perception to thinking, understanding and inference – could be analysed in terms of ideas presented, either singly or in complexes, to the mind. These ideas were, by and large, conceived of by the empiricists as images or as image-like phenomena. However, throughout the nineteenth century it became increasingly evident that this account was

16. Charlotte Eliot, *Savonarola* (London, 1926), Introduction by T. S. Eliot.

inadequate, at any rate to the totality of mental life. The objections made to it were varied, but one pervasive criticism was that this type of account could not properly exhibit the element of meaning or of reference that was inherent in all species of mental experience: it could not, in other words, do justice to the fact that every mental event, whether it is a case of imagination or of perception or of thought, is, in some appropriate sense, *of* something. To make good this deficiency what was required was to substitute for an account of the mind in which it is presented as characteristically engaged in passive contemplation of its own ideas another account in which it is seen as invariably standing in certain relations to things other than or outside itself. But once this general point has been taken, as it increasingly was by late nineteenth-century philosophers, the question that arose was, How sweeping is this substitution to be? How far is it to go? The empiricists, we might say, thought it enough to ascribe to mental states a *content*, and they did not trouble to assign them *objects*. But on a revised view of the matter, according to which each mental state has its object, what place, if any, is left for content? Does it have a residual role to play, or is it totally swallowed up in the object, or (another view) are object and content really the same thing only viewed in different perspectives or from different vantage points?

Now, to ask what is the subject-matter of psychology is a convenient, if oblique, way of raising this question. For, if there is anything left over to content after the necessary subtractions have been made in order to establish objects for mental states, then it would be natural to expect that it would be it, this residue, that was studied by psychology. If, however, there is no residue, then the subject-matter of psychology is problematic. Costello's notes suggest that already Eliot's views on the matter of content, or the subject-matter of psychology, were very negative, going well beyond, for instance, the position occupied by Bradley in the direction of Realism, i.e. in the direction of dissolving all mental states into mere relational complexes in which minds and the objects of which they are aware are the constituents. But, before taking up this point, I shall complete the biographical picture.

In the summer of 1914 Eliot was awarded a Sheldon Travelling Fellowship. He went first to Germany; when war threatened, he

moved to Oxford and to Merton College. Bradley was still a Fellow of Merton, but by this period a total recluse. Bradley and Eliot never met. Eliot worked with Harold Joachim, a pupil of Bradley but whose views did not necessarily receive Bradley's endorsement. With Joachim Eliot read Aristotle, and he gained from Joachim's supervision, as he put it, 'an understanding of what I wanted to say and of how to say it'.[17] In 1915 Eliot left Oxford, but by now he was determined to stay in England rather than to return to America. He earned his living as a schoolmaster, and he continued to work on the thesis, not having as yet abandoned the idea of fulfilling the requirements for the Harvard doctorate. In April 1916 the thesis was completed and dispatched. In the Houghton Library the original typescript has attached to it the carbon copy of a letter to Eliot from Professor Woods, sent soon after the arrival of the MS, saying that Royce had read it and spoken of it as 'the work of an expert'.[18] But Eliot never returned for the defence of the dissertation, the degree was not awarded, and it was only in 1932, seventeen years after he had left it, that Eliot revisited Harvard as Charles Eliot Norton Professor.

3. It was a likely choice on Eliot's part to base his study of Bradley on a study of Bradley's account of Immediate Experience. For the notion of Immediate Experience is, according to Bradley, at the base of his own philosophy. That there is such a condition is, he writes, for him an 'ultimate fact':[19] and elsewhere he says that no one is likely to go far in understanding his metaphysical theory who 'makes a mistake as to the given fact from which in a sense it starts'.[20]

The significance of Immediate Experience (or Feeling, as he also calls it) is for Bradley twofold. In the first place, it is important, because it constitutes the foundations upon which all the higher forms of knowledge or consciousness are grounded. At no point do we ever get outside what is given. Everything that we know, or will,

17. *K & E*, p. 9.

18. *K & E*, p. 10.

19. F. H. Bradley, *Appearance and Reality* (second edition, Oxford, 1922), p. 569. What I say about Bradley's philosophy throughout this essay depends on the more detailed treatment I have given it in Richard Wollheim, *F. H. Bradley* (London, 1959).

20. F. H. Bradley, *Essays on Truth and Reality* (Oxford, 1914), p. 246.

or feel, is already implicit in the condition of immediacy, and it moves into prominence as this condition breaks up or resolves itself into different elements. And it is important to see how broadly this is to be taken: for (to persist for a moment in a terminology that this view ultimately makes absurd) it is not merely the 'content' of any higher form of consciousness, but also the mental 'act' itself, that is contained in the fused-like condition of immediate experience. Secondly, Immediate Experience is important, because it provides us with a model of the kind of whole that we encounter again at the very peak of human knowledge – or, perhaps better, would encounter again if that peak were not unattainable. The non-relational immediate felt unity, which is Immediate Experience, prefigures the supra-rational unity of the Absolute, in which thought and its object are united to form Truth, and the major difference between the two stages or conditions is that, whereas at the former divisions and relations have not yet emerged, at the latter they have been transcended, they merge again in the highest experience.

By and large, Eliot would seem to have accepted Bradley's general estimate of the significance of Immediate Experience for any sound philosophy. Nevertheless, there are, roughly, four reservations that he thought it necessary to enter, or four respects in which he thought that the Bradleian metaphysic, even at this level of generality, was in need of supplementation or elaboration.

In the first place, Eliot was doubtful about the kind of priority that should be attached to Immediate Experience. Is it logical, or temporal? Does it relate to the life-history of the individual or of the species? Since, however, it is far from clear what either Bradley or Eliot concluded on this problem, and since the problem itself is only marginal, I shall not treat of it further.

Secondly, Eliot suggests – and this is definitely in the nature of a criticism on his part – that Bradley is insufficiently radical in his account of what happens when Immediate Experience resolves itself, as it does, into its constituents. I have already touched on this point, in referring to Eliot's views about the presumed subject-matter of psychology.

Thirdly, Eliot claims that the process of the break-up of Immediate Experience into the empirical world would be better understood, or that we should have a better chance of understanding it, if we

examined in detail, or with more emphasis laid upon the peculiarities of each, the different kinds of 'object' into which Immediate Experience is, at any rate partially, resolved: in other words, he argues that we should scrutinize those elements to which Immediate Experience gives rise on the 'objective' or non-self side.

Finally, Eliot would appear to be of the opinion that in one important respect at least Bradley had underestimated the difficulties that attach to the idea of everything being reabsorbed into a higher whole. For Bradley had taken insufficient account of the recalcitrance of 'finite centres', as Bradley calls the units into which experiences group themselves. In the second *Monist* article Eliot goes so far as to compare Bradley's 'finite centres' to Leibniz's monads, the basic units of what is generally conceived to be (though perhaps not by Eliot) one of the most uncompromisingly pluralist philosophies ever devised.

The strategy I shall employ will be to try to analyse *Knowledge and Experience* by working through it in the light of my second and third points. I have, however, said enough about the difficulty of Eliot's thought to hold out no more than hope of partial success.

A good way of introducing the criticism that Eliot makes of Bradley apropos of the resolution of Immediate Experience into its constituents would be to go back to an argument that Bradley himself employs in order to refute the suggestion that Idealism, or the thesis that everything is, or is constituted out of, experience, leads to Solipsism: the argument occurs in Chapter xxi of *Appearance and Reality*. Bradley argues that such a suggestion derives from a misconception of the nature of Immediate Experience. For it would be plausible to think that Idealism led to Solipsism, if, but only if, one also believed that the original form of experience was always given *as my* experience, or *your* experience, or *X*'s, or *Y*'s: if, in other words, the Self were a datum in Immediate Experience. But it is not: as reflection shows. Immediate Experience is essentially undifferentiated. It is only by a process of abstraction, or 'ideality' (where this means, roughly, filtering experience through 'ideas'), that we arrive at the notion of a Self: and when we do, we simultaneously arrive, Bradley insists, at the notion of a not-Self, under which must be subsumed the notion of other selves.

Eliot clearly underwrites this argument. He accepts its premiss: 'We have no right except in the most provisional way, to speak of *my* experience, since the I is a construction out of an experience, an abstraction from it.'[21] And he accepts its conclusion: so much so that when he comes to write of Solipsism in Chapter VI of the dissertation, he uses the word to identify a quite different problem, presumably on the assumption that the problem ordinarily so denoted had already been dealt with.

But feeling is, as we have seen, unstable. In Idealist terminology, it is 'self-transcendent'.[22] Being neither 'complete nor satisfactory' in itself, it disintegrates and develops into 'an articulate whole of terms and relations' the broadest division inside which is that into Subject, on the one side, and Object, on the other. It is necessary, Eliot insists, if we are to have a proper understanding of Bradley's philosophy, or indeed of philosophy, to realize that this process is just as important for the genesis of objects as it is for the genesis of the Self. We may easily accept the idea – at any rate, once it has been pointed out to us – that there is initially a kind of indeterminate feeling, out of which self-consciousness, the awareness of a self, develops: for that ultimately fits in with ordinary thought. But the philosophical point that Bradley makes, and in which Eliot concurs, is that *pari passu* with this, and logically of the same order, is the emergence of objects. And this is much harder to accept. 'It is easy to fall into the error' Eliot writes 'of imagining that this self-transcendence of feeling is an event only in the history of souls, and not in the history of the external world.' Why we should fall into this error so easily is, Eliot argues, not far to seek; and he gives two reasons. The first is that, in order for us to characterize the development or emergence of the subject, we have to assume the stability of external things, which are the objects (in a different sense) of these subjective states. It is only by reference to these objects that we can identify the states. So we can come to think of these external things as somehow prior to the Self. And, secondly, it is possible to ignore the fact that an object, too, depends for its existence on a continuity of feelings, because for the most part the feelings continuous with feelings of ours upon which its identity depends will be concealed from us, being

21. *K & E*, p. 19.
22. *K & E*, p. 21.

other people's: whereas those feelings upon which the existence of our soul depends are all open to us, being ours.

One point is worth noting here. In contradistinction to certain elements in German Idealism, Bradley rejects the idea that the transcendence of Immediate Experience can be regarded as the 'work' or 'construction' of the mind. The mind and the external world being concurrent products of a single process, we would be clearly wrong to attribute the existence of the latter to the agency of the former. Here Eliot obviously agrees with Bradley,[23] and indeed is quick to point out when Bradley, inadvertently, backslides from this position. So strong, however, within Idealism, is the terminological pull in the direction of asserting the workmanship of the mind that Eliot himself is not always able to retain consistency.

However, once the instability of Immediate Experience is allowed, there arises the problem to which, as we have seen, Eliot had already addressed himself, in the paper that he read to Royce's seminar on 5 May 1914. When Immediate Experience, or Feeling, develops into the two groups of Subject and Object, is there anything left over to the mind as its content, which can thus become the special subject-matter of a science of the mind? Eliot's position as he developed it in *Knowledge and Experience* is that ultimately there is nothing left over: mental contents are at best a transient phenomenon: and Eliot expounds at length, and obscurely, three possible confusions from which a continued belief in the existence of such things might draw support.

By now we have arrived at a point in Eliot's thinking which amounts to a definite departure from Bradley. Bradley, it is true, maintained that from a logical point of view we can (more or less) disregard the mere mental presentations that come before the mind. They lack, in themselves, the quality of meaning: and hence they contribute nothing to an understanding of those problems in which philosophy is interested. Nevertheless, Bradley thought that there were such presentations, and he moreover believed that they formed the proper subject-matter of psychology, for there mental phenomena are studied without reference to the issue of meaning. Such a position is not merely defended, it is also developed in certain characteristic Bradleian ways, in a paper (to be found in Bradley's *Collected Essays*)

23. cf. 'I am as much my construction as the world is.' *K & E*, p. 166.

of as late as 1900 significantly entitled 'A Defence of Phenomenalism in Psychology', and with which Eliot explicitly takes issue. Even Meinong, the philosopher who probably did most to influence Eliot towards thinking of the mind as always conversant with objects, postulated for any mental state both object (*Gegenstand*) and content (*Inhalt*). What is distinctive about Meinong is how he conceived content: as, by and large, a kind of arrow which pointed, and pointed in a way that no one could mistake, towards the object of the mental state. Moreover, Meinong did allow some presentational overtones to content.

The first confusion that, according to Eliot, perpetuates the myth of mental contents is the assimilation of feelings in the ordinary acceptance of the term – in which I fear X, or love Y – to feeling in the more metaphysical sense of Immediate Experience. In the former case, a feeling is something objective, to be observed and known in the same way as any other piece of the world. This is confirmed by the fact, which we tend to slur over in philosophy, that 'often an observer understands a feeling better than does the person who experiences it'.[24] However, the objectivity of feelings in this sense can get denied, because we tend to confuse them with the feeling of Immediate Experience, which has nothing objective to it. But if Immediate Experience is not objective, this is only because, as we have seen, it predates the moment at which the objective-subjective classification begins to apply. 'So far as feelings are objects at all,' Eliot sums up his position, 'they exist on the same footing as other objects ... And so far as feelings are merely felt, they are neither subjective nor objective.'[25] Nevertheless, Eliot allows that it is comprehensible, though not condonable, that objectified feelings and the feeling of Immediate Experience should be confused, for the two phenomena are continuous with one another, in that it is the latter that develops into the former.

Eliot's argument here is not as clear as one would wish. For, as even the summary that I have offered brings out, the sense in which objectivity is postulated of feelings, or 'evolved' feelings, suffers

24. *K & E*, p. 24. Eliot returns to this point in the second of the *Monist* articles: 'My emotions may be better understood by others than by myself: as my oculist knows my eyes.' *K & E*, p. 204.
25. *K & E*, p. 24.

from a rather serious ambiguity: an ambiguity which in turn gives rise to a weaker and a stronger version of his thesis. The weaker version is that it is only through a false assimilation of feelings to 'feeling' in the philosophical sense that we overlook the fact that feelings are objective in the sense that they can be studied scientifically, or as objects. However, even if we were clear about this fact, it would do nothing to show that feelings are not, or do not have, mental contents: this is what I had in mind in talking of this as the weaker version of the thesis. The stronger version is that what the assimilation of feelings to 'feeling' leads us to overlook is the fact that feelings just are their objects, or at any rate are so intimately involved with them that they cannot without grave damage to their nature be considered apart from them. Now this fact – if it is a fact – is evidently far more relevant to the view that feelings are contentless. But Eliot offers nothing in support of this thesis: unless it be his opinion, which of course would give a unity to his argument, that the fact that feelings can be studied as objects shows that they are inseparable from their objects: for it is only this inseparability of connection with something public that makes feelings accessible to others.

The second confusion that, according to Eliot, reinforces the notion of mental content is a running together of the two different points of view from which the life of the individual can be seen. From the point of view of the subject, an 'idea' or 'psychological event' (to talk generally) is something that is – with all the ambiguity that we have seen attaches to this term – objective: it belongs to the external world. From the point of view of the observer, however, a psychological event belongs to the history of the subject who experiences it: it is something personal. This theory of the two standpoints – which clearly bears upon it the influence of William James's 'neutral monism' – can also be stated, according to Eliot, as a theory concerning the two different kinds of law in terms of which we can explain the event. We can explain a psychological event in terms of laws asserting 'connections of the real world': that is how the subject would explain it. Alternatively, we can explain it in terms of laws – and this is Eliot's tribute to the materialist psychology that was indigenous to Harvard – asserting 'physiological connections'.[26] 'The idea as you try to grasp it as an object, either identifies itself

26. *K & E*, p. 75.

with the reality or melts back in the other direction into a different reality, the reality of its physiological basis.'[27]

It is, however, (Eliot goes on) natural to pass from one point of view to the other: Eliot uses a word of the period to characterize this transition, 'empathy'. And this ease of transition might then lead us, quite erroneously of course, to try and combine into a single description the attributes that psychological events present from these two different points of view. As a result we would then postulate something that is at once 'out there' (as such events are, seen from the subject's point of view) and also mental (as they are, seen from the observer's point of view). Eliot calls the items of traditional psychology 'half-objects',[28] thereby drawing attention to the ambiguous way in which they have come to be concocted or what he calls 'the psychologist's error of treating two points of view as if they were one'.[29]

The third confusion which, according to Eliot, sustains the belief in mental contents, is a mistaken conception about reference: about, that is, what we are doing when we say or think something about reality. Now Bradley certainly would have agreed, indeed he had been amongst the first to insist, that to mean something cannot be equated, as the empiricists would, with having an image or representation of that thing: this is in large part the burden of Bradley's attack on 'the psychological attitude', in which, as he put it, we, that is, we English, 'have lived too long'.[30] Nevertheless, Bradley seems to have believed that mental imagery has some role to play in the whole process of reference. He puts it (obscurely) by saying that meaning consists of 'a part of the content, original or acquired, cut off, fixed by the mind, and considered apart from the existence of the mind'.

But Eliot argues that this cannot be right. For while it avoids the crude empiricist conception of ideas as portraits of things, it assimi-

27. *K & E*, p. 76.

28. *K & E*, pp. 81–3. The meaning of this phrase comes clearer later, where Eliot says of Meinong's content that it is 'only a half-object: it exists, that is, as an object only by our half putting ourselves in the place of the speaker and half contemplating him as an object'. *K & E*, p. 94.

29. *K & E*, p. 93.

30. *The Principles of Logic*, vol. I, p. 2.

lates ideas to signs: it assimilates (as Bradley intended it to) the relation that holds between an idea and its reference, or between meaning and reality, to that which holds between a fox and cunning, or between a flower and some emotion which it has come to symbolize. But this is wrong for at least two reasons. In the first place, a sign can be misinterpreted, or not recognized as a sign at all. Secondly, we can identify that which is signified independently of the sign, the sign and its significance are heterogeneous. But neither of these characteristics holds good of ideas. We can see this from considering the use of ideas in thinking. A man cannot think without knowing what he is thinking of, nor, for that matter, without knowing that he is thinking. Nor can he identify what he is thinking of without his thinking of it.

How Eliot thinks that the matter should be seen is not so clear. We have, in his terminology, the following items to arrange: the idea, the mental content, the image, the concept, the (identical) reference. Eliot then successively disputes the equation of the idea, which is what we predicate of Reality, with the image, with the concept (here Eliot is criticizing Moore), and with the mental content. So there is left the relation of idea and reference, and Eliot declares that the idea is *almost* identical with its reference. What seems to prevent Eliot from totally identifying the two is a difference of aspect or function between them. For an idea is active, in that it has inherently an ostensive, or 'pointing towards' character. It points towards its reference.

But this way of putting the matter could itself easily be misunderstood, for it might lead us into thinking that an idea points to something outside itself, which is its reference. But this would be wrong. 'Every idea means itself.'[31] Eliot expresses the conclusion that he draws from this whole discussion by saying, 'Ultimately . . . ideality and reality turn out to be the same.'[32]

Eliot's final position on the nature of the mind is radical: and he expresses his position with unaccustomed clarity. 'There is' he says at the end of Chapter III,

in this sense, nothing mental, and there is certainly no such thing as consciousness if consciousness is to be an object or something independent of the objects which it has.[33]

31. *K & E*, p. 56. 32. *K & E*, p. 57. 33. *K & E*, p. 83.

Such a view undoubtedly circumvents certain problems both in the theory of the mind and in the theory of meaning. Yet a philosophy which adopts it thereby exposes itself to the no less serious dangers of Realism. If the ultimate identity of ideality and reality, of consciousness and its object, is maintained, how can one avoid a monstrous over-population of Reality? Monstrous not only in its scale but for its character. For every supposition, paradox, error, self-contradiction, will spawn a corresponding inhabitant of the world: Ivanhoe, the present king of France, the golden mountain, and the round square, all exist. It was against such a vision of the world that Russell, about this period, invoked his 'robust sense of reality':[34] and it is worth recalling that the philosopher who aroused in Russell this vision was the very philosopher whom Eliot appealed to in order to bring Bradley's philosophy of mind more in accord with the ultimate presuppositions, as he conceived them, of Bradley's metaphysic: Meinong.

Indeed, it is arguable that, even without the total replacement of mental content by object, Bradley's later philosophy was similarly exposed to the charge of a reckless proliferation of existences. In Bradley's case the crucial paper was 'On Floating Ideas and the Imaginary' written in 1906, and reprinted in the *Essays on Truth and Reality*, in which he withdrew the thesis maintained in the *Logic* that an idea could be 'held before the mind without any judgment'.[35] Under protracted criticism from Bosanquet, Bradley had come round to the view that every idea that is in the mind is *eo ipso* employed. 'Every idea essentially qualifies Reality.'[36] There are no floating ideas. At most an idea may not be referred to the limited section of reality to which we might immediately or unreflectingly think it relates: but that means only that it refers to another section. So it looked as if Bradley too had to accept the existence of such monstrosities as the golden mountain, or the round square. However, Bradley felt himself able to deal with at least the most outrageous consequences of the new theory by appeal to a new principle. It is certainly true that everything that we think of exists, but it does not necessarily

34. Bertrand Russell, *Introduction to the Philosophy of Mathematics* (London, 1919), p. 170.
35. *The Principles of Logic*, pp. 76–7.
36. *Essays on Truth and Reality*, p. 28.

exist with the characteristics that we think of it as having. The offending incompatibilities or inner contradictions appear only if we take too narrow a view of the groupings in which they are supposed to be contained: if we widen our view, if we take the seemingly contradictory elements as predicated of larger wholes, we shall find a point of union or reconciliation. Eliot is amongst those students of Bradley who have found this resolution of the problem unsatisfactory. For, after all, when we do see the incongruous element in a larger whole, in which it is said to be reconciled, this is because of a change in us, not in it. It is we who have stepped back and altered our point of view. But the element itself still remains as it was. 'In the "transcendence" of error', Eliot writes ('transcendence' being the Anglo-Hegelian word for the process by which something is taken up into a larger whole)

the error, as a real object, is not got rid of. An object is not transcended, though a point of view is; and it is only as we consider the hallucination not as an object, but as an element in a point of view, that it can be said to be 'transcended', 'transmuted', or 'dissolved'. Such a theory as that here outlined by Mr Bradley . . . appears unsatisfactory in that the unreality is merely pushed back and not done away with.[37]

Nevertheless, for all the apparent clarity of what Eliot is saying here, we could easily take his words in the opposite sense from that which he intended. For ultimately Eliot is not saying that Bradley's theory of the transcendence of error is wrong because it fails, despite its professions, effectively to spirit away recalcitrant objects in the world. Where, according to him, it is wrong is in thinking that this needs doing. Eliot's view might be expressed by saying that one has to address oneself to the problem of Realism, i.e. the over-population of the world, if, but only if, one accepts the assumption of Realism. This assumption, which is also called by Eliot 'the assumption of epistemology', is that 'there is one world of external reality which is consistent and complete':[38] more succinctly, that the world is 'made up of objects'.[39]

But, if we accept the full implications of equating, ultimately at

37. *K & E*, p. 119.
38. *K & E*, p. 112.
39. *K & E*, p. 120.

least, ideality and reality, the problem, according to Eliot, transforms itself. For, in admitting the existence of an object, we are not postulating the existence of something which mirrors or reduplicates our experience. To every idea there does indeed correspond an object. 'So far as the idea "golden mountain" is a real idea,' Eliot writes, taking up Meinong's provocative example, 'so far is it a real object.'[40] But that this does not induce a situation from which only 'a robust sense of reality' can save us follows from having a proper sense of what an object is. An object Eliot defines as 'a point of attention'. 'An object is as such a point of attention, and thus anything and everything to which we may be said to direct attention is an object.'[41]

Nevertheless, the issue misleadingly debated within epistemology as the problem of the existence or non-existence of objects, or of when we do and when we do not have knowledge, does for Eliot at least mark the site of a real problem: a problem that is better discussed, he maintains, in the familiar Bradleian terms of degrees of truth and reality. Objects, that is kinds of object, can be ranged according to the degree of reality that they possess, and this in turn is determined by the network of relations into which they enter. 'The reality of the object does not lie in the object itself but in the extent of the relations which the object possesses without significant falsification of itself.'[42] It is only under practical pressures, pressures which are unavoidable outside metaphysics, and also make their mark inside metaphysics, that we abridge the scale of reality and start to pronounce, *tout court*, some objects to be real, others unreal. But we must be on our guard against taking such pronouncements literally. Eliot writes, 'The difference between real bear and illusory bear is a difference of fullness of relations, and is *not* the sort of difference which subsists between two classes of objects.'[43]

What is required, Eliot thinks – and here I come to the third of the four reservations that, as we have seen, Eliot thought it necessary to enter in his support of Bradley – is to categorize the various kinds of object into which Feeling can develop. This is in keeping with what

40. *K & E*, p. 89.
41. *K & E*, p. 99.
42. *K & E*, p. 91.
43. *K & E*, p. 116.

Eliot says concerning the traditional problems of epistemology, as he saw them. 'Of the problems of the genesis of knowledge, of the structure of knowledge, and of the possibility of knowledge, it is the position of all sound Idealism, and I believe it is the position of Mr Bradley that the only real problem is the second.'[44] Costello had already, in his summary of Eliot's paper of 5 May 1914, suggested that 'as regards the classification of objects, the paper was along the lines of Meinong's proposed *Gegenstandstheorie*', and it is evident that once more Eliot is employing Meinong to supplement Bradley.

In his scale of objects Eliot appears to encounter most difficulty at what we might reasonably think of as the top of the scale and the bottom. The top consists in those objects which are fullest in their relations, the bottom in those which are barest. At the top we can place material objects or 'things', at the bottom self-contradictions. The problem about 'things' is that in order to have objects with that richness and permanence of property that belongs to thinghood we have to associate to the perceived, and hence existent, properties other properties which are unperceived or subsistent. Now these subsistent properties are universals, whereas the existent properties are particular, and so we have the problem (which apparently appears everywhere to a greater or lesser degree) that a thing is 'a complex composed of universals and particulars'.[45] Not the least of the difficulties that arises here is how to fit these two elements into the same time-order. The other problematic case, from the bottom of the scale, is that of 'self-contradictory' objects like the round square. Eliot insists – as against Bradley's equivocation on the subject – that, in so far as someone thinks of a round square, there is a round square, i.e. there is something that is both round and square. But we need to appreciate the very faint degree to which such an object has reality. For instance, it is not both round and not round, which is of course what would make it an 'impossible' object: for, on the level on which it exists, squareness does not imply not-roundness, though, of course, in other contexts it does.[46] And if this sounds an absurdly *ad hoc* way out of the difficulty, there are two points we need to remember which may make it slightly more plausible. The

44. *K & E*, p. 84.
45. *K & E*, p. 104.
46. *K & E*, p. 130.

first is that for Eliot presumably, as for Bradley (and, for that matter, for Hume), the relation of contrariety is something that we observe to hold between terms only on the basis of our experience: there are, in Bradley's words, 'no native contraries'.[47] Secondly, the link that holds between a word and its reference has, in Idealist thought, a closeness or intimacy that quite outstrips that between one word and another. What is of supreme importance for Eliot is the way in which any word merges with, and therefore necessitates the existence of, its reference.

However, by insisting more unequivocally than Bradley that we 'arrive at objects . . . by meaning objects',[48] or that every object that a finite centre apprehends is real, Eliot has, to a correspondingly greater degree, the problem how to unite the different points of view into a single world. For since no reduction has been effected on the level of the individual, or within his world, the dangers of conflict between the worlds of different individuals must naturally seem greater. This is the problem that Eliot calls Solipsism, and he treats of it in Chapter VI. Solipsism, he says 'has been one of the dramatic properties of most philosophical entertainers'. Nevertheless it 'rests upon a truth'.[49]

Eliot's argument on this point is hard to follow, but there seem to be roughly two different solutions between which he is indeterminate. One is that the different points of view fit together because we all intend a common reference. And Eliot seems to draw some support from the fact that in our own lives we are often able to transcend one point of view in favour of another; when we pass, that is, from one phase of thinking or feeling to another. For Eliot expressly rejects the equation of the self with a particular point of view: one self will contain many points of view.

To this solution, however, it might be objected, Yes, we may intend a common reference, but *is* there a common reference? At times Eliot seems to allow this objection, and thereby arrives at the second solution: which is that the metaphysic of a common world is based upon 'faith',[50] a word which had acquired a rather special

47. *Appearance and Reality*, p. 572.
48. *K & E*, p. 133.
49. *K & E*, p. 141.
50. *K & E*, p. 163.

sense in Bradley's metaphysic. At other times, however, Eliot seems not to allow this objection, and to reject it as too imbued with the assumptions of 'epistemology'. 'We ask,' Eliot writes

in what the identity consists, beyond the 'identical reference'. Yet while the question is natural, I cannot admit that it is legitimate ... A reference to an identity ... *is* the identity, in the sense in which a word *is* that which it denotes. An identity is intended, and it could not have been intended, we say, unless it was there; but its being 'there' consists simply in the intention, and has no other meaning.[51]

Yet it is in keeping with the obscure and dialectical character of this whole philosophy that we find, only a page later, after the problem had seemed so finally settled, Eliot writing

When I say that there is one world because one world is intended, I have stated only half the case: for any explanation in terms of 'because ...' can only be misleading unless we turn it about the other way as well. Let us say therefore, that we are able to intend one world because our points of view are essentially akin.

However, I do not think that this is quite the perversity of argument that it might at first seem to be. For in such a passage Eliot realized that identity of reference – where this means simply identity in the act of reference or an identity of intention – presupposes, if not a common set of objects where these could be identified separately from the identity of reference, then at least a shared system of reference. And it is this presupposition that he is bringing out in the passage just quoted. Yet it would, I think, be fair to say he failed correctly to appreciate the nature of this presupposition. He failed to see that the kinship required between points of view was the requirement that there should be a common language. Or rather he partly saw this: but partly – and here we have the influence of his old master, Josiah Royce, asserting itself – he thought that the requirement stretched beyond this and necessitated a community of souls upon which the individual was dependent for his existence. And here is the point at which a theory of Eliot's, which has many other roots as well, derives its philosophical support: I refer to his theory of tradition.

With the discussion of Solipsism, Eliot brings to an end his account

51. *K & E*, p. 143.

of what he regards as the one proper subject-matter of a theory of knowledge: as he puts it, in a poignant and dramatic phrase, 'the rise and decay of objects'.[52]

4. Are we now in a better position to trace the influence of Bradley's thought upon Eliot?

Much depends on how we envisage such an inquiry to be undertaken. There is an evident invitation simply to spread Eliot's work out in front of one, and then try to trace this influence upon it in points of detail. But I doubt if this method could take us very far: more specifically, whether we can use it to advantage until we have first settled the very broad question of how Eliot envisaged the assemblage of theoretical or speculative ideas inside literature. On this subject, he was on a number of occasions outspoken. 'A poet who is also a metaphysician' he wrote (and this is typical)

and unites the two activities, is conceivable as an unicorn or a wyvern is conceivable: he is possible like some of Meinong's *Annahmen*; for such a poet would be a monster, just as (in my opinion) M. Valéry's Monsieur Teste is a monster.[53]

Eliot goes on to say that a poet might use philosophical ideas, but he has no need to think them.

It would be a subject in itself to study the irony of many of Eliot's pronouncements on literature in general or on his poetry in particular – of which this passage in which he simultaneously depreciates, and makes clear his own, philosophical culture, is a fine example. Nevertheless, there are reasons, over and above its reiteration by Eliot, why we should take this assertion seriously.

Suppose, for instance, we begin our examination of the relation between Eliot, the mature Eliot, and Bradley's philosophy at the most obvious starting-point: that is, lines 411–14 of *The Waste Land*,

52. *K & E*, p. 156.
53. Paul Valéry, *Le Serpent*, with a translation by Mark Wardle, and an introduction by T. S. Eliot (London, 1924), p. 13. Other similar assertions are to be found apropos of Goethe and Blake in *The Sacred Wood* [*SW*] (London, 1920), pp. 59 and 141–2 respectively, and apropos of Shakespeare, *SE*, pp. 134–9. It is important to distinguish this question from the question whether the reader has to share the beliefs of the poet in order to appreciate the poetry: which is discussed apropos of Dante in *SE*, pp. 268–71, and generally throughout Eliot's criticism.

to which Eliot appends, as a note, a passage from *Appearance and Reality*. The lines run

> I have heard the key
> Turn in the door once and turn once only
> We think of the key, each in his prison
> Thinking of the key.

Here Eliot gives expression to what we might call a metaphysical version of loneliness, of total aloneness: the theme is the utter incommunicability of soul with soul. The passage that Eliot quotes from Bradley runs as follows:

> My external sensations are no less private to myself than are my thoughts or feelings. In either case my experience falls within my own circle, a circle closed on the outside; and with all its elements alike, every sphere is opaque to the others which surround it . . . In brief, regarded as an existence which appears in a soul, the whole world for each is peculiar and private to that soul.

Now this passage from Bradley has nothing to do with the thought that Eliot's lines express, and it is only to an uninformed reader that they seem related. For Bradley's concern is not with the fact of our communication, but with its basis, and his argument here is that our capacity to communicate is grounded not in the common content of our experience – for there is no such common content – but on a common intention. And not merely may we on general grounds assume Eliot to have been aware of Bradley's meaning on this, but in the second of the two *Monist* articles Eliot had already quoted this passage from Bradley, though at greater length, and had interpreted it as I have suggested. 'The world for Bradley' he sums up, 'is simply the intending of a world by several souls or centres.'[54] The view may be extreme, but it has not the edge of melancholy that Eliot a few years later professed, or pretended, to find in it.

Taking this as a warning, I shall confine myself to suggesting three very general tendencies of thought that are to be found in Eliot's writing, particularly his critical writing, and that also occur in Bradley: so we can say of them that, even if they were not transmitted from Bradley to Eliot, they would have been reinforced in Eliot by his reading of Bradley.

54. *K & E*, p. 203.

The first is what might be characterized, very broadly, as a peculiarly empty or hollow way of conceiving the mind. As we have seen, in Bradley's philosophy, and even more in Eliot's emended version of it, everything that would usually be held to constitute an element or content of the mind, either tends to reach out towards, or is itself, an object: so that, whereas from one point of view it belongs to the subject, to the history of a soul, from another point of view it can be easily detached from the subjective side and placed firmly on the side of the external world. And the paradox is that the point of view from which mental contents are subjective is the observer's or outsider's point of view: from the point of view of the person who experiences these feelings, sensations, desires, whatever, they fall on the objective side. It is not hard to see that we have here the background to Eliot's notorious 'impersonal theory of the poet': or, for that matter, to the dissociated way in which the experiences of *The Waste Land* stand to Tiresias, 'the most important personage in the poem, uniting all the rest'.

Nevertheless, there is a difficulty here, which is connected with how precisely the word 'background', as I have just used it, is to be understood. For the conception of the mind that Eliot took over from Bradley and added to, is philosophical in character, not psychological or ethical. In other words, we would expect it to hold at a higher level than, or be neutral between, the descriptions or prescriptions relating to the mind that occur in critical theory or in a poetic programme. And there is indeed some ambiguity or uncertainty in Eliot's essays concerning the extent to which, say, the thesis of the impersonality of the poet derives support from any philosophical 'disproof' of common-sense notions of personality. Is the 'escape from personality', which is the poetic vocation, a direct logical consequence of the dissolution by Idealism of faulty and ultimately incoherent notions of the self or personality – or is it merely an analogue in critical theory to what in metaphysics is a necessary truth? To put it bluntly: Does the poet not express personality, because there is no such thing as personality, or because he shouldn't?

There is a great deal in Eliot to suggest the latter. But also there is enough not to rule out the possibility of the former. For instance, a natural corollary to the philosophical thesis that all states of consciousness are intrinsically connected with their objects is the philosophical

denial of substantiality to the self: and it is significant that, in criticizing
the theory according to which poetry is the expression of personality,
Eliot writes, 'The point of view which I am struggling to attack is
perhaps related to the metaphysical theory of the substantial unity of
the soul.'[55] – How expressive of Eliot is that use of the word 'perhaps'!

Once the metaphysical self has been rejected, the self, as we have
seen, is to be explained entirely in terms of 'point of view': though,
as we have also seen, Eliot regarded it as an error to equate the self
with any one point of view. For we may shift our point of view.
Indeed, if we wish to consider any point of view, including one of
our own, we must adopt another. In that sense, we, as the summation
of our points of view, prove systematically elusive. 'To realize that a
point of view is a point of view is already to have transcended it.'[56]
I have spelled out this theory, because it seems to me that an argu-
ment in favour of interpreting the impersonal theory of poetry 'phil-
osophically', i.e. as a consequence of a philosophical theory about the
self, is that we can now observe the same connection between this new
philosophical theory and a further critical theory. And that is a theory
which Eliot expounds in one place, but which we can assume to have
been more widely operative with him, of the common roots of
poetry and drama. For these roots lie, according to Eliot, in the
continual shifts we make inside our experience in the effort to take
account of, to get the measure of, our ever changing point of view.
'In actual life', Eliot writes,

in many of those situations in actual life which we enjoy consciously
and keenly, we are at times aware of ourselves in this way [i.e. as dramatic
figures], and these moments are of very great usefulness to dramatic
verse. A very small part of acting is that which takes place on the stage![57]

Finally, in trying to determine the relation between the theory of
poetic impersonality and the conception of the mind and its objects
that we find in *Knowledge and Experience*, we should remember this:
that, according to the philosophical doctrine, the objective character
of experience is, as it were, a late development, it is the consequence
of high psychic evolution. So, if Eliot argues for impersonality as

55. *SW*, p. 50.
56. *K & E*, p. 148.
57. *SW*, p. 76.

being true only or supremely of the poet, this is not conclusive evidence that the critical theory is not philosophical: it may rather indicate that for Eliot the poetic consciousness is peculiarly highly developed, and hence reveals consciousness in its purest form.

And now the question arises, Given that the emotions that enter into poetry are impersonal, how are they to be conveyed? And this leads us on to the second and third elements in Eliot's critical thinking that have a distinctly Bradleian character. For, if in Bradley's philosophy of mind emotions are only conventionally associated with what is ordinarily thought of as the self that enjoys or experiences them, they are, in contrast, more intimately connected than they would be in common thought with two other aspects of the world: on the one hand, with objects or with their objects; on the other hand, with symbols or ideality. And Eliot, in the development of his poetics, takes up both these connections.

The connection between emotions and their objects gives us the theory – if that is what we can call something so perfunctorily set out – of the 'objective correlative'. 'The only way of expressing emotion in the form of art' Eliot writes,

is by finding an 'objective correlative'; in other words, a set of objects, a situation, a chain of events which shall be the formula of that *particular* emotion; such that when the external facts, which must terminate in sensory experience, are given, the emotion is immediately evoked.[58]

It will be appreciated that this critical theory derives from Eliot's account of the objectivity of emotions taken in the second of the senses I indicated: that is, that according to which emotions fall increasingly on the object-side, because of the way they coalesce around their objects. (It is irrelevant to the present discussion that the actual use Eliot makes of the idea of 'objective correlative' in his criticism of *Hamlet* is unwarranted on either conception of objectivity.)

The connection between emotions and ideality or, perhaps more simply, language, occurs as part of a critical theory that is generally asserted by Eliot in a historical form in which it is known as 'the dissociation of sensibility'.[59] In the sixteenth century, when there

58. *SW*, p. 92.
59. *SW*, pp. 287–8.

was 'a development of the English language which we have perhaps never equalled ... [s]ensation became word and word was sensation'.[60] Since then the falling apart of language and feeling, from which we have barely recovered, has made the poet's task intolerably difficult. In Swinburne we can see the disintegration at an extreme point: when we take to pieces his verse, we 'find always that the object was not there – only the word'.[61]

Once again there is some obscurity how this critical theory is to be connected with those parts of the philosophy which it seems to parallel: for instance, with the view that the symbol 'is continuous with that which it symbolizes',[62] or, again, with the view that name and object form 'a mystic marriage'.[63] The difficulty is in effect the same as the difficulty we encountered over the thesis of poetic impersonality. For that which, in the critical theory, is asserted as a perfection or as something to be aimed at, is asserted in the philosophical theory as a necessary fact. So, for instance, in a critical writing of Eliot's, we read, 'Language *in a healthy state* presents the object, is so close to the object that the two are identified':[64] whereas in the dissertation we read:

> Idea and phrase both denote realities, but the realities which they denote are so far as idea or phrase denotes, identical with the idea or the phrase. It is a mistake, I think, to treat the word as something which barely points to the object, a sign-post which you leave behind on the road. The word 'chimera' or the idea 'chimera' is the beginning of the reality chimera.[65]

How, we might ask, can it be a criterion of excellence in poetry to aim towards a certain condition of language that language necessarily or in its essence achieves? And here again the answer may lie in recognizing that in Idealist philosophy what is asserted to be the case is often in effect a terminal condition or a condition of perfection: a condition which is realized when the phenomenon in question, say emotion or language, has become everything that it has in it to be.

60. *SW*, p. 117.
61. *SW*, p. 134.
62. *K & E*, p. 132.
63. *K & E*, p. 135.
64. *SW*, p. 136. My italics.
65. *K & E*, p. 129.

Feeling and language are inherently one, but it is only in poetry, in the best poetry at that, that the unity can be exhibited.

The 'dissociation of sensibility' theory contains the further suggestion that the proper development of language, as indeed of knowledge, requires that there should be a shared social context of some considerable stability, within which consciousness can evolve in an unhampered fashion. This, however, brings us once again up to the frontiers of a large theory of Eliot's, which, as I have already had occasion to say, is, I think, only marginally grounded in philosophy: his theory of tradition. For this reason, I shall once again pause upon this frontier.

5. To trace the influence of Bradley's philosophy upon Eliot any way beyond such generalities seems to me a most hazardous and uncertain undertaking: and for a reason that goes deeper than either the obscurity of Eliot's philosophical style or his habit of toying with ideas both in his poetry and his criticism. I refer rather to two dispositions of the psyche of which – as Eliot said apropos of some speculations of his own concerning the Dante of the *Vita Nuova* – we simply become aware in reading the text: though the evidence for them is so fragmentary and elusive that anything we say about them must be confined to 'the unprovable and the irrefutable'.[66]

On the one hand, we may detect in Eliot a certain fear of the intellect: rather as though it were envisaged as something having the power to damage or dement those who used it in a literal manner. And alongside this, and at certain crucial points linked with it, there would appear to be in Eliot's make-up another disposition, which we may characterize by saying that it was only after he had made some kind of initial submission to a force felt in itself to be uncongenial or external, that he felt free to do something for himself or on his own account. Historically, of course, both dispositions have played a large part in the formation of art and its institutions. If we tend in Eliot's case to overlook or discount their operation, this (I suggest) is only because we are so seduced or beguiled by the highly ironical manner by means of which they are characteristically represented in his work, that we think that they are not to be taken seriously. But another way, and a more fruitful way, of looking at the matter is to think of

66. *SE*, p. 272.

the ironical manner itself as a further weapon in Eliot's armoury against himself. If it masks, it also reveals, the consistent self-depreciation in which Eliot indulged. But perhaps to see the phenomenon more clearly, we should divert our attention from its central manifestations and the way in which it conditions Eliot's achievement as a whole, and concentrate rather upon the trivial or peripheral ways in which it betrays itself. In this connection a study of Eliot's inconsistencies, of the way, we might say, in which he was compelled to deny an idea of his own once he had asserted it, might be very revealing as to his general temperament.[67]

The effect of the two dispositions that I have tried to characterize might be put by saying that Eliot, in the pursuit of a certain kind of security or reassurance that we are in no position to define, was progressively led to substitute in his mind, on the one hand, ideas of less content for ideas of more content, and, on the other hand, poorer or softer ideas for better and stronger ideas. To cite Eliot's conversion to religious orthodoxy in this context might seem to some controversial: though certainly the dispiriting nature of the particular theological diet on which he fed is beyond dispute. A clearer case still is provided by the interest Eliot is known to have taken in a work of popular philosophy that enjoyed a considerable middlebrow vogue in the years preceding the last war: J. W. Dunne's *Experiment with Time*. It is no disparagement of the poetic quality of the *Four Quartets* (though why it is not may still be puzzling to some) to say that at the peak of Eliot's career it is difficult to determine with any kind of accuracy when he was expressing the doctrines of idealist metaphysics and when he was writing under the influence of what was the philosophical equivalent of *bondieuserie*.

67. A small example would be the conflicting assessment of Charles-Louis Philippe, who is talked of in *The Sacred Wood* in a way that would not suggest the intense admiration that Eliot felt for him as a writer, both earlier on, when he was a young man in Paris, and later (1932), when he wrote a preface to a translation of *Bubu de Montparnasse*. Or again contrast what Eliot usually says about the relation of a poet to ideas with the criticism he allows himself to make of Poe: 'All of his ideas seem to be *entertained* rather than believed.' *From Poe to Valéry* (New York, 1948), p. 19.

12 On an Alleged Inconsistency in Collingwood's Aesthetic

In Book I of *The Principles of Art*[1] Collingwood asserts that the work of art is something imaginary: it exists in, and only in, the artist's head or mind. In Book III he denies that the relation of the audience to the work of art is non-existent or inessential. Collingwood goes on to say that these two views – one an assertion, the other a denial – which conjointly constitute his aesthetic, are not inconsistent: though superficially they might seem so. The inconsistency that Collingwood concedes that some might allege, but that he would dispute, provides the theme of this paper.

However, two preliminary points.

2. It might be objected that the first of the two views that I have attributed to Collingwood is in fact not his. For the view that he actually holds is considerably weaker. So we find him writing, 'A work of art *need not be* what we should call a real thing';[2] or 'It *may be* what we call an imaginary thing';[3] or, again, 'A work of art *may be* completely created when it has been created as a thing whose only place is in the artist's mind'.[4] In other words (the objection would run) the sense in which the work of art is asserted by Collingwood to be imaginary is perfectly compatible with its being, or its also being, in the real world.

Now, there clearly is such a sense. Moreover, it is a sense that would appear to be recognized by Collingwood: as, for instance, when he writes of the plan for a bridge, which can, at different times, be in the engineer's head and on his drawing board,[5] or, indeed, of the bridge itself which can, at different times, be in the engineer's head,

1. R. G. Collingwood, *The Principles of Art* [*P of A*] (London, 1938).
2. *P of A*, p. 130: my italics.
3. *P of A*, p. 130: my italics.
4. *P of A*, p. 130: my italics.
5. *P of A*, p. 131.

on his drawing board, and thrown across the river.[6] I maintain, however, that it is not in this sense that the work of art is asserted by Collingwood to be imaginary. The point is not easy to establish. With so carelessly written a work as *The Principles of Art*, appeals to the text are vain, if not perilous. So a more fundamental form of argument is called for.

If we start by asking what sort of claim Collingwood thought he was making in asserting that the work of art is imaginary, the answer is that he thought that he was making a claim about the nature of the work of art. Now, to assert that something is imaginary in the sense in which this is compatible with its being, or its also being, in the real world, is to assert that it is being imagined; and to assert that something is being imagined is not to make a claim about its nature. For we can, in principle at least, imagine anything. However, to assert that something is imaginary in the sense in which this is incompatible with its being, or its also being, in the real world, is to make a claim about its nature – as we do, for instance, when we assert this of gods, or the heroes of mythology, or fictitious characters. So, I would maintain, there is at least a *prima facie* case for holding that Collingwood's view that a work of art is something imaginary requires a strong interpretation, or, at any rate, a stronger interpretation than his 'need not be real' or 'may be imaginary', in the formulation of his view, would naturally suggest. Though in this sense, I shall maintain, the claim is certainly false.

3. I have expressed the second of the two views that I have attributed to Collingwood by saying that he is concerned to deny that the relation of the audience to the work of art is non-existent or inessential. And this way of expressing the view might suggest that Collingwood is equally concerned to deny the claim either way round. However, it must be pointed out that Collingwood's primary concern is to deny that the relation is non-existent, i.e. that the audience has no knowledge of, or acquaintance with, the work of art. And, indeed, it is not hard to see how the first of Collingwood's two views might be thought to commit him to the non-existence of a relation of knowledge or acquaintance between the audience and the work of art. If the work of art can never be in the real world but

6. *P of A*, p. 132.

must remain locked in the artist's head, how can the other inhabitants of the real world have knowledge of it?

The view that the relation of the audience to the work of art is inessential comes in only in a roundabout way. It comes in only if, to the view that the work of art is imaginary, is appended a subsidiary premiss designed, in the first instance, to obviate the conclusion that the relation of the audience to the work of art is non-existent. The subsidiary premiss would achieve this design by maintaining that the artist always could, even if he never did, externalize the work of art by making an object which, though not itself a work of art, yet stood in such a relation to the work of art that the audience could, through knowledge of, or acquaintance with, it, have indirect knowledge of, or oblique acquaintance with, the work of art. Collingwood, however, argues that any such subsidiary premiss could be objected to – quite apart, that is, from the conclusion to which it leads, which is, in Collingwood's eyes, no better than the conclusion it is designed to obviate. The subsidiary premiss could, according to him, be objected to because it belongs to what he thinks of as the technical theory of art; and this makes it for him both objectionable in itself and inconsistent with the view about the imaginary nature of the work of art to which it is appended, and which, in some sense, it is designed to protect.

Now let us return to the main stream of Collingwood's argument.

4. Collingwood argues for the view that the work of art is imaginary by considering the way in which the work of art comes into being; more specifically, the fact that it is made, or made up, or created, in the artist's mind or head.

Now, clearly, everything that is imaginary is made or made up in the mind or head: it could not be made or made up in the real world. But does the converse hold? And the answer seems to be, No. For if we accept that the engineer can make, or make up, a plan in his head, the plan that he makes up could also be in the real world – if, for instance, it were drawn. In other words, the engineer's plan would be imaginary only in what we have seen to be the weak sense of the notion: that is, the plan may be imagined, and, indeed, is imagined by the engineer.

I conclude, therefore, that Collingwood is wrong to argue that the

work of art is imaginary, where this touches on its nature, by considering the way in which it comes into being. For such considerations do not provide conclusive evidence as to its nature.

But, at this stage, I might be rounded on in the following way: I argued, in section 2, that Collingwood's view that the work of art is imaginary must be taken in the strong sense, since, in asserting it, he thought that he was making a claim about the nature of the work of art. But now we are considering Collingwood's argument for his view that the work of art is imaginary, and I am arguing that this argument is insufficient to establish that the work of art is imaginary where this touches on its nature. Why do I not rather argue the other way round, and say that, since Collingwood clearly regards his argument as sufficient, this shows that, in arguing for the view that the work of art is imaginary, or in asserting that the work of art is imaginary, he is not concerned to make a claim about its nature?

To this I would have two answers. First, Collingwood clearly regarded his argument not merely as sufficient to establish that the work of art is imaginary but as sufficient to establish this where this touches on its nature. Secondly, his argument is sufficient to establish something about the nature of the work of art – though not that it is imaginary. I shall now take up this last point, and the rest of this paper will be spent on the investigation of it.

5. The example by means of which Collingwood argues for his view that the work of art is imaginary is that of a man making or making up a tune in his head. And there are three features of this case on which he concentrates, and from which he tries to derive the desired conclusion.

The first is that the tune is complete before the man endeavours to set it down on paper. 'This tune is already complete and perfect when it exists merely as a tune in his head.'[7] The second is that, when the man endeavours to set down the tune on paper, what he sets down is not the tune. 'The musician's tune is not there on paper at all. What is on the paper is not music, it is only musical notation.'[8] And the third feature is that, when we listen to music, the music is not just the sounds that we hear. 'What we get out of the concert is something

7. *P of A*, p. 139.
8. *P of A*, p. 135.

other than the noises made by the performers . . . [W]hat we get out
of it is something which we have to reconstruct in our own minds,
and by our own efforts; something which remains for ever inaccessible to a person who cannot or will not make efforts of the right
kind, however completely he hears the sounds that fill the room in
which he is sitting.'[9]

This last feature is one of considerable generality; for what
Collingwood is drawing attention to here is nothing less than the
fact that a tune is something to which meaning or sense can be
assigned. An argument that runs from the fact that something has
meaning or sense to the conclusion that it is in (and not just made,
or made up, in) someone's head or mind not merely lacks any
evident plausibility but raises issues larger than can be dealt with in
the present context. Accordingly, I shall pass over this feature of the
example, and it is with the other two that I shall be largely concerned.

6. Collingwood, I want to maintain, is right to see the first two
features as linked, though wrong in the link that he sees.

Roughly, Collingwood thinks that the fact that what the man sets
down is musical notation is a consequence of the fact that the
tune is complete in the man's head, and, furthermore, it shows that
the view that the tune is imaginary is properly taken in a strong
sense, such that the tune could only be in the man's head. By contrast,
I maintain that the fact that what the man sets down is musical
notation is a precondition of the fact that the tune is complete in the
man's head, and, furthermore, it shows that the view that the tune
is imaginary is properly taken in a weak sense, such that the tune
need not be in the man's head.

7. Let us consider the following activities:
 writing a (short) poem
 composing a tune
 painting a picture
 making a sculpture
I shall call these art-activities.

And now let us in each case postulate an internalized version of
that activity so that, e.g. a man writes a (short) poem in his head.

9. *P of A*, p. 140–41.

It will be evident that, as we go down the list, an increasing discrepancy asserts itself between the original activity and the internalized version of it. The difference between making a sculpture and making a sculpture in one's head is greater than that between writing a (short) poem and writing a (short) poem in one's head. And, significantly – though I shall not make much of this – a natural way of thinking about making a sculpture in one's head, or, for that matter, painting a picture in one's head, is as imagining making a sculpture or imagining painting a picture: whereas to talk of imagining writing a (short) poem is in no sense a natural way of talking about writing a (short) poem in one's head, for it is to talk of something quite different.

There are, perhaps, various ways in which the discrepancy to which I refer, and which manifests itself to differing degrees in different art-activities, can be characterized. One way is that, when I write a poem in my head, I can write a complete poem, whereas, when I paint a picture in my head, I cannot paint a complete picture. Another way is that when I write a poem in my head, there is (or may be) a poem that I have thereby written, whereas, when I paint a picture in my head, there is not (or cannot be) a painting that I have thereby painted. For the moment, I want to bear in mind only the first way in which the discrepancy can be characterized, and to put to one side the second way: for, clearly, to take it up straight away would be to beg the issue at stake.

And now we have a choice. For it would be possible to regard the discrepancy and its varying manifestations as something not further explicable. On this view, it would be an irreducible fact of nature, or of our inner life, or both, that certain art-activities lend themselves readily to internalization whereas others only do so awkwardly or incompletely. Now, there certainly are some broad facts about the various art-activities and, behind them, about the different media of art that bear upon the issue, but to leave the whole problem resting on them, and to leave them quite unspecified, seems highly unsatisfactory. Furthermore, it will be appreciated that the variations in the discrepancy come fully into focus only when we move beyond contrasting, say, writing and writing in one's head with painting and painting in one's head and we take as the terms of the contrast writing a poem and writing a poem in one's head, on the one hand, and

painting a picture and painting a picture in one's head, on the other hand: which is what we have been doing so far in the discussion. In other words, the phenomenon becomes evident when we take into consideration not just the art-activities or the media of art but also the resultant works of art. Perhaps we have here a suggestion or an intimation which will enable us to pursue the phenomenon a little further and not leave it as an unexamined brute fact.

8. Works of art fall into two very different categories. Some, like poems or pieces of music, are types: others, like paintings, are particulars.[10] This distinction is not explicitly recognized by Colling-wood, and I should like to suggest that his indifference to it is responsible for some of the ultimate difficulties of his aesthetic – as well as for some of the unjustified plausibility that attaches to it on a cursory reading. I think that we can come to see this by considering the following three facts, all of which are grounded in this important logical distinction within works of art: between what I shall from now on call work of art-particulars and work of art-types:
 (i) that it is a sufficient condition of the making of a work of art-type that one should internally produce (e.g. say to oneself, play to oneself) a token of that type;
 (ii) that it is a sufficient condition of a work of art's being a work of art-type that it should be expressible in a notation;
 (iii) that the discrepancy between an art-activity and the internalized version of it arises acutely, or more acutely, with work of art-particulars.

These three facts are interrelated in a number of interesting and complex ways. I shall take up just a few of these ways as they are relevant to our theme.

9. Let us begin with (i).
This in part rests upon certain empirical differences between the art-activities or the various media of art to which I have already made reference in general terms (section 7). Nevertheless, it would be quite wrong to think that (i) can be explained entirely in terms of, say, the peculiar adaptability of music to internalization, or a special power that we happen to have for internally producing music. For

10. Richard Wollheim, *Art and its Objects* (London, 1970), secs. 4–9, 20, 35–7.

what is relevant here is not simply that we can internally produce music, nor even that we can internally produce a tune, but that we can internally produce a token of a tune-type. And this depends partly (it is true) on certain empirical differentiae of music, but partly on the fact that tunes are types, or, more generally, that pieces of music are work of art-types. And this last fact is, of course, not an empirical but a logical fact.

However, just as there are empirical considerations that bear upon internalization, so there are also empirical considerations that bear upon the question whether the works of a given art are work of art-types or work of art-particulars. If we turn to (ii), we see that one empirical consideration that bears on this question is whether a notation for the expression of a given art, or of works in that art, is available. For where such a notation is available, then there is a clear and determinate way of individuating particulars as tokens of a given type, and hence of identifying the work of art with a type.[11]

Thus there is clearly a relation between (i) and (ii), in that the existence of a notation enables a certain way in which work of art-types may be made, i.e. through the internal production of a token of these types. The question now arises whether the relation is stronger, in that a notation is required if works of art are to be made in this way. Now, clearly there can be an art whose works are work of art-types and yet there be no available notation for the expression of these works: consider prints. But the further question is whether in such an art work of art-types can be made in the relevant way: that is, by the internal production of a token. (Clearly prints aren't.) And the answer seems to be, No. It is only where a notation is available that this method of making works of art can be employed. To spell out the point: (i) gives a sufficient, but not a necessary, condition for the making of a work of art-type. However, this condition might be misunderstood. For, when a notation does exist and a man makes a work of art-type by playing or saying to himself a token of that type, there is no need for him to employ, or resort to, the notation. If a man composes a piece of music, and does so by playing it to himself, he does not, in the course of this, write out the score to himself. Nevertheless, the existence of a notation in which

11. See on these issues Nelson Goodman, *Languages of Art* (Indianapolis, 1968).

such a score could be inscribed does seem to be a precondition of the way in which he composes the music.

Now, for the relations between (iii), on the one hand, and (i) or (ii), on the other. It must already be evident that the case where the minimum discrepancy arises between art-activity and its internalization is where the work of art can be made through an exercise of the internalized activity. And this, as we have seen, presupposes that the work of art is a work of art-type, not a work of art-particular. Conversely, the discrepancy will be at its greatest where the art-activity is exercised in the production of work of art-particulars. And we can now see that – apart from any empirical considerations that bear upon the issue – there are two closely related logical features of the situation that make their influence felt in all this. In the first place, in internally producing a work of art-particular – say, in painting a picture to oneself (or imagining painting a picture) one is *ex hypothesi* not engaged in internally producing a token of a type which, in turn, is a work of art. What then are we doing? And the difficulty of giving a clear analysis of the internalized activity involved in such cases might lead one to think that in painting a picture to oneself one is not making a picture at all: though it is possible that one might later make the picture that one previously painted to oneself (or imagined painting). However – and this is the second feature – the identity of a painting that one paints to oneself and some painting that, at a later moment in time, one actually paints is notoriously difficult to determine. These two features, taken together, go a long way towards accounting for the somewhat tenuous relation, or the discrepancy as I have called it, between painting a picture and painting a picture to oneself.

10. Collingwood, we have seen, argues for his view that the work of art is imaginary by means of the example of the man who makes or makes up a tune in his head. The preceding discussion will have shown on how complex and delicately poised a set of factors this case rests. What is true of it cannot, without grave risk of error, be generalized over the other arts. It cannot, without certainty of error, be applied to those arts where the two conditions structural to Collingwood's example do not conjointly hold: that is to say, to those arts of which it is not true that their works are both work of

art-types and expressible in a notation. For, unless these two con-
ditions hold, though one may be able to engage in the internalized
version of the relevant art-activity, this will not necessarily result in
the making of a work of art.

Furthermore, in Collingwood's example and in any other case for
which what is true of it holds true, the resultant work of art will be
imaginary only in a weak sense. Indeed, in a sense weaker than any
we have conceived. For, if a man makes up a tune and does so by
playing the tune in his head, it does not seem justifiable to say of this
situation what I said at the end of section 6: that the tune is in his
head, though it need not be – which is, it will be recalled, what it is
for something to be imaginary in the weak sense. That is to say, it
does not seem justifiable to say this so long as reference is intended to
the tune-type: which is surely what we should be talking of, if we
are to talk of the work of art and not just its instantiations. It is
certainly true that there is a tune-token in the man's head, i.e. the
tune-token that he plays in his head in the course of composing
the tune, and it is also true that there could be, probably will be, other
tune-tokens not in his head, i.e. those that are actually played if the
tune receives that degree of attention in the real world. But it is
unclear that this justifies us in saying that the tune, where this now
means the tune-type, is, or ever was, in the man's head: or, for that
matter, out of it. The type is not in this way capable of location.

11. With the first of the two views that constitute Collingwood's
aesthetic so evidently in ruins, it is hard to know what is to be made
of the second view.

Collingwood himself, as we have seen, was anxious to claim the
consistency of the two views. And perhaps the most promising
interpretation that can now be put on this claim is that the second
view deals with those arts to which the first is, though not recognized
by Collingwood to be, inadequate. In other words, the second view
might be taken as giving the aesthetic of those arts whose works are
work of art-particulars. However, it is difficult to proceed far with
this suggestion, precisely because the view that Collingwood ad-
vances in Book III of *The Principles of Art* is so very fragmentary. It
seems that, instead of an internalized art-activity, which was the
principal theme of Book I, the kind of activity that we are now to

260 On Art and the Mind

think of is compounded partly of an art-activity and partly of an internal activity. But before we can get far with this suggestion, we must know how the two constituents are united. And here Collingwood is less than helpful, for he seems prepared to tolerate the thought that the two activities can be independently identified and yet are inextricably connected. For instance, apropos of painting, he writes, 'There are two experiences, an inward or imaginative one called seeing and an outward or bodily one called painting, which in the painter's life are inseparable, and form one single indivisible experience, an experience which may be described as painting imaginatively.'[12] A similar uncertainty attaches to the characterization of the work of art that is supposed to issue from this dual activity, and how it is to be categorized: what principles of identity and individuation apply to it.

Collingwood's aesthetic, for all its audacity and its richness of suggestion, for all the concern it most evidently expresses for art and the arts, suffers irreparably from the failure to harmonize the demands of mental philosophy and those of philosophical logic. It was the fault of the times, as much as the failure of the man, that these demands seemed so irreconcilable, the products of an ultimate conflict of interests.

12. *P of A*, pp. 304-5.

13 Reflections on *Art and Illusion*

There is a question that few of those who feel a concern with painting and have the habit of looking at pictures cannot have asked themselves at some moment or other. The moment most likely was an early one in their experience of art when, on opening some illustrated history of art or trailing through the long endless galleries of a museum, they first became aware of the astounding variety of styles, modes, manners in which at different times different artists have recorded the one unique unchanging reality. Once asked, however, the question is usually put aside, quite rapidly, probably with embarrassment, as revealing a naïvety or literal-mindedness quite unsuitable in a serious and sophisticated lover of the arts.

It is around this question that *Art and Illusion*[1] has been constructed. And if I may for a moment contravene the self-denying ordinance that I have for the course of this lecture passed upon myself and indulge in a brief tribute to the author of the book, I should like to say that I regard it as typical of the fundamental and radical character of Professor Gombrich's thinking that he should take as his starting-point a question that nearly all of us find it natural to raise, but then, instead of, as many do, thinking it superior to ignore it and pass on, he should prefer to press into the service of answering it a formidable and dazzling erudition.

The question might be put like this: Why has representative art a history? Why did Duccio and Rubens, Van Eyck and Monet, Uccello and Watteau, all of whom, it must be granted, were interested in depicting the visible world, depict it in such different, such bewilderingly different, ways – so different, indeed, that we have no method, even in the mind's eye, of abstracting these differences, but invariably see the manner as part of the picture, take in the subject together with the style? Are these differences, we might ask, essential

1. E. H. Gombrich, *Art and Illusion* [*A & I*] (London, 1960, second edition 1962). All page references are to the second edition.

or merely accidental? Could, for instance, the Egyptians have depicted the human body in the way the Florentines did, and could the Florentines have anticipated the Impressionists in the representation of nature? If the answer is yes, in what sense could they have done this? If the answer is no, how and why was the possibility closed to them?

To some these questions will seem quaint, even obsolete. For they carry with them, do they not?, the suggestion of a single end towards which all pictorial art has been directed – the representation of appearances – and in consequence a single criterion – naturalistic accuracy – by reference to which all its efforts are to be judged. Yet today we have outgrown these conceptions. We no longer esteem representational accuracy in our own art, and we are also able to see, by a kind of natural extension, that the hold that it had over earlier art has been much exaggerated. Indeed, so removed are we from this pictorial aim that we can no longer take seriously the problems associated with it. But to such objections Gombrich has his reply. If it is true that the representation of appearances was never the sole aim that earlier artists set themselves, it was certainly one aim and moreover an aim of singular and impressive cogency. And this cogency had much to do with the enormous practical difficulties to which its implementation gave rise. Indeed, the fact that as an aim it no longer commands general assent – or perhaps assent of any kind whatsoever – may very well be because these difficulties have now been largely overcome. They could not arise for the modern artist with the same acuteness with which they were experienced in earlier ages. Effects that would have been taken by the Greeks as indicative of powers of a divine order are now within the reach of any competent commercial artist: we overlook the fact that the 'crude coloured renderings we find on a box of breakfast cereal would have made Giotto's contemporaries gasp'.[2] But, if this is so, it looks as though an understanding of representation and its problems might be helpful for the understanding, not only of the art of the past, but also of the art of the present in so far as that defines itself in opposition to that of the past. Furthermore, it may well be the case, Gombrich argues, that there are other problems related to our understanding of art, specifically of non-representational or at any rate non-figurative

2. *A & I*, p. 7.

art, that are inherently linked to that of representation. An example might be the highly contemporary problem of expression, and it is significant that *Art and Illusion* ends on a brief, a tantalizingly brief, but stimulating, discussion of expression and the issues that expression raises.

2. The question why art has a history does not itself fall within the domain of art-history. Art-history, at any rate as traditionally conceived, is complete when it has recorded the changes that constitute the history of art and, perhaps, gone some way towards offering an explanation why these changes occurred. If we now want to ask why there has been change at all, then we stand in need of some more general body of theory to which we can appeal. There is, however, both in the literature of the subject, to which, indeed, the more philosophical art-historians have made a distinguished contribution, and in ordinary reflective thought, a number of theories which set out to answer our question, and as good a way as any to approach Gombrich's book is via a consideration of them: not only because Gombrich has something to say about each of them but because, in an uncertain terrain, they provide fixed points by reference to which his theory can be plotted. They form the natural background to *Art and Illusion*.

The first theory I shall consider is what might be called the *perceptual theory* of artistic change. According to this theory, each painter paints the world as he sees it, but each painter sees the world for himself, idiosyncratically, so that the various manifestations of representational art can be accounted for in terms of the varieties of human perception. Giotto, Velazquez, Van Gogh painted things differently because, and to the degree to which, they saw things differently. Secondly, there is what might be called the *technological theory* of artistic change, so called because, according to it, the course of art follows the history of technical advance in the skill of representation. It is to specific inventions and discoveries that we can attribute the capacity of successive painters to render effects of likeness or to encompass tricks of verisimilitude that lay quite outside the competence of their predecessors. On this theory, Egyptian art has a childlike character because Egyptian artists could do no better: by contrast, in later art, say in that of the Quattrocento or the High

Renaissance or the nineteenth century, we see the consequences of an ever-increasing body of representational skill and technique. Later, we might say, means better. And, thirdly, there is the *theory of 'seeing and knowing'*, felt by many to be the most sophisticated account of the matter obtainable, according to which artists across the ages have been involved in a kind of continuous and collusive enterprise to rid themselves of the burden of knowledge in their effort to portray the world as it presents itself. For knowledge of how things really are – for instance, that the face is symmetrical along the axis of the nose – is necessarily an obstacle in the way of depicting things as they appear to be – with, for instance, only half the face visible when seen from the side. To achieve a truly visual art what is required is to see the world directly, without preconceptions, and it is this struggle against the corrupting influence of knowledge, this sustained effort to capture the vision of the innocent eye, that accounts for the evolution of the pictorial arts from, say, the highly 'conceptual' art of the Old Kingdom to the totally 'perceptual' art of the Impressionists.

None of these theories is, in Gombrich's eyes, without interest or indeed without its element of truth: but against each of them as it stands, he brings, either implicitly or explicitly, what amounts to a fatal objection.

The perceptual theory is defective because, even if true, it would account only for the fact that art displays diversity, and not for the further fact that it possesses a coherent history. For, if the varieties of art were merely expressive of the varieties of vision, we should have no right to assume, as we do, certainly in connoisseurship, that pictures produced in spatial proximity to one another would be marked by natural likeness, nor should we have any reason to antici-pate the temporal evolution of style, which is not just an assumption, but a fact, about the course of painting. To remedy this defect in the perceptual theory some writers of a more speculative temper have postulated a history for human vision, for 'seeing' itself, tracing its evolution from the simple schematic vision to be found at the dawn of culture to the subtle and sensitive perceptions of modern man: the idea being that, once the history of vision is made out, art could then be geared to this history and so, indirectly, acquire one of its own. But any such supplementary hypothesis either straightway

takes us out of the empirical world into a realm of unverifiable entities, or else degenerates into narrow circularity. For when we ask for the evidence in favour of the hypothesis, either we are given empty speculation or we are referred back to those changes in artistic style which the hypothesis was introduced to explain.

By contrast the technological theory has the dual virtue both of accounting for the historical character of art and of admitting into its framework of explanation only identifiable entities. On the debit side, however, it can be said that the technological theory allows art a history at the expense of denying it value: and, while we are all agreed that art possesses a history, we also all believe that it possesses value. Yet, if the story of art is to be interpreted purely as a story of technical advance, of accumulating skill in the production of certain desired effects, it is hard to see why anyone should esteem the out-moded experiments of the past. They might have archaeological interest or the charm of a lost way of life, but certainly no intrinsic value. Furthermore, though the technological theory gives us a historical account of artistic production, it leads to what might reasonably be thought of as an excessively a-historical conception of artistic psychology. For, according to the theory, Giotto differs from Michelangelo and Michelangelo differs from Degas in that Giotto couldn't do what Michelangelo could do and Michelangelo couldn't do what Degas could do. But this allows the possibility that Giotto might have wanted to do what Michelangelo did, perhaps even what Degas did. But the conception of earlier painters haunted by images which only later painters were able to realize, forming these images in the mind's eye with a clarity and a fineness of execution that unfortu-nately outstripped the technical resources that they had at their disposal – such a conception is surely the product of a quite disordered historical imagination.

And then there is the theory of 'seeing and knowing'. In various ways an advance upon its rivals, able at once to provide an explanation of the phenomena of pictorial evolution and also to furnish a terminology in which they can be profitably discussed, it runs into difficulties because of its attachment to the unexamined distinction between an art based on what we really see and an art to which non-perceptual factors contribute. But notice that the accep-tance of this distinction is not peculiar to the theory of 'seeing and

knowing', though in this theory it comes to the fore. Both the technological and the perceptual theories of artistic change involve, in their different ways, reference to a kind of art which embodies the direct transcription of what the artist sees, free from any ancillary content. In the case of one theory, such an art appears as the aim, in the case of the other, it appears as the norm, of pictorial art. According to the technological theory, a thoroughly naturalistic art is that towards which all the ages aspire; according to the perceptual theory, it is that which they all effortlessly achieve. The question to which the two latter theories presuppose an answer arises in an explicit and inescapable fashion for anyone who takes seriously the theory of seeing and knowing. That question is, Is naturalism possible? For it is on this possibility that all three theories seem to be founded.

3. To the question, Is naturalism possible?, Gombrich's answer might be said to be yes and no. Yes, naturalism is possible: but no, what is commonly assumed to be naturalism is impossible. I shall take the second part of Gombrich's answer, or his attack upon what he calls 'neutral naturalism', first. By 'neutral naturalism' Gombrich would have us understand a form of art within which individual works can, outside any reference to style or convention, be regarded as *the* portrayal of a particular scene or incident, in which every stroke of the pen or brush is uniquely determined by what is given to the senses. Such a form of art is, Gombrich maintains, a fiction. 'There is no neutral naturalism', he writes.[3] And to establish this point, which engages him intermittently through *Art and Illusion*, he uses three different kinds of argument.

In the first place Gombrich employs arguments – most of them familiar enough but here restated with fine lucidity – which relate to the limitation of the artist's media. Take, for instance, the essential problem of colour. Nature produces, as we are all aware, a vast range of chromatic effects, and to achieve this she has at her disposal two variables: local colour, that is the actual colour of the object, and light, the ever-changing light that plays on the object. The painter, by contrast – and this is a fact of which we sometimes lose sight – has only one resource: the actual colour of his pigment, which is always seen in, or at any rate as if it were in, standard conditions. The light

3. *A & I*, p. 75.

in a gallery or a drawing-room may vary, brighten and fade, but such fluctuations are something with which the picture has to contend, not something that the painter can make use of. However, even if *per impossibile* the painter were able to match what he sees area for area, it still does not follow that there would be an identity of colour, or match, between the picture and the scene it depicts. For to assume this in the first place ignores the fact that (apparent) tone varies with size, so that a small patch painted with one pigment will most likely not resemble a larger patch painted with the same pigment:[4] and it is of course most unlikely that a painting will be life-size with its subject. Secondly, the 'mosaic theory of representation', as Gombrich calls it at one point,[5] leaves out of account the further fact that (apparent) tone is affected by the relations between the areas.[6] In this context Gombrich cites the 'spreading effect' in the famous Von Bezold arabesque. But this is only a singularly striking demonstration of the more general truth that, if you alter the relation between two shapes, they will look different even if they are of the same local colour. And it seems inevitable that the relation between two shapes on a flat canvas will be different from those which exist between the two elements in reality that they are supposed to represent.

The second set of arguments that Gombrich employs against neutral naturalism relate to the phrase 'what we really see'. For it must be evident that the artistic ideal of portraying things as we really see them, or of setting down what we really see – and it is around this ideal that neutral naturalism is constructed – could not long survive a demonstration that the phrase 'what we really see' has no clear reference. It seems to be an aim of Gombrich's to provide such a demonstration.

I must say now that I do not follow all of Gombrich's argument on this point, but I get the impression that much of it does not really engage the target upon which he wishes to direct it. For whereas what he claims to be attacking is the proposition that in all cases of seeing there is something that we really see, the proposition that much of the time he in fact attacks is a more specific one: namely, that there

4. *A & I*, pp. 262–3.
5. *A & I*, p. 263.
6. *A & I*, pp. 259–62.

is some *one* thing that in all cases of seeing is what we really see. In other words, Gombrich flings down his challenge in the direction of the very general thesis that all our vision has a determinate object. But the thesis that he actually fights and (I would say) conclusively defeats is one that accepts this and then goes on to identify this object in a special way with a configuration of flat coloured patches lying in a two-dimensional field. And this is, of course, merely a particular version or interpretation of the more general thesis. One could continue to think that in all cases of vision there *is* something that we really see, without thinking that it is always something of a specific and identical kind and *a fortiori* without thinking that it is of the kind that, traditionally, empiricist philosophers and psychologists have thought it to be. One could agree (and I am sure one should) with Gombrich that, 'We do not observe the appearance of colour patches and then proceed to interpret their meaning,'[7] without being forced to maintain that there is nothing that we really observe.

There are passages in *Art and Illusion* where Gombrich certainly shows himself aware of the difference between the avowed and the real object of his criticism. So, for instance, he writes, 'We "really" see distance not changes in size: we "really" see light, not modifications of tone; and most of all we really see a brighter face and not a change in muscular contractions;'[8] and championing Constable's naturalism he writes, 'What Constable "really" saw in Wivenhoe Park was surely a house across a lake'[9] as opposed presumably to a 'flat patchwork of colours' which Gombrich had just denounced as being a fabrication of false theory. Now in these passages Gombrich explicitly admits that there is something we really see, and if he still insists on placing inverted commas around the word 'really', this is no more than a pious tribute he pays to the more extreme thesis that he advocates elsewhere: namely, that whenever we see, there is nothing at all of which it can properly be said that it is what we really see.

Of this more extreme thesis I shall have something to say later. Here I shall only point out a feature of Gombrich's presentation that facilitates the confusion between them. And that is his use of one and the same formulation to cover the limited and the extreme thesis:

7. *A & I*, p. 219.
8. *A & I*, p. 282.
9. *A & I*, p. 278.

namely, that all seeing is interpretation. What suitability this phrase
has for expressing the more far-reaching thesis I shall consider when
I come to consider that thesis. The justice that the phrase does to the
more moderate thesis is that it catches the fact, presumably essential
to that thesis, that what we see is always partly determined by the
concept or concepts that we bring to the perception. It is because of
this that (as the thesis maintains) there is not one thing that we always
see, which might have been plausible if what we saw were entirely
determined by the brute facts of the case.

On the question whether the limited thesis is in any way fatal to
neutral naturalism I find it difficult to arrive at a stable opinion: partly
because the theory of neutral naturalism is itself somewhat indeter-
minate. What the thesis certainly does is to weaken the naturalistic
ideal considerably, by breaking any connection that one might have
supposed to exist between it and a specific or identifiable style – for
instance, Impressionism. For, if there is no one kind of thing that we
really see whenever we see, then the art that sets out to depict what
we really see will not have any consistent look; there is no pictorial
manner in which we can say *a priori* that a naturalistic painter should
work. It certainly seems as though in the three theories of artistic
change that we have considered there was such an assumption: and,
moreover, that this assumption is also at work in calling naturalism
'neutral'.

The third and final line of argument that Gombrich brings against
neutral naturalism derives from the role of projection in our vision of
art. For, even if the artist were able to set down on the canvas an
image that literally resembled exactly what he had seen, there would
be no certainty as to how the spectator would see the image. For the
image would be ambiguous: and ambiguous not just in the theoreti-
cal sense that it *could be* seen in different ways, but in the practical
sense (though Gombrich is not always careful to keep these two
senses apart) that it almost certainly *would be* seen in different ways.
Strictly speaking, this fact need not be seen as an objection to
neutral naturalism when this is defined, as it was above, as a form of art
in which every stroke was uniquely determined by what was given
to the eye. But such a definition, I suggest, seemed satisfactory because
it seemed natural to assume that if there was a one–one correspond-
ence between what the eye saw and what the hand did in obedience

to it, there would also be a one–one correspondence between what the hand had done and what the eye would then see of what it had done. If what is uniquely transcribed may be ambiguously perceived, naturalism as a pictorial aim has lost much of its point.

4. At this stage of the argument, however, when naturalism appears to be fatally trapped, Gombrich suddenly calls off the chase. For has not the argument gone too far? 'The old insight that it is naïve to demand that a painting should look real is gradually giving way to the conviction that it is naïve to believe any painting can ever look real.'[10] And such a conviction, however ingeniously argued for, must ultimately be absurd. For do we not unhesitatingly regard some painters as more realistic than others – Masaccio, say, than Cimabue, or Gainsborough than Perugino? Are there not even certain painters, like Constable or Monet, whom we consider to have achieved about as much in the mastery of appearance as is humanly possible?

The problem, then, is not so much the existence as the definition of naturalism: for if there is a respectable form of naturalism, it cannot be the neutral naturalism whose discomfiture we have observed. At this juncture Gombrich suggests a redefinition of naturalism in terms of the information that the picture conveys. To say, for instance, that a drawing of Tivoli is correct or truthful means 'that those who understand the notation will derive *no false inform-ation* from the drawing'.[11]

This redefinition has two great merits. In the first place it respects the simple logical point that truth and falsehood cannot properly be predicated of objects: strictly speaking, they are properties of statements and, if we loosely talk of a picture as correct or truthful, this is an oblique way of talking about a certain set of assertions that can be derived from the picture.[12] The question then arises, What assertions are we entitled to derive from a picture? – or, to put it another way, How much of the picture are we justified in inter-preting or decoding? And this connects with the second merit of Gombrich's redefinition, namely that it emphasizes the 'conven-tional' element in any form of naturalism. For, in order to know how

10. *A & I*, p. 209.
11. *A & I*, p. 78; cf. p. 252.
12. *A & I*, p. 59.

much of the picture is to be decoded, we must be acquainted with the convention or – to use a locution which Gombrich at one point[13] insists is 'more than a loose metaphor' – with the 'language' or 'vocabulary' in which the picture is composed. For instance, it would be quite erroneous to infer from the fact that our drawing of Tivoli is correct 'that Tivoli is bounded by wiry lines'.[14] To make such an inference would be to misunderstand the contour-convention in a drawing.

From Gombrich's redefinition of naturalism two consequences important for his general theory are derived. The first is that, though certain forms of art are clearly non-naturalistic, there is no unique form of naturalistic art towards which all forms of representational painting approximate to a greater or lesser degree. To posit the existence of such a style would be to make two further assumptions. First, that the conveying of information is a simple cumulative task, so that a picture containing a certain amount of information could always be revised so as to convey some further piece of information. But it may be that some information can be conveyed only at the expense of omitting other information: in constructing a picture we may have to make a choice. Indeed, Gombrich points out not merely that this may be so, but that in fact it is so – and he illustrates his point ingeniously by comparing three representations of a boat, one by Duccio, one by Constable and one by Turner, and he shows how, as we cast our eye across the paintings in historical sequence, we get progressively more information about the appearance of the boat as at a certain moment and in a certain light, and progressively less information about the structure of the boat. We are told new things at the price of having to take familiar things for granted. And the second assumption that seems to be involved in the idea of a unique naturalistic art is that there is only one way of conveying a given piece of information. But this also is clearly false. 'The world may be approached from a different angle and the information given may yet be the same.'[15]

The other consequence of this revised conception of naturalism is that we can now see that a 'correct' or 'truthful' form of art could

13. *A & I*, p. 76.
14. *A & I*, p. 78.
15. *A & I*, p. 78.

not conceivably have been the starting-point of artistic evolution. Defined as it is, it could only be 'the end product' of a long process of trial and error.

And here at last we have the stage set for Gombrich's account of the evolution of representational art: the theory of 'making and matching'. In the beginning, the artist makes a diagram of what he wants to depict – a crude model which, for those who understand it, succeeds in conveying a modicum of information about its object: a schema. Gradually, however, as the schema is matched against the object, deficiencies in its informativeness are brought to light. Suggestions are made as to how these deficiencies could be made good, and both the accuracy and the amount of the information it provided be increased; and so we have the schema corrected. The corrected schema, however, also has its deficiencies, and so the process of making and matching, of schema and correction, unfolds itself. At each step the resultant schema can always be said to be more lifelike than the schema of which it is a correction. And so it might seem that, as the process enters an advanced stage, we attain to an art of verisimilitude, a fully fledged naturalism. And so, in an historical sense, we do. But we should not conclude from this that, if only we had used our eyes properly in the first place, this kind of naturalism could have come into being without the long, painful struggle that led up to it. For such a conclusion would not merely be false: it would be absurd.

5. But, we might reasonably ask, Absurd in what sense? What kind of impropriety would attach to the supposition that representational art did not evolve in accordance with the principle of schema and correction? In other words, what is the status of Gombrich's hypothesis?

It must be admitted at the outset that on this point Gombrich himself is by and large unenlightening. In various places he talks of the 'psychology' of artistic procedure as though his theory were a contribution to our understanding of how the artist's mind actually works. But I do not think that this could really be his intention, for, if it were, one consequence would be that his hypothesis would be purely empirical. It would rest simply on observed fact, and would be overthrown if it could be shown that some artists worked or had

worked in a way other than that of schema and correction. But I do not think that Gombrich really envisages the possibility of a counter-example to his hypothesis, and this suggests that he puts it forward as a logical not as a psychological theory.

In the preface to the second edition of *Art and Illusion* Gombrich addresses himself to the problem, and what he says is revealing. 'I am grateful' he writes,

to one of my painter friends who helped me to formulate my problem afresh by asking me to tell quite simply what would be the opposite of the view I hold. It would be a state of affairs in which every person wielding a brush could always achieve fidelity to nature. The mere desire to preserve the likeness of a beloved person or of a beautiful view would then suffice for the artist to 'copy what he sees'.[16]

Now here Gombrich seems to suggest that things might have been otherwise than as they are, that there is a constructible alternative to the situation that obtains: in fact we cannot achieve instant fidelity to nature, but that possibility isn't ruled out as a matter of logic. Such seems to be Gombrich's suggestion. But if the argument of *Art and Illusion* has established anything so far, it is, surely, that the notion of fidelity to nature, taken in some absolute sense, i.e. otherwise than by relation to some prior process of schema and correction, must be absurd. And, if this is so, then any account that includes this notion must be absurd. So, in purporting to answer his friend's question, Gombrich is in effect saying that there is no fully coherent opposite of the view that he holds. For, in the ultimate analysis, the idea of representation necessarily involves the idea of trial and error. It is not merely that in the history of art, as we have it, making always does in point of fact precede matching, but that making must precede matching.

But, if making must precede matching, what this means is that we cannot have matching without (i.e. without being preceded by) making. But it does not mean that we cannot have making without (i.e. without being succeeded by) matching. Now, this asymmetry is of great importance to Gombrich, for it is in virtue of it that the hypothesis of making and matching acquires its secondary role in his system: that of an historical as well as a logical principle. In Chapters

16. *A & I*, p. xii.

IV and V Gombrich attempts to define certain very general phases in the history of art by reference to the degree to which making was linked with matching.

In Egyptian art making was virtually independent of matching. And this was because of the peculiar function that the Egyptians attached to the image. As far as we can reconstruct the situation their main concern would seem to have been not to secure a representation of an aspect or element of life – which would naturally have led them to correct the image, once they had made it, in the interests of verisimilitude – but simply to make an object. It is only with 'the Greek revolution' that we have the desire for an image that not merely existed but was 'convincing', that not merely stood for itself but also spoke of things outside itself; and it is at this juncture that, for the first time, we come across the restless, dissatisfied reappraisal of the object with the constant aim of bringing it closer and closer to the reality it attempts to mirror.

Again, Gombrich suggests that the connection between making and matching can be used to bring out the difference between medieval and post-medieval art. For in the Middle Ages the impact of 'the Greek revolution' was comparatively spent. The image was still regarded as primarily representational, but there was no longer that burning discontent with each and every effort to make it convey information about the world. For this we have to wait till the Renaissance. 'To the Middle Ages,' Gombrich writes, 'the schema is the image: to the post-medieval artist, it is the starting point for corrections, adjustments, adaptations, the means to probe reality and to wrestle with the particular.'[17] Between the Middle Ages and the world of the contemporary artist there lies a period where not only is matching always preceded by making (as it must be), but making is always followed by matching. In this period occurred the apogee of European naturalism.

6. This highly compressed summary of Gombrich's doctrine might suggest an obvious title for his book: *Art and Naturalism*. Yet if we look to the book, we find it called something quite different: *Art and Illusion*. Nor is this a mere vagary. For when we go on to examine the text itself we find that, throughout, the two sets of terms, 'natural-

17. *A & I*, p. 148.

ism', 'naturalistic' on the one hand, 'illusion', 'illusionistic' on the other, are used interchangeably. And there corresponds to this linguistic practice a substantive doctrine. It appears to be Gombrich's considered view that, within certain limitations, naturalism *is* illusion, and that a painting is to be regarded as more naturalistic the more effective it is in creating its illusion.

Total effectiveness will of course seldom be within its reach: 'that such illusions are rarely complete goes without saying,' Gombrich concedes.[18] And there are reasons for this, some of which at any rate in no way reflect upon the skill of the artist. In the first place, there is the setting or context in which the work of art is displayed, which almost invariably will provide a contrast with the work itself. As the eye passes over the picture, across the frame, to the wall on which it is placed, it cannot but become aware, however cunning the painting may be, of a discrepancy or discontinuity which is fatal to the illusion. In this connection Gombrich refers to the work of Baroque decorators or *quadratisti*, who were as successful as anyone could be in overcoming these difficulties: and he points out how their choice of subject-matter – the sky, a frieze, a cornice, always something which might actually have existed in the very place where it is portrayed – was guided by their determination to reduce or blur as much as possible 'the transition between the solidly built and the flatly painted'.[19]

Secondly, there is the fact that a two-dimensional illusion can only ever work for a stationary eye. Not only must the eye not take in the setting or context of the picture, but it must not move either inside the picture or relative to the picture. For then the illusion could be maintained only by ever-shifting modifications in the perspectival profiles of what is depicted, which of course will not occur. 'As soon as we move,' Gombrich writes apropos of a Fantin-Latour, 'the illusion must disappear, since the objects in the still life will not shift in relation to each other.'[20]

Finally, even if the visual illusion is complete – that is, it works for a stationary eye whose field of vision is wholly contained within the picture frame – it is unlikely to be accompanied by all those other

18. *A & I*, p. 234.
19. *A & I*, p. 221.
20. *A & I*, p. 234.

'expectations' which are, according to Gombrich, an integral part of our recognizing or identifying something as an object of a certain kind: expectations of what we would see if we moved, of what we would feel if we reached out our hand. 'All perceiving relates to expectations' Gombrich writes,[21] and he describes how all painters from the Greeks onwards have struggled to supplement the direct pictorial effects that were within their power with induced expectations. Yet these expectations, even when induced, hang by the slightest thread. We might feel that, if we craned our neck a little, the dinner plate would then look circular, or that, if we reached out our hand, we could succeed in touching the bloom – but we have only to try to crane our neck or to contemplate reaching out our hand, we have only to test the expectations the smallest bit and they evaporate and with them the completeness of the illusion.

Gombrich allows, then, that very few naturalistic paintings are totally illusionistic. 'Only in extreme cases . . . are the illusions of art illusions about our real environment.'[22] But this seems not to go against the view, for he continues to adhere to it, that naturalism depends upon illusion. The illusion may invariably break down: but then who says that a painting is ever totally naturalistic? It would seem an accurate formulation of Gombrich's thought to say that for him naturalism is an approximation to illusion, so that the more naturalistic a painting is, the more illusionistic it is, but that in practice naturalism is partial illusion – an illusion, that is, as successful and sustained as the medium permits.

Such a conception of naturalism is, it seems to me, quite untenable. In the first place it is clearly impossible for Gombrich to hold to such a conception, for it is quite inconsistent with the rest of his thought. Not merely is it out of line with his general notion of art as something conventional, which, for instance, offers up its secrets only to those who 'understand the notation',[23] but more specifically it makes total nonsense of the definition he offers elsewhere of naturalism. For a picture, it will be recalled, is said to be naturalistic in so far as it conveys (or, more precisely, in so far as there can be derived from it) correct information. But how can we be said to gain information

21. *A & I*, p. 254.
22. *A & I*, p. 234.
23. *A & I*, p. 90.

about an object from something that we take to be that object? A *trompe l'œil* painting of a duck, for instance, cannot, at least as long as it succeeds in being *trompe l'œil*, tell us anything about a duck: it is no more informative about a duck than the duck itself would be. If we are to talk meaningfully of information, we must be able to discriminate between, on the one hand, the medium of communication and, on the other hand, the referent or what is communicated.

But quite apart from issues of consistency within a particular system, which relate specifically to Gombrich, there are other and stronger reasons for rejecting the equation of naturalism with illusion: if, that is to say, we take illusion literally, which, I maintain we are required to do by the theory. In the first place such an equation completely distorts the attitude that we adopt to naturalistic painting.[24] It is surely quite untrue to suggest that, in looking at the masterpieces of Constable or Monet, we have any temptation, even a partial or inhibited temptation, to react towards them in a way similar to that in which we would to the objects they represent: that we in any way wish to stretch out a hand and join in the picnic, or to assume dark glasses against the glare of the sun.

Not only is Gombrich's conception of naturalism false to our ordinary attitude to paintings of this kind, but also – more seriously I should say – it conceals or distorts the kind of admiration that we feel for them. When we admire the great achievements of naturalistic art we do so because we think of them as very lifelike representations of objects in the real world: but to think of them in this way is clearly quite incompatible with taking them to be or seeing them as (in, if you like, the most attenuated sense of either of these two expressions) the objects themselves. Indeed, if we took the picture of an object to be that object, what would there be left for us to admire?

Of course, Gombrich does not explicitly deny what he appears to be denying: namely, that we admire naturalistic pictures as pictures. Yet, I maintain, in substance he does – at any rate in the sections about illusion – and I think that why he is able to do this is because

24. I mean by this the psychological attitude that we adopt. My argument would not be affected by any demonstration that, in looking at a picture where a river is depicted as being behind a tree, the eye makes the same kind of accommodation movement as if the river were actually farther away than the tree. (This note is stimulated by an observation made by Gombrich in private discussion.)

of the particular analysis he gives of what it is to see something as a picture of an object. For Gombrich, to see something as a picture of an object is to see it sometimes as a picture and sometimes as that object. To admire something as a good or naturalistic picture of an object is to say something about the speed or facility with which we can move between these two different ways of seeing it.

But now we must ask, Why does Gombrich analyse what it is to see something as a picture of an object in this particular way? And to understand his answer here – which is, roughly, that any other suggestion would be absurd or self-contradictory – we must consider a notion that plays an important role at this stage in the argument: and this is what Gombrich calls 'the inherent ambiguity of all images'.[25] We have already touched on this point, but we now need to look at it in greater detail.

For part of the time what Gombrich means by talking of ambiguity is quite clear. He introduces the notion at the very beginning of the book by a consideration of the now famous duck–rabbit figure (Fig. 6): a drawing which originally appeared in *Die Fliegenden Blätter* and which can, when accurately reproduced, indifferently be seen as a duck (turned to the left) or a rabbit (turned to the right).

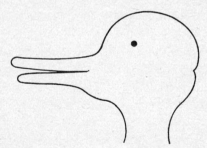

Fig. 6. Duck–rabbit figure

Later on Gombrich illustrates the notion by reference to the outline drawing of a hand, of which it is impossible to tell whether it is a right hand seen from the front or a left hand seen from the back. Having introduced the notion of 'ambiguity' by means of these special cases, Gombrich then goes on to point out[26] that in one signi-

25. *A & I*, p. 211.
26. *A & I*, pp. 209–17.

ficant respect all configurations drawn on a flat surface are ambiguous. For, if we take any given configuration, there is an infinity of shapes in space of which it is the correct perspectival profile. Of course, if the angle and distance from the spectator are known, the shape is determined – just as ordinarily, assuming the shape to be a conventional or familiar one, we can work out the angle and distance. But, if the angle and distance are not determined, we must in principle allow the shape to have any one of an infinite number of values. In this sense, then, all configurations are ambiguous.

So far, I think, everything is clear. Starting from a few particular cases which he characterizes as being ambiguous, Gombrich soon extends the application of the concept. But in doing so he extends only its denotation, and he leaves its meaning or its connotation intact. The feature in virtue of which the duck–rabbit figure, or the drawing of a hand, or all perspectival profiles, can be described as ambiguous is in each case the same: that is, that the figure can be seen in two or more ways, but that it cannot be seen in more than one way at once. This point is expressed by Gombrich at several places by saying that 'ambiguity . . . can never be seen as such'.[27]

But from the very beginning of the book Gombrich assimilates to these cases, and wishes to subsume under the concept of ambiguity, another feature that is universally possessed by images: namely, that they are both pictures (canvas) and of things (nature). Just as the duck–rabbit figure can be seen sometimes as a duck and sometimes as a rabbit, so a picture can be seen sometimes as canvas and sometimes as nature. It was the achievement of the earliest artists, Gombrich writes, that 'instead of playing "rabbit or duck" they had to invent the game of "canvas or nature"':[28] and he thereby suggests that the two games are identical in structure. Later the point is made more specifically. 'Is it possible' he asks

to 'see' both the plane surface and the battle horse at the same time? If we have been right so far, the demand is for the impossible. To understand the battle horse is for a moment to disregard the plane surface. We cannot have it both ways.[29]

27. *A & I*, p. 211; cf. pp. 198, 200, 223.
28. *A & I*, p. 24.
29. *A & I*, p. 237.

But why does Gombrich assume that we can no more see a picture simultaneously as canvas and as nature than we can see the duck–rabbit figure simultaneously as a duck and as a rabbit? Because – it might be said – canvas and nature are different interpretations. But, if this is Gombrich's argument, it is invalid. For the reason why we cannot see the duck–rabbit figure simultaneously as a duck and as a rabbit is not because 'duck' and 'rabbit' are two different interpretations, it is because they are two incompatible interpretations. Gombrich is correct when he writes, 'We can train ourselves to switch more rapidly, indeed to oscillate between readings, but we cannot hold conflicting interpretations.'[30] But it does not follow from this that we cannot hold different interpretations. For Gombrich's specific argument about canvas or nature to be effective, he requires a criterion for distinguishing between conflicting or (as I have called them) incompatible interpretations and merely different interpretations. Gombrich offers no such criterion and, in its absence, he has no right to insist, against common sense, that seeing something as a picture of an object *must be* sometimes to see it as a picture and sometimes to see it as that object. He has no right, in other words, to assert that the picture is ambiguous in the sense in which the figure in the picture is: for so far all he has established about what the two cases have in common is that in both multiple interpretation is possible.

Finally, I should like to consider two lines of thought in Gombrich's book which more indirectly relate to his equation of naturalism with illusion: one which might have led him into the belief, the other which might have helped to sustain him in it. The first is to do with Gombrich's use of the notion of 'projection'. For Gombrich emphasizes, surely rightly, the immense importance of projection in the viewing of naturalistic art. But under the general heading of projection he brings together (I want to suggest) phenomena which, though they can be arranged on a scale, need also to be distinguished rather carefully: by assimilating the phenomena that lie on one end of the scale to those which lie on the other, Gombrich finds support for his view that naturalism is illusion. The variety of phenomenon he has in mind is illustrated by the three examples that he gives of projection. First, the case of Shadow Antiqua lettering, in which

30. *A & I*, p. 198.

letters are indicated only by what would be their shaded side if they were formed of ribbons standing up, but where we tend to see a top to each letter (Fig. 7). Secondly, there is the case of the Giandomenico

ILLUSION

Fig. 7. Shadow Antiqua

Tiepolo etching where we read the garments of St Joseph and the Virgin Mary as coloured (even if indeterminately coloured) (Plate 13): and finally there is the case of *all* representative painting,[31] of Frith as well as of Manet,[32] of Van Eyck[33] as well as the Impressionists, for throughout we project on to the dabs of paint people and objects as they exist in the world. But 'projection' here has no single simple core of meaning, though all the cases may have what is called a family resemblance. In the case of the Shadow Antiqua lettering we see something that definitely is not there: in the case of Van Eyck, or even Manet, the most that can be said is that we would not see what we do if it were not for something outside, or in addition to, the 'visual situation'. In the first kind of case there is a genuine deception: in that the beliefs of the man who makes the projection will be incompatible with those of the man who does not. In the third kind of case there is no such deception: and correspondingly there is no divergence in belief between the man who makes the projection and the man who cannot make head or tail of an Impressionist or even of a Quattrocento painting. By assimilating the latter kind of case to the former, by subsuming all cases of projection under the single pattern provided by the reading of Shadow Antiqua, Gombrich is drawn towards the view that to look at naturalistic art is to experience a kind of illusion.

The second line of thought to which it seems to me some responsibility must be attributed for Gombrich's equation of naturalism with illusion, at least in that it sustains him in this position, is connected with a view of his about perception, which I have already

31. *A & I*, pp. 158, 170, 191.
32. *A & I*, p. 181.
33. *A & I*, p. 184.

referred to but so far delayed considering. I referred to it as the more extreme version of the thesis that all seeing is interpretation, and I said that this is a view to which Gombrich adheres some of the time but not all the time. In the next section I shall consider the view itself in some detail, but I want here to anticipate that discussion to the extent of pointing out one consequence that the view would appear to have. If we accept the view, then we seem committed to assigning to perception, in part at least, a subjective or arbitrary character: it cannot, in its entirety, be checked against experience. If I am right in this, then it would look as though someone inclined to accept this view would be comparatively undisturbed by one kind, and perhaps the most obvious kind, of objection to the equation of naturalism with illusion. That the perception of pictures should involve deception will seem much easier to accept if it has already been conceded that deception is something in which all perception participates to some degree or other. – But now I can delay no longer considering that view of perception which has this for its consequence.

7. In any comprehensive analysis of *Art and Illusion*, it is not possible to pass over Gombrich's more extreme theory of perception. For though it is in itself only a minor theme in the book, as well as one to which Gombrich is only intermittently committed, it emerges from, and remains so entwined with, the major theme, that if it were ignored, the examination of the other would be incomplete.

By the major theme of *Art and Illusion*, I mean Gombrich's account of artistic change, or his answer to the question, Why has art a history? As we have seen, his account is that aesthetic change occurs by means of the mechanism of schema and correction. Without some initial schema, which gradually, step by step, we correct and refine, we would never arrive at anything reasonably naturalistic in the arts.

However, having set out this account of artistic change, Gombrich then goes on to propose a parallel account of perception: an account, that is, according to which perception displays the same pattern. We acquire visual knowledge of the world by first applying schemata to it and then correcting and refining them in accordance with anticipations rewarded or frustrated, until we arrive at an undis-

turbed or, as we might say, 'naturalistic' vision. 'The very process of perception,' Gombrich writes, 'is based on the same rhythm that we found governing the process of representation: the rhythm of schema and correction'.[34]

The question arises, What is the relation between these two isomorphic theories? At first it might seem that this more general theory about schema and correction provides some kind of confirmation for the specific theory. For, if the phenomenon of schema and correction is very widespread, as widespread as vision itself, it is not surprising – one might think – that it is to be found also in the more limited domain of art. Gombrich himself is sometimes of this view: and it is, of course, when he is of this view that he is particularly inclined to assert the schema–correction theory of perception. Against this I want to argue that, if we believe perception to embody the process of schema and correction – where (note) these two latter notions are used in just the same sense as that in which they are said to determine artistic change – then, in the first place, so far from having a theory that gives support to the theory of artistic change, we will have one that is incompatible with it, and, secondly, the theory that we get will be quite inadequate to perception. The two points are related.

The theory of artistic change asserts that we move towards naturalism in art by means of the progressive correction of schematic images. We make a schema that is intended to represent a certain object: we observe the schema and then correct it so as to bring it more into line with the object. Now, for such a theory to hold good, there must at some point be what we might call an 'exit to the object'. Without such a possibility any progression within representational art towards verisimilitude would be purely coincidental, and so, in at least one important respect, Gombrich's theory of artistic change would have failed to explain what it was devised to explain. Now, the natural place to locate this exit to the object would be in perception. And this certainly fits in with our ordinary view of perception. Accordingly, if, as I shall argue, the theory that perception too proceeds in accordance with schema and correction means that perception cannot provide this exit to the object, we can see how the theory is at one and the same time at odds with the theory of

34. *A & I,* p. 231.

artistic change advanced in *Art and Illusion* and false to the nature of perception.

So the question arises whether it is indeed the case that, if the schema-correction process is thought to give the nature of perception, this would have the effect of enclosing perception within itself, of denying it its essential character. I think that there are two ways – both perhaps somewhat oblique – of showing that some such consequence holds.

The first is to contrast the analysis of perception in terms of schema and correction with the corresponding analysis of representation. I have already said something about this. The analysis fits for representation because we can assign a clear meaning to the notion of correction. If we are to talk of the correction of schemata, then there must be available an appeal to something outside the circle of *those* schemata: when the schemata in question are representational, we can clearly envisage such a possibility, and it is consequently on this possibility that the fittingness of the analysis to representation rests. However, when the analysis is re-applied to perception, the situation is radically transformed. For now there seems no possibility of an appeal to anything outside the circle of schemata that the analysis proposes. The only appeal that seems possible is one within that circle, i.e. from one perceptual schema to another. And this, which seems to have no claim to be thought of as correction, will ensure that perception is a purely hermetic activity. At this stage it might be argued that we should understand the notion of schema altogether differently in the context of perception from how we do in the context of representation: but that is to go outside the original terms of the argument. The charm, and the value, of a unitary analysis has been lost. The situation might be put more generally, thus: Representation is a parasitic phenomenon, and that is one reason why the schema-correction analysis suits it. Perception – which is that on which representation is parasitic – is a self-correcting phenomenon. And it is inadequate to apply the analysis that fits the former kind of phenomenon to the latter kind, with simply the adjustment that, in the new case, any reference to anything outside the phenomenon is blocked. For we haven't thereby arrived at a self-correcting process, we have, rather, an incorrigible process.

The second way of bringing out the unacceptable consequences of analysing perception in terms of schema and correction is to contrast this analysis of perception with another analysis of perception. The other analysis is one which, as we have already seen, Gombrich accepts for much of the time. I have referred to it as the more limited version of the thesis that seeing is interpretation, and we are now in a position to recognize that the schema-correction analysis of perception can be equated with the more extreme version of the thesis – though some of the difficulty in *Art and Illusion* comes from the fact that Gombrich does not always recognize the difference between the two analyses.

Now, on the first analysis – or the more moderate version of the thesis that seeing is interpretation – it follows that when I see x, I always see x as y: where, of course, x and y may be identical. On the extreme version of the thesis – or the schema-correction analysis of perception – it follows that when I see x, I always see a schema of x: where *ex hypothesi* x and a schema of x cannot be identical. Now, the first of these two views clearly allows for correction. For when I see x as y, I might learn that I am committing an error, i.e. in how I see x: for the fact that I see x provides me with grounds for such correction. But (apart from its internal incoherence) the second analysis cuts me off from any such possibility. For when I see a schema of x, I don't see x – if, that is, x and the schema of x can never be identical.

Someone, it is true, might take up this last point and suggest, very reasonably, that, when 'I see a schema of x' is given as the analysis of 'I see x', it must be wrong to understand 'a schema of x' in such a way that x and a schema of x can never be identical. And the suggestion might be made that an adequate account of perception could be made out in terms of schema and correction, if 'a schema of x' were understood as more or less synonymous with 'a schematized x'. And taken in this way, the analysis clearly would provide for what in principle it insists on: namely, the possibility of correction. However, while I am in sympathy with this suggestion it does not preserve the parallelism between the schemata of representation and the schemata of perception which is central to Gombrich's case. For the schemata in terms of which representation is analysed cannot be understood in a parallel way. Clearly it could be no part of an analysis, or indeed

explanation, of representation to say that when I represent x, I set down a schematized x. For 'setting down a schematized x' still contains within it the problematic notion of representation: for the only sense in which, when I represent x, I set down 'an x' (schematized or otherwise) is that in which I set down a representation of an x. I conclude, therefore, that if we adhere to a consistent interpretation of the notions of schema and correction, we have once again reason for thinking that we cannot interpret perception as well as representation in terms of them without making perception a hermetic process: which would make not merely perception directly, but representation indirectly, incomprehensible.

8. The strength of *Art and Illusion* must, then, rest upon its major theme: that of the necessary connection between the progress of representation in art, on the one hand, and the employment of pictorial schemata, on the other.

How effective the thesis is for resolving Gombrich's central problem is something that we have already considered. The thesis provides a clue to the question why representational art has a history – though, of course, it makes no attempt to answer the more specific question why art has the particular history that it has. But, even within this limited, though by no means narrow, context the thesis still has at least one residual difficulty. Representational art owes its history, we are told, to the use of pictorial schemata. But what is a schema? Now it is fairly clear what Gombrich does not mean by talking of a 'schema'. And it is fairly clear what, in a very rough way, he does mean. But to say exactly what he means is not without its difficulties. I am not going to say that Gombrich uses the word in different senses. That would be unwarranted. But what I think would be true to say is that at different times he seems to be working under different conceptions of what a typical instance of a schema would be, and these different conceptions lead to an elusiveness in the thesis taken as a whole.

(i) The most ordinary and the most evident thing that Gombrich has in mind when he talks of 'a schema' is any form or configuration that an artist uses to represent, depict, portray an object in the world. In this context a schema has no special degree of complexity or sophistication; it can vary from the simple diagrammatic shapes

employed by Gombrich's niece in her delightful copy after Wivenhoe Park to the minutely detailed (though, as it turned out, quite inaccurate) image of the whale which figures in the two engravings (c. 1600), one Italian, one Dutch (Plate 14), which Gombrich reproduces. It is in this general, extended usage of 'schemata' that Morellian connoisseurship might be said to be characteristically concerned with the morphology of a particular sub-set of schemata: roughly, those used to portray certain parts of the body (notably, the hand and ear) or certain natural objects.

(ii) At other times, Gombrich in talking of schemata has in mind forms or configurations that satisfy a further condition: namely, that they are highly simplified. The divided oval or egg-shape as an abbreviation of the human head – a matter on which Gombrich has some highly illuminating things to say[35] – is a typical example of a schema in this sense; and it is, I think, very significant that in so far as Gombrich writes or thinks under the direction of this conception of the typical schema, he identifies 'schematic' art with what used to be called 'conceptual' art.[36]

(iii) At yet other times Gombrich works with a very different conception indeed of what a schema is, and this is when he identifies schemata with those very general and elusive elements which conjointly make up what we call a style. For instance, in the course of describing Constable's artistic evolution, Gombrich talks of the painter's 'dissatisfaction with ready-made idyllic schemata, his wish to go beyond them and discover visual truth'.[37] But what are these 'idyllic schemata' which Constable rejected? It is evident from the discussion that they are not to be narrowly identified with particular pictorial devices for portraying such things as distant mountains or spreading oaks and ilex. They are to be taken much more broadly and include things as general and as 'non-formal' as the choice of subject-matter, the atmosphere in which the subject is invested, and the preference for a kind of all-over finish, or the lack of it, in a composition.

Of course, Gombrich, by employing the word 'schema' so generously, brings home to us how different elements in a picture

35. *A & I*, pp. 144–8.
36. *A & I*, e.g. pp. 121–3, 247.
37. *A & I*, p. 325.

can have a common function. But at a price. At the price, that is, of making the thesis of schema and correction a bit imprecise.

Basically, the hypothesis of schema and correction relates to the first usage of 'schema' as equivalent to any configuration employed to represent an object. But the existence of the other two usages I have specified leads to confusion in the following ways. First of all, by not distinguishing clearly between schema as *any* inherited or invented configuration and schema as always an abbreviated or simplified configuration, Gombrich slides from the general view that representation always begins with some configuration into the more specific view that representation always begins with a simplified configuration. In other words, setting out to explain why art has a history at all, he commits himself in an entirely *a priori* way to a specific, though still very broad, account of what that history was: namely, that in the beginning there were simple forms. This commitment emerges clearly in Gombrich's discussion of Palaeolithic art, where he treats the complex cave-paintings of Lascaux as though they provided a *prima facie* counter-example to the thesis of schema and correction: and he feels that he can get around this difficulty and save his thesis only by postulating 'thousands of years of image-making' which must have preceded these seemingly early works.[38]

Secondly, Gombrich's use of 'schema' to pick out certain highly general pictorial elements such as the preference for one kind of subject-matter or method of illumination rather than another, makes it difficult to see how much of the phenomenon of art Gombrich thinks his thesis covers. For instance, does the hypothesis of schema and correction provide an over-all explanation of 'stylistic' change? Whether it does or does not depends, presumably, on the prior question whether a style can be analysed without remainder into a set of schemata. I am sure that, on the whole, Gombrich thinks that it cannot be. But there are passages where he suggests that it can. Until such problems are resolved, the scope of Gombrich's hypothesis remains indeterminate, and to this extent its utility is impaired.

9. In this lecture I have singled out certain elements of Gombrich's book for praise, and I have suggested a number of criticisms. 'But why criticism?' I can imagine an impatient listener saying: 'If you

38. *A & I*, p. 91.

have so high an opinion of the book, as you politely say you have, why spend so much time on criticism? For criticism is easy enough.' And that would be a profound and an enlightening mistake.

The great difficulty in any modern book of aesthetics is to find anything to criticize. By and large what is not unintelligible is truism. One of the great merits of *Art and Illusion* is that it permits criticism. It poses a large number of decidable questions, and gives to them answers that are interesting, clear and bold. Professor Gombrich has taken hold of a subject that is habitually given over to vacuity and pretentiousness, and he has granted it some of the precision, the elegance and the excitement of a science. And, eccentrically enough, he has achieved this by writing a book that is both erudite and witty.

14 Nelson Goodman's *Languages of Art*

The impressiveness of Nelson Goodman's *Languages of Art*[1] derives from a twofold source. It derives from the breadth of conception, or the way in which a theory of art has been elaborated as part of a more general theory of symbolism, and also from the fineness of execution, or the way in which the various species of symbolism have been individuated and their contribution to art and the different arts defined. Furthermore *Languages of Art* has a virtue rare amongst works of aesthetics: for it accords the artist, so often the object either of neglect or of sentimentality, something like his due.

This last remark may come to seem paradoxical – though it will be all the more important to have made it – since in the course of this essay I shall be contending that a number of related difficulties arise in *Languages of Art* because the role of the spectator or the audience in art has been underestimated: and this might imply that I think the role of the artist has been overestimated. I shall, however, try to make clear why to my mind such an implication does not hold. More substantively, nothing of what I shall say would, if justified, call for any material revision of Goodman's aesthetic theory, with which I find myself, over a large area, in general agreement: though it may well be that some of my remarks run counter to Goodman's more general philosophical principles – principles which, understandably, are more often assumed than

1. Nelson Goodman, *Languages of Art* [*L of A*] (Indianapolis, 1968). I shall also cite Goodman's reply to some of the points made in an earlier version of this essay. His reply is entitled 'Some Notes on *Languages of Art*', *Journal of Philosophy* [*JP*], vol. LXVII, no. 16 (20 August, 1970), pp. 563–73. I have benefited from this reply, at least to the extent of seeing the error in one point I made in my original piece, and of withdrawing it from this version: it was the fourth point in my original section IX. Since sending this version of the essay to press, I have read two most interesting papers on Goodman, so far unpublished: one by Kendall Walton, another by Robert Howell. I owe much to discussions with Nelson Goodman, David Wiggins, J. J. Valberg, and Sandy Bayer.

asserted in *Languages of Art*. I personally find no difficulty here, since I prefer Goodman's aesthetic to his general philosophy.

2. For this discussion I shall confine myself to the visual arts and to what Goodman has to say about them: more specifically, to those visual arts – for want of a word I shall call them the 'pictorial arts' – which Goodman would think of as autographic. (A work of art is defined by Goodman as 'autographic' if and only if even the most exact duplication of it does not thereby count as genuine. By extension, an art is autographic if and only if the works of art that belong to it are autographic. Otherwise works of art, and the arts to which they belong, are allographic.[2] Goodman, it is true, presents these as only 'preliminary' definitions, but the refinements he thinks they require need not concern us.) Painting and sculpture would be central examples of a pictorial art.

One consequence of the restriction that I have imposed upon this discussion is that I shall, of necessity, pass over nearly everything that Goodman has to say about notation. Of necessity: because notation is employed only in the allographic arts, though not in all of them. However, the area that I have selected for discussion provides ample opportunity to appreciate Goodman's skill and ingenuity in distinguishing and relating the roles of different modes of symbolism within a given art or group of arts.

I begin with the most general thesis that Goodman advances concerning the pictorial arts. It relates to two of the most entrenched problems of visual aesthetics – the nature of representation, and the nature of expression – which the thesis endeavours to clarify by first linking them in a common formula. 'What is expressed' Goodman writes 'subsumes the picture as an instance much as the picture subsumes what it represents.'[3] Many traditional accounts of representation and expression have attempted to locate the difference between representation and expression in the difference between the kinds of thing represented and the kinds of thing expressed. Goodman, however, reverses the procedure and tries to locate the difference in the different ways in which the picture stands to the things it represents and to the things it expresses, though these things may themselves

2. *L of A*, p. 113.
3. *L of A*, p. 52.

be of the same kind. In both cases, according to Goodman, what holds is the relation of denotation, and the difference lies in the sense in which this relation runs. For the picture denotes what it represents but is denoted by what it expresses. Goodman formulates the contrast between his approach and the traditional approach by saying that for him the crucial difference is not 'a difference in domain', but 'a difference in direction'.

Of course, for all its neatness this formula does not give us anything that we can look on as a resolution of the traditional questions about representation and expression. To associate representation with denotation and expression with converse denotation (or 'possession', as Goodman calls it) is not to give their sufficient conditions: at best, it is to give their necessary conditions. Or, to put it another way, Goodman's thesis, as so far unfolded, may bring out the difference, or a very important difference, between representation and expression, but it does not exhibit the nature of either. For this we must, like him, dig deeper.

3. Let us start with expression:
To associate expression with converse denotation is inadequate as an account of its nature, if only for the reason that, whereas expression is symbolization, converse denotation is not. Converse denotation depends on, or results from, a mode of symbolization, i.e. denotation, but it is not one itself. 'To denote is to refer,' Goodman writes 'but to be denoted is not necessarily to refer to anything',[4] where 'to refer' and 'to symbolize' are synonyms for the most general relation that characteristically holds within a symbolic system. Accordingly, if we are to arrive at an adequate notion of expression, we must, for a start, add to the requirement of converse denotation that of reference: so that if a picture expresses a certain property not only is it denoted by it (or more strictly by the corresponding predicate) but it refers to it. Secondly, we must require that the possession of the property by the picture is metaphorical: or that the property that the picture at once is denoted by and refers to (or 'exemplifies', to put the requirements into a single word) denotes the picture metaphorically – and 'metaphorically', Goodman insists, is opposed not to 'actually' but to 'literally'. The picture that expresses e.g. sadness

4. *L of A*, p. 52.

is metaphorically sad, not literally sad: though being metaphorically sad is being sad. We may sum up the position so far by saying that *a* expresses *f* if and only if (1) *a* is denoted by (or possesses) *f*, (2) *a* possesses *f* metaphorically, and (3) *a* refers to *f*.[5]

Certain difficulties attach to the second and third conditions – to their interpretation, that is – and it will belong to my general contention that these difficulties can at least partially be resolved by a greater attention to the role of the spectator. I shall not, however, argue for this here and now. Instead I shall turn straightaway to the other part of Goodman's thesis, that concerning representation, and try to show how there too difficulties arise which require for their resolution the invocation of the spectator. I shall then stay with this second part of the thesis and consider in some detail both the difficulties themselves and my proposed treatment of them. Only then will I return to the problem of expression and indicate briefly where Goodman's account needs supplementation and what in my opinion would fill the gap. I shall pursue this course, oblique though it may seem, in the belief that my contention about 'the missing spectator' can be more readily or more convincingly introduced via representation than via expression: though once it has established itself in one area, it may readily make itself acceptable in the other.

4. Representation is, as we have seen, intimately connected in Goodman's thinking with denotation. 'Denotation' he writes 'is the core of representation.'[6] But this could mislead us as to Goodman's real view. For Goodman allows that there are many cases where we correctly say of a picture *a* that it represents *b*, and yet our assertion doesn't permit of existential generalization in respect of *b*: it is true that *a* represents *b* but false that there is an *x* such that *a* represents *x*. We say of a certain painting that it represents a unicorn without committing ourselves to the existence of unicorns: or we say that an etching represents a warrior without intending that there is a warrior whom this etching represents. But, if null denotation does not invalidate representation, why does this fact not invalidate Goodman's thesis?

5. *L of A*, p. 95.
6. *L of A*, p. 5.

To this Goodman's reply is that there are two senses of representation, not just one, and the sense in which it occurs in the objection to his thesis is not that in which it occurs in the thesis itself. 'Saying that a picture represents a so-and-so is' he writes 'highly ambiguous between saying what a picture denotes and saying what kind of picture it is.'[7]

In suggesting not merely that there is an ambiguity in assertions of the form '*a* represents *b*' but also what the ambiguity is, Goodman in effect proposes a method for removing it. For where the assertion does not permit of existential generalization, or where the existence of *b* is not implied, the assertion should be rewritten in such a way that 'represents' no longer appears in the guise of a two-place or relational predicate, which it isn't, but, instead, manifests itself as a component of an 'unbreakable one-place predicate'.[8] In such cases, we should, in the interests of clarity, not leave it that *a* represents *b*, we should rather say that *a* is a *b*-representing-picture, or a *b*-representation, or, most simply, a *b*-picture. In the other cases, where existential generalization is permissible, or where the existence of *b* is implied by the assertion that *a* represents *b* – in other words, in just those cases to which Goodman's original formulation directly applies – 'represent' is indeed a two-place predicate qualifying both *a* and *b*. This ambiguity in the notion of representation leads to the following reformulation of the connection between representation and denotation: 'A picture must denote a man to represent him, but need not denote anything to be a man-representation.'[9]

Of course, to point out an ambiguity in the notion of representation and to show how this requires a new formulation of the connection between representation and denotation is not to assert that the two senses of 'representation' are unrelated, nor is it to rule out the possibility that, ultimately, perhaps through a series of steps, representation in its entirety can be connected with denotation.

5. To prefer, in the relevant cases, talking of a *b*-representing-picture or (Goodman's favoured abbreviation) a *b*-picture to saying that the picture represents *b*, and further to insist that the preferred locution

7. *L of A*, p. 22.
8. *L of A*, p. 21.
9. *L of A*, p. 25.

contains an unbreakable predicate celebrates the fact that, in those cases where we exercise the preference, we are not entitled to infer from the existence of the picture to the existence of *b*. But any such rewriting presumably does more than merely celebrate this fact. It must in some way explain it or make it pellucid: and, of course, it must also have an adequate and efficient internal economy. It is with these considerations in mind that I shall examine Goodman's proposals about representation.

6. I shall make a start on these proposals by taking up a notion central to them: that of the unbreakable predicate. And I shall ask, When the assertion that *a* represents *b* is taken as ascribing an unbreakable predicate to *a*, what is the extent of the predicate that is said to be unbreakable? Or to put it another way, Where in expressions like 'a *b*-(representing-) picture' or 'a man-(representing-) picture, or 'a King-of-France-(representing-) picture' are the breaks supposed not to occur? Is it the whole phrase after 'a ...' that is unbreakable, or is it just what fills the gap between 'a' and 'picture' that must be taken together? If there is much in Goodman's text that suggests the former or stronger interpretation, there is much in his argument that calls for the latter or weaker interpretation. I shall try to establish that this is so, and its significance. I shall present my argument in three stages, each stage drawing on a consideration adduced by Goodman:

(i) It is conceded by Goodman at a number of points[10] – and surely rightly – that, though from '*a* is a *b*-picture' we cannot infer the existence of *b*, what we can infer is the existence of a picture. Obviously (when one comes to think of it) the totality of the argument in *Languages of Art* concerning representation is based on the correctness of this assumption. For it asks how *pictures* represent.

(ii) It is no less essential to Goodman's account of representation that we can – admittedly with varying degrees of ease – classify representational pictures into kinds. We can classify them as *b*-pictures or *c*-pictures: or, to fill it out, as unicorn-pictures or man-pictures or Louis XIV-pictures or Louis XV-pictures. Now, when we do this we classify pictures, I argue, not just into kinds but into kinds

10. *L of A, passim.* See also Nelson Goodman, 'On Some Differences about Meaning' in *Philosophy and Analysis,* ed. M. Macdonald (Oxford, 1954), pp. 63–9.

of picture: by which I mean that the concept of picture plays an essential role in the classification. It is not just that the objects of the classification are in point of fact pictures but how they are classified rests on this fact. The point can perhaps be brought out by contrasting the way in which we classify pictures according to what they represent and the way in which we might classify pieces of furniture (say, consols) according to their style. We could, with something like an adequate criterion of style, classify consols as Louis XIV consols or Louis XV consols without intermediately having to recognize them as consols: but we could not analogously by-pass the concept of picture in classifying pictures as Louis XIV-pictures or Louis XV-pictures. In the latter case we arrive at the first part of the classification ('Louis XIV', 'Louis XV') only through, or only by making use of, the second part ('picture'). Without thinking of the picture as a picture we would not have any reason for associating it either with Louis XIV or with Louis XV. (More correctly, we would not have any reason of a representational kind. Of course, we might have a reason of a different kind: say, a stylistic reason: with, significantly, a different outcome in classification. A picture *style Louis XV* is not necessarily of Louis XV.) The full force of this point – that when pictures are classified according to what they represent, they are necessarily classified as kinds of picture – will emerge later. And I think it worth pointing out that, though Goodman seems explicitly to reject it,[11] he also gives it a measure of implicit recognition when he says that, in classifying pictures representationally, we do so by reference to and only to their 'pictorial properties':[12] For, in Goodman's use, though he might not put it like this, pictorial properties are those properties, and only those, which a picture has in virtue of being a picture.

I have put these two stages in my argument together because of a common theme that they have: the detachability of the expression 'picture' from within the larger expression '*b*-picture'. At the first stage this is established, at the second it is confirmed. However, though the detachability of 'picture' from '*b*-picture' suggests the breakability of the larger expression at just this point, and consequently seems to lend support to the weaker interpretation of the

11. *JP*, p. 564.
12. *L of A*, pp. 29n., 41–2.

unbreakability thesis, it is not conclusive. For Goodman is ready to admit that there are unbreakable locutions – or 'prime locutions' as he calls them at this stage in his argument – of which a part may denote. Breakability arises only when the denotation of the locution as a whole is determined by and solely by the denotations of the parts combined in the specified way.[13] And neither of the two steps so far taken in my argument establish such a condition for expressions like '*b*-picture' or 'Louis XIV-picture'.

Not surprisingly. For it seems clear that this condition just does not hold for these expressions, that there is no way of breaking them that has this result. But what we should now consider is whether we wish to adhere to Goodman's criterion for the notion of unbreakability. For though the criterion clearly shares the commitment of Goodman's general philosophy, there seems little else to recommend it. For instance: If unbreakability is interpreted in terms of denotation, then it cannot be used to explain the fact that we cannot infer the existence of *b* from '*a* is a *b*-picture' for the ascription of unbreakability to '*b*-picture' simply records this fact. Accordingly I shall operate with a less theoretically committed criterion, and say that a locution is breakable when and only when the meaning of the whole is determined by the meanings of the resultant constituents combined in the specified way.

However, if we adopt this proposal, then it looks as though my argument by its second stage has a more direct bearing upon the unbreakability of expressions like '*b*-picture', and where this occurs, than initially seemed the case. For, in pointing out how with such expressions the meaning of the first part of the expression can be grasped only through the meaning of the second part, or that the concept of 'picture' must be borne in mind throughout, the argument might seem to suggest the following: that, if the concept of 'picture' is kept in mind, if the second part of the expression is not lost sight of, then attention to the first part should, against this background, give the meaning of the whole. We can, in other words, sort pictures into their kinds – *b*-pictures, or *c*-pictures – uniquely through understanding such expressions as '*b*' or '*c*'. However, this is as yet only a suggestion, and to see whether it is justified, I shall now move the argument into its third stage.

13. *L of A*, pp. 146–7.

Before doing so, a terminological point. In order to bring out the fact that in such locutions as '*b*-picture', '*b*' must always be understood as governed by 'picture', I shall in future write the first component in the expression, when considered as a part of the whole, as '*b*-'. The use of the more cumbrous phrase '*b*-representing' would also have registered this fact. Now, the third stage of the argument:

(iii) If it is true that, as I have argued at (ii), we cannot classify pictures as *b*-pictures or Louis XIV-pictures without (first) recognizing them as pictures, we can do so without (first) being able to recognize *b*s or Louis XIV. Goodman observes this when he writes:

The possible objection that we must first understand what a man or a unicorn is in order to know how to apply 'man-picture', or 'unicorn-picture' seems to me quite perverted. We can learn to apply 'corncob pipe' or 'staghorn' without first understanding, or knowing how to apply, 'corn' or 'cob' or 'corncob' or 'pipe' or 'stag' or 'horn' as separate terms. And we can learn, on the basis of samples, to apply 'unicorn-picture' not only without ever having seen any unicorns but without ever having seen or heard the word 'unicorn' before.[14]

Now, at first this might seem to go against the suggestion that we are testing: for does it not imply that '*b*-' or 'Louis XIV-' are semantically inessential to '*b*-picture' or 'Louis XIV-picture'? But that this is a superficial assessment emerges when we consider a corollary of (iii), which I would put thus:

(iii)' If we are (at first) unable to recognize *b*s or Louis XIV, then, other things being equal, we become able to do so, once we are able to classify pictures as *b*-pictures or Louis XIV-pictures. The second ability may precede the first; but, if it does not, the first will ensue upon the acquisition of the second.

(iii) and (iii)', put together, are what account for such well-known facts as that children who are not as yet able to recognize things in pictures learn to recognize them through pictures: and that a picture-book is not merely a mirror of, it is also a guide to, the world. And if (iii), taken by itself, does nothing to bring out the semantic contribution of '*b*' to '*b*-picture', the conjunction of it with (iii)' not only makes good this defect, but establishes quite clearly that, given the meaning of 'picture', the meaning of '*b*'

14. *L of A*, pp. 24–5.

completes the meaning of the whole expression. (It is worth observing that there is nothing parallel to (iii)′ in the case of (Goodman's examples) 'corncob pipe' or 'staghorn', which are therefore misleadingly introduced. I do not have to understand 'horn' before being introduced to 'staghorn' – and if I did know it, learning 'staghorn' would not teach me 'horn'.)

Before drawing any moral from this conclusion, I should first like to draw attention to its scope. So far we have, at any rate explicitly, considered as substitution-instances of '*b*-picture' only comparatively simple locutions such as 'man-picture', 'Louis XIV-picture', or 'King-of-France-picture'. But obviously there could be substitution instances of considerable, indeed of unlimited, complexity, e.g. 'a young-girl-at-her-toilet-picture', 'Louis-XIV-breaking-off-a-walk-with-his-ministers-in-the-gardens-of-Versailles-to-receive-a-rose-presented-to-him-by-a-gardener-on-a-silver-platter-to-the-admiration-and-delight-of-the-court-picture'. Now, it is important to realize that all the constituents of these complex locutions, however deeply embedded they may be, make their semantic contribution to the meaning of the whole: or, to put the matter the other way round, all could in principle be taught through learning to recognize the kind of picture the locutions of which they help to form.

However, it might now look as though my argument as we have it does not simply reject the stronger in favour of the weaker interpretation of the unbreakability thesis. What it does is to make that thesis untenable in any form. And if I have so far hesitated to invoke the most general kind of argument available against the strong version of the unbreakability thesis – namely, that by permitting what is in fact the introduction of an infinite number of prime locutions into the language the thesis offends against the basic requirement of teachability[15] – it is because it too seemed to involve this radical version of the conclusion, or the rejection of the thesis in any form. In effect, the question whether we altogether abandon the unbreakability thesis or continue to accept it on the weak interpretation seems to me largely a terminological issue once we accept the

15. See Donald Davidson, 'Theories of Meaning and Learnable Languages' in *Proceedings of the 1964 International Congress for Logic, Methodology and Philosophy of Science*, ed. Y. Bar-Hillel (Amsterdam, 1965), pp. 383–93.

following three facts: that we cannot understand how '*b*' contributes semantically to '*b*-picture' without bearing in mind throughout the concept 'picture'; that, once we do bear this in mind, then the meaning of '*b*' gives us the meaning of '*b*-picture'; and that we cannot quantify over the '*b*-' part of '*b*-picture'. Another way of putting the matter might be to say that in 'a *b*-picture' 'picture' is an operator whose scope is all that comes after 'a' and precedes it.

However, whichever way of recording the matter we settle for, the moral seems to be clear: namely that, contrary to what Goodman says, some account is called for of how we do classify pictures into their kinds or according to what they represent. Some such account is called for because there seems to be some general principle at work. Of course, any account that we give must respect Goodman's reason for refusing to give one at all: namely, the inadmissibility of quantification into the predicates we employ in making such classification. It must respect this fact, as well as the other two I have just indicated.

7. On the relation between a's being a b-picture and a's denoting x[16] (when it does), or, on the relation between the two senses of representation, Goodman has little to say, perhaps convinced that there is little to be said.

An extreme or simplified view of what Goodman might think the relation to be is the following: That if a is a b-picture, then, if and only if x is a b, a denotes x. In other words, denotation is accounted for in terms of kind of picture plus certain facts of the world i.e. instantiation. But that this is not Goodman's view can be seen from his treatment of 'fictive representations'.[17] For, in discussing Pickwick-pictures, Goodman does not argue, as he surely would have if he held the extreme view, that, since there is no such thing as Pickwick, Pickwick-pictures denote nothing; in this sense they are fictive representations. Rather, he argues that Pickwick-pictures denote nothing since what Pickwick-pictures purportedly denote is

16. Goodman points out (*L of A*, pp. 41–3) that denotation by a picture is not always representation. He cites the example of pictures in a commandeered museum used by a briefing officer to stand for enemy emplacements. However in, talking of denotation in connection with pictures, I shall throughout intend representation.

17. *L of A*, pp. 25–6, 66–7.

fictive, and it is in this sense that they are fictive representations. In other words, in the case of fictive representations, Goodman does not explain their denotation (or lack of it) exclusively in terms of kind of picture plus certain facts of the world: in this case, non-instantiation. He also invokes intention or purported denotation. But on anything like the extreme view such a factor has no place in the explanation of why a certain representation had null denotation or was fictive: at most it could enter into the explanation of why all the same we use or make such a representation.

However, on any less extreme or more complex view of the relation between a's being a b-picture and a's denoting x, a gap opens up between the two senses of representation. And once the gap makes its appearance, some of Goodman's neater formulations about representation seem threatened. On anything except the extreme view, denotation appears not as the core of representation but as the core of representation in one sense of that term. And what is left of the explanation of the difference between representation and expression as a difference not in domain but in direction? For, loosen the two senses of representation, and representation in the sense of kind of picture seems naturally to sort with expression in that it too depends upon converse denotation – it depends on whether predicates like 'b-picture' or 'c-picture' apply to it – and not on denotation.[18]

8. There is, however, one relation between a's being a b-picture and a's denoting x on which Goodman insists: and that is that, when both these conditions are satisfied, then a represents x as a b – irrespective, of course, of whether x is or is not a b.[19]

But how are we to interpret 'a represents x as a b' in this context? Are we, for instance to take it as simply equivalent to the conjunction from which it follows? If we do, then it looks as though the gap between the two senses of representation amounts to a severance. If we don't, then a number of interpretations are open to us. I shall not go into the details of these various interpretations but there is one troublesome feature that they have in common on which I shall say something.

18. Rather surprisingly Goodman seems prepared to accept these consequences, *JP*, p. 565.
19. *L of A*, pp. 27–9.

If '*a* represents *x* as *b*' is not equivalent in meaning to the conjunction '*a* is a *b*-picture and *a* denotes *x*', then it will be taken as saying something about how *a* represents *x*. But, if this is so, then we need to distinguish within any given representation two factors which can be separately identified: one in virtue of which the picture picks out, or is of, a certain object, in this case *x*, and another in virtue of which it describes that object in a certain way, in this case as *b*. Very roughly, there must be a subject-like element to any representational picture, and also a predicate-like element.

Goodman has reasons rooted in his general philosophy for not explicitly accepting any such analysis, yet it is arguable that much of what he says implicitly presupposes it, and in addition the distinction seems to correspond to certain ways in which we use representations. Let me explain this last point. I meet a man who is in pursuit of an enemy and he shows me a photograph of his quarry. 'Oh *him*,' I might say, and thereby reveal that I was using the photograph to pick out a particular person, or in a subject-like way. Alternatively I might say 'How villainous he looks,' and this would show that I was using the photograph to describe someone already picked out, or in a predicate-like way. (I am not implying that in such a situation I – or the spectator – could always choose how to use the photograph: for that might be determined by the situation, or the way in which the photograph was produced.) However, such cases do not really justify the analysis of the representation into two factors – one of which permits the picking out of an object, the other its description. For on each occasion the representation as a whole discharges whatever function it is, and therefore we have no reason to look for a differentiation within it which would allow both functions to be discharged on one and the same occasion. (There can, of course, be seemingly mixed cases where I might say e.g. 'What a villainous-looking man he is', thereby suggesting that I use the photograph both to pick out the man and to tell me something about him, but in such cases the mix really comes from a fluctuation of use on my part: there is still no reason to postulate two separately identifiable factors on which I rely for the two aspects of my assertion.)

That a subject-predicate analysis of representations is ultimately unforthcoming emerges clearly when we recognize that, in the cases where such an analysis is plausible, as with a proposition, there is no

limit to what I can predicate (truly or falsely) of a subject: or, if there is a limit, it is not fixed by considerations of truth-value. But with representation there is a limit. I cannot represent x anyhow I like: once I overstep a certain limit that affects whom or what I represent.

9. It is, as we have seen, Goodman's view that, if a is a b-picture and it denotes x, then a represents x as a b. Does it follow that a is also an x-as-a-b-picture?

Note that, though this question, like those we have just been considering, concerns the relationship between the two types of representation, it differs from them in that the relation with which it is concerned flows in the reverse direction. It is concerned, in other words, with the dependence of representation in the sense of kind of picture upon representation in the sense of denotation.

Now, Goodman certainly permits locutions of the form 'm-as-n-picture'. For instance, he talks of Pickwick-as-clown-pictures and Pickwick-as-Don Quixote-pictures.[20] However, since Goodman uses such locutions exclusively in the context of fictive representations, where there is no m that is denoted, it is not possible to reconstruct what he thinks to be the conditions for their application when 'm' denotes. And, of course, Goodman nowhere supplements practice with explicit statement. For, as we have seen, it is part of his general policy not to give criteria for classifying pictures into their kinds or for saying when a picture is a so-and-so picture.

Now, it is in part because I think Goodman's policy wrong that I raise the question how pictures are to be classified as m-as-n-pictures. But there is, in this case, over and above the general reason, a specific reason for wanting an answer to the question: a reason which stems from the discussion in the previous section. For there it seemed imperative that, if we are to safeguard the concept of 'the way in which a picture represents a certain object' or 'what the picture represents an object as', we need a separate or independent way of identifying that in the picture in virtue of which it represents or picks out what it does. And we might think that a proper understanding of how we come to classify certain pictures as m-as-n could provide us with an answer to this question: more specifically, that we should have an answer to this question if we knew what there

20. *L of A*, p. 30.

was to this process over and above that of classifying these pictures as *n*-pictures. However, for two reasons, this line of inquiry turns out to be unproductive.

In the first place, since it seems (at the lowest) very likely that there are *n*-pictures that denote *m*s and that nevertheless aren't *m*-as-*n* pictures, an analysis of those which are is unlikely to answer our problem. For of necessity we shall be left with the question how it is that *n*-pictures that aren't *m*-as-*n*-pictures but that denote *m*s come to represent or pick out their *m*s. Secondly, even at this stage it looks as though part (though only part) of the explanation of how *n*-pictures that denote *m*s come to be classified as *m*-as-*n*-pictures is that they denote *m*s: more will have to follow, but that much seems sure. However, if the denotation of *m*-as-*n*-pictures is to be invoked to explain how they come to be classified as not merely *n*-pictures but *m*-as-*n*-pictures, then what *m*-as-*n*-pictures have over and above what mere *n*-pictures have cannot without gross circularity be invoked to explain how pictures represent or pick out what they do. We cannot find here a starting-point for an explanation of the subject-like factor in representations: for that factor seems already presupposed.

The general interest of how *n*-pictures that denote *m*s come to be classified as *m*-as-*n*-pictures remains. But there is no reason to think of it in any way apart from the interest that attaches to the general problem of the classification of pictures into their kinds.

This completes my survey of Goodman.

10. I have said that my contention in this essay is that Goodman's account of the pictorial arts, and of the symbolic systems operating within them, could be profitably filled out by greater attention to the role of the spectator or audience. I now want to introduce this contention in the context of representation. What I intend to do is go over what seems to me to be the shortcomings in Goodman's account as it stands and see if these can be made good by a higher estimation of 'the beholder's share'.[21] Any *ad hoc* character that my contention may appear to have will, I hope, be dissipated if the contention can be shown to be multiply useful.

21. This phrase is used as the heading for one of the divisions of E. H. Gombrich, *Art and Illusion* (second edition, London, 1962).

First, I want to suggest that the criterion for classifying pictures into their kinds – something which, as we have seen, Goodman does not provide though I, argue, he should – is to be found in *what we can see in them*. A *b*-picture is (roughly) a picture in which we can see *b*. Of course, it must be understood that what we can see in a picture is itself a complex matter and is determined, or at least influenced, by a large variety of factors such as background knowledge, understanding of the style involved, and what are loosely but intelligibly called pictorial 'conventions'. Goodman has himself much to say on this subject,[22] and I am in agreement with everything that he writes about the non-innocence of the eye and the relativity of vision. It is only if this aspect of our perception of pictures is recognized that my suggestion about their classifications into kinds – as well as my other suggestion about ways in which my central contention may be applied – can lay claim to acceptability.

Though Goodman does not, of course, make a connection between *a*'s being a *b*-picture and *a*'s being a picture in which one can see *b*, there are certain things in his account of representation which prepare the way for it. In the first place – though the point needs further arguing – the ability to see in pictures what they represent seems like the perceptual counterpart to the conditions that Goodman lays down for pictures if they are to be representations. For representations (as opposed to descriptions, on the one hand, or diagrams on the other) must be dense, both syntactically and semantically, and they must be (relatively) syntactically replete.[23] Once we understand these requirements, it seems to me that in effect they stipulate the necessary conditions that a piece of visual symbolization must satisfy if we are to be said to see something in it – as opposed, that is, to reading something off it or just reading it. And if we now ask what are the sufficient conditions for our being able to do this, the requisite supplementation probably comes exclusively from the subjective or spectator's own side: that is to say, to see something in what is before him, he must e.g. possess certain knowledge, or possess certain concepts. Again, the connection between *a*'s being a *b*-picture and *a*'s being a picture in which one can see *b* is not merely compatible with what Goodman says about the predicates we use in

22. e.g. *L of A*, pp. 6–10, 99–112.
23. *L of A*, pp. 226–31, 252–3.

In the first place, if there is to be a distinction between two senses of representation, Goodman's seems to come in the wrong place. Suppose, for instance, we start by contrasting a horseman- (representing) picture and a picture that represents Charles I. Then suppose we are presented with a picture that we describe (neutrally) as a picture of Don Quixote. Then surely it is much more natural to sort this picture with the picture that represents Charles I than with the horseman-(representing) picture. Certainly this seems so in the light of everything that we have said so far about how a picture that is of something specific gains its object. But any such classification would, of course, cut right across Goodman's. Secondly, it might be thought that even if we do well to distinguish pictures that represent something or someone that exists from other representations, it does not seem plausible to think that the distinction arises from the different sense in which, say, a picture 'represents' Charles I from that in which it might 'represent' Don Quixote. If there is a legitimate difference between thinking of Charles I and thinking of Don Quixote this, surely, does not point to an ambiguity in the verb 'to think'. A more plausible kind of analysis in the pictorial case might be to say that the difference between a picture that represents b and a picture that represents c, where the first is a picture of a real person and the second is a fictive representation, lies in the different ways in which the ability to see b and the ability to see c can be acquired. For the first ability cannot be acquired except in a way that is dependent on the existence of b, whereas the second ability can be acquired quite independently of the existence of c. The major advantage of this kind of analysis over Goodman's is that, ultimately, it traces the difference between 'a represents b' and 'a represents c', where these are understood as above, to a difference in the use of 'b' and 'c', not to different senses of 'represent'. – However, I do not wish to pursue this point further. I shall go along with Goodman's distinction between the two senses of 'representation' and simply put it forward as a consideration on behalf of my general contention that it has the effect of finding a point of union for the two senses: whether or not this union ultimately takes the form of identity.

A third question that, as we have seen, is left unsettled by Goodman's account of representation is when we are and when we are not entitled to infer from 'a is a b-picture' and 'a represents x' to 'a is a

x-as-a-*b*-picture'. That this should be unresolved is unsatisfactory at least from the general point of view that we do need an overall method for classifying pictures without exception into their kinds: but perhaps (as we have seen) there is also a special point of view from which lack of an answer is unsatisfactory in a special sort of way. Consonant with my general contention, I would maintain the following: The inference is always legitimate except in certain cases already referred to where the picture's denotation is not, even partially, secured by whom or what we can see in it. One such kind of case is where the denotation is secured along some route involving symbolism: for where this occurs we may well not be able to see *x* in the resultant picture, even though the picture represents *x*. In other words, the symbolical link is adequate to secure expression of the artist's intention to represent *x*, but inadequate to secure our seeing *x* in the symbol. So, on a standard reading of the following two cases, we can infer from '*a* is a hippy-picture and represents Christ' to '*a* is a Christ-as-a-hippy-picture' – for in such a picture we can see Christ: but we cannot infer from '*a* is a sheaf-of-corn picture and represents Christ' to '*a* is a Christ-as-a-sheaf-of-corn-picture' – for in such a picture we cannot (I take it) see Christ.

Apropos of this last point, Goodman incidentally makes the following comment:

> I cannot follow Wollheim's discussion of a picture of a sheaf-of-corn that represents Christ. He says that since we cannot see Christ in the picture, the picture does not represent Christ as a sheaf of corn. While what we 'can see in' a picture seems to me far from clear, I should suppose that if we cannot see Christ in a picture of a sheaf of corn, neither can we see him in a picture of a lamb: yet surely we can say that Christ is often represented as a lamb.[26]

But this seems a misunderstanding. For the argument of mine that Goodman criticizes was directed against saying of such a picture that it is a Christ-as-a-sheaf-of-corn-picture, not against saying of it that it represents Christ as a sheaf of corn. And these are separate issues, to the former of which I devoted section 9 of this paper and to the latter section 8. However, since Goodman has raised the matter, let me say briefly what I do think about the second of these two issues.

26. *JP*, pp. 564–5.

Contrary to what he suggests, I see no difficulty in saying that the sheaf-of-corn-picture that represents Christ represents Christ as a sheaf of corn. I see no difficulty in saying this because I am inclined to think of '*a* represents *x* as a *b*' as simply equivalent to the conjunction from which it follows, i.e. '*a* is a *b*-picture and represents *x*'. The difficulty that I foresaw for Goodman if he were to do this – namely, that it would amount not just to distinguishing two senses of representation but to abandoning the idea that they would ever be reunited – does not threaten me. For, at an earlier stage, by linking each sense of representation to perception, I have safeguarded myself against it.

11. I now want very briefly to turn to the problem of expression, and suggest – no more than that – how the reintroduction of the spectator might do something, here too, to relieve the problems that arise on Goodman's account of the matter. I shall, for these purposes, go along with the assumption that Goodman wishes us to accept that, whenever *a* (a picture) expresses *f*, *a* is an *f* picture – though not, of course, an *f*-picture: that is, it is a picture characterized (or in Goodman's terminology, denoted) by *f*, though not an *f*-representing picture. This assumption can be challenged,[27] for it looks as though a picture can express desperation, alternatively boredom, without being either a desperate picture or a boring picture – or anything that corresponds to any appropriate rewrite of these descriptions. However, I shall not take up this kind of objection, and I shall consider only the difficulties that arise for Goodman from maintaining that in cases of expression the *f* that the picture expresses *metaphorically* denotes *a*: or, to put it another way, I shall consider only the difficulties involved in understanding this assertion.

Goodman himself attempts to explicate metaphorical denotation in terms of two notions: schemata or families of predicates, and transfer of realm. 'Realm' is contrasted by Goodman with 'range', in that, whereas the range of a predicate is what it denotes, its realm is what is denoted by the schema of predicates to which it belongs. More succinctly, a predicate denotes its range and sorts its realm. So the range of 'red' is that specific colour, and its realm is colours

27. See Anthony Savile, 'Nelson Goodman's *Languages of Art*', *British Journal of Aesthetics*, vol. 11, no. 1 (winter, 1971), pp. 3–27.

in general. Now, a predicate is used metaphorically when there has been a transfer of realm in its application. There is a transfer of realm when, say, 'warm' is applied to some colours (though not to others), and 'sad' to some pictures (though not to others).

It seems to me that with this account Goodman still has on his hands the problem how to distinguish metaphorical application from, on the one hand, error and, on the other, arbitrariness or nonsense: the problem how to distinguish 'The slow movement is sad' from either 'The slow movement is very short' (when it isn't) or 'The slow movement is green'. And my suggestion here would once again be to reintroduce the spectator. For, once it has been established that transfer of realm has occurred, we might say that f metaphorically denotes a if and only if we can perceive a as f. In the absence of such a capacity, then the claim of metaphorical denotation lapses. The suggestion, of course, would need considerable amplification.

12. Nowhere in *Languages of Art*, it must be said, does Goodman give any kind of overt licence to the way in which I have systematically, or at any rate repeatedly, called upon the spectator in an effort to fill out or elaborate the central thesis of his book. Indeed, he has in his subsequent article explicitly repudiated such a project.[28] Nevertheless, I think that there is a great deal in his most general observations about art, and about the relations in which art stands to invention, understanding and discrimination, that not merely fits in with, but calls for, some such view as I have been urging.

On the subject of invention Goodman indicates that invention enters into representation when (roughly) two conditions are satisfied. [29] First, the picture, a, that we employ to represent b should be, given its representational function, unexpected or improbable: secondly, having been employed to represent b, a should bring out features of b that we would not otherwise have observed. Now, at his most austere Goodman states this entirely in terms of classification: We wouldn't ordinarily think of classifying a as a b-picture, again, We wouldn't ordinarily think of classifying b by means of the picture a. But this austerity cannot be successfully maintained. It

28. *JP*, pp. 564, 566.
29. *L of A*, pp. 31–3.

gives way initially in respect of the second condition or the consequences of an inventive representation. So Goodman finds himself admitting that the sense in which the picture *a* achieves something by lending itself to the representation of *b* cannot be adequately stated without reference to perception. If *b* is reclassified in consequence of *a*, the new classification must enter into, or modify, the ways in which we are now able to see *b*. An innovating representation, Goodman writes, 'may bring out neglected likenesses and differences, force unaccustomed associations, and in some measure remake our world'.[30] And towards the end of *Languages of Art* he writes

> What a Manet or Monet or Cézanne does to our subsequent seeing of the world is as pertinent to their appraisal as is any direct confrontation. How our lookings at pictures and our listenings to music inform what we encounter later and elsewhere is integral to them as cognitive.[31]

But, if this is so, if *a* allows us to see *b* in a new light, this must be because we are able to see *b* in *a*. Not of course readily – since we are dealing with a case of innovation – but as, and in so far as, our perception adapts itself or responds to the artist's powers of invention. And it is surely significant that in this context Goodman quotes with approval Picasso's retort to the complaint that his portrait of Gertrude Stein did not look like her, 'No matter; it will.'[32] For, in effect, the complaint was that the spectator could not see Gertrude Stein in the portrait, to which Picasso's retort was of the form, 'You will.' Now, if the foregoing argument is correct, both the two conditions that Goodman implicitly lays down for invention can be brought together, and their point of union lies in the assumption that what a picture is of is what we see in it: where seeing something in a picture is a complex achievement, which can be restricted by convention and enlarged by innovation. Now here we have the support that I referred to as existing in Goodman's text for thinking that his larger views on art presuppose something like the emphasis that I place upon the spectator.

However, at this point it might be objected that, though probably

30. *L of A*, p. 33.
31. *L of A*, p. 260.
32. *L of A*, p. 33.

something like my contention about the spectator is compatible with, perhaps even is required by, Goodman's accounts of representation and expression, this is not to say that my contention is acceptable in the form in which I actually state it. In its present form, it falls foul of certain clearly stated views of Goodman's. Specifically it cannot be fitted in with the 'difference of direction' in terms of which, it will be recalled, Goodman seeks to explain the difference between representation and expression, and with which I have expressed general agreement. Representation, according to Goodman, is a matter of what the picture denotes: expression, of what denotes the picture. But if we accept this, how can we also accept what I have argued for: namely, that what we see when we look at the picture bears both upon what it represents and upon what it expresses? I have argued that what we see in a picture (partially) determines what it represents and that what we see it as (partially) determines what it expresses. But does this not dispute the difference of direction thesis?

I think that any such argument is too facile. I think that the ways in which I have introduced the spectator – the tasks that I have assigned him in the (partial) determination of representation and expression – are perfectly compatible with Goodman's thesis. For might it not be the case that a further mark of difference between representation and expression is this: that, if we contrast depictions, which are what is involved in representation in that to represent is to depict, with descriptions, which are what is involved in expression in that to express is to be described, then it may well be that the suitability of a depiction in a given case is to be tested by scrutinizing the depiction whereas the suitability of a description in a given case is tested by scrutinizing what it is a description of? Now, if this is so, if there is this asymmetry, then it would be quite in order, and quite compatible with the difference of direction, that in order to determine what a picture represents and equally what it expresses we should look to the picture: to it, rather than elsewhere.

13. Finally I have a pledge to redeem. For I said at the outset of this essay that, though I should press for a greater recognition of the spectator, this in no way conflicts with my total endorsement of the significance that Goodman attaches to the artist. I now want to

justify this remark: though in doing so I shall only be assembling points that I have already made, explicitly or implicitly.

In the first place, it has been no part of my contention to set up an opposition between the man who is the spectator and the man who is the artist – between, if you like, the non-creative and the creative partners to the transaction of art. All the way along the contrast that I have had in mind is between one role and another, the role of the spectator and the role of the artist. And even this is not quite accurate. I have been arguing for the role of the spectator but not necessarily against anything. For – and this is my second point – it is perfectly compatible with my contention not merely that the two roles should be filled by one and the same person, but that there should be an internal connection or link between the two roles. Indeed, if I am right in thinking that, to some degree or other, both representation and expression depend on an exercise of the spectator's role, that it is through this role that they enter into or qualify art, then it might look as though there is some degree of necessary overlap between this role and that of the artist. The artist is *qua* artist also spectator. In other words, in emphasizing the role of the spectator in the formation of certain intrinsic features of art, I have only been presenting a broader vision of the role of the artist in art. So in general as well as in particular what I have found to say about Goodman aligns itself with the direction of his aesthetic: though not, I must repeat, with its underlying metaphysic.

15 Adrian Stokes

Adrian Stokes was born in 1902. He was brought up in a London that has now largely vanished, and he has lived, for years at a time, in Italy, in Cornwall, on the North Downs, and, since 1956, in Hampstead in an eighteenth-century house, where he paints and writes. His life and his work have always been intimately entwined, and he has cultivated privacy in both. He has been unconcerned with reputation, and the sources of his inspiration have lain in the progress of his own ideas and in the physical environment. In 1925 he first came to live in Venice, and he has described to me how he immediately fell under the influence of the city and its lagoons and also of d'Annunzio's passionate novel *Il Fuoco*, in which the poet not only recounts his affair with the Duse but also makes many references to the Renaissance and to Pisanello. The months that ensued, absorbed in a city and its architecture, in buildings and the life they house, in painters of the past, in what another man had made of these things and how he had invested them with feeling, above all in his own shy intense reactions, epitomize, if in a heightened form, the interplay of reflection, art and place so characteristic of Stokes's work.

Though the body of his writing, which now amounts to some eighteen volumes, is not familiar to a wide circle of readers, its influence, direct and indirect, has been considerable. There are certain painters, sculptors, poets, philosophers, critics and historians of art who are profoundly indebted to him. And, increasingly, some of the earlier volumes, with their thick paper and their velvety old-fashioned photographs, have become eagerly sought after.

Of those aspects of his childhood which have contributed directly to his work, Stokes has given us in *Inside Out* a description, in which he retains throughout the child's perspective. In the phantasies of the young boy, exercised daily in a London park under a succession of governesses, we discover much that is later to assert itself either in

the motivation or as the content of his writing – two things never far apart in the work of an original artist. Fear, concern, the sense of loss, a feeling for order, the desire to restore and to put everything right – first experienced most poignantly in relation to the objects and events of the childhood round, to the drained bed of the Serpentine, the rough boys who infested the park, the magazine by the lakeside in which dangerous explosives were stored, the red-coated soldiers, the big horse-chestnuts in candle, and the myth of the park returned to an eighteenth-century grandeur – to which must be added a powerful capacity to find in the outer world intimations of the inner: these things later manifest themselves as the motive force behind Stokes's work, but they are also what he is eventually to write of, more eloquently, more directly than any other writer I know of, as the perennial subject-matter of art. In the autobiographical pages, mostly to be found in *Inside Out* and *Smooth and Rough*, we find representations, unexcelled in our literature, of the artist and the aesthete in the making. We see the child hungry for experience, and hungry also for the understanding of experience. These passages recall the best of *Praeterita*, and they are the equal of Pater's strange confessional fragment, 'The Child in the House'. But, if in sensibility Stokes has much in common with Ruskin or Pater, in intellectual culture or the degree of self-consciousness there is the difference of a century.

The love of art was of slow formation in Stokes's life, and in its development the first visit to Italy, where he arrived on New Year's Eve, 1921–2, was a crucial event. From then onwards, the craving for sensuous experience, which had so stirred the young boy on his daily walks, gradually turned towards painting, sculpture, above all architecture: for with Stokes the experience of art has always proved most profound, most satisfying, when art finds expression in a corporeal form or in a form sufficiently approximate to the body for us to make the assimilation. Hence, it was only a natural step when, under the influence of the great Diaghilev seasons, Stokes extended the range of his aesthetic interest to take in the dance, and he later came to write some of the best accounts of traditional ballet in the language. More generally, the connection between art and the body, the corporeal nature of art as we might think of it, has always figured centrally in the subject-matter of Stokes's criticism, though, as

this criticism evolves, the connection receives at different times a different elaboration and a different explanation.

But to talk of the evolution of Stokes's criticism inevitably brings us to the second major theme of his writing. For at much the same time as the love of art asserted itself, he began to sense the fascination of psychoanalysis. It was early in the 1920s that Stokes read *The Interpretation of Dreams* and *The Psychopathology of Everyday Life*. From the very beginning he experienced the attraction of the new ideas, and they slowly began to exert their influence over his thinking. The crucial event in this process was still several years off, as we shall see, and even then it was some time before the two themes of art and psychoanalysis were explicitly brought together in the critical writings. Nevertheless, if Stokes's early work can be read much as though it belonged to the tradition of nineteenth-century aestheticism, it is to be observed that, throughout, there is a place reserved for psychoanalytic theory, at which it can be introduced when the moment is right. For from the beginning the notion finds acceptance that art is a form of externalization, of making concrete the inner world, and the evolution of Stokes's criticism can largely be accounted for by the increasingly richer view that is taken of the inner world and of how and by what means it works its way to the surface.

Stokes's first book, *The Quattro Cento*, appeared in 1932, though an article on Rimini and the Tempio Malatestiano, which was to be the subject of his second book, had already been published in T. S. Eliot's *Criterion* some two years earlier. In point of fact, *The Quattro Cento* and its successor *The Stones of Rimini*, the repositories of much intense observation and reflection, represent the work of several years. Throughout the 1920s Stokes revisited Italy on a number of occasions, sometimes making his home there, sometimes travelling extensively. Often he was by himself, and in some of his most memorable descriptions we seem to discern the reverie of the young man, as he stands alone, absorbed in the temple façade, or wandering through the courtyard of a Renaissance palace or the crowded piazza of a small country town. At other times he was in company – for instance, with the Sitwells, met by chance in Italy, who were (he has said) 'the first to open my eyes', though their aesthetic

interests and his were and remained very different. A closer affinity of taste was established with Ezra Pound, whom Stokes first met as a tennis partner in Rapallo in the autumn of 1926: for the two men soon discovered that they shared not only a common admiration for the Tempio Malatestiano and the sculpture that adorned it, which Pound had already written about in the Cantos, but also a community, or perhaps a complementarity, of response.[1]

From the beginning, indeed from the opening words – the first chapter is entitled 'Jesi', and it starts 'No sign of Frederick Hohenstaufen in the railway station at least' – *The Quattro Cento* exhibits an idiosyncrasy of manner, later to become characteristic, that sets it apart from normal critical or art-historical writing. There is an obliquity of approach, long elaborate descriptions suddenly shot through with darting phrases, or an accumulation of detail, closer perhaps to lore than to learning: there is an independence, bordering on eccentricity, of judgement, and a heady freshness of observation: and there is the constant proximity of humour and depth.

In conception *The Quattro Cento* is, it is true, the most conventional of Stokes's books. For it has been endowed with an elaborate architectonic which, if it might have done something to illuminate the place of the book in some rather larger literary scheme which was

1. Of recent years the literary relations between Stokes and Ezra Pound have been the subject of speculation by a number of literary critics. In Donald Davie, *The Poet as Sculptor* (London, 1964), much is made of the connection, and *The Stones of Rimini* is talked of as a commentary on, or an elaboration of, Cantos 17 and 20. The truth would seem to be that Stokes and Pound became independently interested in Rimini, and that it was their common interest that drew them together. There seems little reason to think of Pound as an influence on Stokes's visual aesthetic: though Stokes profited greatly from his encouragement. Pound was the first to read in the late twenties the article, which was subsequently to appear in the *Criterion*, about Agostino and 'stone-and-water'. In a projected volume Stokes intended to explore the purely historical background of the Tempio, and there he would have made explicit reference to the Malatesta Cantos. The volume, however, was never written, partly because, as we shall see, Stokes's visits to Italy were, at this period, abbreviated, and partly because, as he worked on the testimony, his view of Sigismondo's personality became more uncertain and, in particular, his disagreement with Pound's estimate became more marked. And, meanwhile, *Colour and Form* crystallized. Pound was perhaps disappointed by the non-appearance of the second volume on Rimini, and the relations between the two men loosened.

ultimately abandoned, tends to obscure the thesis that it presents. The architectonic of the book is strictly geographical, divided according to the city-states of Renaissance Italy, with the central section devoted to Florence and Verona. The thesis, however, cuts across geographical distinctions and will even divide some part of the work of a given artist from the rest. For the central aim of the book is to identify and to define a mode of art, which, though it produced some of its finest manifestations in Italy in the fifteenth century, cannot be equated in any straightforward way with Quattrocento art nor even with any specific school or tradition within Quattrocento art. For this mode of art Stokes devised the label, 'Quattro Cento', from which in turn the book derives its title.

Quattro Cento art is identified through a number of characteristics varying greatly in generality and in concreteness. Associated with the various characteristics are certain distinctive merits or virtues, but Stokes is careful not to claim for Quattro Cento art supremacy, even within the art of the Renaissance. It is one mode amongst others – though for him at least invested with an inexhaustible poignancy and beauty.

The first characteristic is a passionate attachment to the medium, to stone: 'the love of stone'. But what Stokes means here – and the point is important to emphasize and it is one to which he constantly reverts, elaborating and elucidating it each time he does so – is the love of stone *as a medium*: the stone, that is, is treasured for its potentialities, for what can be coaxed out of it. And if, apropos of Agostino di Duccio or Michelangelo, Stokes talks, seemingly, of the unqualified love of the stone, the love of the block or the slab, this, it must be understood, is a derivative love. That in the first place the stone is loved as a medium is brought out, indirectly, by a kind of compliance that Stokes presupposes between artist and stone. On the artist's side, there is the outward thrust of phantasy, the projection of this on to stone, and parallel to this, there is (as an observed effect, I take it), the way in which the stone, in the hands of such an artist, pushes itself forward on to the surface. The stone blooms, there is 'encrustation', or 'exuberance'. The art of the Quattro Cento is, in a favoured phrase, the art of 'stoneblossom'. And if we are uncertain what are the visual conditions on which these descriptions rest, or

in what precisely the effect consists, it is best to turn to the various detailed accounts that Stokes provides of what are for him clear examples of the Quattro Cento: the courtyard at Urbino by Luciano Laurana, or certain works of Verrocchio. In such passages, where we can set the description against the object, the terms begin to explain themselves.

The second characteristic is mass, where this is contrasted, variously, with massiveness, typical of Roman architecture and the baroque, and with a rhythmic or linear treatment of space, such as we find in the work of Brunelleschi. The third characteristic is immediacy. And it is by design that I group these two characteristics together, because the former is best understood through the latter. For 'mass-effect' can be thought of as that awareness of space which arises (or can arise) instantaneously, or from 'the quickness of the perceiving eye'. It does not require a process of synthesis, taking place over time, in which successive impressions are first accumulated and then pieced together, but it is an immediate response to the tension, or inner ferment, expressed on the surface of the wall. Conversely, the kind of architectural space that engenders this kind of awareness is not cumulative, nor does it appear to be built up out of discrete spatial units. (Stokes, it is true, introduces the notion of mass-effect rather differently, though, I think, nothing I have said is inconsistent with what he says. For the definition of mass-effect he invokes the theory, still current at the time, according to which our awareness of space is ultimately derived from the sense of touch and there is no more than an analogue to this awareness in the visual field. This theory, which was first systematically laid out by Berkeley, died hard in aesthetics: witness the vogue enjoyed, around the turn of the century and then later, by Berenson's notion of 'tactile values' as a vital component of the Florentine achievement. It is in keeping with this tradition that Stokes defined mass-effect as that awareness of space which is peculiarly connected with the sense of sight and hence is to be contrasted with the 'normal' awareness of space. However, nothing that Stokes says commits the notion of mass-effect to this theory irrevocably, and, indeed, freed from its theoretical trappings, the idea of a treatment of space distinctive in its appeal to the eye or to visual cues can only gain in plausibility or clarity.)

The fourth characteristic is the most difficult to pin down. Quattro

Cento art is, we are told, 'emblematic', it has 'the power of emblem'. The concept of the emblematic, which disappears from Stokes's later writings, though not without a trace, falls into two parts, which are evidently if elusively related. The first is that the signs or symbols recurrent in the art render up their meaning readily: they are transparent to the eye, or at least translucent, and are what a whole school of aesthetic philosophers have called 'iconic'. The second is that the process of making the signs or symbols becomes itself symbolical or meaningful – perhaps, indeed, it is the only source of meaning in the arts, and the signs or symbols in which it issues acquire their meaning derivatively from it. And, if this initially seems obscure, we might consider for a moment human expression, or the expression that finds an outlet through the body. For there too it is the very making of the expression, or the gesture, that is in the first instance meaningful, so that the expression itself gains its meaning from the way in which it is made. If this parallel is valid, then it would suggest that at any rate part of what is intended by talking of Quattro Cento art as emblematic is (once again) a claim about the relation in which the artist stands to the medium. He is related to the stone with much the same intimacy as he is to his own body.

To these, the chief characteristics of the Quattro Cento as a mode of art, Stokes next adds perspective, which he regards as an 'indispensable' constituent. And if this strikes us as incongruous, falling clearly on the side of content, or how the subject-matter is represented, while the other characteristics are uncompromisingly formal, this only brings up in a clear because in a concrete form a general difficulty that underlies the whole characterization of the Quattro Cento: and that is the difficulty of seeing where the unity of the Quattro Cento lies, or how, for instance, the various characteristics are supposed to fit together. *The Quattro Cento* contains many fine insights and many beautiful discriminations, yet there is a real problem in knowing in what sense it deals with a single mode of art. For the resolution of this we have to turn to Stokes's next two books on the visual arts, which can conveniently be grouped together: *The Stones of Rimini* (1934), and *Colour and Form* (1937). In the interval Stokes had clarified and integrated his aesthetic categories in a way that was to be of the greatest importance for his later writing. Let us look at this.

In *The Quattro Cento* there is at various points an uncertainty that arises. An observation has been made about this or that work of art, and then the doubt may be experienced how the observation is to be understood or interpreted. Does the observation, we find ourselves asking ourselves, belong to the side of the artist and does it accordingly refer to a way in which he has worked? Or does the observation relate to the spectator, and is its aim to pick out what he can or perhaps should discern? It was in the course of removing this uncertainty that Stokes was ultimately able to resolve the more general difficulty that, as we have just seen, attached to the notion of the Quattro Cento as a unitary mode of art.

The first step was to adopt a consistent point of view. In *The Stones of Rimini* the standpoint of the artist, rather than the spectator, is consistently maintained. And this is achieved through the device of first putting in the forefront of attention a single artistic achievement, the reliefs in the Tempio Malatestiano,[2] and then considering – empathically, we might say – how it could have come to be executed. In *Colour and Form*, once again, a consistency of standpoint is retained, though now it is the more shadowy or generalized figure of 'the painter' who is the protagonist and through whose eyes we are led to reconsider many of the central issues of art and several of the greatest works of art.

In pointing out that the clarification of Stokes's earliest aesthetic is effected through the adoption of a single standpoint, I am not claiming that any viable aesthetic must be written exclusively from the point of view of the artist, alternatively, exclusively from the point of view of the spectator. On the contrary, I would think that any aesthetic written in this one-sided way would be seriously misleading. My point is only that what has first to be done is to collect together those observations which belong to one side or the other and allocate them correctly. For it is only when each standpoint has been fully articulated that the two can be collated: though it is only when they have been collated that an adequate aesthetic is likely to emerge.

2. Throughout *The Stones of Rimini* the master of the Tempio reliefs is unequivocally identified with Agostino di Duccio. This is now a matter of dispute: see e.g. John Pope-Hennessey, *Italian Renaissance Sculpture* (London, 1958); Charles Seymour, Jr, *Sculpture in Italy, 1400–1500* (London, 1966).

However, it is not merely a shift of standpoint, or rather a shift towards consistency of standpoint that occurs between *The Quattro Cento* and its successors, there is also an important conceptual innovation, and one permits the other. In the first book, in the course of trying to identify Quattro Cento art and to distinguish it from other contemporary trends, Stokes had written:

> The distinction I am making is laborious. I might have simplified it into a distinction between carving and modelling, between the use of stone and of bronze, were it not for the fact that the bronze can well convey an emotion primarily imputed to the stone, while, on the other hand, stone can be carved, as it was by Lombard sculptors, to perpetuate a conception not only founded upon the model but inspired by modelling technique.[3]

In this passage the concepts of carving and modelling are, of course, being used literally – in such a way, that is, that they are tied unequivocally to specific techniques or physical processes. And as such the concepts are, he finds, restrictive, or positively misleading. However, once the aesthetic theory comes to be restated from the standpoint of the artist, it seems plausible to reconsider using these concepts and possible to consider using them in an extended or metaphorical sense. Carving and modelling are now thought of as the two most general attitudes that the artist might adopt to his medium – attitudes derived from, but not confined to, the techniques or processes after which they are named. So adjusted, the two concepts move into the centre of Stokes's aesthetic. More specifically, the notion of the Quattro Cento gives way to that of carving: the Quattro Cento artist is recognized as *par excellence* the carver.

The dichotomy of carving and modelling has a longish history not only in artistic practice but also in aesthetic theory. However, in deciding to employ the terminology that he had rejected in *The Quattro Cento*, Stokes would seem to have been influenced less by intellectual precedent than by the painters and sculptors whom he was seeing in England at this time: notably Ben Nicholson and Barbara Hepworth. For in the work of these artists and their associates the sense of direct engagement with the material was a highly self-conscious element, and in this respect they thought of themselves as in deliberate reaction against both the academic and

3. Adrian Stokes, *The Quattro Cento* (London, 1932), p. 28.

the 'fine art' or Rodinesque traditions, in which the making of models which were then sent to Italy to be cast by fine craftsmen still played a significant role. Writing around this period, Henry Moore, who was much involved with this new aesthetic, referred to Donatello the modeller as 'the beginning of the end'.[4]

It would, however, be wrong to think of the prominence now afforded to the notions of carving and modelling as simply a conceptual innovation: or – perhaps a better way of putting the matter – it would be wrong to think of the conceptual innovation involved as simply a change of vocabulary. On the contrary: the introduction of concepts that applied, in the first place, to actual techniques, and then, by extension, to generalized ways in which the artist might regard his relation to the medium, coupled, as we have seen, with the adoption of the artist's viewpoint as that from which aesthetic description or analysis is formulated, allowed Stokes to present a clearer and more far-reaching view of the kind of art with which he was still centrally concerned. We have only to read the central section of *The Stones of Rimini*, with its description of the Tempio reliefs, to see how much the aesthetic has gained in lucidity, in depth, and in subtlety through the changes that occurred since *The Quattro Cento*. There are, however, one or two observations worth making.

In the first place, it is to be observed how the characteristic that Stokes had spoken of in *The Quattro Cento* as 'the love of stone' is clarified within the new conceptual context, and how, in particular, the point to which I drew attention – that it is love of stone *as a medium* to which Stokes makes reference – comes out very sharply. The point is now made by resolving this sentiment into two components. There is, on the one hand, the artist's resolve to project his phantasies and emotions on to the stone, while yet preserving the integrity of the stone. Accordingly, the surface of the stone acquires differentiation, and yet the various layers or facets into which it is resolved contrive to be related without abrupt transitions or emphasis. And it is at this stage that the significance of perspective, which had proved a recalcitrant or heterogeneous element in the original stylistic characterization of the Quattro Cento, is integrated into the new account; for the value of perspective is that it allows the

4. John Russell, *Henry Moore* (London, 1968), p. 19.

externalization of the artist's phantasy (or what in the broadest sense might be called 'representation') in a way that does not involve any undue or assertive attack upon the stone such as we find with other more frankly 'illusionistic' devices for securing depth, such as undercutting or high relief. The stone remains inviolate. Or, more accurately, it has a chance of remaining inviolate: for Stokes distinguishes between the use of perspective within the carving tradition – the 'love of perspective', as he calls it, in writing of Piero, the artist in whom it is exemplified supremely – and the mere exploitation of perspective in chillier ways, which he regards as a characteristic abuse in fifteenth-century Florentine painting. And, on the other hand, there is the artist's attention to the stone itself, to the varied intimations and suggestions it exhales, to what we might think of, or what at any rate the true carver might think of, as the phantasies that in some metaphorical sense it contains. There are many factors – its geological history, its cultural associations, the particular way it responds to manipulation, as well as its appearance to the eye – which determine the precise contribution that a type of stone makes to the art of those who love it. In many passages, limpid, persuasive, moving also below the level of consciousness, Stokes suggests the most intimate connections between marble, low relief, and phantasies of water. However, for Stokes the favoured way of bringing out this connection has always been by invocation of what he sees as its most powerful exemplification: 'the largest, the oldest, the most varied aesthetic object that has survived to-day', Venice, 'the city of Venice among intrusive waters'. It is for this reason, and not for the mere enrichment of the text, that the description of Venice is such a constant point of return in Stokes's writing.

Again, it is to be observed how the adoption of the new concepts helped to free Stokes's aesthetic theory from any residual chronological reference. For it was hard not to associate the Quattro Cento with the Quattrocento, but under the heading of 'the carving tradition' Stokes felt himself able to talk in one breath of the great sculptors and architects of ancient Athens, Alberti, Piero della Francesca, Giorgione and the Venetians, Michelangelo, Vermeer, and Cézanne and his true descendants. And if this list of names suggests a much wider frame of aesthetic reference than anything we had so

far been prepared for, we have at this stage to conjoin *The Stones of Rimini* with *Colour and Form*. For in this later book Stokes explicitly set himself to establish correspondences within the domain of painting for the various characteristics and virtues by reference to which he had identified the carving tradition in sculpture and architecture. Colour takes the place of stone as the loved medium, and the love of colour is then said to find expression in a number of characteristic ways. Stokes enumerates: the depiction of objects as self-lit; the exploitation of near-complementaries, and of the pheno-menon of simultaneous contrast; the application of any specific colour to the surface in such a way as to reveal its constituents. And for one pervasive colour-effect typical of the carving painter, Stokes borrowed a term from a philosopher whose influence he had felt as an undergraduate and to whom he owed (he told me once) one of the few intellectual debts he had contracted at Oxford: the philosopher is F. H. Bradley, and the phrase is 'identity-in-difference'.

That colour – or perhaps more precisely colour-form – should be the major concern, or the prime love, of the carving tradition in painting is based upon the consideration, for which Stokes thought that there was adequate scientific support, that our awareness of something being external to us, or of 'outwardness', is most power-fully given to us not simply by vision but by chromatic vision. It is in virtue of colour – 'surface' colour, that is – that we have the sense of otherness, which in turn is vital to such notions as projection and externalization. Once the centrality of colour is given, then the ways in which the love of colour expresses itself follow very closely the pattern that Stokes had laid down for the love of stone. There is, on the one hand, the projection of the painter's inner states on to the colour surface, while yet retaining the integrity of that surface. And, on the other hand, there is the painter's attention to the potential life, or the 'vitality', of the canvas as the bearer of colour.

So far I have spoken of the concept of carving, how it takes over from that of the Quattro Cento, and how this allowed the tradition picked out by this latter notion to be clarified and generalized – its aims to be more sharply formulated, and its presence in history more widely recognized. But no less important, though less evidently so for the reader of *The Stones of Rimini*, is the introduction of the contrasted or antithetic concept of modelling. In *The Quattro Cento*

we read of values alternate to those of the preferred tradition: there are references to massiveness, plasticity, the scenic, the pictorial, emphasis, 'finish' – sometimes involving the subtlest uses of these terms (as, for instance, in the description of Ghiberti). Nevertheless, the nature of these values is not always clear: and apart from the seemingly accidental fact that they, or groups of them, happen to have been brought together within the great historical styles, it is left unspecified whether they have any principle of unity. With the introduction of the concept of modelling this changes. Subsumed under a single concept, which in turn associates them with a specific attitude or relation of artist to medium, these various values no longer seem to be merely deviant, but interlock to form a counter-tradition. And if the immediate sequel to the conceptual innovation effected in *The Stones of Rimini* happens to be that the carving tradition is upgraded and is now given – as it was not in *The Quattro Cento* – supreme status, in the long run this is not how things are to remain. The characteristics of modelling – once it is recognized that they too constitute a tradition – are to be reconsidered, and in Stokes's later writing they are acknowledged not just as something of which art will never be free, nor as something which forms an inevitable substrate of carving, but as possessing their own significance and value, as 'a vital and irreplaceable constituent' of art itself. But to understand this reassessment and to see how it comes about, we must take a broader view.

I have talked of the two large themes that go to the making of Stokes's criticism – art and psychoanalysis – and I have already said that, if the second of these themes remains latent throughout the earlier writings, there is, as it were, a place reserved for it, which it can, when the moment is ready, come forward and occupy. In this connection I referred to the idea, present from the beginning, of art as a form of externalization or projection. In a moment we shall see that there is more to it than this: that there are other ways in which the later criticism is anticipated in the earlier. Meanwhile we might discern, even in the earliest writings, but markedly in *The Stones of Rimini*, both a reference to and a reliance upon such connections or associations in the mind as psychoanalysis would assume to be not merely present but operative. Assumptions are made about the mind

of the artist and about the mind of the reader, how one is to be described and the other addressed, of a kind that would seem natural to anyone exposed to Freudian theory. But for the explicit appearance of psychoanalysis we have to wait.

The significant date in all this, we might imagine, the beginning of Stokes's analysis with Melanie Klein, which itself ran on through the 1930s; and it is this that I have referred to as the crucial event in the process in which the psychoanalytic colouring to Stokes's criticism becomes more saturated. In point of fact, the immediate consequence of the analysis was the interruption of those leisurely, protracted visits to Italy upon which the first books depended. Life, we must assume, changed. And it should be observed that the earliest attempts to draw upon the findings of psychoanalysis or to bring these findings into connection with the experience of art occur in the autobiographical volumes, where they are carried out on a purely subjective or personal level: as though Stokes felt, in keeping with the tenor of psychoanalysis, that it was only when he had worked out these links or connections for himself, that it was only when he had tested them against his own experience and found them compelling, that he was prepared to generalize them, or assert them as part of a critical theory. In the complexity, the intricate workmanship of *Inside Out* (1947) and *Smooth and Rough* (1951), we see this process at work.

For Stokes psychoanalysis has much of the imaginative richness and vitality of art itself. He has experienced its charms, and he is deeply immersed in its literature. However, that part of psychoanalytic theory which he has taken up and deployed in his criticism and which is therefore relevant to its understanding is restricted, and it falls within the extension effected to Freud's theory by Mrs Klein. More specifically, we can identify it with her account of the two 'positions' which she postulated in trying to characterize the early history of the individual.

The starting-point for Mrs Klein's work was Freud's account of infantile development. For Freud infantile development could be reckoned in terms of comparatively distinct phases, or, as he was later to call them, 'organizations'. Each phase is dominated by a particular part of the body, which currently enjoys primacy in the sexual constitution of the infant, and from which the phase takes its name.

By primacy Freud meant more than that for the infant, during any given phase, the dominant part of the body is the infant's sexual organ, and pleasure derived from that part of the body is the infant's sexual activity: he also meant something to the effect that the whole, or a great deal, of the infant's emotions and relations to objects outside itself are coloured by thoughts of, or feelings about, that part of the body. The parts of the body that enjoy or can enjoy primacy are the mouth, the anus, the penis or its counterpart, the clitoris, and, more generally, the genitals. Primacy passes from one part of the body to another, in accordance with a sequence that is by and large biologically determined, though it can be upset or modified by environmental circumstances or the infant's perception of them. In normal circumstances, the infant passes from the oral, through the anal, and the phallic, to the genital phase, and this cycle is completed within the first five or six years of life.

Each of these phases marks, in the first instance, a stage in the infant's sexual development. Or, to put it the other way round, the infant's development is initially calculated in terms of sexuality and its transformations. Freud, however, never thought of this as the whole story, and he was keen that it should not be thought of as such. For him any totally adequate account of infantile development should correlate the sequence of libidinally distinguished phases with phases in the emergence of the ego. Instinct and that which controls, moderates, or deflects, instinct evolve concurrently and not without interaction. In Freud's thought, an overall or integrated account of infantile development, in which the course of the two evolutionary currents would be traced, remained something of an ideal; though, for a number of specific infantile situations, such as those from which paranoia or melancholia derive, he provided vignettes, worked to some considerable degree of detail, of the total psychological structure and condition.

It was to fill out Freud's account of infantile development that Mrs Klein postulated her two positions which the infant is said to adopt. The very term 'position' discloses this, for by 'position' Mrs Klein meant something considerably more complex than a stage in libidinal or sexual development. She expressly meant it to include, for instance, the mechanisms of defence to which the infant, while it adopts a particular position, characteristically resorts in dealing with

anything painful in the outer or the inner world. Mrs Klein called her two positions the paranoid-schizoid position and the depressive position. These names, however, are not to be taken as indicating that the positions are in themselves psychotic. On the contrary, they are part of normal development, though they are related (like the phases of sexual development that Freud identified) in several significant ways to the disturbances of adult life.

There are, it might be said, three distinct ways in which Mrs Klein's account supplements what Freud found to say about infantile development. In the first place, it is to be noted of both positions that they are initially adopted by the infant at an earlier period than any in which Freud took a close interest: in and just after the oral phase. In this way, Mrs Klein's account contributes to the prehistory of that part of the infantile development which Freud laid bare. Secondly, though we can date the first appearance of the two positions, or their original adoption by the infant, they are not confined to this or to any other of the phases identified in Freud's chronology of the libido. Indeed, the temporal relations between the two positions themselves are not secure, for the movement backwards and forwards between them is superimposed on all infantile development. The transition from the paranoid-schizoid position to the depressive position and the overcoming of the latter – crucial moments, according to this account – are never achieved completely, beyond all danger of regression. In this way, Mrs Klein's account furnishes a counterpoint to Freud's account. Thirdly, the two positions are identified primarily by reference to the ego and its structure, and only secondarily by reference to the libido. Indeed, in so far as reference is made to the libido in defining the two positions, it is impure or oblique, in so far as what is referred to is the libido as channelled or directed by the ego: in other words, to the kinds of relation that the ego establishes with objects or elements in the external world. In the paranoid-schizoid position, the ego lacks integration, the objects to which it is related, both outer and inner, are part-objects, and the characteristic defences to which it resorts are splitting and denial. In the depressive position, the ego has achieved a measure of integration, even if this is not securely established: the objects to which it is related are conceived of in their integrity, which means, significantly, as both good and bad; and instead

of the unrelenting attempts to distort the world, typical of the earlier position, it allows itself to experience guilt, regret, and longing.

Against this background it is now possible to formulate the basic project of Stokes's later writings: *Michelangelo* (1955), *Greek Culture and the Ego* (1958), *Three Essays on the Painting of our Time* (1961) *Painting and the Inner World* (1963), *The Invitation in Art* (1965), and *Reflections on the Nude* (1967). Very roughly, – and for anything even approximating to the subtlety and ingenuity of Stokes's criticism there is no alternative to a return to the writings themselves – what Stokes has endeavoured to do is to associate the two modes of art that he had identified, the carving and modelling traditions, with the two positions that Mrs Klein had postulated. Of course, the associations are both multiple and complex, and in many cases they are mediated by a number of intervening factors or run through chains. The overall point to be made is that, in each case, the mode or tradition of art is held to reflect or to celebrate the kind of relation that is typical of the corresponding position.

The connection between the carving tradition and the depressive position is the more readily grasped. The carver, we are to imagine, in respecting the integrity and the separateness of the stone, celebrates at once the whole object with which he characteristically enters into relation and also the integrated ego that he projects. In a single sentence in *Greek Culture and the Ego* Stokes brings the two aspects together: 'The work of art is esteemed for its otherness, as a self-sufficient object, no less than as an ego-figure.'[5] In talking of self-sufficiency, of aesthetic detachment, of the rejection of taste and smell as constituents of the work of art, Stokes is drawing together characteristics that have often been insisted on, in the drier or more academic forms of aesthetics, as essential to or as definitive of art itself: he then connects these characteristics with others, more immediately linked to observation, which he had described and analysed in his earlier writings: and he is then able to offer this new amalgam as equivalent, for him, to one, but only one, of the great traditions in art.

For perhaps the most intriguing element in Stokes's later writing is what he makes of the modelling tradition. What up till then had

5. Adrian Stokes, *Greek Culture and the Ego* (London, 1958), p. 50.

been comparatively neglected, at times indeed despised, is systematically reconstructed, and then in its reconstructed form is brought into association with the earlier of the two positions. What underlies this is the realization that, in the last analysis, the modelled work of art can be thought of as the mirror-image of the carved work of art. Examine the characteristics of each, and we see that they are those of the other in reverse. So, in the carved work of art there is a lack of any sharp internal differentiation: the individual forms are unemphatic, and the transitions between them are gradual: there is, to borrow the phrase in which Stokes described Piero's figures, a certain 'brotherliness' in the composition. And the reward for this is that the work of art as a whole asserts it distinctness or otherness from the spectator. By contrast, in the modelled work of art, there are sharp transitions and considerable internal differentiation: the forms are distinct and individuated, they billow out from, or burrow their way into, the background: and in the overall composition, either the parts remain quite separate and their effect is cumulative, or else they are somewhat intemperately or arbitrarily brought together by means of some overriding device. And the price that is paid for this is that the work of art as a whole tends to merge with or envelop the spectator. Just as a lack of sharp internal distinctions produces separateness from the spectator, or self-sufficiency, so an insistence upon internal distinctions produces a loss of separateness, or a dependence upon the spectator. In this loss of separateness, which is also called the 'incantatory' element in art or art's 'invitation', we can see how the tradition to which this effect typically belongs enables its objects to epitomize both the part-objects of early relations and the still inchoate ego which enters into such relations. With the expressive value of the once depreciated modelling tradition securely established, it is no surprise that the tradition should be recognized as a rightful partner in the development of art. Earlier reservations fall away. 'For many years now,' Stokes wrote in 1961, 'I have no longer regarded an enveloping relationship to be foreign to the intention of art; on the contrary I have thought of it as a fundamental attribute when associated with the opposite relationship to an independent object.'[6]

It would be vain to take further the summary of Stokes's views as

6. Adrian Stokes, *Three Essays on the Painting of our Time* (London, 1961), p. 28.

these are to be found in the later books. All I should like to do is to point out one feature, already present in the earlier criticism and to which I have made implicit reference, upon which so much of these developments depends.

In discussing the transition from *The Quattro Cento* to *The Stones of Rimini*, I said something about the way in which perspective which seemed a discrepant element in the earlier volume falls into place in the later book. The discrepancy arose, I suggested, because the mention of perspective seemed to introduce a characteristic that belonged to content amongst so many characteristics that were purely formal, and the discrepancy was resolved by a shift to a unitary, and hence an internal, point of view. In this resolution we may now see the presage of much that is to come. For, if we consider the bulk of criticism that has been written under the influence of psychoanalysis, we can see that it deliberately models itself upon those parts of psychoanalysis which are concerned with the discovery of a hidden or latent content inside a public or manifest content: and the parts of psychoanalysis I have in mind are, of course, the analysis of symptoms, the theory of parapraxes (errors, etc.), and, supremely, the interpretation of dreams. And in pursuing this particular course, psychoanalytically orientated criticism has only been following the lead (or so it has assured itself) set by Freud in his famous essays on Leonardo and the Michelangelo *Moses*. By now the methodological inadequacies of this kind of approach have been fully exposed. Most substantially, the point has been made that art criticism framed in this way is likely to leave out of account the 'art' aspect of the work of art. From the beginning Stokes's criticism, even as it began to feel the influence of psychoanalysis, has struggled to avoid these dangers, and to do full justice to that aspect of art for which we esteem it. In part, this has involved bringing certain formal aspects of the work of art under interpretation. But in part, and more significantly, it has meant dismantling somewhat the rigid distinction between form and content on which much traditional art criticism and art theory has indolently rested. It is the first steps in this process that we observe in *The Stones of Rimini*, in the discussion of perspective, or in much of what is written in the early books about art and the body: and it moves forward at such a pace that, by the time we reach the later writings, it becomes for the reader the most natural thing in the

world – in the world of art, at any rate – to assimilate a shape to a feeling, or to equate the use of a specific material with a phantasy. In these works we catch the unmistakable voice of psychoanalytic culture.

If this last observation does not already take us there, it is time to turn to another aspect of Stokes's writing: the style. I have referred, explicitly and implicitly, to a number of transformations that take place in the criticism over the years. As a concomitant, or perhaps a consequence, of these transformations, there goes a no less remarkable transformation of style.

Affected somewhat by Ruskin, Stokes's early style was formed upon that of Pater, a writer whose influence once experienced is never totally shaken off. Stokes read Pater when he first began to visit Italy, and he was, he has told me, 'bowled over'. Stokes's prose exhibits a number of characteristics that we find in Pater: many of the same phrases, the same use of inversion, and some of the same cadences. Above all, Stokes derived from Pater a certain precision in the use of language which no one earlier had attempted in the same fashion. For the precision I have in mind does not consist in the exact setting down of observable features: it is a precision not of description, but rather of presentation, as though the critic's task was to offer up, along with the object, those associations and sentiments that determine its place in our understanding or appreciation. To many of Pater's characteristics – Stokes has not the sureness of ear of Pater, and he is happily free of his whimsicality – Stokes adds things of his own: a certain strength, and a wry oblique humour which is certainly not to be found in the older writer.

But with the increasing influence of psychoanalysis upon the content of the criticism, the style is modified. The old sensibility to associations is retained, but something has to be done to accommodate the intellectually more complex framework within which the consideration of individual works of art or individual artists comes to be set. The style becomes more aphoristic. And the ultimate critical task is now felt to have been incompletely realized unless all the related thoughts, all the relevant sentiments, have been gathered in – as they might be in a psychoanalytic interpretation. One result can be, perhaps, a certain lack of focus, and sometimes it is not easy

for the reader to determine which is the central idea, and which are the reservations or the qualifying thoughts. But then this too can be a form of precision: the finding of a precise equivalent to the fluctuations of feeling and perception, which are inherent in art. Delicately, abstrusely, magically I would say, the struggles of the artist for unity, for some kind of unity, his triumphs and reverses, are recreated for us by someone who knows. '*Poeta che mi guidi*': I can think of no better words, the words of Dante about Virgil, to describe Stokes as a critic of the arts.

Some seven or eight years ago in contributing a preface to *The Invitation in Art* I argued that it was wrong to think of Stokes as narrowly an aesthete, to the exclusion of being a social critic. Indeed, I argued that there was a natural connection between the two roles, and that it was the cases in which they do not coincide, in which the aesthete is indifferent to the conditions of his society, that require explanation. I shall not repeat what I said then, but I should like, in conclusion, to add an observation.

In the intervening years, much has been written about the gap between art and life, and how it might be bridged. Most of what has been written has been absurd. And in part the fault lies in a confusion or uncertainty in the minds of those who have pontificated. For they have failed to distinguish between a conceptual issue and a purely practical issue. That is to say, they have identified the gap sometimes with the essential difference between art and what is not art, and sometimes with the many different devices, generally oppressively or enviously conceived, by which art has been segregated from those for whom it was made and turned into a preserve of the rich and the arrogant. In decrying the latter, they have fallen into denying the former, and accordingly they have railed against both indiscriminately. In objecting to the ways in which art has been exploited and degraded, they have come to assert that there is no such thing as art, that there is only life. To read Stokes's writings on these issues is to be recalled to a fresh sense of their significance and their urgency. For his work has been a sustained attempt to defend, to justify, if need be to sharpen, the conceptual distinction, and also to narrow, perhaps to close, the cultural divide.

Index of Principal Names